Adobe Photoshop Lightroom 4

The Missing FAQ

Real Answers to Real Questions asked by Lightroom Users

Victoria Bampton

Lightroom Queen Publishing

Adobe Lightroom—The Missing FAQ—Version 4
Book update 25 March 2012
Copyright © 2012 Victoria Bampton. All rights reserved.

Published by The Lightroom Queen

ISBN 978-0-9560030-6-5 (eBook Formats)
ISBN 978-0-9560030-7-2 (Paperback)

Table of Contents

Table of Contents... in Detail

Import 77

Editing in Other Programs 469

EDITING IN OTHER PROGRAMS 469

Export 487

Slideshow Module 591

Acknowledgments

A lot of people have contributed to this project, and although I'd love to thank everyone personally, the acknowledgments would fill up the entire book. There are some people who deserve a special mention though.

I couldn't go without thanking the Lightroom team at Adobe, especially Tom Hogarty, Eric Chan, Dan Tull, Max Wendt, Ben Warde, Becky Sowada and Julie Kmoch, who have willingly answered my endless questions.

Of course, there are also those who have helped put this book together. Many thanks go to Paul McFarlane, who did a great job of proof-reading once again, and willingly dropped everything to help get this book finished almost on schedule. Thanks also to Erik Bernskiold, who designed the cover.

Thanks are also due to the team of Lightroom Gurus, who are always happy to discuss, debate and share their experience, especially Jeff Schewe, Andrew Rodney, Peter Krogh, Ian Lyons, Sean McCormack, John Beardsworth, Lee Jay Fingersh, Mark Sirota, Beat Gossweiler, Geoff Walker, Gene McCullagh, Jeffrey Friedl, Rikk Flohr, Don Ricklin, Laura Shoe, John Hollenberg, Brad Snyder, and the rest of the crew!

I'm also grateful to the members of Lightroom Forums and Adobe Forums, who constantly challenge me with questions, problems to solve, and give me ideas for this book. Special thanks go to Denis Pagé, Hal Anderson, Jim Wilde, Cletus Lee and Robert Olsson, who freely give of their time in supporting our members. Also Scott Anderson, Rob Cole, and others who have made many suggestions for the book.

And finally I have to thank you, the Reader. Many of the changes in the book are based on the suggestions and questions that you've sent in, and your comments in my survey. It's your book. The lovely emails I've received, and the reviews you post online, make all the late nights and early mornings worthwhile—so thank you.

The 21 months since the release of Lightroom 3 have been a wonderful rollercoaster ride, and now with the release of Lightroom 4 at its new lower price, I'm excited to see what will happen next.

Victoria Bampton - Southampton, March 2012

Introduction

Adobe® Photoshop® Lightroom™ 1.0 was released on February 19th 2007, after a long public beta period, and it rapidly became a hit. Thousands of users flooded the forums looking for answers to their questions. In the 5 years that have followed, Lightroom has continued to gain popularity, becoming the program of choice for amateur and professional photographers alike.

When you have a question or you get stuck with one of Lightroom's less intuitive features, where do you look? Do you trawl through thousands of web pages looking for the information you need? Perhaps post on a forum and wait hours for anyone to reply? From now on, you look right here! *Adobe Lightroom 4—The Missing FAQ* is a compilation of the questions most frequently asked—and many not so frequently asked—by real users on forums all over the world.

Unlike many 'how-to' books, this isn't just the theory of how Lightroom is supposed to work, but also the workarounds and solutions for the times when it doesn't behave in the way you'd expect. I'm not going to drag you through every single control and menu command because, well, that's boring, and that basic information's freely available in Adobe's Help documentation (http://www.lrq.me/lr4-help) and other books. Instead, we're going to concentrate on real-world use, and the information you actually need to know. Most controls and menu commands will be

discussed in that context, and any I've left out are too obvious to need a book anyway.

I know you're intelligent (after all, you chose to buy this book!), and I'll assume you already have some understanding of computers and digital photography. You'll find an introduction at the beginning of each section, to give you an overview if you're a new user. Unlike the other books, I'm not going to tell you what you 'must' do—I'm going to give you the information you need to make an informed decision about your own workflow so you can get the best out of Lightroom.

Two of my favorite comments about this series of book were "it's like a conversation with a trusted friend" and "it's like having Victoria sat next to you helping." That is my aim—we'll do this together.

The Book Format

As you glance through the pages of this book, you'll notice it's designed primarily as a reference book, so similar topics and questions are grouped together. I've tried to keep things in a logical order for anyone who decides to read the book cover-to-cover, but feel free to skip around to find the answers to your questions.

In the front you'll find a list of all of the questions covered in this book and, of course, no book would be complete without an index in the back. I've left space in the sidebars for you to add your own notes. In the eBook formats, you can also use the search facility or bookmarks to find the specific information you need, and add your own bookmarks and notes too.

As you read on, you'll notice clickable sidebar links to other related topics marked with a pin, which are particularly useful if you're searching for the answer to a specific issue, or want to find out a little more about the current topic. These cross-references usually refer to questions outside of the current section, rather than the question on the previous

 Also check...

Sidebar links are clickable—and then you can use your software's back button to return

page. If you follow one of those cross-references, most eReader software includes a Back button to take you back to your previous page.

There are also links to various websites, including my own. In order to keep those website links current, and make them easy for you to access, I've used my own short-url domain http://www.lrq.me to handle the redirections and you can ignore the www. if you want to make it even quicker to type. There's a full list of links at http://www.lrq.me/lr4-links

The final chapters list other useful information, including default file locations for preferences, presets and catalogs for each operating system, and a list of all of the known keyboard shortcuts.

Windows or Mac?

It doesn't matter whether you're using the Windows or Mac platform, or even both. Lightroom is cross-platform, and therefore this book will follow the same pattern. The screenshots are mainly of the Mac version because I'm writing on a Mac, but the Windows version is almost identical in functionality, and any significant differences will be explained and illustrated.

Where keyboard shortcuts or other commands differ by platform, both are included. The one exception will be the shortcut to view a context-sensitive menu, which is right-click on Windows or Ctrl-click on Mac. I'll keep that simple and just refer to right-clicking, as many Mac users today use 2-button mice, however if you're a Mac user with a one-button mouse, just remember that right-click is the same as Ctrl-click.

Register your book for additional benefits

This book was primarily designed for the PDF format, with easy search and clickable links, but you can choose how to you wish to read it—PDF, ePub, Kindle, Paperback, or all 4! You might want the PDF version on your computer for searching while you work with Lightroom, the Kindle

Also check...

"Register your book for additional benefits"
on page 670

version for reading cover-to-cover while relaxing in the garden, and the paperback for scribbling extra notes. It's up to you.

Better still, when you register your copy of this book, you can download all of the eBook formats AT NO EXTRA COST and get access to updates, as well as gaining access to other member benefits.

If you purchased the book direct from http://www.lightroomqueen.com, you should already be automatically registered, and have received your Members Area login details by email within 48 hours of ordering.

If you purchased the paperback from Amazon, Barnes&Noble or another retailer, the Kindle version direct from Amazon, or the ePub version from iBookStore, you'll find the registration details at the end of the Troubleshooting & Useful Information chapter.

Why is the paperback in black & white print?

I'd love to release the paperback in color, and even better, I'd love to do it spiral bound. Maybe one day I'll be able to do that. If you'd find spiral binding easier, many office supply stores are able to cut the spine off the book and replace it with a spiral binding. I've purposely left additional space in the margin to allow you to do that, if you wish to do so.

So why is it in black & white print? Quite simply, I made a choice to self-publish. My aim is not to become a traditional author. I simply want to provide you with the information and help you need in the best way I can. The content of this book works particularly well in digital formats, so PDF is the primary format, and I have further plans for other digital features. However, as some people prefer to read hard-copy, I've also arranged to have the books printed on demand, although that's only available in black & white print at this point in time. The difference in cost between the eBooks and paperback is purely the cost of printing and distribution, to save you having to print your own copy.

I could have accepted an offer from a large publisher and they would have printed the book in color, but then I couldn't offer you all of the other features, including…

- An early release date - the book is available shortly after Lightroom's release, instead of having a minimum 10-12 week lead time.

- Multiple eBook formats - you can read the book in whichever format suits you best, without having to pay for the same book twice.

- Free updates - you have access to updates between major releases, either by updating the book for new features which are sometimes added in a .1 release, or by other means. (I have plans… keep an eye on the Premium Members Area!)

- An upgrade discount - when the next Lightroom version is released, you can claim your personal discount code so you can always have the latest version of the book without paying full price again.

- Complete control over the content - so I can write the book that you want, rather than the book that the publishers want. This book is based entirely around the suggestions and questions from real Lightroom users like you.

- Personal contact - if you get stuck or have any suggestions, you're very welcome to get in touch via the Members Area.

After reading this book and logging in to the Members Area, I hope you agree that it was the right decision.

Updates

Every time Adobe announce a new dot release (such as 4.1), I get an influx of emails asking whether there's a book update available, so let me save you a job… Adobe doesn't usually add new features to dot releases, so the book should still be current even when 4.6 is released (although

they have been known to make changes to the .1 release). If there are any major changes, the updated book will appear in your Members Area (so make sure you're registered!), an email will be sent to anyone who has joined the 'book updates' mailing list, and a post will go up in the Book Updates category on my blog: http://www.lrq.me/bookupdates

Talk to me!

I'd love to hear your feedback on the things you like about this book, and the things you don't. I'm always looking for ways to make this book even better, so if you come across a question that I've missed, something that's not clear, or you just want to tell me how much you love the book, you can email me at members@lightroomqueen.com or better still, send me a note at http://www.lrq.me/newticket to make sure your message doesn't get caught in spam. I do reply!

If you enjoy the book, posting a review on Amazon or your favorite online bookstore would make my day, and would help other Lightroom users find it too. Thank you!

Now, where shall we start…?

Quick Start Essentials

If you're anything like me, the first thing you want to do with a new program is dive right in. Who wants to read an instruction manual when you can experiment? If you're nodding in agreement, that's fine, but do yourself a favor and just read this short chapter before you jump in head first. You'll save yourself a lot of headaches!

There's no doubt about it, Lightroom has a mind of its own. It's a great mind, but it doesn't always think in exactly the same way that you and I do, or in the way that we're used to working with other programs, so there are a few things that you really need to understand. Read on...

The Basics

Lightroom's designed for nondestructive editing. That's to say, changes you make to your photos in the Develop module aren't applied to the original image data until you export them, and even then it doesn't overwrite the original file, but creates an edited copy.

Firstly you 'import' your photos into Lightroom. That doesn't mean they're actually in Lightroom. They're still on your hard drive as normal files, and in the Import dialog you can decide whether to leave them where they are, or whether to copy or move them to a new location of your choice. To be clear, don't delete your files thinking that they're in Lightroom—they're not.

The Lightroom catalog holds data about your photos. It's just a long text database with small JPEG preview files in a nearby folder structure. It keeps a record of where the photos are stored on your hard drive, and other metadata describing your photos. That's where any changes you make in Lightroom are stored too. So next essential tip—don't tidy up your photos on your hard drive or rename them in other programs, or Lightroom will ask you to find them all. If you need to tidy up, do it within Lightroom's interface.

Next in line, you're going to organize your photos in the Library module, sorting them into groups, choosing your favorites, adding metadata describing the photos such as keywords, and then editing the photos in the Develop module. Because it's a database, you don't have to hit 'Save' every few minutes. All of the changes you make are recorded as you go along, but this isn't like resaving a JPEG over and over again, which would reduce the image quality. Instead, all of your changes are saved as text instructions in the catalog until you choose to remove the photos from the catalog.

Here comes another essential—if you remove photos from your Lightroom catalog, and then import them again, all of the work you did in Lightroom will be gone. There is a partial exception called XMP, but we'll come back to that later. The main things to remember are to back up the catalog regularly, and if you lose track of the files, don't use Synchronize to remove them and re-import—redirect the links to the new file locations by clicking on the question marks instead, so you don't lose your changes.

Finally, how do you get your adjusted photos out of Lightroom? You 'export' them. Consider it a 'Save As'—it creates a new file in the location of your choice, in whatever file format, size and color space that suits your purpose. But that's the great thing about Lightroom—you don't have to keep different sized finished copies of every photo unless you want to, because as long as you have the originals and the catalog, you can output finished photos on demand.

You're not just limited to exporting single photos. The Book, Slideshow, Print and Web modules allow you to create... well, books, slideshows, prints and web galleries. Publish Services also allows you to keep your photos synchronized with online photo sharing websites such as Flickr.

Basic Workflow

Capture
- Think about your file format—raw vs. JPEG
- Expose the photo correctly in the camera to produce the best quality

Import
- Store photos in organized folders
- Consider renaming and converting raw files to DNG format
- Apply basic metadata such as copyright and general keywords
- Apply any Develop presets as a starting point, such as a camera profile
- Render previews to save time later

Organize
- Browse through your photos
- Manage photos in folders
- Group photos into collections and stacks
- Add flags, star ratings and labels to identify your favorite photos
- Add additional metadata, such as keywords and map locations
- Search for photos using filters and smart collections
- Don't forget to back up the catalog as well as the photos themselves

Develop & Retouch

- Adjust tone & color
- Remove noise, sensor dust, sharpen and apply lens corrections
- Straighten & crop
- Apply effects, such as black & white or split tones
- Switch to Photoshop and other external editors for pixel based editing
- Create panoramic shots and HDR photos in external editors

Output

- Create finished files in the size, format and color space of your choice
- Use Export plug-ins to enhance your export, such as adding borders
- Design photo books, save them as PDF eBooks or have them printed by Blurb
- View slideshows and export them to video, PDF and JPEG formats
- Print using your printer or save layouts to JPEG to print at a local print lab
- Create web galleries to upload to your website
- Use Publish Services to synchronize with Flickr and other photo sharing websites or folders on your hard drive

Also check...

"Designing Your Workflow" chapter starting on page 633

We'll go into more detail about workflow in the Designing Your Workflow chapter later in the book.

The Top 10 Gotchas

There are a few things that catch most people out at some stage, so I can't repeat these often enough. We'll go into them in more detail in later chapters.

- Lightroom is designed for nondestructive editing, so don't try to save over your originals.

- Lightroom doesn't 'contain' photos—it just holds data about them—so don't delete your photos from your hard drive thinking that they're safely stored in Lightroom.

- Lightroom's backups only back up the catalog and not your photos—you still need to back up your photos separately.

- Lightroom's catalog is just a database and, while comparatively rare, databases can become corrupted—so backup regularly, and keep older backups for a while.

- Lightroom needs to know where the original files are, so don't move or rename files outside of Lightroom (for example, in Explorer or Finder) otherwise you'll have a long job fixing all of the links.

- Lightroom will not match exactly your camera's rendering when working with raw files, as it's just raw data and there's no right or wrong way of processing it. If you like the camera manufacturer's rendering, you can use profiles in the Calibration panel to emulate that style, or you can build your own profiles to suit your taste.

- Lightroom has 3 different levels of selection—there's most-selected or active, shown by the lightest grey shade, there's the mid-grey shade denoting the photos are also selected but are not the active photo, and there's the dark grey showing the photo isn't selected. Notice the difference, otherwise you could accidentally apply a command to multiple photos.

- Lightroom's Grid view behaves differently to other views—anything you do in Grid view on the primary monitor applies to

all selected photos, whereas most other views only apply to the active or most-selected photo (unless you have Auto Sync turned on—there's always an exception!)

- Lightroom offers a choice of different color spaces when you output photos, but Adobe RGB and ProPhoto RGB will look odd in programs that aren't color managed, such as web browsers. Use sRGB for screen output, emailing or uploading to the web.

- Lightroom's collections have changed. In Lightroom 3 and earlier, when you selected a collection and then created a slideshow, print or web gallery, all of the settings would be saved with that collection. In Lightroom 4, you need to save your book, slideshow, print or web gallery, so that it shows as a separate entity in the Collections panel.

Learning the Basics

Beginner's tips, also known as context-sensitive help, appear when you first open Lightroom. They cover the absolute basics for each module, and highlight areas of the screen in yellow for your attention. You can turn them all off by clicking the checkbox in the bottom left corner and then the X in the top right corner. You can bring them back at any time by visiting the Help

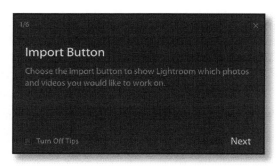

menu. One tip that's not included—Lightroom won't quit while the tips are open, as they're technically a dialog box, so close them before trying to quit Lightroom.

If you want an additional quick start introduction, I highly recommend watching the short Getting Started videos on Adobe's website at http://www.lrq.me/adobevideos They'll give you a brief overview of the basics, and then read on or dive right in.

Import

Because Lightroom is designed around a database, you can't just browse to view the photos—you have to first import them. Importing the photos simply means that the metadata about the photos is added to the database as text records, along with a link to that file on the hard drive. It's like an index of all the books in a library.

Importing photos into Lightroom doesn't force you to move them. Lightroom can copy or move them into a new folder structure if you ask it to do so, but if you already have a good filing system you can also choose to leave them in their existing locations. Either way, the photos remain fully accessible by other programs. Getting your folder structure right is important from the outset, as it's more time-consuming to change later, but if you're keen to dive into Lightroom, you can skip some of the other settings in this chapter for now and learn about them in more detail later. Although we'll refer to importing photos throughout the chapter, most settings apply to videos too.

SHOOTING RAW, SRAW OR JPEG

Before you can import photos into Lightroom, you need to have taken some photos. I'll assume you already know how to do that, but there are a few points to look out for when making decisions at the time of capture.

Also check...

"How do I import my existing photos into Lightroom?"
on page 84

Also check...

"Why do my presets look wrong when used on JPEG/TIFF/PSD files, even though they work on raw files?" on page 410 and "Why don't the Temp and Tint sliders have the proper white balance scale when I'm working on JPEGs?" on page 361

Can I use Lightroom on JPEG files as well as raw files?

Although Lightroom works best with raw files, it also works with rendered files (JPEG, TIFF and PSD), giving you an easy way to process batches of photos.

Any adjustments you make within Lightroom's interface are nondestructive, whichever format you use. The instructions are stored as metadata in the catalog, and even writing that metadata to the file using Ctrl-S (Windows) / Cmd-S (Mac) only updates the text header of the file, and doesn't modify the image data itself. When you export that photo, the adjustments are applied to the image data and a new file is created, so the original still remains untouched.

When you come to edit those photos in the Develop module, you'll find that certain controls are different when working on rendered files, for example, the White Balance sliders change from Kelvin values to fixed values, as you're adjusting from a fixed color rather than truly adjusting white balance.

If I can use all of Lightroom's controls on JPEG files, why would I want to shoot in my camera's raw file format?

So if you can use Lightroom with JPEGs, and take up less hard drive space, why would you want to shoot raw? Well, think of it this way... did you ever play with colored modeling clay when you were a child?

Imagine you've got a ready-made model, made out of a mixture of different colors, and you've also got separate pots of the different colors that have never been used. Yes, you can push the ready-made model

around a bit and make something different, but the colors all smudge into each other, and it's never quite as good as it would have been if you had used the separate colors and started from scratch.

Your JPEG is like that ready-made model—it's already been made into something before. You can take it apart and change it a bit, but if you try to change it too much, it's going to end up a distorted mess. Your raw file is like having the separate pots of clay—you're starting off with the raw material, and you choose what to make with it.

So yes, editing JPEGs is nondestructive, in as much as you can move the sliders as many times as you like and the original file isn't destroyed in the process, but when you do export to a new file, you're applying changes to ready-made JPEG image data. If you're working on a raw file format, you're making a single set of adjustments to the raw data, rather than adjusting an already-processed file. You'll particularly notice the difference when making significant changes to white balance or rescuing a very under or overexposed photo.

If I shoot raw, can Lightroom understand the camera settings?

When you shoot in your camera's raw file format, the data isn't fully processed in the camera, and the mosaic sensor data is recorded in the raw file.

Adobe could use the camera manufacturer's SDKs (Software Development Kits), where provided, to convert the raw data, and the rendering would be the same as the camera manufacturer's own rendering. If they did so, however, they couldn't then improve the processing or add additional features such as the local adjustments. The result is that Lightroom, and many other raw processors, can process the raw file, but the result isn't identical to the camera JPEG. There isn't a right or wrong rendering—they're just different.

Most of the settings you can change on your camera, such as contrast, sharpening and picture styles, only apply to the manufacturer's own processing. It will affect the preview you see on the back of the camera, but not the raw data. However, certain camera settings can affect the exposure of your raw file directly or indirectly.

Canon's Highlight Tone Priority automatically underexposes the raw data by one stop to ensure you retain the highlights, leaves a tag in the file noting that this setting was applied, and applies its own special processing to the JPEG preview that you see on the back of the camera. Lightroom also understands that tag and increases the exposure by one stop behind the scenes to compensate, but if you accidentally underexpose the image with HTP turned on too, you can end up with a very noisy file. When shooting raw for use in Lightroom, there's no advantage to using that setting instead of changing the exposure compensation yourself, so you may wish to turn off HTP and set your exposure to retain the highlights manually.

Canon's Auto Lighting Optimizer and Nikon's Active D-Lighting don't affect the raw data itself, but Lightroom has no idea that you've used those settings, and even if it did, the processing applied by the camera is variable. When ALO or ADL are turned on, that special processing is applied to the JPEG preview that you see on the back of the camera, as well as to the resulting histogram. Seeing that false brighter preview could cause you to unknowingly underexpose the file, and then be disappointed to find it's very underexposed when you view the unprocessed photo in Lightroom, so it's a good idea to turn those settings off unless you're shooting JPEG or only using the manufacturer's own software.

If I shoot sRAW format, can Lightroom apply all the usual adjustments?

Canon's sRAW format works slightly differently to standard raw formats. Full raw files are demosaiced by the raw processor, whereas sRAW files are demosaiced by the camera. The demosaic is the process of turning the raw sensor data into image data.

You still have access to all of the controls that are available for raw files, however there are a few things which are usually part of the demosaic processing which will not be applied to your sRAW files. Other artifacts

may also be present, for example, Lightroom maps out hot pixels (bright pixels that appear on long exposures) on full raw files, but can't do so on sRAW files. On some cameras, for example, the Canon 7d, the highlight recovery potential is reduced when shooting in sRAW. Other settings may also behave differently, for example, the sharpening and noise reduction may need slightly different settings.

If you convert to DNG (except Lossy DNG), you'll notice that sRAW files get bigger instead of smaller, because the way that the sRAW data is stored is specific to the manufacturer, and not covered in the DNG specification.

Also check...

"Proprietary Raw vs. DNG" section starting on page 108

THE IMPORT DIALOG

To get started with Lightroom, go to File menu > Import Photos, or press the Import button at the bottom of the left panel, and the Import dialog will appear. The first time you open the Import dialog you'll see an empty expanded Import dialog, but any future visits to the Import dialog should remember your last used settings.

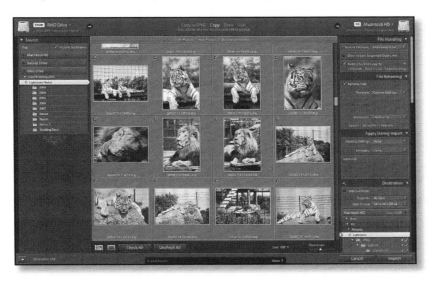

The Import dialog is where you choose which photos to import, how to import them (copy as DNG/copy/move/add without moving), and where to put them. It allows you to choose what you would like to do with the photos while you're importing them too, such as renaming, applying metadata and keywords, creating backups, and building previews. We'll cover all of those options in the following pages.

What's the difference between the compact Import dialog and the expanded Import dialog and how do I switch?

If you press the arrow in the lower left corner of the Import dialog, it toggles between compact and expanded dialog views. The compact Import dialog allows you to change a few of the settings, such as the Source or Destination folders, and add basic metadata. As it's not having to read thumbnails of the photos, it's usually quicker, especially on a slow machine or when importing large numbers of photos. The compact Import dialog also gives you a quick view of your other settings, but if you want to change those other settings, you need to switch to the expanded Import dialog, which gives further options including selecting specific photos, importing from multiple folders and previewing the photos before import.

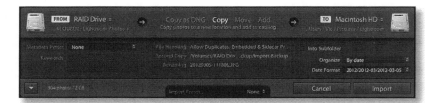

What's the difference between the options at the top of the Import dialog—Copy as DNG, Copy, Move, and Add?

Along the top of both the compact and expanded Import dialogs is the option to copy or move the files, or leave them where they are.

Copy as DNG copies the files to a folder of your choice, and converts the copies of any raw

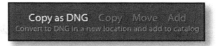

files to DNG format, leaving the originals untouched. There's more on the pros and cons of DNG later in the chapter.

Copy does the same as Copy as DNG except it doesn't convert them, and Move also removes the files from their original location. All of the copy and move options give you additional choices on the folder structure, and allow you to rename at the same time.

Add leaves the files in their current folder structure with their existing filenames, and references them, or links to them, in that original location. This is a great option for importing existing photos if you already have a good filing system that you would like to keep, so it's the default setting the first time you open Lightroom. You'll also note that the File Renaming and Destination panels on the right are missing, since they don't apply when adding photos without moving them.

Also check...

"Proprietary Raw vs. DNG" section starting on page 108 and "Destination Folders" section starting on page 99

SELECTION FOLDERS & FILES FOR IMPORT

Having explored the Import dialog, you then need to decide which photos to import. In the compact Import dialog you're limited to selecting which folders to import, whereas switching to the expanded Import dialog allows you to narrow down the specific photos too. You see the Source panel down the left hand side? At the top you will see your devices—cameras, card readers, iPhones, and so forth—and then you have the hard drives attached to your computer. When you click on one of those devices or folders, the central preview area will start to populate with thumbnails of the photos that

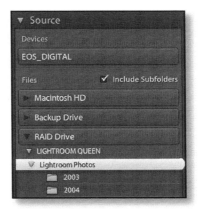

are available for import, which you can then check and uncheck specific photos.

How do I import my existing photos into Lightroom?

If you haven't used previous Lightroom versions, you may have a large quantity of existing photos to import into Lightroom, in addition to any new photos. If those are already arranged in a suitable folder structure that you would like to keep, you can import them using 'Add photos to catalog without moving them,' so that they're referenced in their existing location. If, on the other hand, your photos are spread across your hard drives in a slightly disorganized fashion, it may be a good time to move them into a new logical dated folder structure that you can easily manage.

If you've already used other software to start cataloging your photos, the move may be a little more complicated. Switching between Adobe software is relatively simple. Bridge writes your metadata to XMP, which is read when importing the photos. Lightroom offers a File menu > Upgrade Photoshop Elements Catalog option to upgrade your Elements catalog into a Lightroom catalog, as long as Elements is installed on the same computer.

If you're switching from other programs, the options vary, particularly if you want to transfer existing metadata, but writing any metadata to XMP, where possible, is an excellent start. The File menu > Import from Application command hints at a feature that will make importing from other programs easier, but as of 4.0, there hasn't been an official announcement on its functionality.

Also check...

"XMP" section starting on page 320

How do I import multiple folders in one go?

If you want to import from more than one folder, you can Ctrl-click (Windows) / Cmd-click (Mac) on multiple folders in the Source panel to select them. Those multiple folders don't even have to be on the same

drive, if they appear in the Files section of the Source panel, not the Devices section above.

If all of the photos you want to import are in subfolders under a single parent folder, for example, within your Photos folder, then you can select that parent folder and check the Include Subfolders checkbox.

Is it possible to import from multiple card readers at the same time?

You can't currently import from two separate devices in one go, for instance, 2 card readers. If, however, your operating system sees the memory cards as two drives in the lower Files part of the Source panel, you can Ctrl-click (Windows)/Cmd-click (Mac) on the folders to import both at once.

Why do the folders keep jumping around and what is Docking?

When you navigate around the Source and Destination panels in the Import dialog, they initially appear to have a mind of their own, with different behavior depending on whether you single-click or double-click, but it's actually a really useful feature.

If you navigate around by single clicking on the folder arrows or folder names, the navigation will behave normally. If you double-click, or if you right-click and choose Dock Folder from the context-sensitive menu, you can expand and collapse the folder hierarchy to hide unnecessary folders. It makes it easier to navigate through a complex folder hierarchy, especially if it's many levels deep and the panel is too narrow to read the folder names. If you've collapsed it down too far, just double-click on the parent folder to show the full hierarchy again.

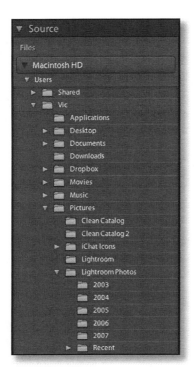

For example, if your photos are all stored in Macintosh HD/Users/ Vic/Pictures/Lightroom Photos/ Recent, and they're divided into another long hierarchy below that, you might choose to dock the Recent folder by double-clicking on it. That would change the view from the screenshot on the left to the screenshot on the right.

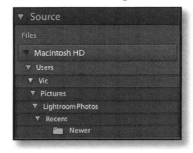

Can I use the operating system dialog to navigate to a folder instead of using Lightroom's Source panel?

If you would prefer to be able to navigate to your folder using the operating system dialog instead, click on the large button above the Source panel and choose Other Source from the menu. The Source panel will open directly to the location you choose. The text on that button

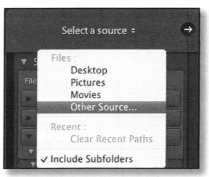

will change—it says 'Select a source' when no folders or devices are selected, but then changes to the source name/ path once you've made a selection.

Can I save favorite import folders?

You can't currently save favorite Source folders, however clicking the button above the Source panel will show you a list of your most recent import folders. Favorite Destination folder can be stored in Import presets, which we'll come to a little later. In the Library module, right-clicking on a folder in the Folders panel will show an 'Import into this folder' option. This automatically sets your Destination folder, which is particularly useful when importing from memory cards.

Also check...

"Import Presets" section starting on page 107

How do I select only certain photos to import?

In the Grid view, in the center of the Import dialog, you can choose which photos to import by checking or unchecking their individual checkboxes. The Check All and Uncheck All buttons can be used to mark all photos or no photos for import, and only the checked photos will be imported into your catalog.

To check or uncheck a series of photos in one go, hold down Ctrl (Windows) / Cmd (Mac) while clicking on photos to select non-consecutive photos, or use Shift to select a group of consecutive photos. Once you have the photos selected, shown by a lighter grey surround, checking or unchecking the checkbox on a single photo will apply that same checkmark setting to all of the other selected photos.

The sort order on the toolbar allows you to sort by Capture Time, Filename, Checked State or Media Type, making it easy to sort through your photos, and if you select any of the photos in the Grid, you can also use the arrow keys on the keyboard to move around, and the P, X and ` keys to check and uncheck photos.

How do I select photos from a specific date?

If you select one of the Copy or Move options along the top of the Import dialog, you can select a dated folder structure in the Destination panel. The dated folders that are shown in italics have checkboxes, which

Also check...

"How do I filter my photos to show photos fitting certain criteria?" on page 226

allow you to check or uncheck specific dates, and unchecking one or more of those dates also unchecks the related photos. Selecting the 2012/03/05 option (the pop-up updates to use the current date) works particularly well for this purpose, allowing you to deselect single days or whole months, depending on which folders you uncheck.

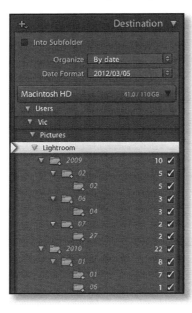

If you're browsing through the photos in the Grid view, choosing the Destination folders view at the top of the Grid splits the thumbnails up into sections and you can check and uncheck them there too.

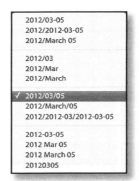

How do I select specific file types to import?

There isn't currently a way to choose specific file types within Lightroom's Import dialog. You can, of course, import all of the photos into Lightroom, and then remove specific photos later using the Library module's Filter bar.

As a workaround, you can also make use of your operating system's sort by file type in Explorer (Windows) / Finder (Mac). You can select the files you want to import and drag and drop them onto Lightroom's icon in the Dock (Mac only) or directly on the Grid view in the Library module (Windows or Mac), and the Import dialog will open with those specific photos already selected.

If you wish to choose between photos and videos, the Media Type sort order on the toolbar will group them together with the videos at the top.

Why are some photos unavailable or dimmed in the Import dialog?

Dimmed photos that don't have a checkbox are unavailable for import. That's because they're either already imported into your current Lightroom catalog in that location, or you have Don't Import Suspected Duplicates checked in the File Handling panel and they're duplicates of existing photos that are stored somewhere else.

Photos shown with a vignette are unchecked photos, but can be imported by toggling the checkbox.

Can I see larger previews of the files before importing?

If you need to see larger previews, you can increase the size of the thumbnails using the slider on the toolbar, but the embedded thumbnails are usually small and low quality. In addition to the embedded thumbnails, there's also a larger JPEG preview embedded in most photos, but they can be a little slower to fetch so they're not used for the Grid view.

There's a Loupe view in the Import dialog which allows you to take advantage of that larger preview. Selecting any thumbnail and pressing the E key, double-clicking on the thumbnail, or pressing the Loupe button on the toolbar, will show a larger preview of the photo, depending on the size of the embedded preview.

At the bottom of that Loupe preview is the checkbox to include or exclude the photo from the Import and, like the Grid view, the left and right arrow keys will move between photos and the P, X and ` keys will check and uncheck them. Pressing the G key, double-clicking on the preview, or pressing the Grid button in the toolbar will return to Grid view again.

As the previews are the small JPEG previews embedded in the files, it can be a faster way of doing any initial culling than waiting for Lightroom to build previews.

IMPORT OPTIONS

Having chosen the photos that you want to import, you now need to decide what you would like to do with them while you're importing them. You make those choices in the panels on the right hand side of the Import dialog.

Why do I have to create previews? Why can't I just look at the photos?

The first option in the File Handling panel is Render Previews. All raw processors create their own previews because raw data has to be converted in order to be viewed as an image. Lightroom offers nondestructive processing for other file types too, so any changes you make later in the Develop module will be applied to previews, enabling you to view your adjustments without affecting the original image data. Those previews also enable you to continue to view the photos when the original files are offline.

Initially Lightroom shows you the embedded JPEG preview from the file, but then it creates higher quality previews which are stored next to the catalog. Select Standard size for the moment, and we'll cover the options in more detail in the Previews & Speed chapter.

What does 'Don't Import Suspected Duplicates' do?

Don't Import Suspected Duplicates checks the photos that you're importing against those that are already in the catalog, to see whether you're trying to import photos which already exist in the catalog. If photo1.jpg in folder A is already in the catalog in that location, then Lightroom will skip it regardless of your suspected duplicates checkbox as it can't import it twice at the same location. If you then put another copy of photo1.jpg into folder B, or you've moved it outside of Lightroom, it should be recognized as a duplicate and only imported it into your catalog if the checkbox is unchecked.

Also check...

"What's the difference between Minimal, Embedded & Sidecar, Standard and 1:1 previews?" on page 333

To be classed as a suspected duplicate, it must match on the original filename (as it was when imported into Lightroom), the EXIF capture date and time, and the file length. It won't recognize photos that you've re-saved as an alternative format—only exact duplicates.

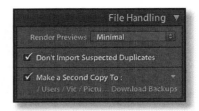

What does the 'Make a Second Copy' option do?

When using one of the Copy or Move options, you'll notice Make a Second Copy To in the File Handling panel. This will back up your original files to the location of your choice, in a dated folder called "Imported on [date]". If you choose to rename your files while importing, those backups will now be renamed to match, but they will always remain in their original file format, even if you're converting to DNG while importing.

The Second Copy option is very useful as an initial backup, while the photos make their way into your primary backup system, but it's not a replacement for good primary backups. We'll consider backup systems in the Working with Catalogs chapter.

What Develop settings, metadata and keywords should I apply in the Import dialog?

The Develop Settings pop-up menu allows you to apply a Develop preset to the photos while importing, for example, you may always apply a specific preset to all studio portraits as a starting point. 'None' will just apply the default settings to new photos but will preserve any existing Develop settings stored with the files, so it's the option to choose if you're ever uncertain. Be careful not to confuse

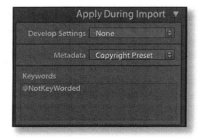

Also check...

"I back up photos using the Import dialog— isn't that enough?" on page 293 and "Presets" section starting on page 404

'None' with 'Lightroom General Presets > Zeroed' which sets every slider back to zero even if there were existing settings.

We'll come back to Metadata presets in more detail in the Library chapter, but you can also create Metadata presets from the Import dialog by selecting New from the Metadata Presets pop-up menu and entering your details in the following dialog. Only checked fields will be saved in the preset, and leaving any fields blank but checked would clear any existing metadata saved in the file, that you may have added in another program.

Adding metadata on import is particularly useful for adding your copyright, to ensure that all of your photos include that vital information. To add a © symbol in the Copyright field, hold down Alt while typing 0 1 6 9 on the numberpad (Windows) or type Opt-G (Mac). In many countries, the copyright notice requires the copyright symbol ©, the year of first publication and then the name of copyright owner, for example, © 2012 Victoria Bampton. Copyright laws vary by country, so please check your local laws for exact specifications.

Keywords can also be applied while importing the photos, however remember that they will be applied to all of the photos in the current import, so it's only useful for keywords that will apply to everything. Specific keywords are better applied individually in the Library module.

Also check...

"How do I create a Metadata preset?" on page 202

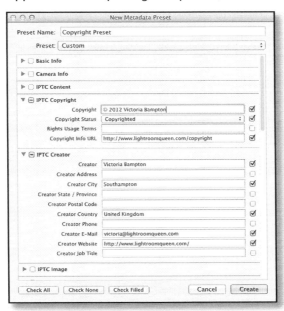

Also check...

"Viewing & Editing Metadata" section starting on page 201 and "Presets" section starting on page 404 and "Keywording" section starting on page 204

How do I apply different settings to different photos while importing?

You can't apply different settings to different photos in the same import. You could start the first import with selected photos, and then go back to the Import dialog, import the next set with different settings, and keep repeating until you've imported all of the photos, but doing so runs the risk of missing a photo or two. It's far easier to import all of the photos in a single import and then add the different settings, or move photos into different folders, in the Library module once they've all finished importing. All of the settings that are available in the Import dialog, such as Metadata and Develop presets, can also be added later in the Library module.

RENAMING

Most cameras use fairly non-descriptive file names such as IMG_5968, and the problem with those names is, over the course of time, you'll end up with multiple photos all with the same name. You don't have to keep those camera filenames though, unless you're particularly attached to them. You can either rename the photos at the time of import, or at any point later in your workflow, but bear in mind that renaming later in your workflow will impact your backup systems as well as the working copies, so the import stage is as good a time as any.

How do I rename the files while importing?

Also check...

"Renaming, Moving & Deleting" section starting on page 196

If you look in the File Renaming panel there are various template options available, which are as simple to use as just selecting them from the pop-up menu. You're not limited to just using those existing templates though. Further down that pop-up menu is the Edit option which will show the Filename Template Editor dialog. In that dialog you can create the file naming structure of your choice by adding, deleting and rearranging the tokens. We'll cover how to use those tokens and save

templates in dialogs in the Workspace chapter, so I won't repeat it here, but don't hesitate to jump forward a few pages if you want to get going now.

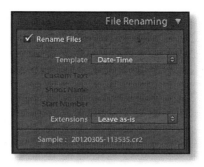

Many choose a YYYYMMDD-HHMM filename structure, which translates to the year, the month, the day of the month, and then the time, so 20120305-1153.jpg would be the filename for a photo captured at 11:53 on 05 March 2012. If you shoot

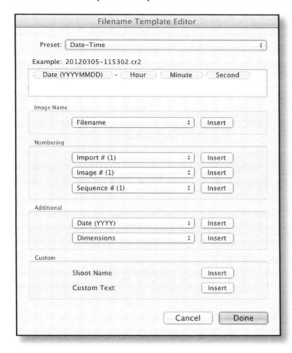

multiple shots per minute, for example, sports photography, you might like to add a Seconds token on the end of that too. The benefit of a filename like this is it's unlikely to be duplicated, and it gives you a quick identification of when the shot was taken, without having to look at the EXIF data. Some like to add a custom text token to include descriptive words like 'BenWedding' to the end of that filename, to easily find specific photos using your normal file browser too.

Others prefer a sequence number combined with some custom text. BenWedding_003.jpg is a popular option, created using the Custom Text and SequenceNumber(001) tokens. Don't actually add the words

Also check...

"Using Tokens in Dialogs" on page 167

'BenWedding' into the preset itself, otherwise you'll have to go back to the Filename Template Editor each time you need to change it. If you use a Custom Text or Shoot Name token instead, you can enter those details directly in the Import dialog.

It's sensible to only use standard characters, such as plain letters and numbers, and use underscores (_) or hyphens (-) instead of spaces when you're setting up your filenames, so your filenames will be fully compatible with web browsers and other operating systems without having to be renamed again. Some characters, such as / \ : ! @ # $ % < > , [] { } & * () + = may have specific uses in the operating system or Lightroom's database, causing all sorts of trouble, so those are best avoided. For more information on recommended filename limitations, check http://www.lrq.me/cv-filenames

Having created your filename template, save it using the pop-up menu at the top of the dialog, giving it a logical name to identify it.

Why is there no File Renaming section in my Import dialog?

If your Import dialog is set to Add, you won't be able to rename while importing. Either change to one of the Copy or Move options, or wait until the photos are imported and rename in the Library module. If you've selected the correct option, you may have hidden the panel. You'll find instructions for unhiding panels in the Workspace chapter.

Also check...

"Where have my panels gone?" on page 171

What's the difference between Import#, Image#, Sequence# and Total#?

When you're setting up your file naming structure in the Filename Template Editor, you will notice that there are a number of different types of sequence number available.

Import # is a number identifying that particular import, which you may want to combine with Image #. It increases each time it's used, for example, if you import some photos from a memory card, that token would be replaced with the number 1, and the next time you import a batch of photos, it would be 2, and so forth.

Image # is another ever increasing number that isn't automatically reset in the Import dialog.

Both Import # and Image # have starting numbers set in Catalog Settings > File Handling tab, with Import Number used for Import # and Photos Imported used for Image #.

Later, when renaming in the Library module, Image # always starts at 1 regardless of the Catalog Settings, and Import # obviously isn't available.

Sequence # is an increasing number which starts at the number of your choice each time you use it—you set the start number in the File Naming panel in the Import dialog or later in the Rename Photos dialog. It's probably the most useful of the automatic numbers, and the variety we're most familiar with from other programs.

Total # refers to the number of photos it's renaming in one go, so if you're renaming 8 photos, the Total# token would be replaced with 8. Like the Import # token, it usually needs to be used with a sequence number, otherwise Lightroom will have to add -1, 2, -3, etc., to each filename to make them unique within the folder. Total# only appears in the Library module Rename Photos dialog, which we'll come back to in that chapter.

Can Lightroom continue my number sequence from my previous import?

If you want Lightroom to automatically remember your last sequence number, you need to choose the Image# token rather than Sequence#.

Also check...

"How do I rename one or more photos?" on page 196

The starting number for Image# is set in the Catalog Settings dialog rather than in the Import dialog, and it's remembered from your last import, whereas Sequence# uses the start number that you set in the Import dialog.

How do I pad the numbers to get Img001.jpg instead of Img1.jpg?

If you use the default sequence number, it doesn't have extra zeros for padding. That can cause a problem sorting in some programs, where it sorts them as 1, 10, 11... 19, 2, 20, 21 instead of intelligent numerical order. The solution is to add extra padding zeros to set the filenames to 001, 002, and so forth.

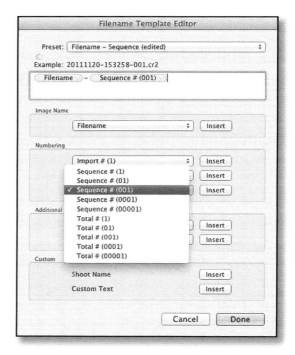

To get a padded sequence number when creating your filename template, click on the number token of your choice and choose "Sequence#(001)" instead of "Sequence#(1)" from the pop-up menu.

Can I have more than 5 digit numbers?

A maximum of 5 digits are available directly within the Filename Template Editor, however if you create your template with a 5 digit sequence number using the Sequence # (00001) option, you can then

edit that template in a text editor. You'll find your template in the Filename Templates subfolder with the other presets—the folder locations for all operating systems are listed in the Useful Information chapter.

Also check...

"The default location of the Presets is..." on page 656

Having opened the template in a standard text editor, edit the line saying: value = "naming_sequenceNumber_5Digits" and change the number 5 to either 6, 7, 8 or 9, depending on the number of leading zeros you would like to see. You'll need to restart Lightroom for the changes to be recognized.

DESTINATION FOLDERS

Having chosen the photos to import, unless you're using 'Add photos to catalog without moving them,' you now need to decide where to put them, and that's where the Destination panel comes into play. It's worth taking the time to get this right before you start importing, as moving the photos after import is a manual process.

I've chosen Copy or Move—how do I organize the photos into a folder structure that will suit me?

You have 3 main options:

'Into one folder' imports the photos into the single folder that you select.

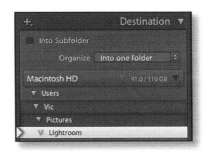

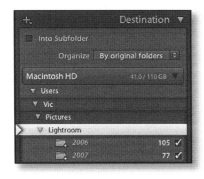

'By original folders' imports in the same nested hierarchy as their existing structure, but in their new location.

'By date' gives you a choice of date based folder structures—the slash (/) creates nested folders so 2012/03/05 will create a folder 05 inside of a folder 03 inside of a folder 2012, not a single folder called 2012/03/05.

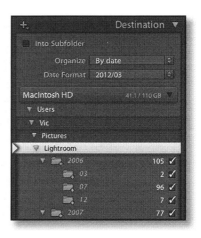

If you want a single folder called 2012/03/05, you need to use other characters such as a hyphen (-) or underscore (_), such as the 2012-03-05 format.

There isn't an option to edit the new folder names in the Import dialog, as there was in Lightroom 1 and 2, but you can rename any of the folders in the Folders panel once the photos have finished importing.

Any of those folder structures can also be placed into a subfolder within the folder you choose at the top of the Destination panel, and you can preview the result below.

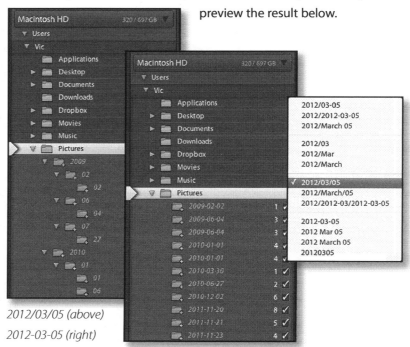

2012/03/05 (above)

2012-03-05 (right)

Why are some of the Destination folders in italics?

The folders shown in italics are folders that don't currently exist, but will be created by the import. It's a really easy way to check that the folder organization setting that you've chosen is the one that you want.

If you've chosen a dated folder structure, you can also use the checkmarks next to the italicized folders to select and deselect photos from specific dates, as we mentioned earlier.

Also check...

"How do I select photos from a specific date?" on page 87

How should I organize my photos on my hard drive?

There's no right or wrong way of organizing photos on your hard drive, but it's worth spending the time to set up a logical folder structure before you start. There are a few important factors to bear in mind when deciding on your folder structure.

Folders work best primarily as storage buckets rather than organizing tools. A file can only be in one folder at a time, so if you divide your photos up by topic, how do you decide where a photo should go? If you have a photo with both Mary and Susan, should it go in the 'Mary' folder or in the 'Susan' folder? Perhaps you duplicate in both folders, but then, what happens when you have a larger group of people? Do you duplicate the photo in all of their folders too, rapidly filling your hard drive and making it difficult to track? And then when you come to make adjustments to that photo, do you have to find it in all of those locations to update those copies too?

Trying to organize photos in folders can rapidly become complicated, but that's where Lightroom's cataloging facilities come into their own. If you catalog each photo once, stored in a single location, you can then use keywords, collections and other metadata to group and find photos easily. That photo of Mary and Susan may be stored in a '2012' folder, but would show up when you searched for Mary, Susan, or even that it was taken at the beach.

Using Lightroom to catalog your photos, however, doesn't mean you can just spread the photos across your hard drive. There still needs to be a level of organization, but for a different purpose.

First and foremost, your folder structure must be scalable. You may only have a few thousand photos at the moment, but your filing system needs to be capable of growing with you, without having to go back and change it again. As with file names, stick to standard characters—A-Z, 0-9, hyphens (-) and underscores (_) to prevent problems in the future. Although your operating system may accept other characters, you might decide to move cross-platform one day, leaving you the time-consuming job of renaming all of the folders manually.

Your folder structure also needs to be easy to back up, otherwise you may miss some photos, and it must be equally as easy to restore if you ever have a disaster. We'll come back to backup systems in the Working with Catalogs chapter, but as a general rule, that will involve limiting your photos to one, or a few, parent folders. You may choose to use a folder within your My Pictures (Windows) / Pictures (Mac) folder, a folder at the root of your boot drive, or better still, another hard drive entirely. Wherever you choose to put that folder, the main aim is to congregate all of the photos in that one place.

Being able to back up your photos the first time is great, but then how will you add new photos to your backups? If you're adding photos to lots of different folders, it can be hard to track which photos have already been backed up, so sticking to a dated structure is usually the simplest option. Adding a 'New Photos' folder, where all new imports are placed until they're backed up to offline media, before being moved into the full filing system, can also help to keep track of your backups if you

Also check...

"Making and Restoring Backups" section starting on page 290

choose to back up manually, although an automated solution (i.e. file synchronization software) is usually a better option.

You'll also need to bear in mind the limitations of your backup system. In addition to your working backups, are you backing your photos up to other hard drives or optical media? If you're limited to optical media, storing the photos in DVD sized folders or 'buckets' of around of 4.3GB, can help you see at a glance which photos have already been backed up, and where.

Over the course of time, your collection of photos will grow, and you'll likely add new hard drives, so a quick tip—if you're putting photos at the root of a hard drive, always put them inside a folder rather than directly at the root, for example, e:\Photos\ (Windows) or PhotosHD/Photos/ (Mac). You can set that Photos folder to show within Lightroom's Folders panel to make it easy to relink those photos if they ever get 'lost'. The same applies to backup optical media such as DVD's, but for those, it's worth giving the parent folder a name that will identify that DVD, such as 'Backup2012-34'

Keeping it simple, many photographers use a dated folder structure, with the number of subfolders dependent on the number of photos you shoot each day, week, month or year. If you shoot few photos each year, a simple folder for each year may be plenty, leaving further organization to Lightroom. If, on the other hand, you shoot most days, a hierarchy of days, within months, within years may be better suited to your needs. If you're dividing by day, you may also want to add a descriptive word to the end of the day's folder name to describe the overall subject, for example, '2012-03-06 Zoo'. That makes it easy to find the photos in any other file browser too.

Lightroom's import dialog sets up some popular date formats for dated folders, which are a good starting point if you're beginning to organize your photos. If you would like your Folders panel to read in chronological order, use 06 for the month rather than the word June, as it sorts in

Also check...

"How do I archive photos to CD/DVD/ Blu-Ray?" on page 331"I have a long list of folders—can I change it to show the folder hierarchy?" on page 178

alpha-numeric order and isn't quite smart enough to know that June should come before August.

 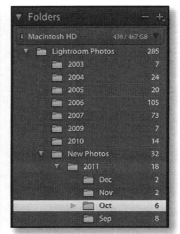

There are exceptions, for example, a wedding photographer may prefer to use a folder for each wedding within a parent year folder, for example, 2012/John_Kate_wedding_20120306, that sorts by name rather than by date. You may prefer to group all of your Personal photos separately from your Work photos, under a 'Personal' parent folder, for example, Personal/2012/03_England, which can also work as long as there's no crossover.

Alternative filing systems aren't a problem as long as you follow the basic principles, but if you're not using a basic dated structure, make sure you think it through properly, and perhaps discuss it with other experienced digital photographers, in case they can see a pitfall that you've missed.

Also, consider how you're going to manage derivatives—retouched masters, and copies exported for other purposes. Are you going to manage those alongside your originals, and if so, how are they going to be backed up and archived?

We could write a whole book on Digital Asset Management, and the pros and cons of various systems, but fortunately Peter Krogh, world-renowned DAM expert, has already done so. If it's a subject that you

would like to learn more about, I can't recommend The DAM Book (http://www.lrq.me/dambook) highly enough.

In summary:

- Don't duplicate photos in different folders—folders are best used for storage, not organization by topic.
- It needs be scalable for larger numbers of photos in the future.
- It's best to use standard folder and filenames that will work cross-platform.
- It must be easy to back up new photos.
- It must be easy to restore from backups.
- Show parent folders to make it easy to relink files if Lightroom loses track.

Can I create a different dated folder structure automatically?

Lightroom offers 13 different folder structures in the Organize by Date pop-up menu, but what happens if you prefer a different folder structure—perhaps using underscores (_) rather than hyphens (-)? There's a low risk hack, originally published by Mark Sirota, which makes use of the TranslatedStrings.txt file that Lightroom uses for language translations. This isn't supported by Adobe, Mark or myself, and it may not continue to work in the future, but if you like to be a little daring from time to time, here's how it works…

Lightroom uses a file called TranslatedStrings.txt, which is contained in the language project file along with the program files. If you're using the English version of Lightroom, the file and folder may not exist, but you can just create a plain text file called TranslatedStrings.txt inside a 'en' (Windows) or 'en.lproj' (Mac) folder. If you're using another language, the file will already be in your language's project folder, for example 'fr.lproj' for French, and you'll need to edit that file. If you're editing an existing file, obviously back it up first!

The language folders are in the following location:

Windows: c:\Program Files\Adobe\Adobe Photoshop Lightroom 4\Resources\

Mac: Macintosh HD/Applications/Adobe Lightroom 4.app/Contents/Resources/

The default lines for the Import folders should read as follows:

"$$$/AgImportDialog/ShootArrangement_1/Template=%Y/%m-%d"

"$$$/AgImportDialog/ShootArrangement_2/Template=%Y/%Y-%m-%d"

"$$$/AgImportDialog/ShootArrangement_3/Template=%Y/%m/%d"

"$$$/AgImportDialog/ShootArrangement_4/Template=%Y/%B/%d"

"$$$/AgImportDialog/ShootArrangement_5/Template=%Y/%B %d"

"$$$/AgImportDialog/ShootArrangement_6/Template=%Y-%m-%d"

"$$$/AgImportDialog/ShootArrangement_7/Template=%Y %b %d"

"$$$/AgImportDialog/ShootArrangement_8/Template=%Y%m%d"

"$$$/AgImportDialog/ShootArrangement_9/Template=%Y/%Y-%m/%Y-%m-%d"

"$$$/AgImportDialog/ShootArrangement_10/Template=%Y/%m"

"$$$/AgImportDialog/ShootArrangement_11/Template=%Y/%b"

"$$$/AgImportDialog/ShootArrangement_12/Template=%Y/%B"

"$$$/AgImportDialog/ShootArrangement_13/Template=%Y %B %d"

Assuming today's date is 5th March 2012, those translate, in order, to:

1—%Y/%m-%d 2012/03-05

2—%Y/%Y-%m-%d—2012/2012-03-05

3—%Y/%m/%d—2012/03/05

4—%Y/%B/%d – 2012/March/05

5—%Y/%B %d—2012/March 05

6—%Y-%m-%d—2012-03-05

7—%Y %b %d—2012 Mar 05

8—%Y%m%d—20120305

9—%Y/%Y-%m/%Y-%m-%d—2012/2012-03/2012-03-05

10—%Y/%m—2012/03

11—%Y/%b—2012/Mar

12—%Y/%B—2012/March

13—%Y %B %d—2012 March 05

You can't create additional templates, but you can edit the existing ones, and when you restart Lightroom, they should be available in the list of dated folder structures. The available date tokens are:

%Y = year in 4 digits (2012) %y = year in 2 digits (10) %B = month in full (March) %b = month abbreviated (Mar) %m = month number (03) %d = day of month (05)

If it won't work, check for stray spaces and other minor differences, for example, it requires straight quotes, not curly ones.

If you're happy with the result, don't forget to back up the TranslatedStrings.txt file, as it may be replaced each time you update Lightroom. If you have any problems, delete the file if you're using the English version, or restore the backup of the other language version.

Can I leave Lightroom to manage my photos like iTunes moves my music files?

Lightroom doesn't automatically rearrange your photos once they've been imported. You can, of course, rearrange the photos manually by dragging and dropping them into other folders within the Library module, but that could be a big job, so it's better to decide on a sensible filing system at the outset. Remember, once you've imported the photos, don't tidy up or rename them using other software, because all of Lightroom's links would be broken, and you would have to relink all of the files again.

IMPORT PRESETS

Don't worry, having made all of these decisions the first time, you can save them to reuse again later. Lightroom will remember your last used settings, but you might find you have different settings for different uses—one set for copying from a memory card, a different set for importing existing photos, and so forth. You can save all of those settings

Also check...

"Lightroom thinks my photos are missing—how do I fix it?" on page 240

Also check...

"Saving Presets in Pop-Up Menus"
on page 166

as an Import Preset, which can be accessed from both the compact and expanded Import dialogs, and then go ahead and press Import.

How do I create Import presets, and what do they include?

The Import presets are tucked away at the bottom of the Import dialog in both the compact and expanded Import dialog views. Set up your import settings and then choose Save Current Setting as New Preset from the pop-up menu. You can also update or delete existing presets from that menu, just like the other pop-up menus that we'll cover in the next chapter.

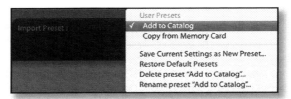

Everything in the right hand panels is included in the presets, along with the Copy as DNG/Copy/Move/Add choice. The photos you're importing aren't included in the preset, as those will change each time you import, so Source panel selections and checked/unchecked thumbnails aren't saved.

PROPRIETARY RAW VS. DNG

One of the Import options is to copy and convert to DNG—but what does that actually mean? DNG stands for Digital Negative. It's another file format, designed primarily for raw image data, but the biggest difference is that it's openly documented unlike proprietary raw files (CR2, NEF, etc.), so anyone can download the information to decode the file.

A DNG file is comprised of 3 different parts—the image data itself, the metadata that describes that photo, and an embedded preview which can be updated to show your adjustments without affecting the raw

data. It may also contain other data, such as Fast Load partially processed data or a complete copy of the original file.

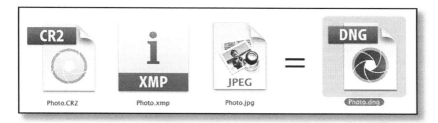

So why consider DNG as an alternative to storing files in your camera manufacturer's format?

Should I convert to DNG?

DNG is a well worn debate on many photography forums on the web, and there's no right or wrong answer, but there are a few pros and cons to consider when weighing your personal decision.

Long Term Storage

The DNG format is openly and completely documented, which means that it should be supported indefinitely, whereas proprietary formats such as CR2, NEF, RAF, etc., aren't. The question is, will you be able to find a raw converter in 20 years time that will convert your camera's proprietary format when that camera model is ancient history? Some of Kodak's early digital formats are already unsupported by Kodak themselves, so how long will it be before other formats start to go the same way? It may not be an issue at the moment, but do you want to have to keep checking your old file formats to make sure they're still supported?

Although DNG is Adobe's baby, there are a long list of other companies supporting it, including Apple, Corel, Extensis, Hasselblad, Leica, Pentax, Ricoh and Samsung, to name a few. It's also been submitted to the ISO to become an ISO Standard, just like Adobe's PDF format many years ago, so it's here to stay.

Also check...

*"XMP" section starting
on page 320*

XMP

In addition to storing metadata in your Lightroom catalog, it's also possible to write that data back to the files in a header section called XMP. Because proprietary raw formats are largely undocumented, it's not safe to write most data back to those original files, so it has to be written to a sidecar file instead. DNG files can safely have that information stored within the DNG wrapper, like JPEG, TIFF and other documented file types.

The question is, do you find sidecar files to be a pro or con? If you use an online backup service, embedding that metadata instead of using sidecars could be a disadvantage. The whole file may need uploading again each time you choose to update the embedded metadata, whereas tiny sidecar files would upload quickly. On the other hand, sidecar files can easily become separated from their raw files. All of your data is stored in the catalog, so you don't have to write to the files, but it might be a factor in your DNG decision if you do choose to use XMP.

Embedded Preview

If you select the DNG format, along with that XMP data in the DNG wrapper, there's an embedded preview. You're in control—you choose how big you want that preview to be, and you can update it to show the Develop adjustments you make in Lightroom. That means that other programs that rely on the embedded preview will be looking at your processed image preview rather than the original camera preview. Updating that preview doesn't touch the original raw data, so it's a nondestructive way of updating the photos to look their best.

Speed—Fast Load Previews & Tiled DNG's

New to Lightroom 4 is a Fast Load Preview for DNG files. It stores partially processed data, like the Camera Raw Cache data which we'll come to in the Previews & Speed chapter. It allows compatible programs, such as Lightroom 4, to show you a preview more quickly than a proprietary raw file or a DNG file without Fast Load data. The difference is more

noticeable on large files or those with complex initial processing, such as DNG Opcodes. Although a recent addition, Fast Load data doesn't affect backwards compatibility and only increases the file size slightly.

Also added in Lightroom 3.6 was multi-core reading for Tiled DNG images. A Tiled DNG is the same data, but arranged in strips instead of one long string. It means that different threads or processors can all be working on decompressing the file at the same time, resulting in a faster load time. ACR and Lightroom have been creating Tiled DNG files for a long time, however if you have a camera that shoots DNG natively, you can update those to Tiled DNG files to take advantage of the new performance improvements.

File size

The DNG lossless compression algorithms are better than those applied by many cameras, so DNG files are usually 10-40% smaller than their original proprietary format, depending on the camera, the amount of noise or detail in the photo, and on the size of the preview that you choose to embed. Although hard drives may be comparatively cheap now, they're not free, so space savings may still be a benefit.

The latest addition to the DNG specification is the concept of a Lossy DNG file. There are significant differences between the new lossy DNG and the standard mosaic DNG that we've been used to, so we'll come back to the pros and cons of lossy DNG's in the following questions.

Early Corruption Warning

If the file's seriously corrupted, it often won't convert, and instead will warn you of the corruption, so you can download the file again before you reformat the cards. It's not infallible, and it's not a replacement for a visual check, but it is an additional check worth considering.

DNG Hash

One of the best features is the DNG Hash, which is written into files created by Lightroom 1.4.1, ACR 4.4.1, and DNG Converter 4.4.1 or later. The DNG Hash allows you to validate that the image data itself hasn't

Also check...

"How can I speed up browsing in the Develop module? And what are these Cache.dat files?" on page 346, "My camera creates DNG files natively—how do I update them to take advantage of the new specification?" on page 124 and "Should I convert to Lossy DNG?" on page 114*

Also check...

"Should I convert to DNG?" on page 109

changed since the DNG file was created. Very few programs can currently check that DNG Hash, but the technology is moving forward rapidly, and any DNG files created now will be able to make use of that validation in the future. Lightroom checks the file hash when it loads a photo into the Develop module.

Manufacturer's Software

Until the main manufacturers start supporting the DNG format, their own software will not read a DNG file. If you use the manufacturer's software regularly, that may prevent you from using DNG. If you only use it occasionally, keeping one of your backup copies as the proprietary format for those occasions, may be another option.

MakerNotes

Never heard of MakerNotes? Then you probably won't care. All of the important data is carried over into the DNG file, but some camera manufacturers also put some secret data in their files. There is DNG support for MakerNotes, however some manufacturers don't stick to the rules, and therefore MakerNotes embedded in an undocumented format can't always be carried over completely to the DNG file. If you shoot CR2 or NEF, as well as a few other formats, all of the data is copied to the correct place in the DNG file, even if Adobe doesn't understand it.

Compatibility with older ACR and Lightroom versions

In order to open files from the latest cameras newly introduced to the market, you have to be running the latest version of Photoshop/ACR or Lightroom. If you buy a new camera, but choose not to upgrade Photoshop or Lightroom to the latest release at the same time, converting the raw files to DNG using the latest free standalone DNG Converter allows you to open those files with your older versions. The DNG Converter may need to be updated before it will convert the latest camera's files, and you'll need to make sure that the compatibility is set to a version that Photoshop or Lightroom can understand.

<u>Extra workflow steps</u>

If your camera doesn't natively create DNG files, the conversion would add an additional step to your workflow unless you convert at the time of import. You may also decide to back up the proprietary raw file in addition to the DNG files, so you'd need to consider how that would fit into your workflow. We'll come back to possible DNG workflows in the Designing your Workflow chapter.

Also check...

"Designing Your Workflow" chapter starting on page 633

So should you convert to DNG? Only you can decide whether it's right for you. If you believe it's worth considering further, read on…

Do I lose quality when converting to DNG?

There are 3 flavors of DNG—mosaic, linear and now lossy too.

A standard or mosaic DNG file takes the existing mosaic data straight out of the proprietary raw file without applying any processing, and simply wraps it in a DNG wrapper. That's usually the best option as it maintains flexibility for the future, and there's no loss of quality. Lightroom automatically uses this option where possible, with the main exceptions being sRAW files and Lossy DNG files.

The DNG Converter, under Compatibility > Custom, offers a linear DNG option which changes the way that the data is stored, resulting in much larger files. A linear DNG is demosaiced at the time of conversion, which means that the mosaic sensor data has some initial processing applied and it's no longer in the sensor format. You lose the option of using a newer or better demosaic algorithm in the future, such as the new demosaic that was introduced in Lightroom 3, so you do need to question how much further you think demosaic processes will improve in the future. A few programs will only read or output a linear DNG and not a mosaic DNG. DXO is a well known example which only creates linear DNGs. It's not a user-option in Lightroom, so you don't need to debate that too carefully.

And finally there's a lossy DNG, which we'll discuss in the next question. It's a cross between a raw file and a JPEG. In that case, the clue is in the name—it is a lossy process. You, however, are in control.

Should I convert to Lossy DNG?

An extension of the linear DNG, the lossy DNG is demosaiced at the time of conversion and JPEG compression is applied. It's important to understand that a lossy DNG is no longer a traditional raw file—it's not unprocessed sensor data—it's a hybrid. The benefit is a much smaller file which still behaves like a traditional raw file—in some situations, that may be the best of both worlds. But the lossy DNG format goes further—it also allows you to reduce the pixel count, much like Canon's sRAW files but at a later stage in the workflow, resulting in even smaller DNG files.

You're in control of how much data you lose. You can keep the original resolution and apply compression approximately equivalent to a JPEG level 10, out of Photoshop's 0-12 scale. If you compare the original mosaic data with a lossy DNG, you're unlikely to spot the difference without zooming into 1:1 view, and even then, it's barely visible. Try taking 1:1 crops of a photo—the mosaic data and a full resolution lossy DNG. Open the two versions in Photoshop as layers, and set the layers to Difference mode to highlight the pixel level details. I was intending to include examples, but it was impossible to see the difference at less than 500% zoom. The difference is barely noticeable, but the difference in file size is significant.

Or you can take it one stage further and reduce the file resolution.

To give you an idea of the file sizes involved, and a point of comparison, I ran an 18mp CR2 file through a series of exports with different settings. You'll note that the lossy DNG file size is fairly close to its JPEG equivalent. This is only a random example, as file sizes and compression will vary depending on the noise and detail in a photo.

	CR2	DNG						JPEG 8-bit		TIFF 16-bit		TIFF 8-bit		
Preview		Full Size		Medium Size		No Preview		Quality		Compression		Compression		
Fast Load Data		Yes	No	Yes	No	Yes	No							
Compression								100	85	None	ZIP	None	ZIP	LZW
Lossless Full Res	23.6mb	21.5mb	21.1mb	20.2mb	19.9mb	20.2mb	19.8mb			104.4mb	66mb	52.2mb	14.8mb	15.8mb
Lossy Full Res		8.3mb	8mb	7.1mb	6.8mb	7mb	6.7mb	7.1mb	4.1mb					
Lossy Half Size		1.6mb	1.2mb	1.3mb	0.9mb	1.2mb	0.9mb	2mb	1.1mb	26.9mb	17mb	13.5mb	3.9mb	4.1mb

Converting to a lossy DNG is a lossy process, so you probably won't want to apply it to your prized photo originals, but the format has potential workflow benefits. Consider a couple of possibilities:

- You could keep full resolution lossless DNG files on your main computer or in backups, and work with smaller versions on your laptop or in the cloud. The format has been designed to make their settings interchangeable, so you can make Develop adjustments to a small lossy DNG copy and then apply those same settings to the full resolution originals when returning to your main computer.

- If you only usually keep your favorite photos in their raw format and convert the rest to JPEGs, you can now use lossy raw for the latter group, retaining their editable state. The file sizes are comparable, as you can see from the table above.

So returning to the original question, should you convert to lossy DNG? The answer is simply, 'it depends.' While I would never recommend throwing away your original files, just as I'd never recommend a film photographer throw away their negatives, there are certainly potential uses in many workflows.

Why do some files get bigger when converting to DNG?

Standard raw files get smaller when converting to DNG due to the improved lossless compression. Some files, such as sRAW files, have to be stored as a type of linear DNG as the sRAW format isn't supported by the DNG specification, so they get larger. Lossy DNG is an option for

Also check...

"If I shoot sRAW format, can Lightroom apply all the usual adjustments?"
on page 80

sRAW files, as it's an extension of the Linear DNG specification, and it won't balloon the file size. Lossy DNG will apply JPEG compression, and although artifacts resulting from the compression are rare, they could show in extreme cases.

As a guide to the difference in sizes, and a point of comparison, I took a 16mp CR2, 9mp mRAW and 4mp sRAW file of the same scene, and converted them using the default DNG settings and full resolution lossy DNG too. You'll note that the mRAW and sRAW photos get larger when converting using default DNG settings. This is only a random example, as file sizes and compression will vary depending on the noise and detail in a photo.

Canon 1D Mk4	CR2	Default DNG	Lossy DNG
Full Size 16mp	21.7mb	17.2mb	6.2mb
mRAW 9mp	13.9mb	23.3mb	3.3mb
sRAW 4mp	9.3mb	11.7mb	1.6mb

Should I use Lossy DNG instead of sRAW?

Lossy DNG also has significant advantages over choosing a downsized lossy format, such as sRAW, in the camera.

- You're making the decision at a later stage in the workflow, so you can retain your favorite images as their full lossless raw while downgrading the lesser photos.

- You can choose how much quality to give up in return for the smaller file sizes, rather than being limited to fixed sizes.

- The lossy compression used is much more efficient, so a full resolution lossy DNG file is usually smaller than the low resolution sRAW file. For example, in another test, a Canon 1d 18 megapixel raw file is around 24mb in size—that becomes a 6mb lossy DNG at full resolution, whereas the 12.3mb sRAW file has only 1/4 of the pixels (4.5 megapixels).

- Since the white balance is not applied to the image data in a lossy DNG, as it is with an sRAW file, you retain full highlight recovery

and white balance adjustment potential. In most cases, that isn't a significant issue if the white balance was close at the time of shooting, however extensive white balance adjustments will perform better on a lossy DNG than the equivalent sRAW file.

On the other hand, because you're shooting full size raw files and then converting to Lossy DNG later in the workflow, you would of course need more memory cards.

Do you convert to DNG?

I'm often asked whether I convert my own files to DNG, and the answer is yes. Why? Primarily for data validation.

The DNG Hash is stored in the DNG file at the time of conversion. If even a single bit of the image data is subsequently changed—corrupted—it would no longer match that hash, alerting me to problems before they spread. ACR, Lightroom and the DNG Converter all check the DNG Hash and confirm that the data still matches the original hash, but they only run when you open the file, so checking your entire library could be a long job. ImageVerifier (http://www.lrq.me/imageverifier), however, can check all of the files and folders as a batch process. I usually run it 3-4 times a year, and always before updating my offline backups, to ensure that I never risk overwriting a good file with a corrupted one.

ImageVerifier can also check other formats, but those hashes would be stored in its own local database, whereas the DNG hash always remains with the DNG file. Also, other file formats are expected to change, usually because you've intentionally edited them. The MD-5 validation hash in a DNG file only applies to the main source image data, which should always remain unchanged, so I can safely update previews and metadata without causing a false corruption warning. You can learn more about DNG Validation at http://www.lrq.me/dngvalidation

Personally, I won't be converting my raw originals to Lossy DNG as disc space isn't an issue, but the format will find a home in my workflow. Uploading Lossy DNG's into the cloud, where I can access them from my

Also check...

"I embedded the proprietary raw file— how do I extract it to use it?" on page 127

laptop without filling up the SSD, is my first step. My early JPEG originals will now be converted to Lossy DNG, as that will protect them from accidental editing and they'll benefit from the same data validation.

As well as my main backups, I do use the Make a Second Copy option in the Import dialog to keep a backup of my proprietary raw files, which are then copied to offline storage, but in the 5 years since I converted to DNG, the only occasions I've gone back to those proprietary raw files were for testing Lightroom and writing this book.

If I convert to DNG, can I convert back to the proprietary raw file format again?

Conversion to DNG is a one-way process, unless you've embedded the proprietary raw file which could then be extracted.

If you're concerned about accessing the proprietary raw file, either archive the proprietary raw file as well as the DNG file, embed the proprietary raw file in the DNG file, or forget DNG altogether.

As you no doubt keep more than one copy of your photos, storing one of those backups as the proprietary format would leave all of your options open, while still gaining the benefits of DNG.

Which preferences should I choose when converting to DNG?

In Lightroom, the DNG Preferences are found in the main Preferences dialog > File Handling tab, which you can find under the Edit menu (Windows) / Lightroom menu (Mac). You'll only need to set them once.

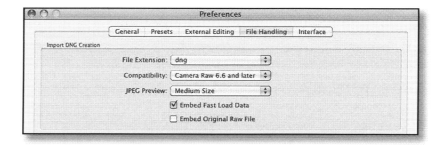

File Extension

Upper or lower case file extension is just a matter of personal choice and makes no difference to the DNG file itself.

Compatibility

The DNG Specification has grown over the years, as new features have been added. All DNG files are forwards compatible, which means that they can definitely be opened by future programs. In most cases the files are also backwards compatible, however there are exceptions, so if you need to guarantee compatibility with an older program such as CS3, you can select an older compatibility version. It's like saving a Microsoft Word 2010 document in Word 98 format—by selecting that format, you're guaranteeing compatibility with the older version, but losing out on the benefits of the features that have been added more recently. As a general rule, unless you have a reason to select an earlier version, you can select the latest version.

Preview size

None creates a thumbnail of only 256px along the longest edge, which results in the smallest file size.

Medium creates a preview of 1024px along the longest edge, which is ideal for general file browsing.

Full creates a full resolution preview, which is useful if you want to print or zoom in on an image using DNG-compatible software without having to render the raw data, but does also create the largest file size.

None of these preview sizes make any difference to Lightroom 4 itself, as Lightroom has its own preview system.

Embed Fast Load Data

Fast Load Data allows compatible programs, such as Lightroom 4, to show you a preview more quickly than a proprietary raw file or a DNG file without Fast Load data. It doesn't affect backwards compatibility and only increases the file size slightly, so I would recommend turning it on.

Also check...

*"Should I convert
to Lossy DNG?"
on page 114*

Use Lossy Compression

Lossy Compression is disabled on import to avoid accidentally applying it to your original files. It is available in the Library menu > Convert Photo to DNG and Export dialogs. For more detailed information on the pros and cons of Lossy DNG, turn back a couple of pages.

Embed Original Raw File

Embed Original Raw File embeds the proprietary raw file inside the DNG wrapper too, and that can be extracted again later to use with software that can only read the proprietary raw format. It does essentially double the file size, so you may prefer to keep copies of the proprietary raw backup separately instead.

Quick Defaults

If you're still not sure which settings to use, here are some defaults to get you started:

Compatibility: the highest number, currently 6.6 at the time of writing

JPEG Preview: Medium
Embed Fast Load Data: yes
Use Lossy Compression: no
Embed Original Raw Files: no

How do I convert to DNG?

There are a few different stages of your Lightroom workflow when you can convert to DNG—while importing, while the photos are in your catalog, while exporting, or entirely separately using the DNG Converter. We'll cover them all together here, but if you're new to Lightroom, you may decide to skip some and refer back to them later, instead of joining me on this slight tangent.

Converting when importing into Lightroom

In the Import dialog, one of the Import options is Copy and Convert to DNG. Selecting that option will import the photos in the DNG format,

converting on the fly, using the DNG options set in the Preferences dialog. If you use the Make a Second Copy option in the File Handling panel, the copy will be of the original file format, not the converted DNG file.

Also check...

"What does the 'Make a Second Copy' option do?" on page 92

Converting existing Lightroom files

Why might you want to convert files that are already in your Lightroom catalog?

- You may have been in a hurry when initially importing the files, and therefore imported without converting—on large volumes of photos, it's often more convenient to leave the DNG conversion running as a separate process overnight.

- You want to copy the proprietary raw files over to your backup in their mirrored folder structure before converting your working copies to DNG.

- You want to convert photos that were in the catalog before you decided on a DNG workflow.

- You want to convert your lower quality photos to Lossy DNG, while retaining your best photos as full size DNG or proprietary raw files.

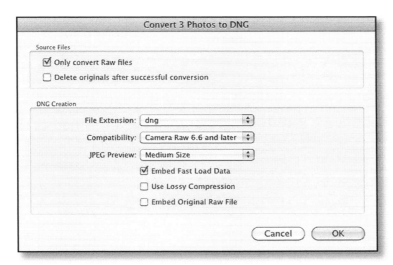

Simply go to Library module's Grid view and select the photos you want to convert, and then select Library menu > Convert Photos to DNG. Choose the DNG options discussed previously, and press OK. The progress will be shown in the Activity Viewer in the top left corner of Lightroom's workspace.

You have 2 additional options in this dialog, but they're not rocket science. 'Only convert raw files' will, fairly logically, only convert the raw files. That's useful if you've accidentally included other formats such as JPEGs in your selection. 'Delete originals after successful conversion' will move the proprietary raw files to the Recycle Bin (Windows) /Trash (Mac) once the DNG file has been created, instead of leaving it in the same folder.

<u>Converting when exporting from Lightroom</u>

Lightroom has one more DNG conversion option, at the opposite end of the workflow. You have the option of converting to DNG when you export the files—perhaps you prefer to work on proprietary raw files within your own workflow, but then archive as DNG, or you want to send a DNG format to someone else.

Go to File menu > Export and the DNG options are under the File Settings section. Most of those preferences are no doubt quite familiar by now!

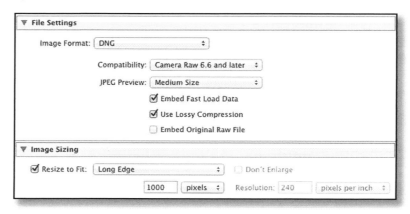

There is an extra option at this stage, which isn't available in the other locations—reducing the pixel count. Lightroom doesn't offer this in other locations as it's obviously a very destructive process that you'd only want to apply to copies of the original photo. We covered Lossy DNG in more detail earlier in this section. To reduce the resolution/pixel count, select Use Lossy Compression and then choose your size in the Image Sizing section below.

Also check...

"Should I convert to Lossy DNG?" on page 114

Using the DNG Converter

So that's it for Lightroom, but what happens if you don't have Lightroom around at the time, or you're using an older version of Lightroom that doesn't support your camera? Not a problem! Adobe provides a free standalone DNG Converter which is updated at the same time as each Adobe Camera Raw release. You can download it from http://www.lrq.me/dngconvert The DNG Converter comes with a standard installer, and once it's installed, it will be available in Start menu > Program Files > Adobe > Adobe DNG Converter for Windows, or Applications folder > Adobe DNG Converter for Mac.

The DNG Converter will take any ACR-compatible raw format and convert it to DNG format. First select the folder containing the proprietary raw files and choose where to save the resulting DNG files, set the renaming options if you wish to rename at the same time, and choose the Preferences discussed earlier. Pressing Convert will

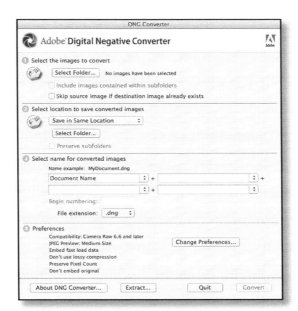

begin the conversion, and a second dialog will keep you informed of the progress. When you've finished, simply quit the program.

My camera creates DNG files natively—how do I update them to take advantage of the new specification?

Most cameras that create DNG files don't embed Fast Load data or store the image data as tiled strips for speed. By running Lightroom's DNG conversion on those native DNG files, you can update them to the latest specification. Any of the conversion options mentioned previously will work. Converting to DNG on import is the most efficient workflow for most people. There's no loss of quality in this process, unless you choose to apply lossy compression.

If you only want to embed the Fast Load data or update the embedded preview, selecting the photos in Grid view and selecting Metadata menu > Update DNG Previews & Metadata will do so without rearranging the image data.

Can I replace my full size proprietary raw or DNG files with smaller ones?

If you simply want to convert proprietary raw files to Lossy DNG's, you can select them in Grid view and go to Library menu > Convert Photos to DNG and select the Use Lossy Compression option. You can decide whether to keep the proprietary raw files in the same folder or delete them automatically, and Lightroom's catalog will be updated to use the DNG file.

If you're converting DNG files from Lossless to Lossy, you can use the same command, but there's one extra thing to look out for—if you don't select 'Delete originals after successful conversion,' the new Lossy DNG will have a −2 added to the end of the filename, which can be difficult to remove later.

If you're wanting to downsize further, reducing the resolution, you have to use the Export dialog to create those Reduced Resolution Lossy DNG files, and then manually replace them. A metadata conflict exclamation mark will show, and reading the metadata from the file will update the DNG Metadata in the Metadata panel and Filters.

Also check...

"XMP has been updated on another program or computer. Why don't the changes show in Lightroom?" on page 324

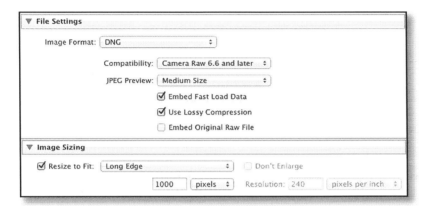

Should I convert other formats like JPEG or TIFF to DNG?

It's possible to convert JPEG and TIFF files to DNG using Library menu > Convert Photos to DNG, however that doesn't turn them into raw files—it just wraps the rendered data in the DNG wrapper.

There are three advantages—you can update the preview without affecting the original image data, you can't accidentally save over your original, and they will benefit from the DNG Hash for data validation.

There are disadvantages, of course—the resulting linear DNG files aren't compatible with as many programs as their more universal JPEG or TIFF counterparts.

Historically, JPEGs converted to DNG have been bigger than their original JPEG format, for example, a 1.7MB JPEG became a 7MB DNG file. If you select the new Lossy DNG format, the JPEG data will be copied over verbatim, rather than losing even more quality by decompressing and recompressing the data.

How do I update my embedded preview?

If you have a DNG file in Lightroom and you've made Develop adjustments to the photo, you may want to update the embedded preview to reflect those changes. To do so, go to Library module > Grid view, select the photos you want to update, and go to Metadata menu > Update DNG Preview & Metadata.

How do I change my embedded preview size?

If you've changed the size of your embedded preview in Preferences, for example, switching from Medium size to 1:1, selecting the photos and using the Metadata menu > Update DNG Preview & Metadata command will update the size of the embedded preview to match your new setting.

How do I find more information about the type of DNG file?

With a wide variety of DNG flavors now available, it's more important than ever to identify the type of DNG. If you select a DNG file and choose the DNG view in the Metadata panel, you can see information such as the backwards compatibility, whether Fast Load data is embedded in the file, the size of the embedded preview and original file, whether any compression has been applied, whether the proprietary raw file is embedded, and so forth.

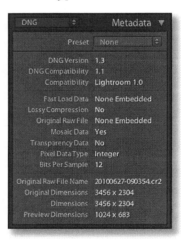

Also check...

"Viewing & Editing Metadata" section starting on page 201

If it says the data is 'unknown,' select the photos and go to Metadata menu > Update DNG Preview and Metadata. The file will then be updated to include that information.

When searching for the files using Smart Collections or Metadata Filters, DNG files are split into DNG Lossless, DNG

Lossy Compressed and DNG Reduced Resolution, allowing you to quickly identify them.

Also check...

"Sorting, Filtering & Finding Photos" section starting on page 223 and "Smart Collections" section starting on page 234

I embedded the proprietary raw file—how do I extract it to use it?

If you chose to embed the proprietary raw file, and then you want to extract it, you need the standalone DNG Converter, which you can download from http://www.lrq.me/dngconvert Press the Extract button at the bottom of the dialog, choose the source and target folders, and press Extract to start the process. It only works on whole folders, and not single files, so move the file into a temporary folder if you only want to process a single file. The DNG file isn't affected by the process and the embedded raw file remains within the DNG wrapper, in addition to the extracted version.

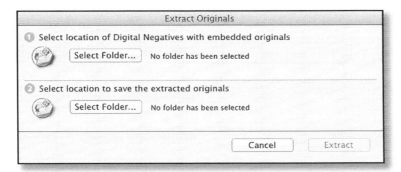

I embedded the proprietary raw file—is there any way to remove it?

If you originally embedded the proprietary raw file, but then change your mind, you can strip it, again using the standalone DNG Converter. Uncheck the Embed Original Raw File checkbox in the DNG Converter

Preferences dialog, and run the files through the DNG Converter again. Once they've finished converting, you can replace Lightroom's DNG files with those smaller DNG files using Explorer (Windows) / Finder (Mac). Stripping the proprietary format deletes it, rather than moving it elsewhere, so be careful to extract the proprietary raw file first if you want to keep it.

OTHER IMPORT QUESTIONS

Having explored all of the Import dialog options, there are a few other related questions which regularly appear on the user forums, including what the error messages actually mean.

Why does Lightroom load or open the Import dialog every time I insert a memory card or device?

There are 2 different factors involved in Lightroom automatically launching—whether Lightroom opens the Import dialog if the program is already open, and whether the programs loads by itself even though it was closed. You may wish to disable either or both.

To change the behavior, go to Preferences > General tab and check or uncheck 'Show Import dialog when a memory card is detected.'

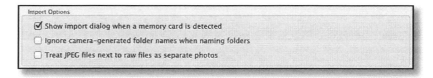

On Windows, that checkbox controls the Windows AutoPlay mechanism. It not only controls the Import dialog opening automatically, but also the program launching from closed.

On Mac, the checkbox only controls whether Lightroom opens the Import dialog when the program is already open. If you'd like Lightroom to launch from closed when you connect a memory card, insert the

memory card or plug in the device. Go to the Applications folder, open the Image Capture app, and in the lower left corner, select Lightroom as the program to automatically open.

The same logic applies, not just to card readers and cameras, but also to iPhone, iPod, USB keys, printers with card readers, and various other devices.

I can't see thumbnails in the Import dialog, I just see grey squares. How do I fix it?

If not all of the photos show grey thumbnails, it may be that the file is corrupted, not supported by Lightroom, doesn't have an embedded preview, or that Lightroom simply hasn't finished retrieving all of the embedded previews yet. Make sure you're running the latest Lightroom update—if your camera is a new release, support may have been added recently, or may not be available yet. If Lightroom can't import the photo, the error message that will follow should give more information on the reason.

If your camera's connected directly to the computer, a lack of previews can be a result of problems with the camera driver at the operating system level. In that case you should be able to import the files without seeing the Import dialog previews and then Lightroom's own previews will be rendered once the photos are imported. You may consider purchasing a card reader, as they are usually quicker, reduce the wear and tear on your camera, and can show previews more reliably.

Being unable to see previews anywhere within Lightroom's interface is a slightly different problem which we'll cover in more detail in the Previews chapter.

Also check...

"Why do I just get grey boxes instead of previews?" on page 338 and "Lightroom appears to be corrupting my photos—how do I stop it?" on page 134

Can I set Lightroom to delete the photos from the memory card once they've uploaded?

When you're importing from a device, such as a camera or card reader, Lightroom disables the Move and Add options to protect you from accidental loss. Most file corruption happens during file transfer, and if you selected Move, you would no longer have an uncorrupted copy on the card if corruption did occur. If you selected the Add option, you could format the card believing that the files are safely imported into Lightroom, only to find that Lightroom can no longer find the files as it was reading them directly from the memory card.

For that same reason, there's no 'delete photos from memory card once uploaded' option because it's good practice to verify that the data is safe before you delete the files, and also, formatting the cards in your camera, rather than the computer, minimizes the risk of card corruption.

What happens to the other files on a memory card, such as sound or video files?

Lightroom will import and manage video files from most digital cameras, as if they were image files. AVCHD format now has limited support—Lightroom will import the MTS video clips but not the whole AVCHD folder structure. You'll need to manually copy the AVCHD file to your hard drive.

Sound files (i.e., WAV and MP3) with the same names as imported photos are copied and marked as sidecar files. This means that they're listed in the Metadata panel, and if you move or rename the original file, the sidecar will also be affected.

Files that aren't created by digital cameras, for example, text files that you may have placed alongside the photos, will not be copied to the new location, so always check before formatting the card if you've added extra files.

Also check...

"Can I import and listen to my camera's audio annotations?" section starting on page 203 and "Managing & Editing Videos" section starting on page 218

Can I import CMYK photos into Lightroom?

You can import CMYK photos to manage them alongside your other photos, use the Edit in Photoshop menu command to pass the original file back to Photoshop, and export as Original format, all still in CMYK. Any Develop editing within Lightroom, and export to any format other than Original will, however, use the RGB color space, which can result in unexpected shifts in untagged images.

It says: 'Some import operations were not performed. Could not copy a file to the requested location.'

If Lightroom can't copy or move the photos to their new location, it's usually because the Destination folder is read-only. You can try another location, or correct the permissions for that folder. If the permissions appear to be correct already, it may be a parent folder that has the incorrect permissions. Other possibilities include the drive being nearly full or the drive may be formatted using an incompatible format, such as a Mac computer trying to write to an NTFS formatted drive.

It says: 'Some import operations were not performed. The file is too big.'

Lightroom 4 has a file size limit of 65,000 pixels along the longest edge, and up to 512mp, whichever is the smaller. If it tells you that the file is too big, then you're trying to import a photo that's larger than that—perhaps a panoramic photo. If you have any such files that you can't import, you could create a small version of the photo to import into Lightroom to act as a placeholder.

Also check...

"How do I find out whether my new camera is supported yet?" on page 665 and "How do I update Lightroom with the latest version of ACR?" on page 665

It says: 'Some import operations were not performed. The file is from a camera which isn't recognized by the raw format support in Lightroom.'

Lightroom needs to be updated to read raw files from new cameras, so if Lightroom says that it doesn't recognize the raw format, make sure you're running the latest Lightroom update. You can check whether your camera is supported by the latest version of Lightroom by visiting Adobe's website: http://www.lrq.me/camerasupport

Updates are usually released every 3-4 months, along with an update for ACR (Adobe Camera Raw plug-in for Photoshop/Bridge), so if your new camera doesn't yet appear on the list, it shouldn't be too long a wait.

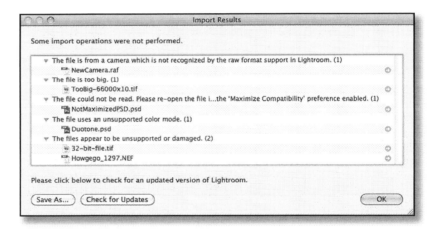

It says: 'Some import operations were not performed. The files use an unsupported color mode.'

If a photo is in a color mode which Lightroom doesn't support, such as Duotone, it will be unable to import it, so you'll need to convert the photo to RGB, CMYK, Lab, or Grayscale, or import an RGB copy as a placeholder instead. If you're going to edit the file in Lightroom, remember that all editing and export takes place in RGB. This could result in unexpected shifts in files with other color modes, so you may

prefer to control the conversion to RGB yourself using Photoshop, and then import the RGB file into Lightroom for further editing.

It says: 'Some import operations were not performed. The files could not be read. Please reopen the file and save with 'Maximize Compatibility' preference enabled.'

Lightroom doesn't understand layers, so if there isn't a composite preview embedded in a layered file, it can't be imported, and you'll need to resave those PSD files with a composite preview.

You'll find Photoshop's Preferences under the Edit menu (Windows) / Photoshop menu (Mac), and in the File Handling > File Compatibility section, there's an option to Maximize Compatibility with other programs by embedding a composite preview in the file. The preference only applies to PSD and PSB format files, as other formats such as TIFF embed the composite by default.

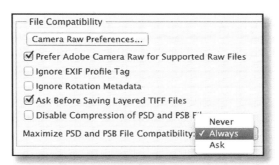

Maximize Compatibility does increase file size, but it ensures that other programs—not just Lightroom—can read the embedded preview even if they can't read the layers, so it's best to set your Photoshop Preferences to Always. If you set it to 'Ask,' it will show this dialog every time you save a layered PSD file.

It says: 'Some import operations were not performed. The file appears to be unsupported or damaged.'

Lightroom requires 8-bit or 16-bit images, however some HDR images are 32-bit, which won't import. In that case, you could create a small 8-bit version of the photo to import into Lightroom to act as a placeholder.

If the file's not 32-bit, then the photo you're trying to import may be corrupted instead. File corruption sometimes prevents photos from being imported, resulting in the 'unsupported or damaged' error message, but more often it shows up once a photo is imported into Lightroom and the previews are being built.

Lightroom appears to be corrupting my photos—how do I stop it?

Even if photos import into Lightroom without showing an error message, corruption may appear when you start working with the photos. The preview you see in other browsers, and initially in Lightroom, is the small JPEG preview embedded into each file by the camera, which often escapes corruption because it's confined to a small area of the file. Lightroom then reads the whole file to create an accurate preview, and is unable to read it fully due to corruption, resulting in the distorted view.

Unfortunately the files are usually corrupted before they reach Lightroom, and in most cases it's turned out to be a result of hardware

problems. Corrupted files are most often caused by a damaged card reader or cable, but other regular suspects include damaged flash cards or problems with the camera initially writing the file. If a photo gets corrupted some time after the original import, a damaged hard drive or connection, damaged

memory, or a variety of other hardware issues would also be worth investigating. Most file corruption happens at the time of file transfer, so moving photos between hard drives repeatedly increases the risks. Using file synchronization software which will allow byte-for-byte verification helps to minimize the risk of data loss if you do have to move files between hard drives.

If you don't have an uncorrupted version, Instant JPEG from RAW may be able to extract a readable embedded JPEG preview from a raw file. You can learn more at http://www.lrq.me/instantjpegfromraw

Why is Lightroom changing the colors of my photos?

If Lightroom starts changing the appearance of the newly imported photos automatically, there are a few settings that you might have changed.

Are the photos raw? If so, the changes are likely just a difference in rendering, because raw data is just that—raw—and each raw processor has its own default style. We'll come back to raw profiling options in the Develop chapter.

There are a few other possibilities, however, which would also apply to JPEG and other rendered formats. We'll cover the options in more detail later, but a quick checklist for now:

- Have the photos been edited in Lightroom or ACR previously? If so, they may have Develop settings recorded in the metadata.

- Did you apply a Develop preset in the Import dialog? Set it to None and see if the problem recurs on future imports.

- If you go to Lightroom's Preferences > Presets tab, is Apply auto tone adjustments checked? If so, uncheck it for future imports.

For photos that are already imported, if you go to the Develop module and press the Reset button at the bottom of the right hand panel, does it change? If so, you may have changed the default settings, so go to

Also check...

"What Develop settings, metadata and keywords should I apply in the Import dialog?" on page 92 and "Raw File Rendering" section starting on page 353

Also check...

"Defaults" section starting on page 414 and "Everything in Lightroom is a funny color, but the original photos look perfect in other programs, and the exported photos don't look like they do in Lightroom either. What could be wrong?" section starting on page 338

Preferences dialog > Presets tab and press the 'Reset all default Develop settings' button.

There's one other final possibility, which is a corrupted monitor profile, which we'll discuss in the Previews & Speed chapter a little later.

I shot Raw+JPEG in camera—why have the JPEGs not imported?

In Lightroom's Preferences > General tab is an option to 'Treat JPEG files next to raw files as separate photos.'

With that option checked, Lightroom will import the JPEG files alongside the raw files. If the checkbox is unchecked, then the JPEGs are recorded as sidecar files, showing the filename as 'IMG0001.CR2 + JPEG', and noting the JPEG as a sidecar in the Metadata panel. Photos imported as sidecar files aren't treated like photos, so you can't view them separately, and if you move or rename the raw file, the sidecar is moved or renamed too.

If you've imported the raw files already, and you now want to import the JPEGs as separate photos, you can turn off the checkbox and re-import that folder—the raw files will be skipped as they already exist in the catalog, and the JPEGs will be imported as separate photos. The raw files will remain marked as Raw+JPEG, and there isn't an easy way of changing that. Removing them from the catalog and reimporting them will reset that label, but if you've made any changes since import, those changes may be lost, so the best solution currently is to close your eyes and ignore them.

TETHERED SHOOTING & WATCHED FOLDERS

Tethered shooting involves connecting your camera directly to the computer, and as you shoot, photos appear on the computer's monitor immediately, rather than having to download them later. Lightroom offers two different options, depending on your requirements.

If you're using one of the supported cameras, you can use the Tethered Capture tool, which allows you to connect your camera to the computer, view your camera settings and trigger the shutter using Lightroom's interface.

If you're shooting wirelessly, or you want to use other remote capture software, perhaps because your camera isn't supported by Lightroom's Tethered Capture tool, or you need to control all of the camera's settings remotely, you can use Auto Import to monitor a watched folder instead. Auto Import collects photos from a folder of your choice as they appear and automatically imports them into Lightroom, moving them to a new location in the process.

Which cameras are supported by the built-in Tethered Capture?

The current list of cameras supported for tethering can be found on Adobe's website at: http://www.lrq.me/tethersupport

Lightroom uses Canon and Nikon's own SDKs to control the camera, which results in some slight differences between manufacturers, for example, if there's a memory card in the camera, Canon cameras can write to the memory card in addition to the computer hard drive, whereas Nikon cameras will only write to the computer hard drive. Other Canon cameras may also already work, but Nikon cameras are limited to the list linked above, due a difference in the SDK's.

How do I set Lightroom up to use Tethered Capture?

Connect your camera to the computer using your USB or Firewire cable and go to File menu > Tethered Capture > Start Tethered Capture and choose your settings in that dialog. A few cameras need to be in PC Connection mode, but most need to be in PTP Mode.

Photos will be placed into a subfolder within the Destination folder you choose, with the subfolder name taken from your Session Name. The Segment Photos by Shot option subdivides the shots into further subfolders, using the Shot Name. That Shot Name can be changed at any

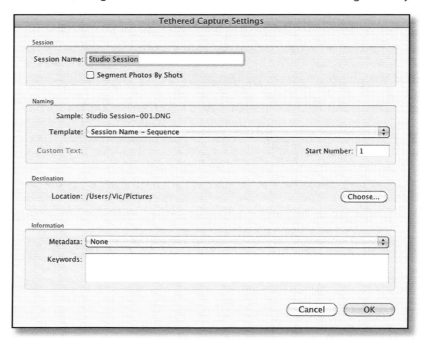

point, automatically creating another new subfolder, by clicking on the Shot Name in the Tethered Capture window.

The Tethered Capture window shows you the current camera settings, but doesn't currently allow you to change those settings remotely. In that dialog you can set a Develop preset to apply to each photo on import, and you can drag the dialog to another location if it's getting in your way. It floats over the top of Lightroom's standard window so you can carry on working without closing the Tethered Capture window. Press the shutter button on the camera, or the silver button on the dialog, to trigger the shutter.

Crops can't be saved in presets, so how do I get it to apply a crop to my Tethered photos?

As in the main Import dialog, Develop presets allow you to automatically apply certain Develop settings to your photos, and those same presets are available in the pop-up menu in the Tethered Capture window.

Certain settings, such as Crop, can't be included in Develop presets, however that doesn't prevent you from applying them automatically. Simply shoot the first photo, apply your crop along with any other Develop settings, and then select the Same as Previous option in the Develop presets pop-up menu. Any further tethered shots will automatically have those previous settings applied, including the crop.

Also check...

"Presets" section starting on page 404

Can I see a Layout Overlay, to preview the positioning of my photo in its final layout?

If you're shooting for a particular purpose—perhaps for a magazine cover—then you may need to preview how the photo will look in its final layout. Lightroom 4 adds a Layout Overlay for that purpose. It can be used on any photo in the Library module, however it's most useful when shooting tethered. To activate the overlay, go to View menu > Layout Overlay > Show Layout Overlay and it will ask you to choose a transparent PNG file. You can change the overlay file again later by selecting View menu > Layout Overlay > Choose Image.

To adjust the overlay, hold down the Ctrl key (Windows) / Cmd key (Mac) to show the controls. When the hand tool is showing, dragging the overlay moves it around on the photo. Dragging the corners resizes the overlay. Below the overlay are additional controls—opacity affects the opacity of the overlay itself, and matte affects the opacity of the black area surrounding the overlay. The matte works like Lights Out mode, hiding excess picture under a black matte.

Can I convert to DNG while tethering?

You can usually convert to DNG when importing, but Tethered Shooting doesn't offer that option for performance reasons. If you allow Lightroom to automatically import the photos and work on them as usual, you can then use the Library menu > Convert Photos to DNG command to automatically convert and swap the proprietary raw files for DNG files later without losing anything.

Also check...

"How do I convert to DNG?" on page 120

How do I set Lightroom up to use a watched folder?

You can use your own camera manufacturer's software (EOS Utility, Camera Control Pro, etc.) or other remote capture software to capture the photos, and set it to drop them into Lightroom's watched folder. Lightroom can then collect the files from that watched folder, and move them to another folder of your choice, importing them into your Lightroom catalog, renaming if you wish, and applying other settings automatically.

To set it up, go to File menu > Auto Import Settings and select an empty folder, perhaps on your desktop. Choose your other import options in that dialog, and then enable the auto import using the checkbox at the top of the dialog or the File menu > Auto Import > Enable Auto Import menu command.

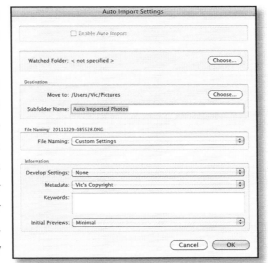

Switch to your camera's remote capture software and set it to drop the photos into that folder. Lightroom moves the files from the watched folder to the destination folder as photos appear there, so it needs to be empty

when you set it up. Make sure your camera's remote capture software (i.e. EOS Utility, Camera Control Pro) doesn't create a dated subfolder as Lightroom won't look in any subfolders in the watched folder.

You can test that Lightroom's Auto Import is working by simply copying a file from your hard drive into the watched folder. As soon as the file lands in the folder, it should start the import, and you should see the file vanish from the watched folder. It should then appear in the destination folder and in Lightroom's catalog. If that works, then you've set up Lightroom properly.

Finally, connect the camera to the capture software, and ensure it's saving to the right folder. Release the shutter and you should see a file appear in the watched folder, then Lightroom should take over, just like in the test.

Is there a way to have Apple's Photo Stream automatically import into Lightroom?

On Windows, the iCloud Control Panel allows you to select a Download folder for your Photo Stream. You can select that folder as Lightroom's Auto Import folder, as discussed in the previous question.

On Mac, it's not quite so simple as it integrates directly with iPhoto and Aperture, both of which tuck their photos away in package files. There is a small donationware app called PhotoStream2Folder, however, which will copy the photos from your Photo Stream into a folder that can then be used with Lightroom's Auto Import. You can download it from http://www.lrq.me/photostream2folder You must have iPhoto 09 or later installed, but it doesn't need to be running.

There are 2 things to look out for on either operating system—the folder must be empty when you initially set up Lightroom's Auto Import, and Lightroom will remove the photos from the folder when it copies them into your chosen location, although that won't affect the other computers or devices using the same Photo Stream.

Workspace

This is one section where we will break partially from the FAQ format, and cover some of the basics of working within Lightroom's interface, because you may need to refer back to some of these sections later in the book. We'll not only cover the obvious parts, such as the different sections of the screen, but also how to work with selections, sliders, tokens in dialog boxes, and updating presets in pop-up menus. Although we'll refer to photos, most instructions also apply to video.

THE MAIN WORKSPACE

When you first open Lightroom, you'll be viewing the main workspace.

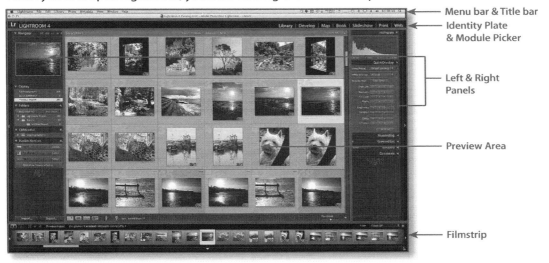

- Menu bar & Title bar
- Identity Plate & Module Picker
- Left & Right Panels
- Preview Area
- Filmstrip

Also check...

"Viewing & Comparing Photos" section starting on page 161

Menu bar, Title bar and screen modes

Menu bar (a) Title bar (b) Current catalog (c)

Lightroom offers 3 different screen modes, each offering a few less distractions than the previous, and you press the F key to cycle through them. The normal window mode allows you to resize or move the window, and the Title bar (b) along the top of the window shows the name of the current catalog (c). The next mode is Full Screen with Menu Bar, which fills the screen but leaves the menu bar (a) showing. The final mode is Full Screen where the menu bar disappears from view. Floating the mouse right to the top of the screen will briefly show the menu bar, or you can press F once or twice to return to another view.

Module Picker, Identity Plate and Activity Viewer

Lightroom is divided up into modules. Library is where you manage your photos, Develop is where you process them, Map allows you to add location metadata, and then Book, Slideshow, Print and Web are for displaying your photos in different formats.

Along the top of the Lightroom workspace is the Module Picker where you click to switch between the different modules. As you'll likely spend most of your time switching between the Library and Develop modules, it's worth learning those keyboard shortcuts—G for Grid view, E for Loupe view, and D to switch to the Develop module. We'll come back to those different view modes a little later.

If the Module Picker won't fit because you're working on too small a screen, an arrow appears on the right, allowing access to the other

modules. If you don't use a specific module often, for example, you don't print from your netbook, you can right-click on the module name and hide it. It will still be accessible from the View menu, and you can show it again at any time by right-clicking on the Module Picker and reselecting

the module name in the context-sensitive menu.

You can also change the font used for the Module Picker to a smaller size or narrower font, allowing them to fit on small screens without hiding any modules. You'll find that setting in the Identity Plate Setup dialog, which is under the Edit menu (Windows) / Lightroom menu (Mac). You'll need to enable the custom Identity Plate using the checkbox in the top left corner of the dialog before the change of Module Picker font will be applied.

The Identity Plate is the area to the left of the Module Picker, and it allows you to personalize your Lightroom catalog. It's particularly useful if you keep multiple catalogs for different purposes, allowing you to see at a glance which catalog you have open.

Also check...

"How can I overlay a graphic such as a border onto my print?" on page 613

In that same Identity Plate Setup dialog, check Enable Identity Plate and select Use a graphical identity plate. Drag a photo into the space available, or use the Locate File button to find a suitable file. Standard image formats are fine, but the PNG format will also allow for transparency. You can also Use a styled text identity plate and type the text of your choice, changing the font, size and color to suit. These Identity Plates can also be used in the Slideshow, Print and Web modules, so you may want to save them by selecting Save As in the pop-up menu at the top of the dialog. They're stored with the catalog, rather than in a global location, so if you have multiple catalogs, you'll need to set them up in each catalog.

When there's an active process running, for example, a large export, the Identity Plate is temporarily replaced by the Activity Viewer. It shows the progress of any current tasks, and clicking on the X at the end of any of those progress bars

will cancel it. Lightroom is multi-threaded, which means it can do lots of tasks at once, so you don't need to wait for it to finish before doing something else. When there are too many tasks to show in one view, for example, more than 3 exports, it will show a combined progress

bar. In that case, the X at the end of that combined progress bar changes to an arrow, and clicking that arrow will cycle through each of the individual active tasks.

Panel Groups & Panels

Down the left and right hand sides of the screen are panel groups, each holding individual panels. The panels on the left always hold the Navigator or Preview panels and other sources of information—folders, collections, templates, presets, etc. The panels on the right allow you to work with the photos themselves, adding metadata, changing Develop settings, and adjusting settings for books, slideshows, prints and web galleries.

You can customize some of the panel options. If you drag the inner edge (a) of those panel groups to make them wider or narrower, it also changes the width of the sliders, making them easier to adjust. In the Preferences dialog > Interface tab you can also adjust the font size and change the panel end marks at the bottom of each panel group (b).

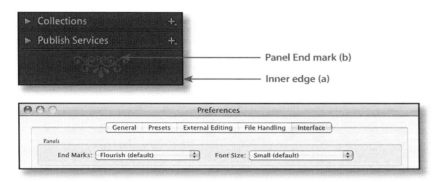

If you want even more control over the interface such as changing font sizes, extending the panel widths further and making other non-standard changes, consider Jeffrey's Configuration Manager: http://www.lrq.me/friedl-config

I haven't checked all possible variables, but those I did check were working as expected.

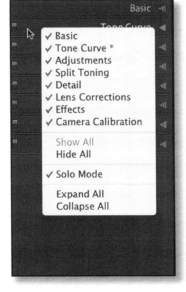

Many users have asked for tear-off panels that can be placed on another screen, such as those in Photoshop, but that's not currently possible with the modular design. The alternative is Solo Mode. If you right-click on the panel header, in the black area next to the panel label, you can select Solo Mode from the menu. Clicking on a panel header would usually open that panel, but with Solo Mode activated, it also closes the other panels, so you just have one panel open at a time.

Shift-clicking on another panel while in Solo Mode opens that panel without closing the first one. Particularly in the Develop module, where there are lots of panels to switch between, it's quicker than leaving them all open and having to scroll up and down constantly. If you find that there's a specific panel that you never use, you can uncheck it in that same menu, which will hide it from view. If you ever need it back, right-click on a panel header to show that menu again.

Panel Auto Hide & Show

The black bar along the outer edges of the panels (a) control whether that panel is showing or hidden, and when you click on that bar, it opens or closes the panel group. The most useful panel keyboard shortcuts are Tab to hide and show the side panels and Shift-Tab to hide and show all of the panels including the Filmstrip.

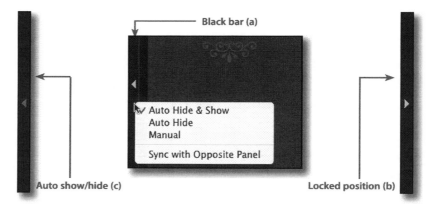

The panels are set to Auto Hide & Auto Show by default, which means that if you click on the black bar to hide the panel, every time you float the mouse close to the edge, the panel will pop into view. A solid arrow (b) in that bar indicates that the panel is locked into position, and an opaque arrow (c) indicates that it's set to automatically show or hide itself when you float the mouse over that bar. If you right-click on those black bars, you can change the behavior for each panel group. Personally, I have the side panels set to Auto Hide so I have to click to show the

panels, but when I've finished using them, they automatically hide again. I leave the Filmstrip on Manual so that it remains in view unless I choose to hide it.

Filmstrip

The bottom panel is called the Filmstrip. It shows thumbnails of the photos in your current view, which makes them accessible from the other modules. If you find that the Filmstrip thumbnails become too cluttered with icons, you can change the visible information using the Preferences dialog > Interface tab, or the right-click menu > View Options. To change the size of the thumbnails, drag the top of the Filmstrip to enlarge it. If you right-click on that edge, the context-sensitive menu will even show you preset Filmstrip thumbnail sizes.

Along the top of the Filmstrip are other useful tools. The Secondary Display icons are on the left (a) followed by a Grid view button (b). The Forward and Back buttons (c) step backwards and forwards through recent sources, like your web browser buttons. For example, it will remember each time you switch between different folders.

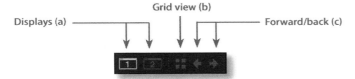

The breadcrumb bar lists additional information about your current view. It shows whether you're viewing a folder or a collection (d), the folder or collection name (e), the number of photos that are currently visible and aren't hidden by a filter or collapsed stack (f), the total number of photos in that folder/collection (g), the number of photos selected (h), and finally the name of the currently selected photo (i).

Clicking on that breadcrumb bar shows a list of your recent folders or collections, so you can easily skip back to a recent view, and it allows you to add favorite folders/collections that you visit regularly.

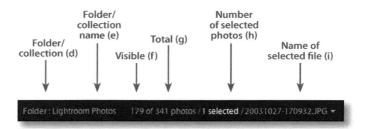

At the other end of the Filmstrip are the Quick Filters. They give easy access to basic filtering without having to switch back to Grid view. We'll come back to filtering in the Library chapter, but to toggle between the compact and expanded views, click the word Filter, and to disable the filters temporarily, toggle the switch on the right.

PREVIEW AREA

In the centre of the window is the main work area which shows the photo(s) that you're currently working on. In the Library module, that can be a Grid, Compare or Survey view with multiple photos, or a large Loupe view of the whole photo. We'll come back to those view options in the Viewing & Comparing Photos section. In the Develop module it shows a high quality preview of your photo, and in the other modules the main preview area shows the output layout you're working on, such as book pages, slides, print packages or web gallery previews.

By default, the background surrounding the photo is mid-grey, however you can change that to white, black, or other shades of grey. Go to Lightroom's Preferences dialog > Interface tab, or right-click on that grey surround and select an alternative shade from the context-sensitive menu.

Also check...

"Viewing & Comparing Photos" section starting on page 161

Toolbar

Beneath the main work area, or preview area, you'll see the toolbar. If it ever goes missing, press the T key on your keyboard or select View menu > Show Toolbar. The options that are available on this toolbar change depending on your current module or view, but if you click the arrow at the right hand end, you can choose to show different tools. In the Grid view, the available options are Grid view (a), Loupe view (b), Compare view (c), Survey view (d), Painter tool (e), sort order (f), flags (g), star ratings (h), color labels (i), rotation (j), navigation arrows (k), impromptu slideshow (l), thumbnail size slider (m) and finally the arrow which allows you to change the toolbar buttons (n).

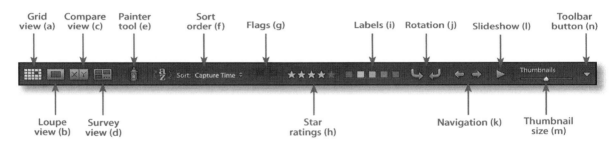

Grid View & Filter Bar

If you press the Grid view button on the toolbar, or press the G key, you'll switch to Grid view. The Grid is made up of thumbnails, which we'll dissect in a moment. You change the thumbnail size using the slider on the toolbar or the = (or +) and—keys on your keyboard.

At the top of the Grid view is the Filter bar. We'll come back to the different filter options and their icons in the Library chapter, but if you can't see the Filter bar, press the \ key on your keyboard or select View menu > Show Filter Bar.

On the right of the Grid view is a scrollbar which allows you to scroll through the thumbnails. My favorite trick is to Ctrl-click (Windows) / Opt-click (Mac) anywhere on that scrollbar to scroll directly to that point.

Also check...

"*Sorting, Filtering &
Finding Photos*" section
starting on page 223

It's much quicker than having to scroll a line at a time and get dizzy watching the thumbnails pass before you!

Loupe View, Info Overlay & Status Overlay

If you press the Loupe button on the toolbar, or press the E key, you'll switch to Loupe view, which allows you to see a larger preview of your photo. In the top left corner of the preview you can show the Info Overlay (a), which gives information about that selected photo. If you go to View menu > View Options, you can change the information that is shown in each of the two Info Overlays, and then you can cycle through them using the I key.

Info overlay (a)

Status overlay (b)

The Status Overlay (b) appears whenever you use a keyboard shortcut to apply a setting, such as 'Set Rating to 3,' but it also appears when Lightroom is loading or rendering previews. If you find that Loading overlay distracting, you can turn it off in View menu > View Options. I always leave it turned off in the Develop module, as you can start working on the photo long before it's finished loading.

Zooming using the Navigator panel

Along the top of the Navigator panel are the zoom options. The standard view is the Fit view which fits the whole photo within the preview area.

Fill view fills the entire width or height, hiding some of the photo, but personally I haven't found a good use for it yet. 1:1 is a 100% view, and the final option is a pop-up menu which allows you to switch through other zoom ratios. And yes, that last 11:1 option is a This is Spinal Tap movie reference!

You can change the zoom ratio by clicking on those buttons on the Navigator panel, by clicking on the photo itself, or by using the keyboard shortcuts. Spacebar switches between your two most recent zoom settings, so to switch between Fit and 3:1, you'd click on Fit and

then 3:1, and they would then be set as your Spacebar zoom ratios. The Z key does the same, except if you're in Grid view, it will toggle between Grid view and a 1:1 or greater zoom.

In Compare, Loupe or Develop, clicking directly onto the photo toggles between your two most recent zoom settings. Ctrl + and Ctrl— (Windows) / Cmd + and Cmd—(Mac) will step through each of the four main zoom ratios and adding the Alt (Windows) / Opt (Mac) key to those shortcuts zooms through each of the smaller zoom ratios as well.

Once you've zoomed in to the photo, the cursor will become a hand tool and you can drag the photo around to view different areas, also known as panning. You can also move the selection box on the Navigator preview.

THUMBNAILS

In the Grid View and Filmstrip, the thumbnails of the photos are contained within cells which hold additional information about the photos. There are 3 varieties of cell, which you cycle through using the J

key or View menu > Grid View Style. First is a very minimal view showing the thumbnail without any other distractions, then a compact cell view showing the icons and some file information, and also an expanded cell view showing additional lines of information.

If you go to View menu > View Options, you can choose the information you want to show, and the view of the thumbnails will update in the background as you test various combinations of settings.

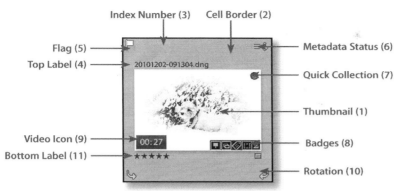

Index Number (3) Cell Border (2)

Flag (5)
Top Label (4) — 20101202-091304.dng

Metadata Status (6)

Quick Collection (7)

Thumbnail (1)

Video Icon (9) — 00:27
Bottom Label (11) — ★★★★★

Badges (8)

Rotation (10)

Also check...

"What's the difference between the selection shades of grey?" on page 158

Thumbnail (1)

When you need to drag a photo, perhaps to another folder or collection, click on the thumbnail itself rather than the cell border surrounding it.

Cell Border (2)

The cell border or matte surrounds the thumbnails, and clicking on that border is a quick way of deselecting all of the other photos. The color of the cell border changes through 3 different shades of grey, depending on the level of selection, and we'll come back to that in more detail in the next section. You can also tint the cell border with the label color, which makes them easy to see at a glance. You'll find that option under View menu > View Options.

Index Number (3)

The index number is relative to the current view, so if you have 230 photos in your current folder, the first will be marked as 1 and the last as 230. It's encouraging when you're developing your photos, to see that you've already done 178 out of 230!

Top Label (4)

On the cell border you can also add file information, which we mentioned in the introduction to this section. By default, the top label is turned off, but if you go to View menu > View Options, you can turn it on

 Also check...

"Is it possible to view flag/rating/color labels status when in other modules?" on page 193 and "How do I filter my photos to show... just one flag/ color label/rating?" on page 229

 Also check...

"Lightroom thinks my photos are missing—how do I fix it?" on page 240 and "Lightroom appears to be corrupting my photos—how do I stop it?" on page 134

and assign the information you want to show on each cell. File Name is the default, and often the most useful, but you can also set it to other EXIF data such as the camera settings. If you switch to the Expanded Cells, there are additional lines for file information.

Flag (5)

The flags can be in one of 3 states—flagged, unflagged, and rejected. We'll come back to the use of flags in the Library chapter.

Metadata Status Icon (6)

Lightroom primarily stores your image metadata in your catalog, but it's also possible to store it in XMP with the files too. We'll come back to XMP in the Working with Catalogs chapter.

The Metadata Status icons keep you informed of the status of the external files, and whether the metadata in those external files matches the catalog or not.

 Lightroom is checking the previews are current, rendering new previews, or waiting for a better quality thumbnail to load.

 The file is missing or is not where Lightroom is expecting, so click the icon to locate the missing file. More on that in the Library chapter.

 The file is damaged or cannot be read, likely as a result of file corruption, which we discussed in the Import chapter.

If you have Unsaved Metadata icons turned on in View menu > View Options, you may also see additional metadata icons. These show the result of checking the file against any XMP data in the files or sidecars.

 Lightroom's catalog has updated metadata which hasn't been written to XMP. Click the icon to write to XMP.

 Metadata in the file has been updated by another program and is newer than Lightroom's catalog. Click the icon to read from XMP.

 Metadata conflict—both the XMP data in the file and Lightroom's catalog have been changed. Click the icon to choose whether to accept Lightroom's version or the XMP version.

 Also check...

"XMP" section starting on page 320

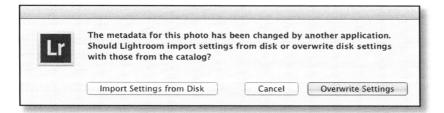

Quick Collection Marker (7)

The Quick Collection is a way of temporarily grouping photos, but if you accidentally hit the circular Quick Collection marker regularly, you can turn it off in the View Options. More detail about that in the Library chapter.

Badges (8)

Badges give additional information about the settings you've applied to the photo within Lightroom. From left to right, they show:

There is a Map Location for this photo.

This photo is in at least one collection—clicking will show a list of the collections containing that photo.

Keywords have been applied to this photo—clicking will open the Keywording panel.

A crop has been applied to this photo—clicking will go to Crop mode.

 Also check...

"What are the Quick Collection and Target Collection?" on page 186

Also check...

"Managing & Editing Videos" section starting on page 218 and "How do I use the Painter tool to quickly add metadata?" on page 192

Develop changes have been applied—clicking will to go to the Develop module.

Video Icon (9)

The video icon shows the length of the video, and as you move your cursor horizontally across the thumbnail, it scrubs through the video, showing you the content.

Rotation (10)

The rotation icons rotate your photo when you click on them. If you have lots of photos to rotate, it's often quicker to use the Painter tool as you don't have to hit an exact spot, so we'll come back to that in the Library chapter.

Bottom Label (11)

Like the earlier top label, you can adjust the file information shown in the bottom label. By default, the bottom label shows the star ratings and color labels, and you can click on those ratings and labels to change them. Right-clicking on those labels allows you to change the file information shown, without going back to the View Options dialog.

SELECTIONS

To work on photos in Lightroom, you have to first click on the photos to select them. Selections in Lightroom catch most people out at some stage, because there are multiple levels of selection, rather than simply selected or not selected.

What's the difference between the selection shades of grey?

When you select photos in Lightroom's Grid view or in the Filmstrip, you'll notice that there are 3 different shades of grey. Because Lightroom

allows you to synchronize settings across multiple photos, there needs to be a way of choosing the source of the settings as well as the target photos, so Lightroom has 3 levels of selection, rather than 2—or 2 levels of selection plus a deselected state, depending on how you look at it.

The lightest shade of grey is the active, or most-selected, photo. If you're synchronizing settings across multiple photos, Lightroom will take the settings from that active photo and apply it to the others.

The mid grey is also selected, but is not the active photo. If you're synchronizing settings across multiple photos, Lightroom will apply the settings to those photos.

The darkest shade of grey isn't selected.

Why don't the rest of my photos deselect when I click on a single photo?

The key to deselecting photos is knowing where to click. Clicking on the thumbnail itself will retain your current selection and make that the active photo, leaving the others selected too. Clicking on the cell border surrounding the thumbnail will deselect all other photos, just leaving that photo selected. If you prefer keyboard shortcuts, Ctrl-D (Windows) / Cmd-D (Mac) will deselect all of the photos.

How do I select multiple photos?

To select non-contiguous photos—ones that aren't grouped together—click the first photo and then hold down the Ctrl key (Windows) / Cmd

key (Mac) while clicking on the other photos. If you want to select contiguous or sequential photos, click on the first photo, but this time hold down the Shift key while you click on the last photo, and all of the photos in between will also be selected.

I have multiple photos selected—why is my action only applying to a single photo?

If you're in Grid view on the primary window, actions will apply to all selected photos, however in any other mode or module, for example, Loupe view, Survey view, Develop module, etc., most actions will only apply to the active (most-selected) photo by default. Why, you may ask? If you're viewing a single photo and the Filmstrip is hidden, it's easy to forget how many photos are selected, and applying a setting to all of them could spoil hours of work.

Of course, with every rule, there are always exceptions, and on this occasion the main exception is the right-click context-sensitive menu on the Filmstrip or Secondary Display Grid view, which applies the menu selection to all selected photos regardless of other settings (because you're obviously looking at multiple photos), and also a few commands such as Export which export all selected photos regardless of your current view.

You can change the global behavior by turning on Auto Sync under the Metadata menu, which will cause any actions to apply to all selected photos regardless of the current view.

Also check...

"Secondary Display" section starting on page 168

How does Auto Sync work?

There are 2 separate Auto Sync toggle switches—one under the Library module > Metadata menu and one under Develop module > Settings menu, and they both also appear as switches on the Sync buttons at the bottom of the right-hand panel groups when multiple photos are selected. The Library switch applies to metadata actions—assigning keywords, flags, labels, etc.—regardless of which module you're viewing,

whereas the Develop switch applies only to Develop changes made in the Develop module.

In the previous question, we said that actions only usually apply to the active (most-selected) photo except in Grid view, however Auto Sync breaks that rule. When Auto Sync is enabled, your actions apply to all selected photos. Use it with caution if you work with the Filmstrip hidden, as you may not realize you have multiple photos selected. Auto Sync is one of my personal favorites, however I do recommend picking a setting and sticking with it, rather than turning it on and off, as it's easy to forget which behavior is currently selected.

Also check...

"How do I copy or synchronize my settings with other photos?" on page 388

VIEWING & COMPARING PHOTOS

Lightroom offers a number of different ways of viewing your photos in the Library module, where you'll do most of your browsing and management.

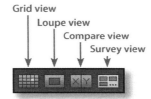

Grid view
Loupe view
Compare view
Survey view

Grid View

Much of the work you'll do in Lightroom will be in the Grid view, which can be accessed using the Grid icon on the toolbar, by pressing the G key on your keyboard, or via the View menu.

Anything you do in Grid view, such as adding star ratings or keywords, applies to all of the selected photos, whereas other views only affect the active or most-selected photo. There are, of course, exceptions which we mentioned in the previous section.

You can drag and drop photos around, changing the sort order or drag them onto other folders, collections or keywords. To do so, you have to pick them up by the thumbnail itself and not the border surrounding it. Remember, the cell border only affects selections.

The thumbnail size is changed using the slider on the toolbar, or using the + (or =) and—keys on your keyboard. As the thumbnails get smaller,

the badges and other information become more distracting, so you may want to hide these by pressing the J key once or twice.

Compare View

When you start sorting through your photos, you'll need to view them in greater detail and compare them to choose your favorites.

The Compare view allows you to view 2 photos at the same time. The C key, or Compare view icon on the toolbar, will take you into the Compare view. First you select two photos, and the active or most-selected photo becomes the Select, marked with a white diamond icon, and the other becomes the Candidate, marked with the black diamond icon. I always struggle to remember which is which, but 'white for good and black for bad' is a handy memory prompt.

The Select on the left is fixed in place, and as you select different photos, the Candidate on the right changes. When you find one you like better than the current Select, you can press the XY buttons on the

toolbar to switch them round, making the other photo your new Select.

Imagine you have a series of 5 similar photos, and you want to pick the best one. You start out with number 1 as the Select and number 2 as the Candidate. You decide you don't like number 2, so you move to the next photo by pressing the right arrow key. You're now comparing photos 1 and 3, and you decide you like 3 better, so you press the X<Y button to make number 3 the new Select. You compare that against number 4, but you still like 3 better, so you press the

right arrow key to compare 3 and 5. In the end, number 3 is your favorite, so you mark it with a star rating.

The Compare view, unlike Survey view, also allows you to zoom in on one or both photos at the same time. The Zoom Lock icon is particularly useful when you need to check focus on similar photos, or perhaps whether all of the people in a group photo have their eyes open. If both photos are identically aligned, you can click the lock before zooming, and as you pan around the photo, both photos will pan. If they're not aligned, zoom in first and match up the alignment and then lock the position, so that the positioning follows you on both photos. With the lock unlocked, they pan and zoom independently.

Survey View

Survey view allows you to view numerous photos in one go, perhaps comparing for composition. When you click the Survey button, or the N key, the selected photos are added to the Survey view. Most of the shortcuts use quite logical letters, but there isn't even an N in the word 'survey.' As an interesting piece of trivia, and easier way of remembering the N shortcut, this view was initially called N-Up while it was being developed, which is where the shortcut originated. When you hover over a photo, the rating/flag/label icons appear, along with an X icon which removes the photo from the selection and the Survey view.

Loupe View

The Loupe view shows you a full preview of your photo, and allows you to zoom in on the photo to check the detail. We'll come back to preview quality and size in the Previews & Speed chapter.

Lights Out

Lightroom offers a couple of distraction-free viewing modes, called Lights Dimmed and Lights Out. They dim or black out the interface around the photo, allowing you to focus solely on the selected photos

Also check...

"Previews & Speed"
chapter starting
on page 333

in the preview area. To cycle through the Lights Out modes, press the L key on your keyboard. You can adjust the color and dim level in the Preferences dialog under the Interface tab.

WORKING WITH SLIDERS & PANEL ICONS

Within the right hand panels are sliders and buttons. Moving sliders, pressing buttons and selecting presets from pop-up menus are all quite obvious actions, but there are a few other tips and tricks which can save some time.

Moving Sliders

The obvious thing to do with a slider is to grab the marker and move it, and of course that works, but there are also other options which may suit your workflow better.

If you like dragging sliders, but find it difficult to make fine adjustments, drag the edge of the panel to make the panel wider. It will make the sliders longer and easier to adjust.

Scrubby sliders, such as those used in Photoshop, also work in Lightroom. As you float over the numeric value field at the end of the slider, the cursor changes to a hand with a double arrow, and clicking and dragging to the left or right moves the slider.

While we're looking at the numeric value fields, you can click directly in one of those fields and either type the number that you're aiming for, or use the up/down arrow keys to move in smaller increments. If you've activated a field to type directly, don't forget to hit Enter or click elsewhere to complete your adjustment.

Also check...

"Working with Sliders & Targeted Adjustment Tool" section starting on page 378

There are other shortcuts which are specific to the Develop module, such as floating over the slider and using the up/down arrow keys to move it, but we'll come back to those in more detail in the Develop chapter.

Resetting Sliders

We'll come back to resetting sliders to their defaults in the Develop chapter too, as that's the primary place it applies, but in short, to reset a single slider, you can double-click on the slider label. Within many panels, you'll also find a panel label, such as Tone in the screenshot, and double-clicking or Alt-clicking (Windows) / Opt-clicking (Mac) on that label resets that whole panel section.

Finally, if you want to reset all of the Develop settings on a photo, there's a large Reset button at the bottom of the right hand panel in the Develop module, in the Quick Develop panel in the Library panel, and in the right-click menus too.

Disclosure Triangles

The little triangles that appear in various places in Lightroom's interface are officially called Disclosure Triangles. When you click on them, they toggle to show or hide parts of the interface, such as sliders, buttons, folders, etc.

You'll also find those triangles in the Folders, Collections, Publish Services and Keyword List panels, where they have two different styles.

The solid arrows indicates that the folder, collection or keyword has subfolders and those marked with opaque arrows don't have any subfolders.

Panel Switches

On the end of some panel headers in the Develop module, such as the Tone Curve panel, there's a toggle switch. That toggle temporarily enables or disables the sliders in that section, so you can preview the

Also check...

"How do I reset a single slider or panel section to its default setting?" on page 421

photo with and without the effect of those panel sliders. You'll also find the toggle switch at the bottom of the Adjustment Brush and other tool options panels, which enable and disable your Local Adjustments.

WORKING WITH DIALOGS

Besides the Presets and Template Browser panels in the Develop, Book, Slideshow, Print and Web modules, Lightroom also uses pop-up menus to allow you to save settings as presets. You'll find them in dialogs, such as the Filename Template Editor dialog used when renaming photos, and also in the small pop-up menus, such as the Presets pop-up at the bottom of the Import dialog.

Saving Presets in Pop-Up Menus

To save a preset using one of those pop-up menus, select your new settings and then choose Save Current Settings as New Preset at the bottom of the pop-up menu. Give it a name, press OK, and your new preset will appear in the pop-up menu.

Renaming, Updating and Deleting Presets in Pop-Up Menus

To edit an existing preset, you first have to select that preset in the pop-up menu. The Delete and Rename options appear at the bottom of the menu, and obviously delete or rename that selected preset.

If you want to update an existing preset, for example, in the Watermarking dialog, you first have to select that preset in the pop-up menu and then edit it. Once you've done so, the pop-up

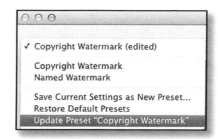

menu will show (Edited) next to the preset name, and Update Preset will appear in the menu.

Using Tokens in Dialogs

In many of Lightroom's dialogs, such as the Filename Template Editor dialog, you'll find tokens which look like small blue lozenges on the Mac version, but are only text surrounded by curly brackets on the Windows version.

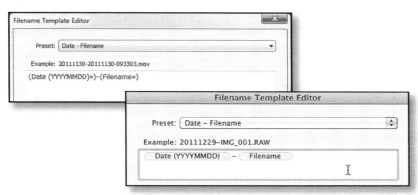

You use these tokens to build filenames or other text directly from the photo's metadata, rather than typing fixed text. For example, if you combine the Date (YYYY) Date (MM) and Date (DD) tokens, it will take the Capture Date from the file, resulting in 20120305 for 5th March 2012. You can use the Delete key to delete them as if they were text, and on the Mac version you can also drag and drop those tokens around to change the order.

You can type additional fixed text between those tokens, for example, you can add hyphens, resulting in 2012-03-05. If you're going to add custom text which will change each time you rename, use the Custom Text token and then add the custom text in the main dialog, rather than entering it directly into the Filename Template Editor dialog, otherwise you'll have to keep editing the template each time you need to change the text.

SECONDARY DISPLAY

When many users think of using dual monitors, they think of Photoshop and tear off panels. Lightroom's current Secondary Display options don't allow you to tear off panels, but they do allow you to display the photos on a secondary display, whether that's on a second monitor or just another floating window on the same monitor.

The Display controls are at the top of the Filmstrip on the left. Depending on your current full screen settings, the Secondary Display icon will either be a second monitor or a window icon.

A single click on the Secondary Display icon turns that display on or off, and a long click or right-click on each icon shows a context-sensitive menu with the View Options for that display. These options are also available via the Window menu > Secondary Display.

Which views are available on the Secondary Display? How are they useful?

The Secondary Display offers a few different view options.

Grid is particularly useful for gaining an overview and context of all of the photos whilst working on a single photo in Develop module, or for selecting photos for use in one of the output modules. You can only have a Grid view on one display at a time.

Normal Loupe shows a large view of the photo currently selected on the main screen.

Live Loupe shows the photo currently under the cursor, and updates live as you float the mouse across different photos.

Locked Loupe fixes your chosen photo to the Loupe view, which is particularly useful as a point of comparison or reference photo.

Compare is the usual Compare view, but allows you to select and rearrange the photos in Grid view on the main screen while viewing Compare view on the secondary display.

Survey is the usual Survey view, but allows you to select and rearrange the photos in Grid view on the main screen while viewing Survey view on the secondary display.

Slideshow is only available when the Secondary Display is in Full Screen mode, where it runs a slideshow of the current folder or collection, while you carry on working on the main screen. Just be aware that if you switch folder/collection on the main screen, the secondary slideshow will also follow the change.

If you're using Loupe, Compare or Survey at the same time as the Grid, it's usually better to switch the displays so that the Grid is on the Secondary Display. This is because there's no way of assigning a flag, rating or label to a single photo on the Secondary Display when multiple photos are selected in Grid on the Primary.

Why do shortcuts and menu commands only apply to a single photo even though I have multiple photos selected on the Secondary Display Grid?

Lightroom doesn't know which screen you're looking at when you press a keyboard shortcut or menu command. For that reason, it always assumes that you're looking at the Primary Display. Any shortcuts or menu commands will apply to the photo(s) shown on the Primary

Also check...

"I have multiple photos selected—why is my action only applying to a single photo?" on page 160 and "How does Auto Sync work?" on page 160

Display, unless you have Metadata menu > Auto Sync turned on, in which case it will apply to all selected photos.

The exception is the context-sensitive menu command on Grid on the Secondary Display, because if you've just clicked on the Secondary Display, you're obviously looking at it, and you realize that multiple photos are selected. That same principle doesn't work in Compare or Survey on the Secondary Display.

Why does the Secondary Display switch from Grid to Loupe when I change the Main Screen to Grid?

Grid view can only be open on one display at a time for performance reasons. If you already have Grid view open on one display, and you switch the other display to Grid view, the first display will automatically switch views.

What does 'Show Second Monitor Preview' do?

If the Secondary Display is in full screen mode, there's an additional option available—Show Second Monitor Preview. If your second

monitor is facing away from you, for example, facing a client on the opposite side of the table, you can view and control what they see without repeatedly running round to the other side of the table. The pop-up menu in the top left corner controls the current view.

How do I move the Library Filter bar to the Secondary Display?

If you have the Grid view open on the Secondary Display, the shortcut Shift-\ or Window menu > Secondary Display > Show Filter View will

move the Library Filter bar to the top of the Grid view on the Secondary Display.

FREQUENT WORKSPACE QUESTIONS

Many of the answers to the following questions are covered in the previous pages, but they're asked so often on the forums, I had to include them separately too.

My toolbar's disappeared—where's it gone?

If your toolbar disappears, press T—you've hidden it!

How do I stop the panels opening every time I float near the edge of the screen?

To stop the panels automatically opening, right-click on the outside black edge strip of each panel and choose Manual or Auto Hide.

Where have my panels gone?

Press Tab to hide the side panels, Shift-Tab to hide all of the panels, and repeat to bring them back. Alternatively, clicking on the black outer edge strip of each panel controls the individual panel groups. If only a single panel has gone missing, you may have deselected it. Right-click on another panel header to show the context-sensitive menu and put a checkmark against the name of the missing panel.

Can I detach the panels and rearrange them?

The panels aren't detachable, but you can hide panels you don't use by right-clicking on the panel header and unchecking the panels you don't want to see.

Also check...

"Sorting, Filtering & Finding Photos" section starting on page 223

Also check...

"Panel Groups & Panels" on page 146

Also check...

"Panel Groups & Panels" on page 146

The alternative to consider is Solo Mode, which you'll find in the panel header right-click menu. It closes one panel as you open another, keeping just one panel per side open at any time. You can show multiple panels while in Solo Mode by Shift-clicking on each panel to open it.

My eyesight isn't very good—can I change Lightroom's UI?

If your eyesight is no longer as good as it used to be, Lightroom's grey-on-grey interface may be difficult to see. It's not possible to change Lightroom's UI colors, other than the background of the area around the photos. In the Preferences dialog > Interface tab you can enlarge the font size, but even the large setting is not that big. You can, however, use Jeffrey's Configuration Manager (http://www.lrq.me/friedl-config) to change the font and font size. There are limits to the font sizes you can reasonably use, as some areas such as the Folders panel lines are a fixed size. One thing that may help, however, is setting a bold font, which increases the contrast between the text and background slightly further.

Where have the Minimize, Maximize and Close Window buttons gone?

If you can't see the standard window buttons, you're in Full Screen mode. Press the F key once or twice to get back to your normal view.

It's all gone black! How do I change the view back to normal?

If everything goes black or dimmed apart from the photos, then you're in Lights Out mode. Press the L key once or twice until it reverts to normal view.

I can see Badges in Grid view, but not in my Filmstrip. Where have they gone?

Ensure Show badges in Filmstrip is turned on in Preferences dialog > Interface tab, and if they still don't appear, enlarge your Filmstrip by

dragging the top edge of the Filmstrip, because the badges disappear when the thumbnails become too small to fit 3 full badges along the long edge.

Also check...

"Badges (8)" on page 157

How do I turn off the overlay which says Loading?

Go to View menu > View Options > Loupe Info tab and uncheck 'Show message when loading or rendering photos' if you find the overlay distracting. There are separate settings for the Library and Develop modules, so make sure you have your intended module open before visiting the View Options dialog.

Is it possible to see camera setting information while in Develop module, rather than constantly switching back to the Metadata panel?

Just under the Histogram is basic information about your camera settings, which are visible any time that your mouse isn't hovering over the photo itself.

Additional information can be shown in the Info Overlay, which you toggle using the I key, or selecting View menu > Loupe

Also check...

"Process Versions"
section starting
on page 356

Info > Show Info Overlay. You can select the information shown in the Info Overlay using the View menu > View Options dialog.

Why is there an exclamation mark near the preview in the Develop Module?

The exclamation mark to the lower right of the preview shows that you're using the old Process Version 2003 or 2010 from earlier Lightroom or ACR versions, and you're not taking advantage of the new Develop improvements. If you click on that icon, the process version is updated to the newest rendering. Your photo may visibly change, and you can then adjust the sliders to taste. We'll come back to Process Versions in the Develop chapter.

How do I bring back the warning dialogs I've hidden?

If you've hidden some of the dialogs by checking the Don't Show Again checkbox, you can bring them back by pressing the Reset all warning dialogs button in the Preferences dialog > General tab.

Why won't Lightroom show a dialog, such as the Export dialog?

When using dual monitors, Lightroom remembers which monitor you last used to display each dialog. If you then unplug one of those monitors, Lightroom may still try to show the dialog on the detached monitor, resulting in an error beep when you try to press anything else. To solve it, press Escape to close the imaginary dialog, and either plug the second monitor back so you can see the dialog to move it back, or delete the Preferences file, which will reset the dialog locations along with the other settings. The location of the Preferences file is listed in the Useful Information chapter.

Also check...

"How do I delete the
Preferences file?"
on page 651

Library Module

Having imported and viewed your photos, it's time to start managing them—organizing them into groups, sorting through them and choosing your favorites, adding metadata to describe the photos, and then later going back to find specific photos using various filtering options.

FOLDERS

Let's start with managing the files on your hard drive. The folders in the Folders panel are references to folders on your hard drive or optical discs, so when you import photos into Lightroom, the folders containing those photos are automatically added to the Folders panel ready to browse.

Anything you do in Lightroom's Folders panel will be reflected on the hard drive. For example, creating, renaming or deleting folders in Lightroom does the same on your hard drive. You can drag photos and folders around to reorganize them, just like you would in your file browser. The opposite doesn't work in the same way—when you rename or delete a file or folder on your hard drive, Lightroom will simply mark it as missing rather than deleting it automatically, otherwise you could accidentally lose all of your settings.

Also check...

"Lightroom thinks my photos are missing—how do I fix it?" on page 240

Also check...

"Renaming, Moving & Deleting" section starting on page 196

We'll come back to moving, renaming and deleting the photos themselves later in the chapter, along with how to deal with missing photos, but for the moment, let's concentrate on the Folders panel.

Can I change the way the folders are displayed?

The Folders panel is divided into Volume Bars for each volume (drive) attached to your computer, whether they're internal or external hard drives, network attached storage, or optical drives. Although the disclosure triangle is shown on the right, clicking anywhere on a Volume Bar will expand it to show the folders contained in that drive.

Each of those Volume Bars can give you additional information about the drive—how many imported photos are on each volume, whether it's online or offline, and how much space is used or available. You can choose which information to show by right-clicking on the Volume Bar.

The colored rectangle on the left shows the drive space available:

Green = drive online with space available

Yellow = drive online but getting low on space

Orange = drive online but very low on space

Red = drive online but full

Black = drive offline (and volume name becomes darkened)

While you're exploring the Folders panel view options, clicking on the Folders panel + button also gives additional path view options for the root folders.

For example, this folder is LIGHTROOM QUEEN/Lightroom Photos/2003. Depending on the option you choose, that can be shown as:

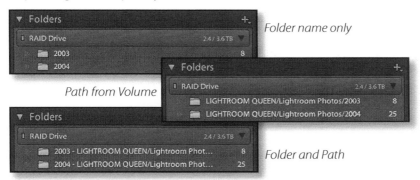

Folder name only

Path from Volume

Folder and Path

Why does my folder say it contains 0 photos? Or, can I view the photos directly in the folder, instead of a composite view of its subfolders?

Lightroom can show either the content of individual folders, or it can show a composite view of all of the photos in the selected folder and its subfolders. In many situations, it's useful to see a composite view of the subfolder contents, but there are certain restrictions—you can't apply a custom sort (user order) or stack photos across multiple folders in a composite view.

By default, Show Photos in Subfolders is turned on, showing a composite view. The folder counts are also affected by that setting, showing either the composite count, or the number of photos directly in each folder. If you've been used to seeing a composite photo count, it can be confusing if the folder counts suddenly change to 0, but it doesn't necessarily mean that your photos have gone missing. You can toggle that setting by going to Library menu > Show Photos in Subfolders and checking or unchecking it. You'll find the same option in the Folders panel menu, accessed via the + button.

I have a long list of folders—can I change it to show the folder hierarchy?

Depending on your Import dialog settings, the folders may be in one long list regardless of their hierarchy on the hard drive. That can make them hard to find and relocate if they're ever marked as missing.

As a preventative measure, you can configure Lightroom to show a few top level folders, with subfolders below. If Lightroom ever loses track of your photos, perhaps as a result of a hard drive failure or the drive letter changing, you'll only need to relink the top level folders and that will cascade through the rest. It also makes it easier to visualize where the photos are stored on your hard drive.

So how do we go from this slightly nondescript tangle of folders on the left… to the tidy hierarchy on the right…?

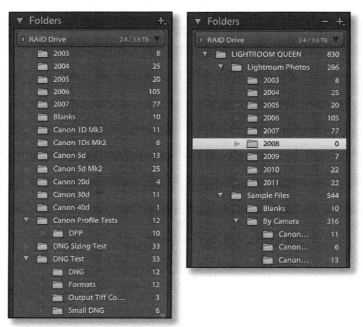

Right-click on the current top level folder and select Show Parent Folder. This doesn't import new photos—it just adds an additional hierarchy level to your Folders panel, and does a lot more behind the scenes.

Keep repeating that process on each top level folder until it shows your chosen parent folder.

The top level folders are those without a parent folder, so in this screenshot, they are 'Lightroom Photos' and 'Sample Files' and all of the others are subfolders.

If you go too far and want to remove a top level folder, right-click on that folder and choose Hide This Parent. It does the opposite of Show Parent Folder, and will ask for confirmation before removing that top level folder from your Folders panel, as there may be photos directly in that folder that would be removed from the catalog.

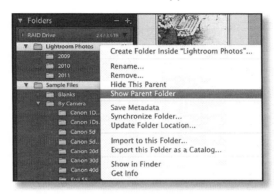

Why aren't 'Show Parent Folder' and 'Hide This Parent' showing in my context-sensitive menu?

If the Show Parent Folder and Hide This Parent (formerly called Add Parent Folder and Promote Subfolders) options don't appear in the menu, you're right-clicking on the wrong folder. You have to right-click on the top level folder, rather than a subfolder or Volume Bar, for those options to appear. In the screenshot, you would need to right-click on the folder 'Lightroom Photos' instead of '2009', and 'Sample Files' instead of 'Blanks.'

Why are some folders not slotting into their correct place in the hierarchy?

Depending on how the photos are imported, folders may end up showing as top-level folders in the Folders panel, rather than slotting

Also check...

"Disclosure Triangles" on page 165, "How does Export as Catalog work?" on page 305 and "Are there any limitations when importing and exporting catalogs?" on page 308

into their correct place in the hierarchy. In most cases, following the instructions for showing the folder hierarchy on the previous pages will correct that.

How do I expand or collapse all of a folder's subfolders in one go?

If you want to open or close all of the subfolders in one go, you can Alt-click (Windows) / Opt-click (Mac) on the parent folder's disclosure triangle.

If you find your subfolders appear to have a mind of their own and are automatically opening themselves when you open your Lightroom catalog or move photos between folders, and the previous trick doesn't solve it, there's one more thing to try—select everything and export it all to a new catalog. The odd behavior usually gets left behind in the process, however there are some disadvantages to using Export as Catalog, for example, Publish Services data is not transferred by default.

How do I find out where a photo is stored on my hard drive?

If you ever need to find a photo on the hard drive, for example, to open in another program, you can right-click on a single photo and the context-sensitive menu will give you the choice of Go to Folder in Library, which selects the folder in the Folders panel, or Show in Explorer (Windows) / Show in Finder (Mac).

How do I move folders into other folders or drives?

Moving folders in previous versions of Lightroom was time-consuming because you could only move one folder (and its subfolders) at a time. Lightroom 4 has taken a huge leap forward in efficiency—you can now select multiple folders and drag them into another folder in one go. Ctrl-click (Windows) / Cmd-click (Mac) or Shift-click to select the folders, and then simply drag and drop.

You do need the destination folder showing in the Folders panel, so if it's not listed you'll need to add it using Library menu > New Folder.

I've added new photos to one of Lightroom's folders—why don't they show in my catalog?

Lightroom doesn't perform live checking against all of your folders for performance reasons. If you import a folder into Lightroom's catalog and then later add additional photos to that folder using other software, Lightroom won't know about those additional photos until you choose to import them.

If you go back to the Import dialog and import that folder again, Lightroom will just import the new photos, skipping the existing ones. Alternatively, you can use the Synchronize Folder command in the folder's context-sensitive menu. If you choose to use Synchronize, only check the Import New Photos checkbox and leave the Remove missing photos from catalog and Scan for metadata updates checkboxes unchecked.

How does the Synchronize Folder command work?

If you right-click on a folder and choose Synchronize Folder from the context-sensitive menu, it gives you a few different options, but be careful as they can cause trouble! Its main purpose is to update Lightroom's catalog with changes made to that folder by other programs, for example, adding or deleting photos or updating the metadata.

First, it searches the folder and subfolders for any new photos not currently in this catalog and asks you if you want to import them. If you've dropped photos into the folder using other software, it saves you navigating to the folder in the Import dialog.

Synchronize Folder also checks for photos that have been moved, renamed or deleted from that folder and gives you the option to remove those missing photos from the catalog. Be very careful using that option

Also check...

"Lightroom thinks my photos are missing—how do I fix it?" on page 240 and "XMP" section starting on page 320

because any metadata for those photos, such as Develop settings and ratings would be lost, even if the photos have simply been moved to another location. When in doubt, leave that option unchecked, as we'll cover relinking missing photos later in the chapter. Synchronize doesn't do intelligent relinking at this point in time.

Scan for metadata updates checks the metadata in the catalog against the file, to see whether you've edited the file in any other programs, such as Bridge. If it's changed in another program, but not in Lightroom, Lightroom's catalog will be overwritten by the external metadata. If both Lightroom's catalog and the external file have changed, you'll see a Metadata Conflict badge, and you'll have to click on that icon to choose which set of data to keep—the metadata in your catalog or the metadata in the file. We'll come back to that XMP header section in more detail in the next chapter, including the use of the Metadata Conflict dialog.

The Show Missing Photos button searches for photos missing from that folder and creates a temporary collection in the Catalog panel. You can then decide whether to track them down and relink them, or whether to remove those photos from the catalog. If you want to check your entire catalog for missing photos, it's quicker to use the Library menu > Find Missing Photos command instead. Once you've finished with that temporary collection, you can right-click on it to remove it.

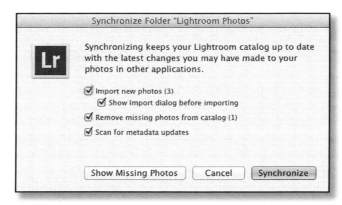

COLLECTIONS

Having found the photos on the hard drive, it's time to start organizing them. Remember, folders are primarily storage buckets. Lightroom offers other tools, such as collections and metadata, that are better suited to organizing your photos.

How are Collections different from Folders?

Collections are a way of grouping photos together without actually moving them on your hard drive, so a photo can belong to multiple collections at the same time, but still only be stored in one folder on your hard drive. For example, when you import photos into your catalog, they appear grouped in a Previous Import collection in the Catalog panel.

Collections aren't limited to containing photos—they store your chosen sort order, and they can also remember your filtering, depending on your preference setting. Special types of collection store Book, Slideshow, Print or Web module settings too.

Your collections can be organized into nested collection sets, just like folders. Collection sets can only contain collections or other collection sets, not photos.

Smart collections are saved search criteria, smart folders or rules, so we'll come back to those later with the filtering tools.

You can choose whether to sort the Collections panel by name or type, using the + button on the Collections panel to show the menu. Collections can easily be

Also check...

"Why does my filter disappear when I switch folders?" on page 225 and "Smart Collections" section starting on page 234

Collection set

Standard Collection

A Book

A Slideshow

A Print

A Web Gallery

Smart Collection

reselected at any time simply by clicking on them, and double-clicking on any module-specific (Book, Slideshow, Print or Web) collection will take you directly to that module too.

How are Books, Slideshows, Prints and Web Galleries different to standard collections?

In Lightroom 3 and earlier, any collection also automatically stored output module settings, so a standard collection could also remember Slideshow, Print and Web module settings.

In Lightroom 4, that's changed. Normal collections no longer store output module settings. Instead, you save an individual book, slideshow, print or web gallery, and they can't contain settings from other modules.

When you first enter an output module, you're viewing an unsaved book, unsaved slideshow, unsaved print, or unsaved web gallery, depending on the module. That's like a scratchpad, where you can play around with things without saving them.

When you want to keep something you've created, you save it as a book/slideshow/print/web gallery. These show up as separate items in the Collections panel, each with their own icon to identify the module. We'll go into more detail in each module's chapter.

How do I create a collection and add photos to it?

You can either create an empty collection by clicking on the + button on the Collections panel and choosing Create Collection and then add photos to that empty collection, or you can select the photos first and then create the collection with Include Selected Photos checked.

To add photos to a collection that you've already created, you just drag and drop them, making sure you pick up the photos by the middle of the thumbnail, rather than the cell border, otherwise you'll deselect them. If you prefer not to drag and drop, you can also select the photos,

right-click on the collection and choose Add Selected Photos to this Collection from the menu.

If you have a whole folder of photos that you'd like to turn into a collection, drag the folder from the Folders panel to the Collections panel. A collection with the same name will be created, containing all of the photos in the folder.

If you need to duplicate a collection, hold down the Alt key (Windows) / Opt key (Mac) and drag the collection within the Collections panel. The same shortcut works for smart collections and even whole collection sets.

Removing photos from a collection is as simple as hitting the Delete key. When you're viewing a collection, Delete only removes the photo from the collection, rather than from the catalog or hard drive.

How do I organize my collections into collection sets?

There's a notable difference between collections and collection sets. Collections can only usually contain photos and videos, whereas collection sets can contain collections or other collection sets but not the photos or videos themselves.

Those collection sets allow you to build a hierarchy of collections, just like you would with folders. For example, you may have a collection set called Vacations, and within that set, sets for each of your vacation destinations. Those vacation destinations might divide down further into sets for each year that you visited, and then individual collections for the long slideshow of all of your photos from each vacation, the web galleries you created to show your friends, and the book you created, and the individual pictures you printed.

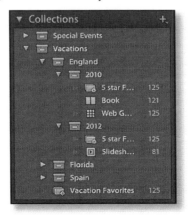

Also check...

"Smart Collections"
section starting
on page 234

You can also include smart collections inside your collection sets too, so you might have additional smart collections for all the 5 star photos, all of the photos of beaches, and so on. We'll come back to smart collections later in the chapter.

Standard collections can't contain other collections, with one exception. If you start with a standard collection, and then create a book, slideshow, print or web gallery, you can store it inside the first collection. That parent collection becomes a composite view of its children—books, slideshows, prints and web galleries. If you add a photo to one its children, it will appear in the parent collection. If you remove a photo from the parent collection, it will also be removed from any books/slideshows/prints/web galleries nested within.

What are the Quick Collection and Target Collection?

The Quick Collection is a special collection for temporarily holding photos of your choice, and it permanently lives in the Catalog panel along with other special collections (All Photographs, Previous Import, etc.). If you've added a group of photos to the Quick Collection and then you decide you would like to turn it into a permanent collection, you can right-click on it and select Save Quick Collection from the context-sensitive menu.

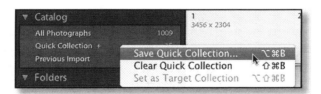

The Target Collection isn't a collection in its own right—it's just a shortcut linking to another collection. It's marked by a + symbol next to the collection name, and pressing the shortcut key B or clicking the little circle icon on the thumbnail will add to, or remove the photo from, that Target Collection. By default it's assigned to the Quick Collection, but you can change the Target Collection to the collection of your choice

by right-clicking on your chosen collection and choosing Set as Target Collection from that menu.

How do I see which collections a photo belongs to?

If you right-click on any photo and choose Go to Collection, it will show you a list of your collections containing that photo, or just clicking on the Collection badge in the corner of the photo will show the same list if you have badges showing on the thumbnails.

If you're checking a large number of photos, switch to Grid view and hover the cursor over the collections individually and all photos belonging to that collection will show a temporary thin white border around the thumbnail.

STACKING

Stacking is an alternative way of grouping photos in their folder. There are limits, for example, it only works for photos stored in the same folder or now also for photos grouped in a collection. It's useful for grouping similar photos such as 5 shots of same flower, bracketed shots, or original photos and their TIFF/PSD/JPEG derivatives. Once the photos are stacked, you can put your favorite photo on top of the stack and collapse the stack down, hiding the other photos underneath, to clear some of the visual clutter.

How do I stack photos?

To create a stack, select the photos and press Ctrl-G (Windows) / Cmd-G (Mac) or go to Photo menu > Stacking > Group into Stack. When you create a stack it immediately collapses, but you can open it up again by clicking on the stacking icon or pressing the S key.

To remove a photo from a stack, you can either ungroup the whole stack using Ctrl-Shift-G (Windows) / Cmd-Shift-G (Mac), or you can drag the single photo out of the stack to a different place in the Grid view, leaving the rest of the stack intact.

Why are the stacking menu options disabled?

Stacks only work when all of the stacked photos are stored in a single folder or collection, so if the stacking options in the Photo menu are disabled, you're probably viewing a composite folder view and trying to stack photos which are in different folders.

Go to the Folders panel and either select a folder which doesn't have subfolders, deselect Show Photos in Subfolders in the Library menu, or group the photos in a collection, and then the photos will stack correctly.

How do I move a photo to the top of the stack?

The idea behind stacking is that you can put your favorite version of a photo on top of the stack and have the others hidden underneath. If your favorite isn't already on the top of the stack, selecting the photo and going to Photo menu > Stacking > Move to Top of Stack will move it. Better still, just click the stacking number box of your favorite picture once, and that photo will jump to the top of the stack.

How do I apply metadata to multiple photos in a stack?

If a stack is closed, adding metadata such as keywords to the stack will only apply that metadata to the top photo. There's a trick, however, to make it a little quicker. If you double-click or Shift-click on the stack number, it will open the stack with all of the stacked photos already selected, so you can go ahead and add the metadata without having to stop to select them.

If you want to expand all of the stacks in one go, perhaps because you want to filter for photos that are currently hidden in collapsed stacks, use the Photo menu > Expand All Stacks command.

I've placed retouched derivatives into the same folder as the originals and I'd like them stacked in pairs. Can I do it automatically?

If you want to automatically stack photos by their timestamps, for example, to stack retouched files with their originals, you can select the photos and choose Photo menu > Stacking > Auto-Stack by Capture Time and choose a 0 second time difference (0:00:00). You will see the number of stacks change at the bottom of the dialog. It might need a little tidying up where you've shot in really quick succession, but it should do most of the work for you.

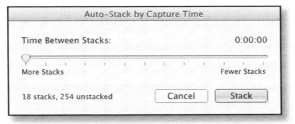

When I create a virtual copy, it should automatically stack them, but it hasn't—why not?

When you create a virtual copy, it will automatically be stacked with the original in the Folder view. If you can't see those stacks, you may be viewing a collection rather than a folder view, or the stacks might be

Also check...

"Snapshots & Virtual Copies" section starting on page 417

open, which makes them more difficult to spot. The border surrounding the thumbnails is slightly different, as you can see in the screenshot, but it's not always obvious as the thumbnail divide lines don't disappear until the photos are deselected.

RATINGS & LABELING

Having found your photos in the folders where they're stored, and perhaps created collections for each shoot, it's then time to sort through those photos to choose your favorites and weed out the rubbish. Lightroom offers 3 different labeling systems—flags, ratings and labels—so you can decide how to use them in your own workflow.

Which rating or labeling system should I use?

Star ratings have a fairly universal meaning. They're used to record the quality or value of the photo, with 1 star photos being poor and 5 star photos being the best you've ever taken. Star ratings are standard across almost all DAM software, so if you chose to use other software in the future, these settings could be transferred.

There isn't an equivalent standard usage for color labels. You can use them for your own purposes. Many photographers use them as workflow tools, perhaps using Red for dust retouching, Yellow for other retouching, Green and Blue to mark groups of photos for HDR and Panoramas, and Purple for finished files. Personally, I find them most useful when processing a shoot with a mix of different cameras.

When synchronizing Develop settings, each camera may need different settings, and the labels make each camera easy to identify at a glance.

Also check...

"XMP" section starting on page 320

The final rating system is the flags. In earlier versions of Lightroom, flags were local to the folder or collection. Since Lightroom was introduced, however, picks and rejects have become a primary rating system for photographers, and Lightroom 4 has therefore changed accordingly. Now when you select a flag in a folder or collection, that flag will appear everywhere, just like star ratings and color labels. This also means that flags may, at some time in the future, be written to XMP and shared with other software, although that's not available in the current release.

How do I apply ratings and labels quickly?

The quickest way of adding star ratings, color labels and flags is using their keyboard shortcuts rather than trying to click on exactly the right spot.

The 0-5 keys are for star ratings, with 1-5 obviously setting 1-5 stars, and 0 clearing your star rating. The 6-9 keys apply colors Red, Yellow, Green and Blue. Purple doesn't have a keyboard shortcut because there aren't enough numbers. Flags have P for Picked or Flagged, U for Unflagged, and X for rejected. Those keys are spread a little further over the keyboard, so if you would prefer to use keys a little closer together, the ` key will toggle between Flagged and Unflagged. Select your first photo, press the shortcut for the rating you want to add, and move on to the next photo.

If you're in a decisive mood and would like Lightroom to automatically move on to the next shot as soon as you've added a flag, rating or

label, turn on Caps Lock or hold down Shift while using those keyboard shortcuts, and Lightroom will apply the rating and immediately select the next photo. You can do the same by turning on Auto Advance under the Photo menu.

You can add the flags, ratings and labels to the toolbar by clicking the arrow at the end of it, and they're available in the right-click menu as well as the Photo menu too. If you prefer to use the mouse, you can set the View menu > View Options to show the star ratings, labels and flags around the edge of the thumbnails.

If you like working in Grid view with the mouse, the Painter tool is even quicker.

How do I use the Painter tool to quickly add metadata?

The Painter tool, shown by a spray can icon in the toolbar below the Grid view, is ideal for quickly applying various metadata and settings to larger numbers of photos without having to be too careful about where you click.

The Painter tool can be used to assign not only labels,

ratings and flags, but also to add keywords, metadata presets, settings (Develop presets), change the rotation or add to the Target Collection.

Simply select the Painter tool from the Grid view toolbar—press T if you've hidden the toolbar. Choose the setting you would like to paint from the pop-up menu, and start spraying. Click anywhere on a thumbnail image to apply the setting, or click-and-drag across a series of photos to apply the setting to all of the photos it touches.

The photos that already have that setting applied will have a thin white border around the thumbnail, making them easy to spot.

To use the Painter tool to remove a setting, hold down the Alt (Windows) / Opt (Mac) key and the cursor will change to an eraser, then you can click or click-and-drag across the photos to remove the setting.

Is it possible to view flag/rating/color labels status when in other modules?

When you turn on the toolbar, you can choose which information to show by clicking on the arrow at the right hand end. Flags, ratings and labels are amongst those choices in the Library and Develop modules.

If you work with the Filmstrip open at the bottom of the screen, you can also see the flags, ratings and labels on the thumbnails, as long as you have 'Show ratings and picks in Filmstrip' turned on in Preferences > Interface panel and 'Tint grid cells with label colors' turned on in View menu > View Options… The ratings and labels may disappear if the thumbnails are too small.

Since flags are no longer local, how do I access my old local flags?

If you had a photo flagged or rejected in a folder in Lightroom 3 or earlier, that flag will become the main photo flag. If you also used flags in collections, you can right-click on the collection to access additional options—Select Old Contextual Flagged and Select Old Contextual Rejected. Selecting each in turn, you can apply your choice of global flag, color label, star rating, keyword, or any other marker to replace the old local flag.

I gave my photos stars or color labels in Lightroom—why can't I see them in Bridge?

Lightroom's settings are only stored in Lightroom's own catalog, which Bridge can't read, so if you want to view those stars or labels in Bridge, you need to write your settings back to the files. They're stored in a

Also check...

"Toolbar" on page 151 and "Filmstrip" on page 149

Also check...

"How do I write settings to XMP?" on page 321

metadata section called XMP, which we'll come to in the next chapter, but in the meantime, select the files in Grid view and press Ctrl-S (Windows) / Cmd-S (Mac) to write to the external files.

I gave my photos different color labels in Lightroom—why are they all white in Bridge? Or I labeled my photos in Bridge— why isn't Lightroom showing my color labels?

If you've changed label names, or you're using different label sets in Lightroom and Bridge, the labels may show as white in Bridge, showing that the names don't match. You can check Lightroom's label names by going to Metadata menu > Color Label Set > Edit, and to check in Bridge, go to Bridge's Preferences > Labels section. If you change them both to the same values, they'll show as the same colors. Lightroom ships with a label set called Bridge Default which match Bridge's default settings. You'll find it under Metadata menu > Color Label Sets.

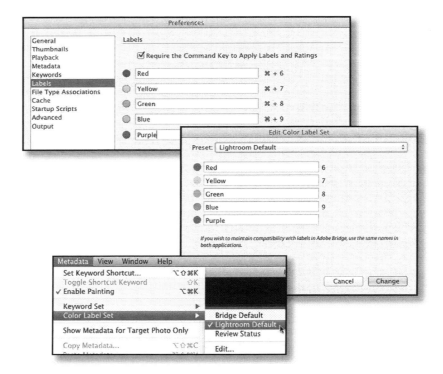

Lightroom's not quick enough to sort through a large shoot—is there anything I can do to speed it up?

Lightroom likes a fast computer however there are a few things you can do to help speed it up when you're sorting through your shoot. We'll come back to speed tips in more detail in the Previews & Speed chapter, but here are a few tips to get started in the meantime.

- Work in Library module, not Develop module, as Develop reads the original raw file and is therefore slower moving from one photo to the next.

- Render previews before you start—there's nothing more frustrating than waiting for a preview to become sharp. If you're going to need to zoom in on many photos, render 1:1 previews rather than standard size.

- Resist the urge to start making Develop changes while you're sorting through them. If you correct one, then sync the changes with others, Lightroom has to regenerate the previews for the photos that have changed. Do your tweaking after you finish sorting through them.

- Turn on Auto Advance either under the Photo menu or by leaving caps lock turned on—as you rate a photo, it will move on to the next photo automatically.

- Use filters to hide photos you've rejected rather than deleting immediately.

If you shoot raw+JPEG, there's one more trick which can help with speed. John Beardsworth has written a plug-in called Syncomatic, which allows you to use the JPEGs while sorting through your photos, as they're quicker to load, and then sync the ratings and other metadata back to their matching raw files once you've finished. You can download it from http://www.lrq.me/beardsworth-syncomatic

Also check...

"How can I speed up browsing in the Library module?" on page 345

Also check...

"How do I rename the files while importing?"
on page 94

RENAMING, MOVING & DELETING

Once you've finished sorting through your photos, there are one or two more file management tasks you might need, such as renaming, moving or deleting photos. Remember, anything you do in the Folders panel is reflected on the hard drive as well as within Lightroom's catalog.

How do I rename one or more photos?

We've already considered the basics of file renaming in the Import chapter, however you're not limited to renaming only while importing—you can also rename while working in the Library module, as long as the original files are available, or later when exporting the photos.

To rename photos in the Library module, selecting them in Grid view, and then pressing the F2 shortcut key or selecting Library menu > Rename will take you to the Rename dialog, which is similar to the File Naming panel in the Import dialog.

That's great if you want to rename multiple photos, but to rename just a single photo, it's often quicker to open the Metadata panel. If you click in the Filename field, you can edit the existing filename rather than having to use a template in the full Rename dialog. Clicking the little icon at the end of the Filename field takes you directly to the full Rename dialog if you do decide to use a template after all.

How do I rename photos back to their original filename?

There's another useful rename option which wasn't available in the Import dialog—Original Filename. If you've renamed a photo within Lightroom since you imported it into the current catalog, Lightroom should still have a record of the original filename. That Original Filename field would actually be better named Import Filename, as it's the name at the time of import, not the original name at the time of capture. If you want to check whether you have an original filename to revert to, select the 'EXIF and IPTC' view at the top of the Metadata panel. If the original

filename is present in the database, you can go to the Rename dialog and select Edit in the pop-up to show the Filename Template Editor. You'll find the Original Filename token in the Image Name section.

Can I do more complex batch renaming, perhaps replacing part of a filename?

Lightroom's file naming allows for the creations of complex new filenames, but reusing part of the existing filename is not quite so simple. There's no way to, for example, remove −2 from the end of filenames, unless you can recreate the filename using metadata. It's one reason using a date/time filename is a particularly good choice!

There is a workaround, however, using John Beardsworth's Search Replace Transfer plug-in (http://www.lrq.me/beardsworth-searchreplace). Taking the −2 scenario as an example, you'd use Search Replace Transfer to copy the filename to any unused IPTC field that Lightroom's renaming dialog can use—perhaps the Headline field. Then you use the plug-in again, this time to remove −2 from the Headline field, and repeat to remove the file extension too. Finally, you'd use Lightroom's main Rename dialog, set to use the Headline token for the new filename.

How do I move or copy photos between folders?

Although folders are primarily storage buckets, you may need to move photos at times, and to do so you simply drag and drop them around the Folders panel within Lightroom, ensuring that you grab the thumbnail itself and not the surrounding border.

Copying isn't quite so simple, because the idea is that you use collections and virtual copies rather than having multiple copies of the same photo. If you do need to create a physical copy on the hard drive, use File menu

Also check...

"Why would I want to use virtual copies?" on page 417

> Export, set to save the duplicate in the location of your choice, adding to the catalog automatically, and using the Original file format setting.

If you only need a copy of the photo to try out some different Develop settings, or you want to apply different metadata, consider virtual copies instead. They don't create an additional copy on the hard drive, but they behave like separate copies within Lightroom. We'll come back to virtual copies in the Develop module chapter.

When I delete photos, am I deleting them only from Lightroom, or from the hard drive too?

Within Lightroom, there's a difference between the word remove, which only removes the photo from the catalog, and delete, which moves the original file to the Recycle Bin (Windows) / Trash (Mac) too.

When you press the Delete key, or use Photo menu > Delete Photo or Delete Rejected Photos, it will show a dialog box asking whether to remove them from the catalog or delete them from the disk. Removing from the catalog can be undone using Ctrl-Z (Windows) / Cmd-Z (Mac) if you immediately realize you've made a mistake, whereas Delete doesn't have an undo option.

Why can't I delete photos from the hard drive when I'm viewing a collection?

The Delete key works slightly differently when viewing a collection than it does in a folder. It assumes that you want to remove the photo

from that collection rather than from the catalog or hard drive. The wonderfully named 'splat-delete' or Ctrl-Alt-Shift-Delete (Windows) / Cmd-Opt-Shift-Delete (Mac) will delete from the hard drive whether you're viewing a folder, collection or even a smart collection. It also bypasses the dialog, so use it with care!

I'm deleting photos in Lightroom, set to send to Recycle Bin/ Trash, so why isn't it deleting them?

If you're having problems deleting, or even renaming photos, check the file permissions within your operating system, as you might not have permission to delete the file. It's also worth double-checking that you're looking at the right files on your hard drive by right-clicking on a photo and selecting Show in Explorer (Windows) / Show in Finder (Mac). You may be looking at duplicate files in a different location, perhaps by accidentally selecting one of the 'Copy' options in the Import dialog.

Why did Lightroom delete all of my photos?

If all of the photos in your current view are selected, the shades of grey can make it appear to have only 1 photo selected. In the Delete confirmation dialog, it states how many photos will be deleted, so it's worth stopping to read that dialog when deleting photos.

I accidentally deleted my photos from my hard drive and I don't have backups! Can I create JPEGs from Lightroom's previews?

If you've deleted your original files, you don't have backups, and they're not in the Recycle Bin (Windows) / Trash (Mac), the next thing to check is whether the photos are still on the memory card. If you haven't reshot the entire card, it may be possible to rescue some of the original photos using recovery software.

Also check...

"What's the difference between the selection shades of grey?" on page 158

Also check...

"How do I find my catalog on the hard drive?" on page 271

If that's not possible, before you do anything else, close Lightroom, find the catalog on the hard drive, and duplicate the catalog and previews.

Adobe have written a script that retrieves Lightroom's previews and saves them as image files. The resulting JPEGs are only the size and quality of the previews, but they're better than nothing.

1. Download the script from http://www.lrq.me/extractpreviews If it's a zip file, double-click to unzip it. You'll find a script file inside called ExtractPreviews.lua.

2. Go to Lightroom's Preferences dialog > Preview tab and make sure Store Presets with Catalog is not checked. Click the Show Lightroom Presets Folder and create a folder called Scripts.

3. Copy the ExtractPreviews.lua file to that location and restart Lightroom.

4. Select the photos that are missing their originals.

5. Next to the Help menu will be a Scripts menu. On a Mac, that may be a symbol rather than the word Scripts.

6. Select Extract Previews from the menu.

7. Lightroom will ask where to create the new JPEGs, so navigate to a folder of your choice.

8. Lightroom will extract the previews from the catalog, naming them with their filename and dimensions.

9. The extracted previews will be missing their AdobeRGB profile. Ideally, you should assign the AdobeRGB profile using Photoshop's Edit menu > Assign Profile (not Convert to Profile) command, so that Lightroom will preview the photo correctly. If you don't own Photoshop, there are alternative ways of assigning that profile, using Exiftool on Windows or Automator on Mac. You can import the photos into Lightroom without doing this step, however the appearance will shift slightly as a result.

10. You can then import the extracted previews into your catalog as new photos.

The extracted previews won't have any of their metadata. It would be possible to copy some of the metadata from the missing files onto the extracted previews, however those possibilities are too varied to cover in this book.

VIEWING & EDITING METADATA

Now you've decided which photos to keep, it's time to add some additional metadata so you can easily find those photos again at a later date.

Certain metadata such as camera settings, called EXIF data, is added by the camera at the time of shooting. Apart from the capture time, Lightroom doesn't allow you to edit that EXIF data. IPTC data, which Lightroom does allow you to add and edit, primarily includes information about the creator of the photo, the subject and its ownership.

You may have already entered your copyright data in the Import dialog, but some other photo-specific information is also worth adding to the Metadata panel. The location of the photo could be added using keywords, but there are official Country, State, City and Location IPTC fields that are better suited. You might also add a title and caption to your photos in the Metadata panel, especially if you're going to use them in a slideshow or book.

How do I add metadata to multiple photos at once?

Adding metadata would quickly become boring if you had to do one photo at a time by just typing that information into the Metadata panel. To make it quicker, however, you can select multiple photos in Grid view and apply it to all of those photos in one go, as long as Metadata menu > Show Metadata for Target Photo Only is unchecked.

 Also check...

"How do I add captions to the slides?" on page 593, "How do I automatically enter text based on metadata?" on page 573 and "XMP" section starting on page 320

Working directly in the Metadata panel can be slow when working on a volume of photos, as it updates each time you move between fields, so it's often quicker to select the photos and press the Sync Metadata button below the Metadata panel (not the Sync Settings button). In the Metadata dialog, enter the details for any fields you want to update, and put a checkmark next to those fields, as only checked fields will be changed. Press Synchronize when you're finished, and the metadata will be applied to all of the selected photos.

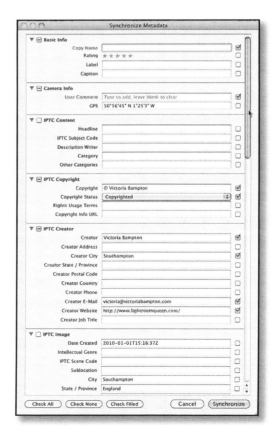

How do I create a Metadata preset?

If you find you're regularly applying the same metadata, you can save it as a Metadata preset for use in the Import dialog as well as the Library module. Go to the Presets pop-up menu at the top of the Metadata panel and choose Edit Presets. The dialog will automatically fill with the Metadata from the selected photo, and you can edit the information that you want to save in the preset. Just like the Sync Metadata dialog, only checked fields will be saved in the preset. Leaving any fields blank but checked would clear any existing metadata saved in that field.

There's one other thing to look out for when

creating metadata presets. It's easy to accidentally save keywords in a Metadata preset, and then have those keywords mysteriously appear on all imported photos because you're applying the Metadata preset while importing, so it's usually a good idea to exclude keywords from the preset.

How do I select which metadata to view in the Metadata panel?

The Metadata panel in the Library module can show a variety of information, most of which is hidden by the default view. It can be accessed from the first pop-up menu on the Metadata panel, selecting the 'EXIF and IPTC' view. If you want to view additional metadata available to Lightroom, or create your own view preset with information you most often use, try Jeffrey Friedl's Metadata Editor Preset Builder: http://www.lrq.me/friedl-metadatapresets

Why are the Location fields dimmed or italic?

The Location fields are dimmed (and also italicized on Windows) to signify that the location metadata was generated using Google's reverse geocoding, and may or may not be correct. We'll come back to reverse geocoding in more detail in the Map chapter. If the metadata is correct, you can commit it by clicking on the field label, or you can edit it manually. Once you've done so, the metadata will become white and will no longer update if you move the photo to a different map location.

Can I import and listen to my camera's audio annotations?

If Lightroom finds a WAV audio file alongside the photo at the time of import with the same name, it will be listed in the Metadata panel, but you'll only be able to see it listed as an Audio File if you're using certain Metadata panel view presets such as 'EXIF and IPTC'.

 Also check...

"Reverse Geocoding" section starting on page 262

Also check...

"I shot Raw+JPEG in camera—why have the JPEGs not imported?" on page 136

Those audio annotation files can be played within Lightroom by pressing the arrow icon at the end of the Audio field, but it only currently works with WAV files, and not MP3 format which some cameras use.

Why do some files say CR2+JPEG and some just say CR2?

The files marked as CR2+JPEG, NEF+JPEG or similar are raw photos that were imported with sidecar JPEG files (JPEGs with the same name in the same folder), and with the 'Treat JPEG files next to raw files as separate photos' preference setting turned off. Those JPEG sidecar files may have been created by exporting the raw files to JPEG format in the same folder, or by shooting Raw+JPEG in the camera.

Some of my lenses are listed twice in the Metadata filters, for example 24.0-105.0 mm and also as EF24-105 IS USM. Why?

Although it's slightly irritating, different cameras record the same lens differently, and Lightroom just reads that metadata from the file, which can result in the same lens appearing with different names. Other than manually updating the EXIF data using tools such as ExifTool, there isn't an easy fix at this point in time.

KEYWORDING

Besides the EXIF and IPTC data, it's worth spending a little time adding keywords to help you find the photos again later. Keywords are used to describe the content of the photo, so you can quickly find all photos of a particular bird, family member, or type of scenery.

How should I keyword my photos?

There are no hard and fast rules for keywording unless you're shooting for Stock Photography. Assuming you're shooting primarily for yourself, the main rule is simple—use keywords that will help you find the photos again later! It won't help to tag photos of your pet dog with the Latin name 'canis lupus familiaris' if you don't speak Latin and you would look for 'William' or 'dog' instead.

As with folders and collections, you can use a hierarchical list of keywords instead of one long list, and there are advantages and disadvantages either way. A hierarchical list isn't always backwards compatible with older software, and some older software ignores hierarchical keywords entirely, so flat keyword lists are more universal. On the other hand, a tidy hierarchy is much easier to navigate and it keeps related items together in the list, which helps to prevent variations in spelling on the same keyword. If you do use a hierarchy of keywords, the photos can later be exported with flattened keywords to solve compatibility issues. Personally I find a hierarchical list easier to handle.

Spaces are currently best avoided in Lightroom's keywords. When you search for a keyword with a space in it, such as 'John Jack,' it sees them as individual words instead of a phrase. It would return photos tagged with 'John Jack,' 'Jack John' or with both 'John' and 'Jack.' If you need a space in a keyword, consider using an underscore instead, such as 'John_Jack.'

It's possible to download extensive controlled vocabulary keyword lists, covering just about every possible keyword you could imagine, and for Stock Photographers, those lists are ideal. You may find it less confusing to create your own list that applies to your own photos. Many of the keywords you'll use won't appear on the downloadable lists, as they'll be names of friends, family and local places.

To create a keyword, either type it in the Keywording panel, or press the + button on the Keyword List panel to view the Create Keyword Tag dialog. That dialog gives you additional options, namely Synonyms, Include on Export, Export Containing Keywords and Export Synonyms.

You can also access those options for existing keywords by right-clicking on the keyword in the Keyword List panel and selecting Edit Keyword Tag.

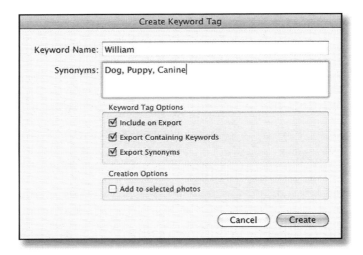

The Synonyms field is the one field where 'canis lupus familiaris' could be useful, as those synonyms can be searched and exported with the photos and found in searches, without cluttering your keyword list. For dog, you might add other synonyms such as 'canine,' 'hound,' 'mutt,' 'puppy,' or any other related words that you might use to search for a photo of a dog.

You might not want all of your keywords included with exported photos, particularly if they include private information, or they're just header keywords such as 'Places' or 'Subjects.' They can be excluded by unchecking the 'Include on Export' checkbox in the Create/Edit Keyword Tag dialogs.

Don't go overboard, at least to start with, because if you make it too big a job, it's easy to get bored and give up. Just add a few basic keywords to all photos, and concentrate primarily on your higher-rated photos, as those are the ones you're most likely to want to find again in the future.

How do I change my long list of keywords into a hierarchy? Or change the existing hierarchy?

If you've started out with a long list of keywords and now want to rearrange them into a hierarchy, you can pick them up and drag and drop them into a new structure.

If you drop the keyword on top of an existing keyword, it will become a child of that keyword. As you drag, the new parent keyword will become highlighted to show that the keyword will become a child, for example, in the screenshot, we're making 'William' a child of 'Pets'.

If you want to do the opposite and change a child keyword into a root keyword, drop the keyword between existing root level keywords instead. As you drag, a thin line will appear showing the new position.

Don't worry about getting it in the right place in the list, as the Keyword List is automatically set to alpha-numeric sort, for example, in the screenshot , we're now making 'William' a root keyword.

How many keywords can I have?

There isn't a known limit to the number of keywords in a hierarchical structure, but 3271 top level keywords seems to be the magic figure now due to some Windows limitations. Past that point, the keywords will exist and are shown in the Keyword List, but on Windows they can't be selected unless they're within the first 3271. It's possible to work around using the Filter Keywords field at the top of the Keywords panel, but it's far easier to avoid by using a hierarchy instead.

How can I keep certain keywords at the top of the list?

The list of keywords is displayed in standard alpha-numeric order, so adding a symbol to the beginning of the name, for example, the @ symbol, will keep those specific keywords at the top of the keywords list. It's particularly useful for workflow keywords, for example, I always add an @NotKeyworded keyword to all photos as they're imported, and remove it when I've finished keywording. If I get interrupted while applying keywords, those half-done photos might not show in the Without Keywords smart collection, but will still appear in my @ NotKeyworded filter.

Is there a quick way of finding a particular keyword in my long list?

If your keyword list becomes really long, or keywords are hidden under collapsed parent keywords, it can be difficult to find a specific keyword quickly. Fortunately Adobe thought of that too, and there's a Keywords Filter at the top of the Keyword List panel, which will instantly filter the keyword list to show matching keywords. It's useful if you drop a keyword in the wrong place while making it a parent or child keyword, and then can't find it again.

What do the symbols in the Keyword panels mean?

Also check...

"What are the Quick Collection and Target Collection?" on page 186

The plus symbol next to the keyword shows that the keyword is assigned to the Keyword Shortcut, just like the Target Collection we discussed earlier, so pressing Shift-K will assign that keyword to the selected photo(s). You can change the keyword assigned to the shortcut by going to Metadata menu > Set Keyword Shortcut, or by right-clicking on any keyword and choosing that option from the context-sensitive menu. It can also show that the keyword is currently set in the Painter Tool for easy application to multiple photos.

To the left of the keyword are additional symbols showing whether the currently selected photos have that keyword assigned. When you hover over a keyword, a box appears, and if it's empty it means that the keyword isn't currently assigned to the selected photos, but clicking in that box will assign that keyword. A check mark shows that all of the photos you've selected have that keyword assigned. If you see a minus symbol, it means that some of the photos you've selected have that keyword assigned, or a child of that keyword. If it's a parent keyword, it can also show that all of your selected photos have some, but not all, of its child keywords assigned.

Also check...

"How can I view all of the photos tagged with a specific keyword or keyword combination?" on page 228

Finally, at the right hand of each keyword is an arrow which appears when you float over the keyword. That's a shortcut to filter the photos with that keyword, and we'll come back to filtering later in the chapter.

In the Keywording panel, above the Keyword List panel, all of the keywords assigned to the selected photos are listed. Where a keyword is marked with an asterisk (*), some of the selected photos have that keyword assigned, but it's not assigned to all of them.

Is there an easier way to apply lots of keywords in one go, other than typing or dragging them all?

Adding keywords can be a time-consuming task, so anything that can make it quicker is a bonus. You can drag photos to the keyword in the Keyword List, or drag the keyword to the photo, but the quickest keywording is done in the Keywording panel.

In the Keywording panel you have a number of options. You can type the keywords directly into the main keywords field divided by commas, or into the Add Keywords field directly below if you don't want to interfere with existing keywords. As you start to type, Lightroom will offer autofill suggestions from your keyword list, and you can either click on one of those suggestions, or use the up/down arrow keys followed by tab to select the keyword you want to apply, or type a new keyword.

The Keyword Suggestions panel below intelligently suggests keywords based on your previous keyword combinations and the keywords already assigned to photos nearby, and clicking on any of those keywords assigns it to the photo. It's remarkably powerful!

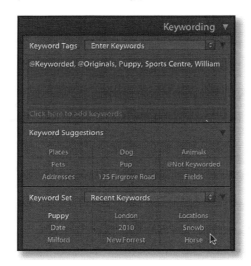

The other option in the Keywording panel is Keyword Sets. Using the pop-up menu in the Keyword Sets section, you can create multiple different sets of keywords that you tend to apply to a single shoot—perhaps the names of your family members. To apply the keywords you can either click on them or use a keyboard shortcut—hold down Alt (Windows) / Opt (Mac) to see which numerical keys are assigned to each word.

The Painter tool is another quick way of applying one or more keywords to a series of photos quickly and easily, particularly if you're just skimming through them in Grid view. For example, when you're getting started with keywording, you might like to assign the keyword 'William' to the Painter tool and scroll through your photos clicking or dragging over each photo of William. If you find yourself regularly using a string of keywords in the Painter tool, such as 'William, Southampton,' save the strings in a text file and copy and paste them into the Painter tool to save typing the list each time.

Also check...

"How do I use the Painter tool to quickly add metadata?" on page 192

Why are there only 9 keywords in the Keywords panel?

Each of the cells in the Keywords panel matches up with a key on the number pad that can be used as a shortcut, for example, top right is Alt-9 (Windows) / Opt-9 (Mac). That means that there are only 9 visible at a time, but you can create additional sets of keywords and switch between them.

I mistyped a keyword and now Lightroom keeps suggesting it—how do I clear the autofill?

If a misspelled keyword keeps being suggested, that's because it's misspelled in the Keyword List panel. If you correct it or remove it from the Keyword List, Lightroom will stop suggesting it.

While we're on the subject of misspellings, if you come across the same problem with any other metadata apart from keywords, there's a Clear All Suggestion Lists button in the Catalog Settings dialog under the Metadata tab, or you can click on the field label in the Metadata panel to clear the suggestions for that field only.

How do I remove a keyword from a photo without deleting it everywhere?

As with many things in Lightroom, there are many ways to remove a keyword from a photo. With the photo selected, you can click to remove the checkmark in the Keyword List panel, right-click on the keyword and select Remove this Keyword from Selected Photo, or delete it from the Keywording panel.

Is it possible to display all of the photos in a catalog that aren't already keyworded?

If you want to find photos that haven't yet been keyworded, look in the Collections panel. There's a default smart collection called Without

Also check...

"Sorting, Filtering & Finding Photos" section starting on page 223 and "Smart Collections" section starting on page 234

Keywords, or you can use a Text filter set to Keywords > Are Empty. We'll come back to filtering and smart collections later in the chapter. If you don't always complete your keywording in one session, you could also use my @NotKeyworded trick mentioned previously.

I use multiple catalogs, but I'd like to keep my keyword list identical and current across all of the catalogs—is there an easy way?

Trying to keep settings, particularly keyword lists, identical across multiple catalogs is one of the disadvantages of using more than one catalog, however there's a partial workaround. The easiest option is to use a single photo which is imported into each catalog, and keep that photo updated with all of your keywords applied.

First, import a photo into the catalog, perhaps choosing a plain grey image to make it easily identifiable, and apply all of your keywords to that photo. Write those keywords back to the file using Ctrl-S (Windows) / Cmd-S (Mac), and then import it into each of the other catalogs, making sure you set the Import dialog to 'Add photos to catalog without moving' so that all of the catalogs are referencing the same file on your hard drive. From that point on, whenever you open a catalog, select that same photo and go to Metadata menu > Read Metadata from File. That will update your keyword list with new keywords, and don't forget to write back to the file each time you close each catalog, so that they all stay up to date.

Alternatively you could use Metadata menu > Import Keywords and Export Keywords each time you open and close a catalog. That's the simplest option if you're not switching back and forth regularly—for example, you want a clean catalog while you're away on vacation which will be imported into your main catalog on your return. Either way, keywords only get added to the list and not removed from it, so it would be easy to get into a tangle. If keeping matching keyword lists is

Also check...

"XMP" section starting on page 320

important to you, you might want to reconsider using a single catalog instead.

How do I import my keywords from Bridge?

If you already have a list of keywords in Bridge, you can transfer that over to Lightroom instead of rebuilding the whole list. To do so, you have 2 main options. You can use Bridge to apply all of the keywords to one specific photo, import that photo into Lightroom, and as Bridge is set to write to XMP, all of your keywords will show up in the Keyword List.

You can also use the keyword list import and export tools mentioned in the previous question. Open the Keywords panel in Bridge and go to the menu icon in the top right hand corner of the panel. You'll find Export in that menu, which will export the keywords to a text file, and you can then go to Lightroom and use Metadata menu > Import Keywords to import that text file into Lightroom.

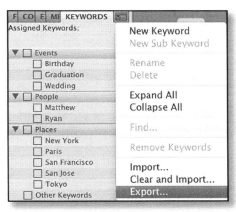

Also check...

"Should I use one big catalog, or multiple smaller catalogs?" on page 279

If I can import keywords from Bridge using a text file, does that mean I can create my keywords manually using a text file and then import them into Lightroom?

You can create your keyword list using a text file, but be aware that any formatting mistakes could prevent the keywords from importing, and it can be a time-consuming job to figure out what's wrong.

When creating the text file, only use a tab to show a parent-child hierarchy, and no other characters. If it won't import, you've probably

got some blank lines, extraneous spaces, return feeds, etc., or perhaps a child keyword without a parent.

Here's an example showing the formatting characters:

EDITING THE CAPTURE TIME

We've all done it… you go on vacation abroad, or Daylight Savings Time starts, and you forget to change the time stamp on the camera. It's not a problem though, as Lightroom makes it very simple to correct the time stamp.

What do the different options in the Edit Capture Time dialog do?

If you go to Metadata menu > Edit Capture Time, the dialog shows 3 different options for changing the capture time of your photos.

Adjust to a specified date and time adjusts the active (most-selected) photo to the time you choose, and adjusts all other photos by the same increment.

Shift by set number of hours (time zone adjust) adjusts by full hours, which is useful when you've only forgotten to adjust the time on vacation.

Change to file creation date for each image does exactly what it says.

The options in the Edit Capture Time dialog don't allow you to set all selected photos, such as old scans, to a specific time, as Lightroom's designed primarily for digital capture.

The time on my camera was incorrect—how do I change it?

1. First, make sure you're in Grid view so that your changes apply to all selected photos.

2. Find a photo for which you know the correct time and note that time down—we'll call this the 'known time' photo for the moment.

3. Select all of the photos that need the time stamp changed by the same amount.

4. Click on the thumbnail of the 'known-time' photo that we identified in step 2, making that photo the active (most-selected) photo without deselecting the other photos.

5. Go to Metadata menu > Edit Capture Time to show the Edit Capture Time dialog. The preview photo on the left should be your 'known time' photo.

6. If you need to change the time by full hours, you can select Shift by set number of hours and enter the time difference, but otherwise, choose the first option, Adjust to a specified date and time, as this allows you to change by years, months, days, hours, minutes or seconds.

7. If you've selected the Adjust to a specified date and time option, enter the correct time—the time you noted down earlier for the 'known-time' photo. You can select each number (hours, minutes, etc.) individually, and change the value either using the arrows or by typing the time of your choice.

8. Click Change All to update all of the selected photos.

While not entirely obvious, when changing the time stamp on a series of photos, the active (most-selected) photo will be set to the time you enter in step 7, and the rest of the photos will be adjusted by the same incremental time difference. It won't set them all to the same date and time, and that applies whether your active (most-selected) photo is the first in the series or not. For example, if you've selected 3 photos and you set the correct time for the middle one to 16:26, that photo will be the 'known-time' photo identified in step 2, and the others will be adjusted by the same time difference.

So you would have:

	Original Time	New Time
Photo 1	10:14	14:26
Photo 2	**12:14**	**16:26**
Photo 3	15:34	19:46

If you make a mistake, the original time stamp is stored in the catalog until the photo is removed, and you can return to that original time stamp by using Metadata menu > Revert Capture Time to Original.

The updated capture time is stored in the catalog, and if you write to the files using Ctrl-S (Windows) / Cmd-S (Mac), it will be written to the metadata of the file too. For proprietary raw files, most other metadata is written to an XMP sidecar file, however the updated capture time can be written back to the raw file itself.

Writing to the file shouldn't cause any problems, as it's written to a known portion of the metadata file header and doesn't affect the raw image data itself. However it's a point of concern for some people who feel that those undocumented raw files should never be touched in any way. For that reason, there's a checkbox in Catalog Settings > Metadata tab which allows you to choose whether the updated time is stored only in the catalog, exported files, and XMP sidecar files, or whether it can be updated in your original raw files too.

How do I sync the times on two or more cameras?

If you're shooting with two cameras, matching the capture times can be even more important, as the Capture Time sort order would also be incorrect, muddling up your photos. Of course, synchronizing the time stamps on the cameras before shooting would save you a job, but if you forget, all is not lost.

The principle remains the same as adjusting the time on a single camera, but you need to repeat the process for each camera with the wrong time stamp. It's easiest if you have a fixed point in the day for which you know the correct time and were shooting on all of the cameras involved, for example, signing the register at a wedding.

First, separate each camera, so that you're working with one camera's photos at a time. You can do that very easily using the Metadata filters, which we'll cover in more detail in the following pages. Then, using the instructions in the previous question, change the capture time for each camera in turn, until they all match.

Also check...

"How do I filter my photos to show photos fitting certain criteria?"
on page 226

How do I change the date and time for scans?

Lightroom's Edit Capture Time is designed for digital capture rather than scans, so it won't set all photos to a fixed date and time. John Beardsworth's CaptureTime to Exif plug-in, however, uses Exiftool to add your chosen date to TIFF, PSD, JPEG or DNG files. You can download it from http://www.lrq.me/beardsworth-capturetimetoexif

MANAGING & EDITING VIDEOS

Many digital cameras now produce, not only stills, but also video. Lightroom 3 allowed you to manage those videos alongside your digital photos, and Lightroom 4 has now taken it one stage further, offering basic video editing tools including limited Develop adjustments and trimming.

Like your photos, once you've finished editing, you can export your changes to a new video file, and we'll come back to those settings in the Export chapter. You can't currently include the videos in Slideshows (it will just show the Poster Frame) or Web Galleries, however you can upload the original or edited videos to photo sharing sites such as Flickr.

How do I play videos in Lightroom?

As you move horizontally across a video thumbnail in the Grid view, it scrubs through the video so you can check that you've selected the right clip. If you see a progress wheel, the video is loading into the cache and will be available shortly. If you regularly work with video, you may want to enlarge the video cache size in Preferences > File Handling

Also check...

"How do I export or save my edited videos?" on page 491

tab, so that more of your video footage can be cached for faster previews.

When you open the video in Loupe view, you'll see a bezel with a play/ pause button, timeline, timestamp, thumbnail button and editing button. When you press the triangular play button, the video will begin to play.

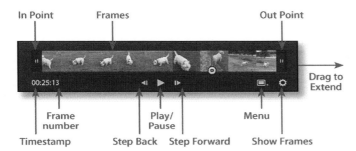

There are additional view options in the View menu > View Options dialog under the Loupe View tab. 'Show frame number when displaying video time' adds the frame number to the minutes:seconds display when the playback controller is expanded. 'Play HD video at draft quality' uses a lower resolution for smoother playback on slower machines.

How do I trim videos?

In the Loupe view, click on the Edit button which looks like a cog, and the bezel will enlarge to show the video frames. If the bezel isn't wide enough to accurately scrub through the video, you can drag either end to enlarge it.

At the left and right ends of the bezel are the trim handles. Dragging those toward the center will non-destructively trim the video. The easiest way to select the best trim position is to drag the position marker or pause the video. You can then drag the trim handle to that position, or press Shift-I / Shift-O to set that frame to be the start or end point of the video.

The trimmed sections of video are not removed from the original file, but they're hidden when playing the video in Lightroom, and will be excluded when you export the video to a new file. There can only be one start and end point per video, but you can create virtual copies of your video, allowing you to trim a different section from each. There isn't, however, a way of merging those clips back into a single video within Lightroom.

What do Capture Frame and Set Poster Frame do?

Under the rectangular thumbnail button on the video bezel there are 2 options. Capture Frame extracts the current frame as a JPEG and automatically adds it to the folder. Set Poster Frame allows you to select which frame is shown as the video thumbnail in the Grid view, and as the preview in other modules.

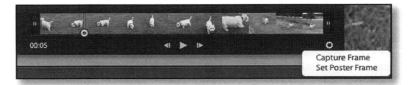

How do I select a specific frame without constantly sliding the position marker back and forth?

If you're trying to select a specific frame for the Capture Frame or Poster Frame, it can be difficult to drag the position marker to exactly the right spot. If you drag it to approximately the right spot, you can use the arrow buttons either side of the play button to step through one frame at a time.

I'm selecting Capture Frame—why isn't it working?

The captured frame won't appear in your current view if you're working in Previous Import, Quick Collection, any view with a video-only filter applied, or in a 'File type is video' smart collection. If you're viewing a

folder or standard collection, the captured frame should appear next to the video.

Can I view video metadata such as Frame Rate?

 Also check...

"Editing the Capture Time" section starting on page 214

If you select the Video preset in the Metadata panel, you'll be able to see additional video metadata, such as the Frame Rate, Dimensions and Audio Sample Rate.

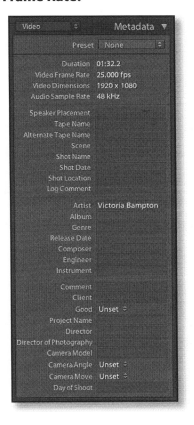

You will note that there's very limited metadata included in most video files. Details that we're used to seeing in digital image EXIF data, such as the camera and lens used, are not usually present. If that data is important to you, consider taking a photo just before recording, so that you have a permanent record.

You can add or edit the capture time for videos, just as you can for photos, which can help if the capture time wasn't initially recorded with the video.

Can I edit my videos in the Develop module?

Video isn't supported in the Develop module, however you can make Develop changes, either using the Quick Develop panel or Develop presets. Any changes you make apply to the whole video, not just the selected frame.

The Quick Develop panel in the Library module gives you quick access to basic controls—Treatment (Color or B&W), White Balance, Auto Tone,

Also check...

"Why doesn't my Quick Develop panel match the screenshots?" on page 239 and "Can I synchronize my settings with other photos?" on page 467

Exposure, Contrast, White Clipping, Black Clipping, Vibrance, and also Saturation when holding down the Alt (Windows) / Opt (Mac) key.

Additional adjustments can be made to Tone Curve, Split Toning, Process Version & Camera Calibration by including them in a Develop preset. That enables you to make your videos sepia or apply other effects, in addition to basic corrections.

If you use Capture Frame to create a JPEG from the video, you can switch to the Develop module and make Develop changes to that JPEG using selected sliders, and save it as a preset or sync the changes. Using that JPEG, you can preview your adjustments before applying them to the whole video, rather than using trial and error. When syncing the settings, you'll note that only settings that can be applied to videos are active.

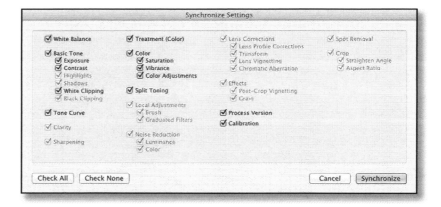

How do I open my video in an External Editor?

Lightroom 4 doesn't offer External Editors for video. You can right-click and choose Show in Explorer (Windows) / Show in Finder (Mac) and then open into the editor of your choice.

Also check...

"Plug-ins" section starting on page 526

Alternatively, John Beardsworth's Open Directly plug-in will allow you to open the original video into the software of your choice, including video editing software. http://www.lrq.me/beardsworth-opendirectly

Why does Lightroom keep asking me to install QuickTime?

QuickTime is needed for playing certain video formats, so Lightroom may show an error message if it's not installed. If you don't use video at all, or your videos play correctly, you can check the Don't show again checkbox and skip the error message. If, however, your videos won't import or play, installing QuickTime will likely solve the problem. You can click the Download button in the error message or go straight to http://www.lrq.me/quicktime

Should I enable OpenGL for video?

In Lightroom's Preferences > Interface tab, on Windows only, there's an Enable OpenGL for Video option. It doesn't appear on the Mac version because all Macs that meet the minimum specification also have suitable graphics cards, but Windows machines may be missing OpenGL features. You can leave it enabled unless you see problems with playing videos, such as no video preview, a strange video preview (distorted, inverted colors, etc.), or the graphics card driver crashes when you open a video.

SORTING, FILTERING & FINDING PHOTOS

Being able to add metadata to your photos is great, but the purpose of a database is to be able to easily find those photos again. Lightroom offers plenty of options for sorting and filtering based on various metadata.

How do I change my sort order?

The Sort Order pop-up menu lives in the toolbar in Grid view, so press T if you can't see the toolbar. You can reverse the sort order using the A-Z button, and you'll find all of those options under View menu > Sort too.

Can I set a default sort order regardless of folder?

The default sort order when you first select a folder is Capture Time, and you can't change that. If you change the sort order for a specific folder, that sort order should be remembered the next time you return to the folder. The special Previous Import collection defaults to Added Order as the photos are imported, rather than Capture Time.

How do I sort my entire catalog from earliest to latest, regardless of their folders?

If you want to view your whole catalog in date order, click on All Photographs in the Catalog panel and then select Capture Time as the sort order. The All Photographs collection is also useful if you need to search your entire catalog.

Why can't I drag and drop into a custom sort order or User Order?

Custom sort orders, officially known as User Order, only work when viewing a single folder or collection. They don't work when you're viewing a composite view—a folder with subfolders or a collection set with subcollections. You can either select a folder with no subfolders, or you can turn off Library menu > Show Photos in Subfolders, so you're only seeing photos directly in the selected folder or collection. If you

need a custom sort across multiple folders, put the photos into a collection instead.

You also need to pick up the photo by the center of the thumbnail itself, not the grey border surrounding it. As you drag the photo, you'll see a black line appear between two photos, which shows where the photo will drop.

Also check...

"Why does my folder say it contains 0 photos? Or, can I view the photos directly in the folder, instead of a composite view of its subfolders?" on page 177

Why does Lightroom add new photos to the end of the sort order when editing in Photoshop?

If your sort order is set to User Order, Edit Time, etc., Lightroom will put the edited file at the end of the series of photos, and if you have it set to Stack with Original in the Edit dialog, it will also move the original photo to the end. If you don't want to have to keep scrolling back again, use a sort order such as Capture Time or Filename that won't automatically be updated.

Why does my filter disappear when I switch folders?

When you switch folders, any filters will automatically be disabled, and you can turn them back on by pressing Ctrl-L (Windows) / Cmd-L (Mac), or using the switch at the end of the Filmstrip Filters. That only turns back on the last filter that you used—not the last filter used on that specific folder. You can also lock a filter state, using the Lock icon on

Also check...

"Editing in Other Programs" chapter starting on page 469

the main Filter bar, so that your filter always remains enabled when you switch folders.

If you preferred the Lightroom 1/2 'sticky filters' behavior, where it remembered the filter settings you used on each individual folder/ collection, go to File menu > Library Filters and select Lock Filters, and then return to that same menu and select Remember Each Source's Filters Separately.

What does the Filter Lock icon in the Filter bar do?

At the right hand end of the Filter bar is a small Filter Lock icon. If the Lock icon is locked, the current filter remains enabled as you browse different folders or collections, so you don't have to keep pressing Ctrl-L (Windows) / Cmd-L (Mac) to turn them back on, whereas unlocked uses the default behavior and disables the filter each time you switch folders.

How do I filter my photos to show photos fitting certain criteria?

At the top of the Grid view is the Filter bar—if it isn't visible at the top of your Grid view, press the \ key, or go to View menu > Show Filter Bar.

The filters apply to the photos or videos in the current view, so they can be used on a single folder, collection, or a larger set of photos such as the All Photographs collection. Select the folder or other view to set the context before you start applying filters.

Clicking on each of the Filter labels switches between the different Filter bars, and Shift-clicking on the labels shows multiple Filter bars at the same time. If you've already set filter options in one Filter bar, clicking on another, even without holding down the Shift key, will keep that bar in view while opening the other.

The Text filters allow you to search the metadata of each photo for the text of your choice. It replaced the Find panel from Lightroom 1. For

example, searching All Photographs for part of a filename using the Text filters will quickly find that photo in your catalog.

The Attribute filters allow you to filter by flag status, star rating, color label, master/virtual copy status and also videos, for example, all of the master photos with red labels and 2 stars.

The main Attribute filters can also still be found on the Filmstrip for easy access. If your Filmstrip Filters are collapsed, click on the word Filter to expand it to show the full range of options.

The Metadata filters allow you to drill down through a series of criteria to find exactly the photos you're looking for, for example, dates, camera models, and keywords.

To disable the filters temporarily, select the None option, use the keyboard shortcut Ctrl-L (Windows) / Cmd-L (Mac), or Library menu > Disable Filters.

Also check...

*"Saving Presets in
Pop-Up Menus"
on page 166*

If you want to clear them completely, select the Filters Off preset on the right of the Filter bar. You can save your own filters using that pop-up menu too.

Can I save the filters I use regularly as presets?

At the right hand end of the Filter bar is a pop-up menu of default filter presets, and you can add your own by creating your filter and then selecting Save Current Settings as New Preset, as we discussed in the Workspace chapter. Those filter presets will also be accessible from the Quick Filters on the Filmstrip, so it's useful to save your most often used filters, such as 0 stars, 5 stars, as well as sets of column headings and more complex filters.

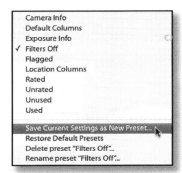

How can I view all of the photos tagged with a specific keyword or keyword combination?

There are multiple ways to filter by keyword, the easiest being the Text or Metadata filters. To quickly show the photos from just one keyword, click the little arrow that appears at the right hand end of the keyword in the Keyword List panel. The Filter bar will open with that keyword already selected and you can add other keywords to the filter.

How do I view only the photos with the parent keyword directly applied, without seeing the child keywords?

If you've temporarily applied the parent keyword 'Animals' to a group of photos, it's not immediately obvious which photos only have 'Animals' applied, and which are tagged with the child keywords 'Dog,' 'Cat' and 'Mouse.'

You can use the Metadata Filter bar to find the photos with 'Animals' directly applied. Click the arrow that appears at the right hand end of the keyword in the Keyword List panel, as a shortcut to the Metadata filters.

At the right hand end of each column header there's a pop-up menu which offers a Flat or Hierarchical view for keywords. If you select the Flat view, the parents keywords will be separated from the child keywords, allowing you to view photos with only the parent keyword 'Animals' applied. If the keyword doesn't appear in the Flat list, it's not assigned directly to any photos.

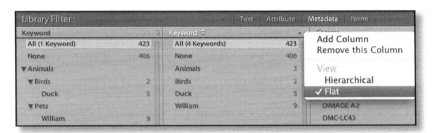

How do I filter my photos to show… just one flag/color label/ rating?

To filter by flags, labels or ratings, use the options in the Attribute filter bar or on the Filmstrip Filters. They're toggle switches, so click the red icon once to add the red labeled photos to your filtered view and click again to remove those red labeled photos from your filter.

The last 2 white and grey color labels are for Custom and No Label. Custom label means that the label name doesn't match a label color in the current Label Set, for example, labels set in Bridge, as we mentioned earlier.

The star ratings have additional criteria to allow 'rating is greater than or equal to,' 'rating is less than or equal to,' or 'rating is equal to,' and they can be accessed by clicking on the symbol to the left of the stars.

Also check…

"I gave my photos different color labels in Lightroom—why are they all white in Bridge? Or I labeled my photos in Bridge— why isn't Lightroom showing my color labels?" on page 194

You can combine the various filters, for example, to show red and yellow labeled photos with exactly three stars, you would set it up as follows:

Can I select all photos with a specific flag, color label or rating without changing the filtering?

If you Ctrl-click (Windows) / Cmd-click (Mac) on the flag, color label or star rating on the main Filter bar or on the Filmstrip, the cursor will change to show that you're selecting rather than filtering, and it will select all of the photos in the current view with that flag, label or rating without changing the filtering.

How can I use the Text filters to do AND or OR filters?

By default, the Text filters are set to Contains All, which means that only photos matching all of the words you type will be shown, but there are a few other options:

- Select Contains from the pop-up menu for an OR filter, such as photos with either 'dog' or 'cat' keywords, including partial matches such as 'doggy,' 'cattle' or 'tomcat.'

- Select Contains All from the pop-up menu for an AND filter, such as photos with both 'dog' and 'cat' keywords, including partial words such as 'do'.

- Select Contains Words from the pop-up menu for an AND filter, such as photos with both 'dog' and 'cat' keywords, but only including whole matching words.

- Select Doesn't Contain from the pop-up menu for a NOT filter, such as photos with the keyword 'dog,' including partial matches such as 'doggy.'

- Select Starts With from the pop-up menu for an OR filter with photos starting with your chosen letters, for example 'cat' would show photos with 'cat,' 'cattle' or 'caterpillar,' but not 'tomcat'.

- Select Ends With from the pop-up menu for an OR filter with photos ending with your chosen letters, for example 'mouse' would show photos with 'mouse' or 'dormouse,' but not 'mousetrap'.

- To combine AND or OR searches with NOT searches, you can add an exclamation mark symbol (!) before the NOT word in the Filter bar, for example to show all photos with the keyword 'mouse', but without 'dog' or 'cat', you would use:

There are some special characters to remember, particularly when creating complex Text filters—a space is AND, ! is NOT, a leading + is Starts With, and a trailing + is Ends With. They only affect the adjacent word, so you would use 'dog !cat !mouse' to find images with dog but not cat or mouse.

Quotation marks don't work, so you can't search for 'John Jack' to exclude photos of another man called 'Jack John.'

How do I change the Metadata filter columns?

Although the Metadata filter columns default to Date, Camera, Lens and Label, you're not limited to searching on those fields. Clicking on the name of each column in the column header shows a pop-up menu of other columns you can use.

Clicking on the button which appears at the right hand end of each column header shows another pop-up menu, which allows you to add and remove columns, up to a maximum of 8. Certain columns, such as the date and keyword columns, offer additional options in that pop-up menu, including a Flat or Hierarchical view. If you need a bit more vertical space to see a longer list of metadata, drag the bottom edge of the Filter bar to resize it.

How do I select multiple options within the Metadata filter columns?

Selecting across multiple columns gives an AND filter, so to search for all photos with both a cat and a dog, you would show 2 keyword filter columns, and select 'cat' in one, and 'dog' in the other. When you select 'cat' in the first column, the second column will update to only show the keywords that are also assigned to cat photos and the photo counts change accordingly.

Ctrl-selecting (Windows) / Cmd-selecting (Mac) or Shift-selecting in the same column creates an OR filter, so to search for all photos with either a cat or a dog, you would have a single keyword filter column, and you would select 'cat' and then hold down the Ctrl (Windows) / Cmd (Mac) key while clicking on 'dog' as well, so that they're both selected. Holding down Shift instead of Ctrl/Cmd will select consecutive keywords rather than separate keywords, so if your keyword column showed 'cat, chipmunk, dog,' clicking on 'cat' and then shift-clicking on 'dog' would include 'chipmunk' in your selection too.

Can I combine Text filters, Attribute filters, and Metadata filters?

As with most tasks in Lightroom, there are multiple ways of combining features, and the filters are no exception. For example, if you wanted to find all of the photos with the word 'dog' somewhere in the metadata, with a red color label, shot in 2010, on a Canon 350d, with 18-200mm lens, and rated above 3 stars, you could combine all 3 filter types.

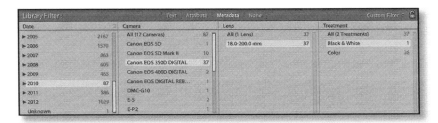

The criteria will filter down in order, from top to bottom and from left to right, and it can be narrowed down further by starting off in a specific folder or collection view.

Even more extensive filtering is available via smart collections, which we'll cover in the next section.

Also check...

"Why would I use smart collections instead of standard collections or filters?" on page 234

How do I search for a specific filename?

To go directly to a photo that you know the name of, select All Photographs in the Catalog panel to search the whole catalog, and then type the filename into the Text filter bar and set it to the All Searchable Field or Filename options in the pop-up menu.

If you want to search for a series of filenames, enter them all into the search field with spaces between the filenames, and change Contains All to Contains. For longer lists, Tim Armes' LR/Transporter plug-in (http://www.lrq.me/armes-lrtransporter) will accept a text file and mark the related photos in your catalog automatically.

SMART COLLECTIONS

Smart collections are like saved searches, smart folders or rules in other programs. Like the Filter bar, smart collections automatically update as files meet, or stop meeting, the criteria you've set, but they allow you to do more extensive filtering than the Filter bar. They also show in the Collections panel in the other modules, which saves switching back to Library repeatedly.

Why would I use smart collections instead of standard collections or filters?

Standard collections, which we discussed earlier in the chapter, require you to manually add or remove photos from the collection, and filters only filter the current view, so you have to remember to switch back to All Photographs to filter the whole catalog, whereas smart collections update themselves without any user-intervention, and once they're set up, you don't have to remember which metadata you used for the filter.

Also check...

"Collections" section starting on page 183

You can combine smart collection criteria with a folder, either by entering that folder name in the smart collection criteria, or on-the-fly by clicking on the folder and Ctrl-clicking (Windows) / Cmd-clicking (Mac) on a smart collection. Doing so limits the context, so the smart collection criteria is only applied to that folder and its subfolders.

How do I create smart collections?

To create a smart collection, click the + button on the Collections panel, and choose Create Smart Collection. Select your chosen combination of criteria, adding additional criteria by clicking the + button at the end of each row.

If you hold down Alt (Windows) / Opt (Mac) while clicking on the + button, you can fine tune it further with conditional rules, which show as indented lines of criteria.

Smart collections, particularly with conditional rules, are ideal for workflow collections. For example, I have an 'Unfinished' smart collection, in case I don't get to finish adding metadata when sorting photos. It holds all of the photos that are both rated and labeled, but are either missing keywords or my name in the Creator metadata field.

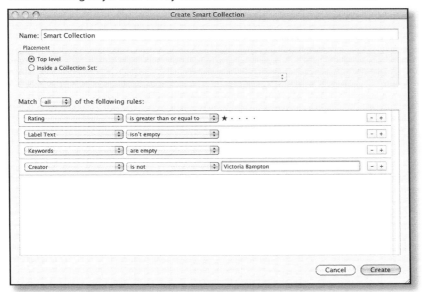

Also check...

"Designing Your Workflow" chapter starting on page 633

As an example of the workflow benefits of Smart Collections, you can download John Beardworth's complete set of workflow smart collections from http://www.lrq.me/beardsworth-workflowsc

How do I find empty metadata fields which don't have an "is empty" option?

There are many occasions where you want to search for missing metadata—for example, 'Title is empty'—but many of the smart collection fields are missing 'Is Empty.' You can work around that, however, by using 'Title doesn't contain a e i o u,' with spaces between each letter, as most words will include one of those letters. If there's a chance you may have used words that wouldn't include those letters, or you're using a field that may have had a code such as y-1, you can take it one stage further and type 'a b c d e f g h i j k l m n o p q r s t u v w x y z 0 1 2 3 4 5 6 7 8 9' with spaces between, to catch every eventuality.

How do I duplicate a smart collection?

If you're creating a set of smart collections with very similar criteria, for example, 5 star photos taken in 2012 and tagged with names of family members, you may want to set up the first smart collection and then duplicate it. In the past, you had to select Export Smart Collection Settings in the context-sensitive menu, followed by Import Smart Collection Settings to create duplicates. In Lightroom 4, you can hold down the Alt key (Windows) / Opt key (Mac) and drag a collection, smart collection, or even a collection set, to a new location in the Collections panel, and a duplicate will be created. You can either drag onto another collection set, in which case a + icon will appear, or you can drag between existing collections so that a line appears.

How do I transfer smart collection criteria between catalogs?

Smart collections, like other collections, are stored within the catalog, so if you want to use them in other catalogs, you need to create them in

each catalog. If they use complicated criteria, that could take a while. Instead, you can right-click on the smart collection and use the Import and Export Smart Collection Settings to export them to individual template files.

Also check...

"How does Export as Catalog work?" on page 305 and "How does Import from Catalog work?" on page 306

If you have many smart collections, even importing and exporting them individually can take a long time. The quickest

solution is to select a single photo, go to File menu > Export as Catalog to create a catalog of the single photo, switch to the target catalog, go to File menu > Import from Another Catalog to pull that tiny catalog into your open catalog. All of your smart collections will automatically be imported at the same time, and then you can remove that temporary photo. We'll go into importing and exporting catalogs in more detail in the next chapter.

How do I automatically add my smart collections to new catalogs?

If you choose to use multiple Lightroom catalogs, and you always create the same smart collection, you can save yourself some work. Export the existing smart collections and change their extension from ".lrmscol" to ".lrtemplate" Then go to Preferences dialog > Presets panel and press the Show Lightroom Presets Folder button. You'll find a folder call Smart Collection Templates—if you add your renamed smart collections in there, they'll automatically be added to any new catalogs. It only works for new catalogs, so the instructions in the previous question are still needed for existing catalogs.

QUICK DEVELOP

The Quick Develop panel applies Develop corrections to your photos, relative to their existing settings. It's useful for applying quick corrections when you're sorting through photos, to decide whether to keep them or not, and it's ideal for applying Develop settings to multiple photos in Grid view.

Why is the Quick Develop panel so useful?

Imagine you've processed a series of photos, each with different settings, and then you decide you would like them all 1 stop brighter than their current settings. The first photo is currently at -0.5 exposure, the next is at 0 exposure, and the third is at +1 exposure.

You could use Synchronize Settings, but that would move the sliders of the selected photos to the same fixed value as the active (most-selected) photo. If you select those photos in Grid view and pressed the >> Exposure button in the Quick Develop panel however, it will add +1 exposure to the existing settings—giving you +0.5 for the first photo, +1 for the second photo, and +2 for the third. The same principle applies to the rest of the settings in the Quick Develop panel, so you can add +5 Black Clipping, remove -20 Contrast, and so forth.

Why am I missing some Quick Develop buttons?

Also check...

"Can I synchronize my settings with other photos?" on page 467 and "Disclosure Triangles" on page 165

The full Quick Develop panel looks like the screenshot on the opposite page, however by default, part of the panel is hidden. Click the disclosure triangles down the right hand side to open it up to show all of the available options.

Why doesn't my Quick Develop panel match the screenshots?

The Quick Develop panel may show Exposure, Recovery, Fill Light, Blacks, Brightness and Contrast buttons, or it may show Exposure, Contrast, Highlights, Shadows, Whites and Blacks, depending on whether the selected photo is set to Process Version 2003/2010 or the new PV2012.

Also check...

"Process Versions" section starting on page 356

Why are some of the Quick Develop buttons unavailable?

If you have multiples photos selected, and some are set to PV2003/2010 and others are set to PV2012, then the Quick Develop panel will disable some buttons. To enable them, select photos with the same Process Version or update all of the photos to PV2012. You can filter for PV2003/PV2010 photos by selecting Library menu > Find Previous Process Version Photos.

Including videos in your selection may also make some of the Quick Develop buttons available. You can filter for those using the Attribute Filter bar.

Can I adjust any other sliders using Quick Develop?

If you hold down the Alt (Win) / Opt (Mac) key, the Clarity buttons temporarily change to Sharpening, and the Vibrance buttons temporarily change to Saturation.

MISSING FILES

At some stage, most people run into worrying question marks denoting missing files, which are usually a result of files being moved or renamed outside of Lightroom, or an external drive being unplugged and changing its drive letter. If that happens, Lightroom can no longer find the photos at their original location and needs pointing back in the right direction.

The file named "20060718-090849.dng" is offline or missing.

Missing files can be identified by a little question mark in the corner of the Grid thumbnail, or if the entire folder can no longer be found, the folder name in the Folders panel will go grey with a question mark folder icon. When you switch to the Develop module or try to export those files, Lightroom will tell you that the file is offline or missing.

Lightroom thinks my photos are missing—how do I fix it?

If Lightroom tells you that files are missing, before you start relinking, first check whether it's only specific files, or whether the folder is missing too.

If the whole folder is missing and the folder name has turned grey, you can right-click on the folder and select Find Missing Folder. Point Lightroom to the new location, and it should update the links for all of the photos contained in that folder and its subfolders, as long as their names haven't changed.

If a whole hierarchy of folders has gone missing, perhaps because the drive letter's changed, you can relink just the parent folder, and it will cascade through all of the other missing files without further interaction. That's why it's useful to set your Folders

panel up as a hierarchy before you run into problems. Alternatively, you could change the drive letter back to the letter Lightroom's expecting.

If only specific files have been moved, click on the question mark icon, and a dialog will appear, 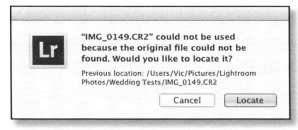 showing the file's last known location. Locate the missing file, and check the Find nearby missing photos checkbox shown in the dialog above in order to try to automatically relink other files in the same folder. Unfortunately if you've renamed the files outside of Lightroom, each file will need linking individually, but there are a couple of workarounds that we'll come back to in a moment.

Why does Lightroom keep changing my drive letters and losing my files?

When using external drives, Lightroom doesn't change the drive letters, but Windows often does. That can confuse Lightroom, requiring you to relink missing files on a regular basis. Leaving the drives plugged in to your computer, or always reattaching them in the same order can help avoid the drive letter changing.

How do I reassign a drive letter on Windows?

If you want to set the drive letter a little more permanently, or reset them if they change, you can go into Windows Disk Management and assign a specific drive letter. You'll need to be logged in as an Administrator. On Windows 7, go to Start menu > Control Panel > Administrative Tools > Computer Management. In either case, Disk Management will then be listed in the left hand panel under Storage. Selecting this will connect to the Virtual Disk Service and will display the drives seen in the main panel.

Find the relevant drive in the list, right-click and there's an option to Change Drive Letter and Paths. Be very careful to ensure you have the correct drive! Selecting Change will display a list of available letters to select from. Selecting a letter outside the range Windows would usually assign automatically helps to reduce the possibility of it changing, so a letter from the latter half of the alphabet is a good choice. When you've finished, press OK, and select Yes when prompted to confirm the drive letter change.

How do I prevent missing files?

Prevention is better than a cure, and preventing missing files will save you some additional work, so there are a few things to look out for...

- Set Lightroom's Folders panel to show the full folder hierarchy to a single root level folder. If a folder is moved from its previous location, or the drive letter changes, it can easily be updated using Find Missing Folder in the right-click context-sensitive menu.

- Move any files or folders within Lightroom's own interface, simply by dragging and dropping around the Folders panel.

- Rename any files before importing into Lightroom, or use Lightroom to rename them. Whatever you do, don't rename in other software once they're imported.

- Don't use Synchronize Folder to remove missing files and import them again at their new location as you'll lose all of your Lightroom settings.

How do I filter for all of the missing files in my catalog?

If you go to Library menu > Find Missing Photos, Lightroom will create a temporary collection of the missing photos so that you can relink them. It doesn't update live, so even after you've located the missing photo, it will still appear in that collection, complete with its question mark badge. The missing photo question mark icons will automatically update

Also check...

"I have a long list of folders—can I change it to show the folder hierarchy?" on page 178 and "Renaming, Moving & Deleting" section starting on page 196 and "How does the Synchronize Folder command work?" on page 181

when you switch to a different folder or collection. You can remove that temporary collection from the Catalog panel at any time by right-clicking on it.

I've renamed the files outside of Lightroom and now Lightroom thinks the photos are missing. Is it possible to recover them?

If you've renamed the files using other software, and Lightroom now thinks they're missing, you have a big job on your hands!

If you have a copy of the files before they were renamed, maybe on a backup drive, you can move the renamed files, and put the originals in their place. Lightroom would then be able to find the original files—and you can rename again using Lightroom's rename facility if you need to do so.

Alternatively, if you wrote the settings to XMP, either manually or by having Automatically write changes into XMP turned on in Catalog Settings, and the program you used to rename was XMP-aware (i.e., it renamed the XMP files to match), then you could just re-import the renamed files into Lightroom. You would lose anything that isn't stored in XMP, but you'll be back in business.

Other than that, you'll need to relink the files one by one, and remember not to do that again!

I've deleted some renamed photos. I do have backups but they have the original filenames, so Lightroom won't recognize them. Is it possible to relink them?

If you've deleted renamed files and your backup filenames don't match, you'll have to relink each photo in turn. That's a long job, but there may be a quicker way.

If your file naming structure is easily reproduced from the metadata, for example, a YYYYMMDD-HHSS filename, you could just import the backup photos into a clean catalog and rename the backups, and

Also check...

"Which of Lightroom's data isn't stored in XMP?" on page 321

then put those backups back where the main catalog is expecting to find them. It's a good reason for using a naming structure that can be reproduced.

If the filename can't be reproduced from metadata, there's another possible option. Look in the Metadata panel, set to the 'EXIF and IPTC' view, and see if Lightroom has an earlier filename in the Original Filename field. If it does, and that matches the names of your backup files, you can use dummy photos to reset Lightroom back to your original names and then relink them.

Lightroom will only rename photos if it has files to rename, but it's possible to trick it. As always, back up your catalog before you try any troubleshooting tips! Find some duplicate photos—you're going to delete them once we're done, so any files of the same format will do—and name them to the same names that Lightroom's expecting to see, either using an empty temporary Lightroom catalog or other renaming software. Obviously this is only quicker if you've used an easy naming format which can be batch renamed!

Now put those photos in the folder that should hold the missing photos, and restart Lightroom or click the question mark to link one of the missing files with the dummy file. The previews may start to update with the wrong photos, but just ignore that. Select all of the photos in Grid view, and go to Library menu > Rename Photos, scroll down to Edit and in the Filename Template Editor, change the naming tokens to Original Filename. Press OK so that the dummy photos are renamed.

By this point, all of the references in Lightroom should now be back to their original filenames, which should match your original filenames on your backup, so you can close Lightroom, delete the dummy photos, and replace them with the original photos from the backup. If you then open Lightroom, hopefully you'll be back to normal, and can rename the photos to your choice of filename. You may want to update the previews by selecting all of the photos and choosing Library menu > Previews > Render Standard-Sized Previews.

Also check...

"How do I rename one or more photos?" on page 196 and "How do I rename photos back to their original filename?" on page 196

Map Module

The Map module is listed after the Develop module in the Module Picker, however since we're already talking about metadata and file management, we'll consider the Map module before moving on.

The Map module is designed for easily adding location data to photos, viewing those photos on a map, and searching for photos by their location. Lightroom uses Google Maps, offering detailed mapping of most of the planet. You don't need any high-tech equipment to use the Map module as Lightroom 4 makes it very easy to assign locations by dragging and dropping the photos directly onto the map. If you have a GPS device, or a smart phone app that creates a tracklog, Lightroom also assists you in linking that with the photos. Any existing GPS data, either added by other programs, or by the camera or phone at the time of capture, are automatically shown on the map.

NAVIGATING THE MAP

When you initially switch to the Map module, you'll be presented with a map of the whole world. The first thing you need to do is find your way around. If you want to try some of these options, select a photo from the Filmstrip and drag it onto the map in any location—you can move it to the correct location later.

How do I zoom in or out?

The quickest way to zoom in is to hold down the Alt (Windows) / Opt (Mac) key and drag a rectangle on the map, enclosing the area you want to view.

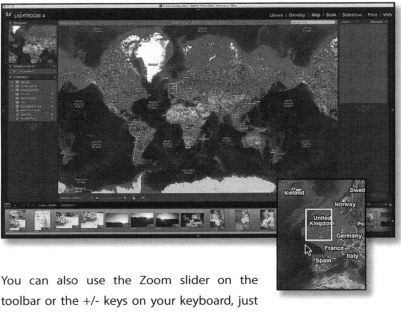

You can also use the Zoom slider on the toolbar or the +/- keys on your keyboard, just like zooming in on photos in the Library module.

The maximum zoom depth is dependent on the map style—the Hybrid, Road Map and Satellite views offer more detail than the Terrain view. It may also vary by location, with big cities showing more detail than less built-up areas. This is dependent on the information available from Google Maps.

How do I switch between different map styles?

On the toolbar is a pop-up menu, allowing you to select an alternative Map Style. The default is the Hybrid style, which is a combination of the Road Map and Satellite views.The Light and Dark options are the Road Map view in alternative color themes.

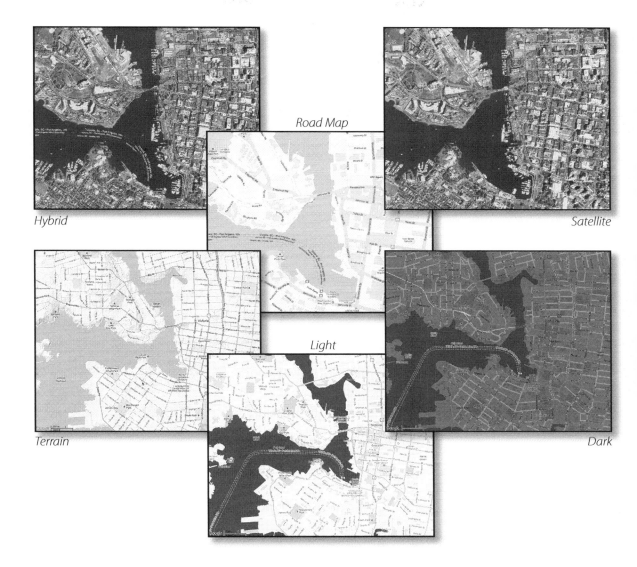

Road Map

Hybrid

Satellite

Light

Terrain

Dark

I closed the marker key—how do I bring it back?

In the lower right hand corner, when you initially open the Map module, is a key showing the different markers. The markers show which locations have photos associated with them.

You can close the key by clicking the X in the corner, and if you want it back, you'll find it under View menu > Show Map Key.

What do the icons mean?

Dark orange shows unselected photo at location.

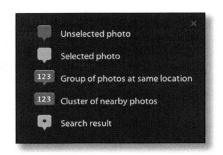

Light orange shows selected photo at location.

Dark orange with numbers shows a group of photos at the same location.

Dark orange with no arrow shows a cluster of photos near to each other, but not actually at the same location—it's mainly seen when you're zoomed out.

Light orange with a black spot shows the search result location.

What's the difference between a group and a cluster of photos?

A group of photos are all shot at the same location, whereas a cluster of photos were shot at different locations near to each other. Single photos and groups of photos will merge into clusters as you zoom out, and split into their individual markers again as you zoom in.

Why are the map markers bouncing?

When you roll over or select a photo in the Filmstrip which is marked on the map, the marker will bounce up and down to help you find its location. It doesn't work for clusters or groups though, due to a Google Maps API limitation.

How do I avoid accidentally moving a marker?

The lock icon on the toolbar prevents you moving existing marker locations. If you've hidden the toolbar, you'll find it under View menu > Lock Markers or the shortcut Ctrl-K (Windows) / Cmd-K (Mac) will also toggle the lock.

Why would I want to turn the marker lock on?

If you accidentally move a marker while navigating the map, you also change the location data for the photo. Assuming you dropped the photos in the right place initially, you'll likely want to leave the markers locked most of the time. With the markers locked, you can still add new photos to the map, and also change the location of existing photos by dragging them from the Filmstrip onto their new location.

Also check...

"Using Saved Locations" section starting on page 258

Why are there circles on my map?

Circles on the map show the range included in your saved locations, and they only appear when a saved location is selected. We'll come back to the purpose of saved locations later in the chapter. If you want to hide the circles, the O key toggles the visibility, or you'll find them under the View menu > Show Saved Location Overlay.

How do I show or hide the Location Name overlay?

In the top right corner of the Map, you'll see an overlay with the name of the current location. Like the Info overlay elsewhere, you can press the I key to show and hide it.

Penzance, England, United Kingdom

How do I view the photos attached to each location marker?

If you hover over a marker, a pop-up shows the photos under that pin. If it's a group or cluster of photos, you can click on the left and right arrows or scroll the mouse wheel to scroll through the photos. If it's slow to show the photos, it's usually because the previews are being rendered.

Also check...

"How do I render previews after importing the photos?" on page 335

When you move away from the marker, the pop-up will automatically be dismissed. If you'd like to fix the pop-up, so that it doesn't automatically dismiss, click on a selected marker (a yellow one) or double-click on an unselected marker (an orange one), and it will stay on screen until you click elsewhere.

How do I find a location on the map?

There are many ways of finding a location on the map, other than the obvious solution of moving around the map until you find it. The search bar in the top right corner of the map view allows you to search for the location. You can search by the name of the location, a zip or postal code, or by coordinates such as 50°44'17" N 1°42'59" W or -33.840663, 151.071579. If there are multiple locations that meet your search criteria, it will show you a list and give you a choice.

Why isn't my location search finding the correct location when I search by name?

If you search for a location and Lightroom doesn't offer the location you're expecting, navigate to the general geographic region and try again. It's reliant on the results that Google Maps returns. For example, if you are viewing the whole world when searching for 'Windsor,' the search results offer a number of places in the United States and Canada.

If, however, you zoom into the United Kingdom, the search results change to include Windsor in the UK.

ADDING LOCATION METADATA USING THE MAP

Once you've found your chosen location on the map, it's time to start adding location data to your photos.

How do I mark photos on the map?

To add a photo to the map—and add location metadata to the photo—you simply drag the photo from the Filmstrip or secondary window onto the map. When you drop it on the map, a marker will appear. You don't have to drop a single photo at a time—selecting multiple photos and dropping them on the map works equally well. Alternatively, you can select the photos, right-click on the correct location on the map and select Add GPS Coordinates to Selected Photos from the context-sensitive menu.

If you have any saved locations, which we'll come back to in the following pages, you can select the photos in the Filmstrip and go to the Saved Locations panel. As you float over the locations in

that panel, a checkbox will appear for each saved location. Clicking in the checkbox will assign the selected photos to the central point of that saved location without having to find it on the map.

How do I add photos to an existing location?

When you find additional photos for the same location, you drag and drop them in exactly the same way. They'll merge into a group automatically.

How do I use the Map Filter bar?

At the top of the map view is the Map Filter bar, offering three ways of filtering photos in the Filmstrip based on their location data.

- Visible on map hides photos that aren't tagged with the current map location.
- Tagged dims the untagged photos, making it easy to spot the tagged ones.
- Untagged dims the tagged photos making it easy to spot the ones who haven't been tagged yet.
- None clears the filtering.

Untagged is particularly useful, as it helps to identify photos that you haven't finished geocoding.

Like the Filter bar in the Library module, press the \ key to show or hide it.

How do I find photos that have no location metadata?

There are a number of ways of searching for photos that have no location metadata, in order to tag them. The Map Filter bar at the top of the map view, mentioned in the previous question, can dim the tagged or

untagged photos. If you're working through your entire back catalog and tagging photos with locations, it can be useful to use the Grid view on the secondary window and use the main Metadata filter set to GPS data to No Coordinates. As you drag photos from the secondary window onto the map, they disappear from view. It works very well as long as you drop them in the right place! If you drop them in the wrong place, press Ctrl-Z (Windows) / Cmd-Z (Mac) to undo and try again.

Also check...

"How do I change the Metadata filter columns?" on page 232

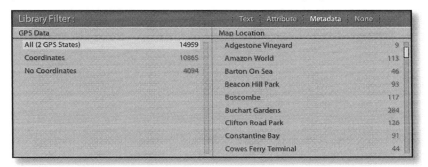

What's the quickest way to add location information to my existing photos?

If you've already been adding location information to your photos, perhaps by marking them with keywords or with IPTC data, you can use the Library module Metadata Filter bar to find and select groups of photos taken at the same location and drag each group of photos onto the map in one go.

ADDING LOCATION METADATA USING TRACKLOGS

A tracklog is a series of GPS locations and timestamps showing when you were at each location. When matched up with a series of photos, it allows you to see exactly where you were when a photo was taken.

Where do I get a tracklog from?

There are many dedicated GPS devices available, some of which track your location and create a tracklog, and others which attach directly to the camera, tagging the photos themselves at the time of shooting.

If you don't have a dedicated GPS device, but you want to use a tracklog rather than adding locations manually, then you can use a smart phone app. For example, Geotag Photos Pro is an iPhone and Android app which can create a GPX tracklog for use with your normal camera. Learn more at their website: http://www.lrq.me/geotagphotosapp They also have a desktop application available, although it's not required as Lightroom only requires the GPX tracklog direct from the phone. GPS tracking using a smart phone will obviously affect your phone's battery life, and be careful to ensure that you don't get caught by high roaming charges when abroad!

Which tracklog formats can Lightroom understand?

Lightroom will import GPX files, which is a standard format for the interchange of GPS data, used by many devices. Many devices, or the desktop applications that come with them, can create GPX files. If your device doesn't offer that facility, you can use GPS Babel (http://www.lrq.me/gpsbabel) to convert the tracklog to a compatible GPX format. Just take care to select the correct format for the input file, and GPX XML for the output format.

How do I import my tracklog?

Lightroom doesn't handle getting the GPX tracklog off the device, so you'll need to do that part of the process yourself. Once the tracklog is on your computer, switch to the Map module and go to Map menu > Tracklog > Load Tracklog. The same menu is accessible from the Tracklog button on the toolbar.

Once the tracklog is loaded into Lightroom, it's broken up into its individual sections, which are listed in the pop-up on the toolbar. You'll see the track marked

in blue on your map, and you can hide tracks by selecting Turn Off Tracklog from the Map menu > Tracklog or via the Tracklog button.

How do I apply a timezone offset?

GPX logs, by definition, are time stamped in UTC (Coordinated Universal Time), whereas photos are usually stamped in local time. Rather than changing the photos to match the UTC time, you can apply a timezone offset to the tracklog. Import the tracklog as before, and select the related photos as if you're going to apply the tracklog. In the Map menu, or under the Tracklog button on the toolbar, you'll find Set Time Zone Offset, and moving the slider in the dialog will allow you to match the photo times to the tracklog times. You don't even need to know what

the time difference was, as the times for both the selected photos and tracklog are shown in the dialog, allowing you to match them. The text in the dialog turns black when a likely match is found based on the selected photos, and turns red when the offset is wrong. Having applied the timezone offset, you can auto-tag the photos.

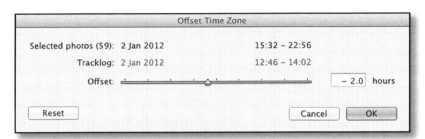

How do I match the tracklog with my photos?

Once the tracklog is showing on the map, you can add the photos. Select all of the applicable photos in the Filmstrip and either via the Map menu, or the Tracklog button on the toolbar, select Auto-Tag Photos. Lightroom will check the photo timestamps against the tracklog timestamps and automatically drop the photos on the map.

My camera time doesn't quite match the tracklog—how do I fix it?

If the photos don't land on quite the right spot, perhaps because your camera timestamp was a few minutes off. Lightroom will allow you to correct the camera timestamp using Edit Capture Time. Turn back to the Library module chapter to learn more, and then correct the time on your camera for future shoots.

You can also match the photos up with the tracklog by manually moving them along the track. Select all of the photos you want to adjust, either in the Filmstrip or secondary window. Choose a photo for which you know the correct location, and click on its thumbnail to make it the active photo, shown by the lightest grey thumbnail border. Drag that

Also check...

"Editing the Capture Time" section starting on page 214

photo from the Filmstrip to the correct position on the blue track line. Lightroom will ask whether to adjust all of the photos or just that photo. When you allow it to adjust all of the photos, it will shift all of the photos along the track using their timestamp to calculate their new locations.

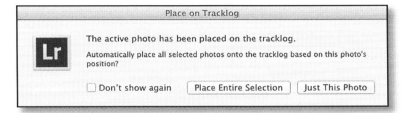

CHANGING LOCATION METADATA

If you make a mistake when adding location metadata, you can easily move the photos to a new location.

How do I move a photo or group of photos to a different location?

To move photos that you've already added to the map, select them in the Filmstrip or secondary window grid view and drag them onto a different location, as if you were adding a location for the first time. If a single pin is in the wrong place, you can also unlock the Marker Lock on the toolbar and drag the single pin to a new location.

Why can't I move a group marker?

You can't drag groups—it's a Google Maps API limitation. You can, however, click on the group marker to automatically select the photos, and then drag them from the Filmstrip to the new location, which will move the marker automatically.

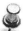

Also check...

"Reverse Geocoding" section starting on page 262

How do I change the location for a single photo which is currently grouped with other photos?

If a photo is currently part of a group, and you don't want to move the entire group, select the photo from the Filmstrip and drop it on the new location. That will separate it from the rest of the group.

How do I delete location information?

To remove location information from photos in the Map module, select the photos and go to the Photo menu, where you'll find 2 delete options. Delete GPS Coordinates removes the GPS data, removes the photo from the map, and removes any unconfirmed IPTC location data that was automatically added using Reverse Geocoding. Delete All Location Metadata does the same, but also removes any IPTC Location data that you've added yourself. If you have multiple photos selected, a dialog will ask whether you want to remove the data from all of the photos or only the active photo.

If you're in the Library module, go to the Metadata menu and ensure that Show Metadata for Target Photo only is unchecked. Select multiple photos in the Grid view and then delete the contents of the GPS coordinates field in the Metadata panel, and perhaps the other IPTC location data too. The photo marker will be removed from the map in the process.

USING SAVED LOCATIONS

Saved locations are like presets for maps, offering a number of benefits:

- They're shortcuts straight to a location, which saves having to search for it.
- You can filter to find photos at that location using the Metadata Filter bar.

- The count shows you how many photos are tagged with that location.

- If you mark a saved location as private, you can selectively remove the location information when exporting photos, while retaining location information on other exported photos.

How do I create a saved location?

To create a saved location, navigate to the location on the map and then click the + button on the Saved Locations panel. Don't worry about getting the size and location exactly right, as you can change those details once the saved location is created. Although the radius slider is measured in kilometers by default, you can also select miles, meters or feet.

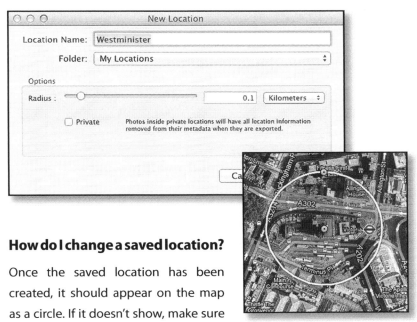

How do I change a saved location?

Once the saved location has been created, it should appear on the map as a circle. If it doesn't show, make sure it's selected in the Saved Locations panel and press the O key to toggle the overlay. At the top of the circle is a dot. If you drag that dot, you change the size of the area included in your saved location. If you need to move it, drag the central spot.

You can rename it, or change the privacy settings, by right-clicking on the saved location in the Saved Locations panel and selecting Location Options to access the Edit Location dialog.

What does the lock icon on the central spot mean?

If there is a small lock icon at the center of saved location circle, it means that you've set that location to private. To change that, right-click on the location in the Saved Locations panel and select 'Location Options' from the menu. The Edit Location dialog includes the privacy setting.

 If a location is Private, any photos taken within the area can selectively have their location data stripped, while retaining location information on other exported photos. For example, you may want to mark the area surrounding your home as private, so that photos uploaded to the web can easily be stripped of your home address.

Can I have saved locations within other saved locations?

You can have saved locations within other saved locations, for example, you may have a saved location which covers a whole country, and another saved location for a specific town or address.

How do I return to a saved location?

To return to saved location, click the arrow at the end of the saved location name in the Saved Locations panel, or double-click on its name.

As you explore the map, you'll also notice that the names of saved locations within the current view light up.

SEARCHING FOR PHOTOS USING LOCATION METADATA

Of course the purpose of adding location metadata is to be able to easily find the photos again later. As usual, Lightroom offers a number of ways of doing that.

How do I find a photo on the map?

If you already have a photo selected and you want to see where it was taken, there are a few shortcuts for finding it on the map. Clicking on the

GPS badge on the thumbnail will take you directly to the location on the map, as will clicking the arrow at the end of the GPS line in the Metadata panel.

Is a Google Map link available for a GPS location of a photograph?

Alt-clicking (Windows) / Opt-clicking (Mac) on the GPS arrow in the Metadata panel will open Google Maps in your default web browser instead of Lightroom's Map module.

How do I filter for all of the photos at a specific location?

If you have a specific location in mind, and you want to find all of the photos taken at that location, there are also a number of options. Of course finding the location on the map and then looking at the pins is the obvious choice! The Visible on Map option in the Location Filter at the top of the map is also useful, as it will remove any other photos from the Filmstrip, leaving only the photos in the current map location.

You can also use the Library module Metadata Filter bar to filter for photos by location. If you've grouped them into Saved Locations, the Map Location criteria will offer a list of the saved locations. Alternatively, if you've manually entered IPTC Location data or turned on reverse

Also check...

"How do I change the Metadata filter columns?" on page 232

geocoding, you can search on the Location, City, State/Province and Country fields.

REVERSE GEOCODING

Reverse geocoding is the process of converting your GPS latitude/longitude data—your map location—into a readable address, which is then entered automatically into the IPTC Location fields. For example, Adobe's Headquarters location may be entered as GPS coordinates of 37°19′52″ N 121°53′36″ W. From those coordinates, Lightroom's reverse geocoding in conjunction with Google Map's API would work out the San Jose address details.

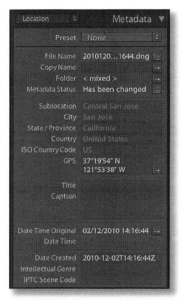

Should I turn on reverse geocoding in Catalog Settings?

If you turn on reverse geocoding, Lightroom sends the GPS coordinates to Google, so that they can return the address. Only the coordinates are sent, without any personal information, but you must decide whether you're comfortable with that.

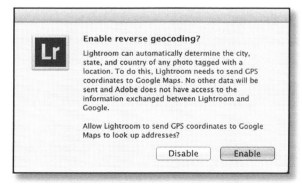

Enable reverse geocoding?

Lightroom can automatically determine the city, state, and country of any photo tagged with a location. To do this, Lightroom needs to send GPS coordinates to Google Maps. No other data will be sent and Adobe does not have access to the information exchanged between Lightroom and Google.

Allow Lightroom to send GPS coordinates to Google Maps to look up addresses?

Disable Enable

That permission is stored for each catalog individually, so you can have different settings for each catalog, and you can disable it again by going to Catalog Settings > Metadata tab and unchecking the Reverse Geocoding checkboxes.

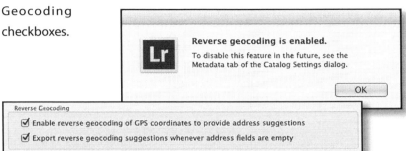

Will reverse geocoding overwrite my existing location data?

Lightroom will only calculate location data if the Location fields (Sublocation, City, State/Province, Country or Country Code) are all empty. If you've already entered data in any of those fields, the reverse lookup will be skipped.

I've just turned on reverse geocoding—how do I trigger the reverse geocoding for existing photos?

Reverse geocoding will be performed automatically on any photos tagged with GPS coordinates but missing IPTC Location data, even if they were tagged before importing into Lightroom. There may be a slight delay while it works through the backlog of photos.

What happens if I turn off reverse geocoding and then turn it on later?

If you turn off reverse geocoding or refuse it initially, and then decide to turn it on later, the location data may not show in the Metadata panel immediately. Carry on working as normal, and the reverse geocoding lookup will run in the background, gradually updating your photos with missing data.

Why is reverse geocoding not working?

If you're dropping photos on the map and nothing's appearing in the Metadata panel Location fields, there are a few possibilities to check:

- Go to Catalog Settings > Metadata tab and ensure that 'Enable reverse geocoding of GPS coordinates to provide address suggestions' is checked. If you've only just turned it on, leave it for a while to catch up or restart Lightroom to trigger the lookups.

- Check that you have internet access and there isn't a firewall preventing Lightroom from accessing Google Maps. If you can navigate around the map in the Map module, that's probably fine.

- Check that you don't already have some user-entered location metadata. If any of the Location fields contain data, the reverse geocoding lookup for that photo will be skipped.

- If Google sees the same IP address hit it for more than 100,000 requests per day, it will stop sending responses until the next day.

How do I wipe existing location metadata as a batch to replace it with reverse geocoded data?

If you want to use reverse geocoding, but some Location fields already have manually entered data, you'll need to clear that data before the lookup will work. You could manually remove all of the data, but it's quicker to do as a batch process.

Go to the Metadata panel and select Edit from the Preset pop-up. Uncheck all of the checkboxes, with the exception of the Sublocation, City, State/Province, Country and ISO Country Code fields in the IPTC Image section. When you check those fields, the field names will go red and the fields will say 'Type to add, leave blank to clear.' Leave them blank, and save preset as a 'Clear Locations' preset using the pop-up at the top of the dialog.

In Grid view, make sure that the photos are selected and choose your new Clear Locations preset from the Metadata panel. All of the manually

entered data will be removed and will be replaced by reverse geocoded address data instead.

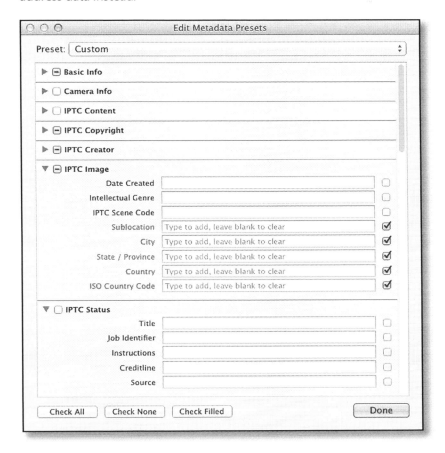

Also check...

"How do I create a Metadata preset?" on page 202 and "Saving Presets in Pop-Up Menus" on page 166

Is it possible to connect certain IPTC fields or keywords with each GPS location, so adding images would automatically populate that data?

At the time of writing, you can't attach keywords or other metadata to a location, apart from the automatic reverse geocoding for the IPTC Location fields. You can use the location data to filter the photos, so that you can manually add keywords or other metadata based on the location.

How do I make the reverse geocoded data permanent?

IPTC Location data created by reverse geocoding is shown in the Metadata panel as grey text, instead of white, and it's also italic on Windows. It's not fixed, so if you move the map marker to a new location, that data will also update. If you want to fix that data, as if you'd entered it manually, click on the field label and on the pop-up that appears. If it's incorrect, you can type something different in the Location fields. Once you've done so, the metadata will become white. It will then be included

when writing to XMP, as if you'd entered it all manually. There isn't a way of committing the location data as a batch process, however.

SAVING LOCATION METADATA TO THE FILES

All of the location metadata that you add in Lightroom will be stored safely in your Lightroom catalog. In addition, you can choose whether to write that information back to the original files, and also to any exported photos.

Can I save my location metadata in the files?

Also check...

"Why are the Location fields dimmed or italic?" on page 203

If you write metadata back to the files using Metadata menu > Write Metadata to Files, it's stored in a format called XMP. We'll come back to that in more detail in the next chapter. That data will include the GPS longitude and latitude data, whether it's been created by dragging and dropping or via a tracklog. The IPTC Location data will only be included if it's been committed—white instead of grey text—and not if it's simply reverse geocoded.

In Catalog Settings > Metadata tab, there's an 'Export reverse geocoding suggestions whenever address cells are empty.' That applies to exported files, rather than writing metadata to xmp in the originals. It controls

whether the uncommitted IPTC Location data is included in exported files, or whether only manually entered or confirmed Location data is included. Why might you choose not to include Google's guesses? They have been known to be wrong on occasion!

Can I prevent location metadata being included in exported files?

When you come to export the files, the location data will be included unless you choose to strip it. There are a number of ways you can strip the location information to protect your privacy. In the Export dialog, there's a Remove Location Info checkbox, which removes both the GPS coordinates and the IPTC Location data for all of the photos in the export. You can also selectively remove specific locations by encircling the private photos in a Saved Location and marking them as private.

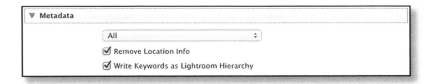

TROUBLESHOOTING THE MAP MODULE

There's a limited number of things that can go wrong with the Map module, but there are a couple of potential issues to be aware of.

What limitations does the Map module have?

Lightroom's Map module does have some limitations, for example, in 4.0, the elevation/altitude is not included.

If the Map module has whetted your appetite for geocoding, you may be interested in Jeffrey Friedl's Geocoding plug-in, which offers further options and features including altitude, enhancing Lightroom's own facilities. You can download it from http://www.lrq.me/friedl-geocoding

Why does it say "We have no imagery here" or "Map is Offline"?

The Map module requires internet access to be able to view the maps, and Google's terms of service don't allow Adobe to cache that information. If internet is offline or a firewall is blocking access to Google, it says "We have no imagery here" and then "Map is Offline." When you reconnect to the internet, the Map module will automatically reconnect to Google's maps.

Why can't I import my tracklog?

If your tracklog won't import, check that it's a supported file type. Lightroom only currently supports GPX files natively. If you used GPSBabel to convert the file, try reconverting from the original format, double checking your settings. There's also a 10mb tracklog file size limit on Mac, which could prevent the file from importing, but no equivalent limit on Windows. It may be possible to open the tracklog in a text editor and split it into multiple files, or Jeffrey Friedl's Geocoding plug-in can handle larger tracklogs.

Working with Catalogs

Many of Lightroom's features are dependent on its database backbone, and wouldn't be possible using a simple file browser. Amongst other things, Lightroom can create virtual copies, store extensive edit history for each image, and track information on settings for books, slideshows, prints and web galleries and their associated photos, all of which depend on the database. Searching image metadata (EXIF, keywords, etc.) is also much faster as a result of the database, and Lightroom can search for photos which are offline, as well as those currently accessible. Each catalog is a separate database containing all this information. Adobe produced Bridge for those who prefer a browser setup without these additional cataloging features.

MANAGING CATALOGS

When you first open Lightroom, it needs to create a catalog in which to store your work. If you've never used Lightroom before, and therefore there are no existing preferences or catalogs, it will ask you for a catalog name and location. By default, it puts the catalog in your user account Pictures folder and calls it 'Lightroom 4 Catalog.lrcat.' If you select the Choose a Different Destination button, you can choose a different name and location for the new catalog.

Also check...

"Should I use one big catalog, or multiple smaller catalogs?" on page 279

Even if you use the default settings, you can later rename and move your catalog to another location of your choice, and you can also switch back and forth between multiple catalogs, although we'll come back to the pros and cons of multiple catalogs in a moment.

How do I create a new catalog and switch between catalogs?

If you hold down the Ctrl key (Windows) / Opt key (Mac) while opening Lightroom, a dialog will appear, asking you to open an existing catalog, or you can create a new catalog with the name and location of your choice.

If Lightroom's already running, you can also create a new catalog using File menu > New Catalog, or open an existing catalog using File menu > Open Catalog.

How do I find my catalog on the hard drive?

If you have Lightroom open, go to Edit menu > Catalog Settings (Windows) / Lightroom menu > Catalog Settings (Mac) and under the General tab is the location of your catalog. Pressing the Show button will open an Explorer (Windows) / Finder (Mac) window, taking you directly to that location.

If you can't open Lightroom, perhaps because of catalog corruption, then you'll need to use your operating system's search facility to search for files with a *.lrcat file extension.

> *Also check...*
>
> *"The default location of the Lightroom catalog is..." on page 654*

Why do I have a few different files for my catalog?

If you use Explorer (Windows) / Finder (Mac) to find view the catalog on your hard drive, by default in your My Pictures (Windows) / Pictures (Mac) folder, you'll see a few different files.

LR4 Previews.lrdata

LR4.lrcat

LR4.lrcat-journal

LR4.lrcat.lock

*.lrcat is the catalog/database which holds all of your settings. That's LRCAT for Lightroom Catalog, not IRCAT, as it's often mistaken for.

*.lrdata contains the previews. It's made up of lots of little preview files, with multiple different size previews for each photo. On Windows, those previews are stored within a series of folders and subfolders, and on a Mac, they're within a package file.

If Lightroom is open, you may also have a couple of additional files.

*.lrcat.lock is a lock file that protects the database from being corrupted by multiple users attempting to use it at the same time. If Lightroom is closed and the lock file remains, you can safely delete it. It can sometimes get left behind if Lightroom crashes, and it will prevent you from opening the catalog again.

*.lrcat-journal is a very important file that you never want to delete—it contains data that hasn't been written to the database yet, perhaps because Lightroom's crashed, so when Lightroom opens, the first thing it does is check for a journal file to update any incomplete records.

What does the catalog contain?

Let's start with what the catalog doesn't contain... it doesn't contain your photos. Remember, the photos are stored on your hard drives as normal image files. The catalog contains links to those image files and other metadata—that's information about the photos, including the EXIF data from the camera, any IPTC data, keywords and other metadata you add in Lightroom, and also any Develop changes you make in Lightroom, all of which are stored as text instructions.

Is there a maximum number of photos that Lightroom can hold?

There's no known maximum number of photos you can store in a Lightroom catalog. Theoretically, your computer might run out of address space for your photos between 100,000 and 1,000,000 photos, although there are many users running catalogs of more than 100,000 photos, myself included. My largest catalog is now running at 800,000 photos, so it's definitely possible.

If your catalog's stored on a FAT32 formatted hard drive, 2GB is the maximum file size allowable on that drive format, so your catalog could

hit that limit, but then you could always move the catalog onto a drive formatted as NTFS on Windows or HFS on Mac.

Also check...

"Speed Tips" section starting on page 344

Is there a maximum number of photos before Lightroom's performance starts to degrade?

There's no magic number of photos before performance declines—it depends on the computer specification. Many people are running catalogs of a few hundred thousand photos. Browsing or filtering the All Photographs collection may be slower as it's searching a larger number of photos, but general browsing and work shouldn't be badly affected by the larger catalog size, as long as it's optimized regularly. Backup may also take longer due to the larger catalog file size.

Is there a maximum image size that Lightroom can import?

The maximum image size that Lightroom 4 can import is 65,000 pixels along the longest edge, or up to 512 megapixels—whichever is smaller. A photo that is 60,000 x 60,000 is under the 65,000 pixel limit, but it still won't import as it's over the 512 megapixel limit. As most cameras range between 8-36 megapixels, that's only likely to become an issue for huge panoramic or poster shots created in Photoshop.

Can I move or rename my catalog?

You can move or rename the catalog in Explorer (Windows) / Finder (Mac) as if you were moving or renaming any other file, but don't forget to close Lightroom first.

Ideally you should also move or rename the previews folder so that it reflects the new name of the catalog too. If you don't rename the previews correctly, Lightroom will simply recreate all of the previews. No harm done except for the time involved, although if you have offline files, previews for those photos won't be recreated until they're next

online. If Lightroom creates previews with a new name, you may want to delete the old previews file to regain the drive space.

So, for example: Lightroom Catalog.lrcat —> New Name.lrcat Lightroom Catalog Previews.lrdata —> New Name Previews.lrdata

When you next come to reopen Lightroom, hold down Ctrl (Windows) / Opt (Mac) to navigate to the renamed catalog, or just double-click on the catalog file. You may need to change the default catalog so it opens the correct catalog automatically in future.

How do I set or change my default catalog?

By default, Lightroom opens your last used catalog, however you can change that behavior in Lightroom's Preferences > General tab. You can choose to open a specific catalog, open the most recent catalog, or be prompted each time Lightroom starts.

If you have it set to open a specific catalog, or the most recent catalog, you can override it and view the Select Catalog dialog by holding down Ctrl (Windows) / Opt (Mac) while starting Lightroom.

How can I remove everything I've done and start again?

If you're just getting started with Lightroom, you may be 'playing,' and then decide to start again with a clean slate for your primary catalog. Rather than deleting everything from the catalog, consider storing that catalog somewhere safe, in case you want to go back to it, and create a new catalog using File menu > New Catalog. Storing the old catalog as a compressed zip file would prevent you from accidentally using it, and also reduces the size considerably.

If you do decide to delete the old catalog, simply find it in Explorer (Windows) / Finder (Mac) and delete the *.lrcat and * Previews.lrdata files, and any related backups too, if you wish.

What general maintenance will keep my catalogs in good shape?

Under the File menu, you'll find Optimize Catalog. That command checks through your catalog, reorganizing your database to make it run faster and more smoothly.

For the more technically minded, over the course of time, with many imports and deletes, the data can become fragmented and spread across the whole database, making Lightroom jump around to find the information it needs, so Optimize Catalog runs a SQLite VACUUM command to sort it all back into the correct order, bringing it back up to speed.

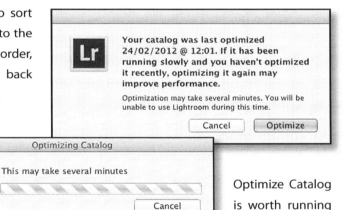

Optimize Catalog is worth running whenever you've made significant database changes, such as removing or importing a large number of photos, or any time you feel that Lightroom has slowed down. You'll also find a checkbox in the Back Up Catalog dialog to automatically run the optimization each time you back up your catalog.

Besides looking after the catalog itself, regular computer maintenance can help—defragmenting the hard drives regularly if you use Windows, making sure there's plenty of free space on all working drives, and so forth. And don't forget to back up regularly!

Also check...

"Should I turn on 'Test integrity' and 'Optimize catalog' each time I back up?" on page 296 and "Making and Restoring Backups" section starting on page 290

Why can't I open my catalog?

If you can't open your catalog, there are a few possible reasons. Firstly, Lightroom requires read and write access to the catalog file, so it may show an error message that says "The Lightroom catalog cannot be used because the parent folder ... does not allow files to be created within it" or "Lightroom cannot launch with this catalog. It is either on a network volume or on a volume on which Lightroom cannot save changes." If you see either of those errors, check your folder and file permissions as they're probably set to read-only. It may not be the catalog folder specifically that has the wrong permissions, but possibly a parent folder. Also check your catalog location—it can't be on read-only media, such as a DVD, a network drive, or an incorrectly formatted drive, such as trying to use an NTFS drive on a Mac. On Windows, there are additional security layers which can cause similar issues.

If the file permissions are correct, check the catalog's folder for a *.lrcat.lock file. If Lightroom's closed, it shouldn't be there, so you can safely delete it. They sometimes get left behind if Lightroom crashes. Remember, if there's a *.lrcat-journal file, don't delete that journal as it contains data that hasn't been written back to the catalog yet.

Finally, Lightroom might give a warning about the catalog being corrupted. That can be a little more serious, so we'll cover that in more detail in the next section.

CATALOG CORRUPTION

Lightroom's catalogs are basic databases, so it is possible for them to become corrupted, even though it's relatively rare. You have nothing to fear from keeping all of your work in a single catalog, as long as you take sensible precautions.

How do catalogs become corrupted?

Generally speaking, corruption happens as a result of the computer

crashing, kernel panics, or power outages, which prevent Lightroom from finishing writing to the catalog safely.

Catalogs also become corrupted if the connection to the drive cuts out while Lightroom is writing to the catalog, for example, as a result of an external drive being accidentally disconnected. Some external drives drop their connection intermittently for no known reason, so it's safest to keep your catalog on an internal drive if possible.

How can I keep my catalogs healthy and prevent corruption?

A little bit of common sense goes a long way in protecting your work.

- Back up regularly, and keep older catalog backups.
- Always shut your computer down properly.
- Don't disconnect an external drive while Lightroom is open.
- Keep the catalog on an internal drive if possible.
- Turn on Test integrity and Optimize catalog in the Backup dialog to run each time you back up.

Lightroom says that my catalog is corrupted—can I fix it?

If Lightroom warns you that your catalog is corrupted, it will also offer to try to repair it for you. In many cases the corruption can be repaired automatically, but it depends on how it's happened.

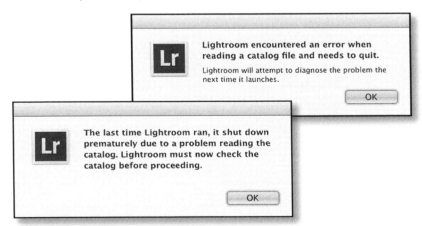

Also check...

"I have a problem with Lightroom—are there any troubleshooting steps I can try?" on page 649 and "How do I restore a catalog backup?" on page 298

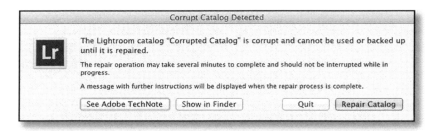

If the catalog repair fails, restoring a backup is your next step, which we'll cover in detail later in the chapter. You can also try moving the catalog to a different drive, which can solve some false corruption warnings.

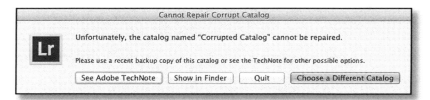

If you don't have a current backup catalog, there are a few rescue options you can try, which involve using Import from Catalog to transfer the uncorrupted data into a new catalog. Usually the corruption is confined to one or two folders that were being accessed when the catalog became corrupted, so working through methodically can usually rescue almost all of your data. It's worth a shot!

1. Close Lightroom and duplicate the corrupted catalog using Explorer (Windows) / Finder (Mac) before you proceed with rescue attempts, just in case you make it worse.

2. Create a new catalog, as we covered on the previous pages and then go to the Catalog Settings dialog and set the backup interval to 'Every time Lightroom exits.' You can change this back again later, but it saves you starting again from the beginning if you pull some corrupted data into the new catalog.

3. Go to File menu > Import from Another Catalog and navigate to the corrupted catalog. If it will get as far as the Import from

Catalog dialog box, select just a few folders at a time to import the records into your new catalog.

4. Between imports, close and reopen Lightroom, so that a new backup is created, and the integrity check runs to ensure that your new catalog hasn't become corrupted.

5. Repeat the process until each of the folders are imported from the corrupted catalog. If you hit another corruption warning, go back a step, restore the previous backup, and make a note of the folders you had just imported, skipping them. If you were importing chunks of folders, you may be able to narrow it down to a single folder or even specific photo's records that contain the corrupted data.

6. Once you've finished, and you have a working catalog again, select all of the photos and go to File menu > Export as Catalog and export the whole lot to a new catalog, which will help to clear any orphaned or unexplained data.

Of course, having current backups would have prevented all of this work, so you'll want to make sure that your backups are current in future!

Also check...

"Are there any limitations when importing and exporting catalogs?"
on page 308

SINGLE OR MULTIPLE CATALOGS

Since version 1.1, Lightroom has made it easy to create and use multiple catalogs, but the question is, just because you can, should you? We'll consider some of the pros and cons, and how to make it work if you do decide that multiple catalogs are right for you.

Should I use one big catalog, or multiple smaller catalogs?

There's no 'right' number of catalogs. As with the rest of your Lightroom workflow, it depends on how you work. So should you use multiple catalogs for your main working catalog, or should you split your photos into multiple catalogs? We're not referring to temporary catalogs which

are created for a purpose, for example, to take a subset of photos to another machine before later merging them back in, but more specifically your main working or master catalog.

The main benefit of keeping all of your photos in a DAM (Digital Asset Management) system is being able to easily search through them and find specific photos, but there are a few other pros and cons to consider.

Pros of Multiple Catalogs	Cons of Multiple Catalogs
• Smaller catalogs may be faster on low spec hardware. • Multiple catalogs give a clear distinction between types of photography, i.e., work vs home. • If multiple users need to be working on photos at the same time, it's easier to track individual catalogs.	• Can't search across multiple catalogs. • Potential variation in metadata and keyword spellings. • Harder to track backups. • Have to keep switching catalogs. • Some photos not in any catalog. • Duplicate photos in multiple catalogs by accident.

There are few questions to ask yourself:

- How many photos are you working on at any one time? And how many do you have altogether?

- How fast is your computer—can it cope with a huge catalog at a reasonable speed? Or does it run much better with a small catalog?

- Do you want to be able to search through all of your photos to find a specific photo? Or do you have another DAM system that you prefer to use for cataloging your photos?

- If you decide to work across multiple catalogs, how are you going to make sure your keyword lists are the same in all of your catalogs?

- If you use multiple catalogs, is there going to be any crossover, with the same photos appearing in more than one catalog?

- How would you keep track of which photos are in which catalog?

- Do you want to keep the photos in your catalog indefinitely or just while you're working on them, treating Lightroom more like a basic raw processor?

- How would you keep track of catalogs and their backups?

Your answers will likely depend on your reasons for using Lightroom. For some people, using multiple catalogs isn't a problem—they already have another system they use for DAM, and they want to use Lightroom for the other tools it offers. For example, some wedding photographers may decide to have a catalog for each wedding, and if they know that a photo from Mark & Kate's wedding is going to be in Mark & Kate's catalog, finding it really isn't a problem. But then, if you had to find a photo from a specific venue, or to use for publicity, you'd have to search through multiple catalogs.

Many high-volume photographers need the best of both worlds—a small fast catalog for working on their current photos, and then transferring them into a large searchable archive catalog for storing completed photos. That's certainly another viable option, and a good compromise for many.

There are some easy distinctions, for example, you may also decide to keep personal photos entirely separate from work photos. Those kind of clear-cut distinctions work well, as long as there's never any crossover between the two. Keeping the same photo in multiple catalogs is best avoided, as it becomes very confusing! The more catalogs you have, the harder they become to track.

Can I search across multiple catalogs?

Lightroom doesn't allow you to search across multiple catalogs, or even have multiple catalogs open at the same time, so you would have to open each in turn. It's one of the biggest disadvantages to having multiple catalogs, so you might want to consider merging them back into one larger catalog if you often need to search through different catalogs.

How do I set default Catalog Settings to use for all new catalogs?

Certain settings are catalog-specific, primarily the Identity Plates, anything set in the Catalog Settings dialog, smart collections and keyword lists. Lightroom doesn't currently provide a way of making those settings available to new catalogs as templates, however there is a workaround. Set up a new empty catalog with the settings of your choice and save it somewhere safe. Whenever you need a new catalog with all of your favorite settings, simply duplicate that template catalog using Explorer (Windows) / Finder (Mac) instead of using File menu > New Catalog.

I seem to have 2 catalogs. I only use 1, so can I delete the other?

If you appear to have a spare catalog, it's probably a good idea to open it before you delete it, to check that you definitely don't want to keep it. To do so, either use File > Open Catalog or double-click on the catalog in Explorer (Windows) / Finder (Mac). You can safely delete the spare catalog and its previews files as long as you're sure there are no settings in it that catalog that you need, or if in doubt, delete the previews (*.lrdata), zip the catalog (*.lrcat) and keep it somewhere safe.

How do I split my catalog into multiple smaller catalogs?

If you need to split an existing catalog into smaller catalogs, you can use Export as Catalog.

1. Select the photos in Grid view and go to File menu > Export as Catalog, or right-click on a folder or collection and select that option from the context-sensitive menu.

2. Choose the name and location of the new catalog in the Export as Catalog dialog. We'll come back to the other checkboxes later in the chapter.

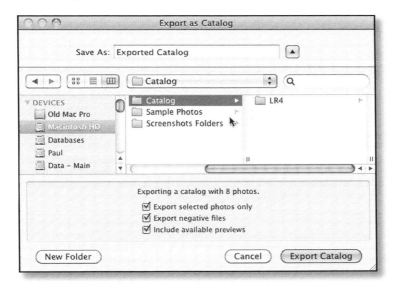

3. Once the export has completed, open that new catalog to check that everything has transferred as expected.

4. (Optional) Switch back to the original catalog and remove those photos from the catalog. Make sure you've backed up the catalog first, if you're going to remove files from the catalog, just in case you find you've made a mistake.

Also check...

"How does Export as Catalog work?" on page 305 and "Are there any limitations when importing and exporting catalogs?" on page 308

How do I merge multiple catalogs into one larger catalog?

If you want to merge your existing catalogs into one large catalog, it's simply a case of using Import from Catalog to pull the data into a new combined catalog.

1. Select File menu > New Catalog and create a clean catalog which will become your new combined catalog.

2. Go to File menu > Import from Another Catalog and select one of the smaller catalogs.

3. Repeat the process for each of the other smaller catalogs until you've imported them all.

4. Keep the individual catalogs at least until you're sure that everything's transferred correctly.

Be careful if some of the same photos appear in more than one catalog. Choosing the 'Create virtual copies' option in the Import from Catalog dialog will create virtual copies of each of the different sets of settings, so you can go back through later and decide which to keep. We'll cover the Import from Catalog options in more detail in the Working with Multiple Machines section.

How do I transfer photos between catalogs?

It's just as easy to transfer photos between catalogs, for example, from a small working catalog into a large archive catalog.

1. Open your Archive catalog, or create one if you haven't done so already.

2. Select File menu > Import from Another Catalog, and navigate to the Working catalog. In the Import from Catalog dialog that follows, select the folders that you want to transfer into your Archive catalog, deselecting the others.

3. Import those folders into your Archive catalog and check that they've imported as expected.

Also check...

"How does Import from Catalog work?" on page 306 and "Working with Multiple Machines" section starting on page 305

4. Close your Archive catalog and open your Working catalog again.

5. Make sure you have a current backup, before you start removing photos from a catalog, just in case you make a mistake.

6. Select the photos that you've just transferred.

7. Press the Delete key to remove those files from the Working catalog, being careful to choose 'Remove from the catalog' rather than 'Delete from the hard drive.'

Repeat the process whenever you want to transfer more photos into the Archive catalog.

I have multiple catalogs with duplicate photos and I've been working in all of them—how do I untangle the mess?

Let's assume, for the sake of argument, that you have a complete tangle. Somehow you've ended up working in a backup catalog rather than your main catalog, at one stage you thought multiple catalogs would be a good idea so you started extra catalogs by topic, and you have a couple of other mystery catalogs on a laptop too. Some of the photos are duplicated in more than one catalog, but you're not sure which are the most recent edits on some of those photos. The photos are spread across multiple different locations, and some photos don't even seem to appear in any of the catalogs. Yes, it's a mess. So where do you start trying to clean up?

First things first, you need to sit down and assess exactly what you have to work with. It's checklist time! Make a list of all of the catalogs and their locations. Their 'last modified' date can be seen using Explorer (Windows) / Finder (Mac) and may offer an additional clue about which hold the most recent edits. You might like to move all of the catalogs to one location for simplicity. Make sure all of your backups are current, just in case you make a mistake. That's photo backups as well as catalogs.

Next, open each catalog in turn and look at the contents. Which photos are included in the catalog? Are they duplicates of another catalog? Do you remember when you last edited them? If you're not sure, don't worry, we'll come to duplicates in the next step.

Before we can start untangling, it would help to have everything in one place. Go to File menu > New Catalog and create a clean catalog and store it somewhere safe. This will become your new working catalog.

Go to File menu > Import from Another Catalog and import from each catalog in turn, ideally working from the oldest to the newest. Remember we checked the 'last modified' date earlier? This is where it may help! There are a couple of settings to look out for in the Import from Catalog dialog...

- Set 'New Photos—File Handling' to 'Add new photos to catalog without moving' as we'll come back to their locations later.
- Set 'Changed Existing Photos—Replace' to 'Metadata & develop settings only'
- Make sure 'Preserve old settings as a virtual copy' is checked

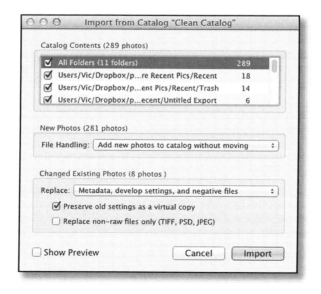

Also check...

"How does Import from Catalog work?" on page 306

Repeat the process on each of the catalogs, until your new working catalog contains the data from all of the tangled catalogs. There will likely be numerous duplicates, but now we can start tidying up. Back up the catalog at this point, because we're going to start removing photos.

There's no point complicating the task with photos that haven't been touched in Lightroom, so we'll remove those from the catalog and import them back later.

Create a Smart Collection (Library menu > New Smart Collection) and set it to the following settings...

- Has adjustments—is false

- Rating—is 0

- Pick Flag—is unflagged

- Label Color—is none

- Title—doesn't contain a e i o u (or extend to all letters of the alphabet and numbers, if you think that might miss some)

- Caption—doesn't contain a e i o u

Is there anything else you might have done to the photos? The aim is to find and select all of the unedited photos. Having created the Smart Collection, check that none of those photos appear in Collections or have any other metadata that you'd object to losing. Once you're happy that you wouldn't be losing work, you can select all of the photos and go to Photo menu > Remove Photos from Catalog. Don't delete from the hard drive—just remove from the catalog—as we'll import the photos back into the catalog once we've sorted all of the duplicates.

Next, it's time to hunt down any missing files. Look down the Folders panel, looking for any missing folders, and choose Find Missing Folder from the right-click menu. Navigate to the new location of that folder, if you know where it's now stored. Once you've completed the missing folders, go to Library menu > Find Missing Photos and Lightroom will create a collection of the leftover individual missing files. You'll then need to click on the question mark on each of the photos and find those on your hard drive too.

The photos left in the catalog should all have some kind of edits, but there's a good chance there are duplicates. If you don't have too many, you could scroll through and manually choose which to keep, removing the other photos. If a virtual copy has the correct settings, you can promote it to master using Photo menu > Set Copy as Master, and then remove the virtual copy. The aim is to remove all of the duplicates that were created by the multiple catalogs, keeping just the ones with the right settings. If you have hundreds or thousands of photos, you might appreciate a helping hand—the Duplicate Finder plug-in (http://www.lrq.me/keir-duplicatefinder) can find duplicates based, not only on their filename, but also on metadata such as the capture time. You still have to then sort through the duplicates and choose which of the copies to keep though!

Once you've finished selecting which photos to keep, removed the duplicate virtual copies and found the missing files, you should have a clean tidy catalog. It's then time to import all of the unedited

Also check...

"Lightroom thinks my photos are missing—how do I fix it?" on page 240

photos—not just the ones we removed earlier, but also any other photos scattered across your hard drive. When you import the photos, check 'Don't import suspected duplicates' in the File Handling panel of the Import dialog. We'll come back to extra duplicates later.

At this point, run the Duplicate Finder plug-in again, just in case you've just imported duplicates that had been renamed, which Lightroom's duplicate checking won't necessarily detect. Again, remove any duplicates from the catalog.

The final stage of imports is to detect files that are real duplicates on the hard drive, so that we can move them into a separate folder or delete them from the hard drive. Create a folder using Library menu > New Folder and name it 'Duplicates,' or something along those lines. Now import from the same folders again, with 'don't import suspected duplicates' unchecked. This should import any photos that weren't already in a tangled catalog, or that we removed as duplicate files in the previous step. Importing them in one go makes them easy to find and select. Select them in the Previous Import collection and drag them to the Duplicates folder you created. Once you've confirmed that these are unnecessary duplicate files, you can delete them from the hard drive, although I'd recommend backing them up first, just to be on the safe side.

Still with me? At this stage, your catalog should be clean and tidy, with one of each photo. If you look in the Folders panel, however, you might find you have photos spread in untidy folders and across different locations. You could leave them there, but it's easier to back up if they're in a single location. You can create new folders and drag and drop folders and files around using the Folders panel. Just remember that you'll be moving the files on the hard drives. If you want to move the photos into dated folders, create the dated folder manually. Select All Photographs in the Catalog panel, and then use the Metadata filter to select photos by year or month, and drag them into the dated folders.

Also check...

"How do I move or copy photos between folders?" on page 197

Also check...

"XMP" section starting on page 320

When I used ACR I only kept the XMP files archived—can't I just do that?

If you've previously used ACR or another raw processor that created sidecar settings files, and you have another DAM system, then you do have the option of removing photos from the catalog and just keeping the XMP settings files instead. Not all of Lightroom's information is stored in XMP, as we'll discuss later in the chapter, so just double check that you won't be deleting something you need. Don't forget, you will be missing out on the benefits of Lightroom's cataloging facilities.

Lightroom doesn't write to XMP by default, so you'll need to either enable Automatically write changes into XMP in Catalog Settings > Metadata tab, or select all of the photos in Grid view once you've finished editing and press Ctrl-S (Windows) / Cmd-S (Mac) to manually write the settings to XMP.

MAKING AND RESTORING BACKUPS

We've already said that catalog corruption is always a risk with any database, so sensible backups are essential. Lightroom's backup system can take care of versioned catalog backups, but there are other files that you'll also want to include in your own backups, most notably the photos themselves.

I'm going to repeat myself a few times on one essential point— Lightroom's catalog backup does not include your original image files—it only backs up the catalog containing metadata about the

photos. I regularly hear from people who have deleted their original photos, thinking that Lightroom has them backed up, and I don't want to hear that you've fallen into the same trap.

When considering your backup system, don't limit the backups to attached hard drives, because viruses, theft, computer malfunctions, lightning strikes, floods, and other similar disasters could wipe out all of your backups along with the working files. Online backups are an option if you have a fast internet connection, or there's always the lower tech solution of leaving backup DVDs or external hard drive with a friend or family member. NAS (network attached storage) units are an option for onsite backups, although they still won't protect you if a disaster affects your house.

The true test of a backup system is how easily you can restore from those backups and continue working in the event of a disaster. Hopefully your only backup restores will be intentional, perhaps because of moving to a new computer or reinstalling the operating system, but it's important to test your system and make sure that you know how to restore everything back to normal, just in case.

I run my own backup system—do I have to let Lightroom run backups too?

You don't have to let Lightroom run its own backups if you have a solid backup system, but be very careful if you choose to turn them off. Lightroom's backups create versioned backups and are primarily protection against catalog corruption, whereas many backup programs just back up the latest version and could overwrite an uncorrupted copy with a corrupted one, which would defeat the object. Each time Lightroom backs up a catalog, it creates a folder named with the date and the time of the backup, for example, '2012-03-06 2100,' so previous backups aren't overwritten or automatically deleted.

Also check...

"Lightroom appears to be corrupting my photos—how do I stop it?" on page 134

Does Lightroom back up the photos as well as the catalog?

Lightroom's own backups are simply a copy of your catalog, placed in a folder named with the date and time of the backup. The catalog only contains references to where your photos are stored, and information about those photos, so you must ensure that you're backing up your photos separately, including any derivatives edited in other software, for example, photos retouched in Photoshop. File synchronization software, such as Vice Versa (http://www.lrq.me/viceversa) for Windows or Chronosync (http://www.lrq.me/chronosync) for Mac, makes it very easy to keep a mirrored backup on another drive without wrapping your photos up in a proprietary backup format. Many, including the 2 programs mentioned, can verify your data during the transfer, as most file corruption happens while copying or moving files between hard drives.

How do I back up Lightroom?

Ideally you'll be running a full system backup, but as far Lightroom is concerned, there are a few essentials to ensure you've included:

- The catalog(s) (*.lrcat extension)—holds all of the information about your photos, including all of the work you've done on the photos within Lightroom.

- The catalog backups—just in case your working catalog is corrupted.

- The previews (*.lrdata extension)—these would be rebuilt on demand as long as you have the original photos. If you have available backup space, backing them up would save time rebuilding them, and if you deleted your original photos accidentally, they may be the only copy left. If you run a versioned backup system, which keeps additional copies each time a file changes, you may want to exclude the previews as they change constantly and will rapidly fill your backup hard drives.

- The photos—in their current folder structure, in case you ever have to restore a backup. You'll want to include your edited files too.

- Your presets—includes Develop presets, Slideshow, Print and Web templates, Metadata presets, Export presets, etc.

- Your defaults—includes Develop default settings and Lens Profile defaults, which are shared with ACR.

- Your plug-ins—includes export plug-ins, web galleries and any other extensions that you may have downloaded for Lightroom. Don't forget to keep their serial numbers somewhere safe too.

- Your profiles—includes any custom camera profiles and lens profiles that you've created.

- Your camera raw & lens profile default settings

- The preferences file—includes last used catalogs, last used settings, view options, FTP settings for uploading web galleries, some plug-in settings, etc. The preferences could be rebuilt if necessary, but you would save yourself some time by backing them up and restoring them.

You'll find the default locations of all of those files in the Useful Information chapter at the end of this book. If you've saved all of those files and you ever have to restore from your backups, you can simply return those files back to their correct locations, open your catalog, and carry on working as if nothing has happened.

Matt Dawson's LR Backup plug-in makes it very easy to back up most of those files into a single location, as long as they're stored in the standard user locations. You can download it from: http://www.lrq.me/photogeek-backup

I back up photos using the Import dialog—isn't that enough?

The Make a Second Copy option in the Import dialog has improved in recent versions—if you rename in the Import dialog, the backup copies

Also check...

"Default File Locations" section starting on page 654 and "Where should I store my plug-ins?" on page 529

Also check...

"What does the 'Make a Second Copy' option do?" on page 92

will also now have those new names. The folder structure of those copies, however, won't match the folder structure within Lightroom, and any renaming or deleting that you later do within the Library module won't be updated in the backups either. Should you ever have to try to restore from those backups, you'd have a very time-consuming job reorganizing all of the photos, which would be best avoided. It's safer to consider those Second Copy backups as temporary backups while you make sure that the newly imported photos are added to your normal backup system.

How often should I back up my catalog?

You can change the backup interval in the Catalog Settings dialog. The interval between backups depends on how much you'd be willing to lose if something went wrong. If losing a week's work would be your worst nightmare, set it to back up every day, or even more often, for example, every time Lightroom exits. If, on the other hand, you only use Lightroom to edit a few photos every few weeks, a monthly backup interval may be better suited to your requirements.

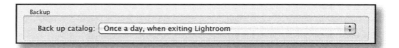

How do I run a catalog backup on demand?

You may want to run a backup on demand, perhaps because you've done a large amount of work and your backup isn't scheduled to run for a few days. Go to Catalog Settings > General panel and change the backup frequency to 'When Lightroom next exits' and then close Lightroom so that the backup can run. When you reopen that catalog, it will automatically revert to your normal backup schedule.

Where does Lightroom save the backups?

By default, Lightroom saves the backups in a Backups subfolder next to the original catalog. That's a fairly logical place, as long as those folders are also backed up to another drive by your primary backup system. However it won't help if those are your only catalog backups and your drive dies.

Also, because those backup catalogs have exactly the same name as their original, some people have opened one of the backup catalogs and accidentally started using that as their working catalog, ending up in a bit of a tangle. If you think that might happen to you, change the backup location to another drive, or another backup folder elsewhere on the same drive, so as to avoid confusion.

How do I change the backup location?

The backup directory is changed in the Back Up Catalog dialog, which appears when a backup is due to run. If you need to show the Back Up Catalog dialog to change the location, when a backup isn't normally due, you can run a backup on demand. To do so, go to Catalog Settings > General panel and change the backup frequency to 'When Lightroom next exits.' Close Lightroom so that the backup dialog appears, and then you'll be able to change the backup location.

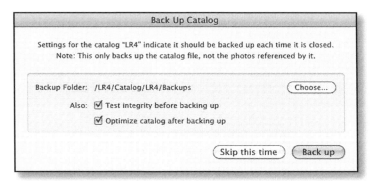

Also check...

"What general maintenance will keep my catalogs in good shape?" on page 275

Should I turn on 'Test integrity' and 'Optimize catalog' each time I back up?

In the Backup dialog, there are two important checkboxes, which are worth leaving turned on. 'Test integrity before backing up' will check that the catalog hasn't become corrupted and attempts to repair any problems and 'Optimize catalog after backing up' tidies up and helps to keep your catalog running smoothly and quickly.

Can I delete the oldest backups?

You can safely delete all but most current backups if you wish, however it would be sensible to open the last couple of backups to ensure that they're not corrupted, before you delete the earlier versions.

Alternatively you could zip them into compressed folders. They compress very well, massively reducing the file sizes. They aren't zipped by default, because if a zip file becomes corrupted, there's little chance of retrieving the catalog inside without corruption. It's a reasonable compromise for older backups however, particularly if you're considering deleting them to reclaim hard drive space.

Is it safe to have Time Machine back up the catalog?

Due to way Time Machine works, trying to back up the catalog file while it's open may result in the backup being corrupted. It's safest to exclude your active Lightroom catalog from the Time Machine backups, or only turn on Time Machine with Lightroom closed. Allowing Lightroom to run its own backups, and setting Time Machine to back up those backup files is a safe alternative.

You may want to consider excluding the previews file (* Previews.lrdata) from a Time Machine versioned backup, as that will take large amounts of storage because it's constantly changing. Those previews can be recreated from the original files, as long as the original files have been safely backed up.

I'm worried about keeping all changes in one catalog—are there any other options?

As long as you're sensible about backups, then you have nothing to fear from keeping your data in a single catalog. However if you like a belt-and-braces approach to backup, you could also write most of your data to XMP, which is stored in the header of JPEG/TIFF/PSD/DNG files and in sidecar files for proprietary raw files. XMP doesn't hold all of the information that's stored in the catalog, but as the XMP is stored with the image files, it has been known to save the day on occasion. We'll come back to XMP in more detail.

Also check...

"XMP" section starting on page 320 and "How do I create a new catalog and switch between catalogs?" on page 270

I haven't got time to back up now—can I postpone the backup?

In the Back Up Catalog dialog, which appears when a backup is due to run, you have the options to either skip this time, which postpones the backup until the next time you close the catalog, or skip until tomorrow, or whatever other time period you've chosen for your backups. Don't be tempted to skip it too often, or you could find yourself without a recent backup.

How can I quickly back up recent changes without waiting for my huge catalog to back up?

If you have a huge catalog and only a small part of it has changed, you may want to only back up those changes. Although Lightroom's backup facility always backs up the whole catalog, you can use Export as Catalog to back up smaller folders or collections.

Why does Lightroom say it's unable to backup?

If Lightroom says it hasn't been able to back up your catalog, there are a few possibilities to check:

Also check...

"How does Export as Catalog work?" on page 305

- Check the backup location—is that drive accessible and does that folder still exist?

- Check the folder permissions for the backup location—do you have write access?

- Is there enough space on the drive?

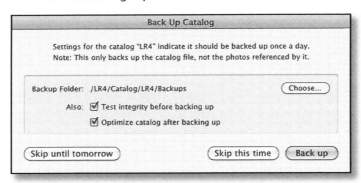

If everything looks correct, try changing the backup location, and if that works you can try changing it back again.

How do I restore a catalog backup?

Lightroom's backup simply makes a copy of your catalog and places it in a dated subfolder, so restoring the catalog is simply a case of opening that backup file. Let's be a little more cautious though—you wouldn't want to risk damaging your last good backup.

First, if you're restoring a catalog after corruption, find your existing corrupted catalog and rename it, move it or zip it up somewhere safe. That's only the *.lrcat file at this stage. The previews may be unaffected, and if there are continued problems, then you can delete the *.lrdata previews file and they'll be rebuilt from the original files.

Now copy (not move!) your last good backup from the backups folder and paste it into the main catalog folder, so that the *.lrcat replaces the corrupted catalog that was there before.

Also check...

"Lightroom says that my catalog is corrupted—can I fix it?" on page 277 and "Lightroom says my preview cache is corrupted—how do I fix it?" on page 343

Double click to open the copy of the backup, or hold down the Ctrl (Windows) / Opt (Mac) key to show the Select Catalog dialog. If everything's now working correctly, you can delete the corrupted catalog and you should be ready to continue working.

How do I restore everything from backups?

If you're having to do a complete restore, perhaps because your hard drive has died or you're reinstalling the operating system, then ideally you've got a solid backup system, and you can simply put the catalog, photos, and other files back exactly where they were, double-click on the catalog (*.lrcat file) to open it, and carry on working as before. We'll go into more detail on those options in the Moving Lightroom to a New Computer section, as it's the same process.

If you don't have quite such a straightforward restore option, for one reason or another, then you'll need to restore as much as you do have backed up. Copy (not move!) the catalog and photos back to your computer from the backup drives, keeping an identical folder hierarchy for the photos if you possibly can. For example, if your photos were in dated folders, within year folders, and you put them back in a folder called Pictures, with subfolders for different people's names, you're going to have a long job ahead.

Now double-click on the catalog (*.lrcat file) to open it, and survey the damage! Are there question marks on any of the folders or photos? If so, those photos are no longer in the location that Lightroom is expecting, and you need to update the links to point to the new location, as we discussed at the end of the Library chapter. Once you've finished relinking any missing files, you can then get back to working normally.

If you're reading this before your hard drive dies, prevention is better than cure, so now is an excellent time to make sure that your backup system would be easy to restore in the event of a disaster.

Also check...

"Moving Lightroom to a New Computer" section starting on page 302

Also check...

"Lightroom thinks my photos are missing—how do I fix it?" on page 240

Also check...

"XMP" section starting on page 320

If I'm restoring from backups, does the catalog or the XMP data take priority?

Even if you've written to XMP as a belt-and-braces backup, the catalog will always take priority, and the XMP will be ignored. Only if you import the photos into a new catalog, or you use the Metadata menu > Read Metadata from Files command, would the XMP metadata be used.

MOVING LIGHTROOM ON THE SAME COMPUTER

The time may come when you run out of space on your hard drive and need to move Lightroom to a new home on a bigger hard drive.

Before you do anything else, follow the backup procedures outlined in the previous sections, including backing up your catalog, presets, preferences and photos, and most importantly, setting up your catalog folder hierarchy. It will save a lot of headaches. Having done so, it's time to transfer. If you're simply moving between hard drives on the same computer, your preferences and presets can stay in their current location, as they won't be affected.

How do I move only my catalog to another hard drive, leaving the photos where they are?

If only your catalog is moving, and the photos are remaining in their existing locations, you can close Lightroom and move your catalog using Explorer (Windows) / Finder (Mac). When Lightroom next launches, it won't be able to find the catalog, so select the Choose a Different Catalog button in the Select Catalog dialog, or double-click on the catalog (*.lrcat file) in Explorer (Windows) / Finder (Mac) to open it directly. As none of the file locations should have changed, you should be able to continue working without further issues.

How do I move only my photos to another hard drive, leaving the catalog where it is?

If you need to move photos to another hard drive, perhaps because you've outgrown your existing hard drive, there are a number of options, but these are the easiest:

Option One—move in Explorer/Finder and update Lightroom's links

1. First follow the instructions in the Library chapter to show the folder hierarchy. That will make it easy to relink the files that will be marked as missing in the process.

2. Close Lightroom and use Explorer (Windows) / Finder (Mac) or file synchronization software to copy the files to the new drive.

3. Check the files have arrived safely, and then rename the original folder using Explorer (Windows) / Finder (Mac) temporarily, while you confirm that you've reconnected everything correctly.

4. Open Lightroom and right-click on the parent folder.

5. Select Find Missing Folder or Update Folder Location from the list, depending on which option is available.

6. Repeat the process for any other parent folders until all of the photos are shown as online, without question marks.

7. Once you've confirmed that everything has transferred correctly, you can safely detach the old hard drive or delete the files from their previous location using Explorer (Windows) / Finder (Mac).

Option Two—move the photos using Lightroom's Folders panel

1. Go to Library menu > New Folder.

2. Navigate to the new drive and create a new folder or select an existing folder where you plan to place the photos. This option only works if you select an empty folder, or you import one of the photos in the folder you select.

3. Drag the folders and/or photos onto that new location.

Also check...

"I have a long list of folders—can I change it to show the folder hierarchy?" on page 178 and "Lightroom thinks my photos are missing—how do I fix it?" on page 240

Also check...

"Does Lightroom back up the photos as well as the catalog?" on page 292

4. Check that the entire folder contents have copied correctly before deleting the originals, particularly if you're dragging and dropping the photos themselves, rather than the folders. Remember that Lightroom might not move/copy files that aren't currently in the catalog, such as text files, as Lightroom won't know that they exist.

Personally I prefer to use the first option when moving between hard drives, because file synchronization software, which we mentioned earlier in the backup section, allows me to verify that all of my files have moved correctly, byte-for-byte. File synchronization software will allow you to do a one-off copy, as well as proper drive synchronization.

How do I move my catalog & photos to another hard drive?

If you need to move both the catalog and the photos to a new hard drive, you can use the same steps as moving each individually.

There's another option which has been recommended in the past, which involves using Export as Catalog to create a new catalog and duplicate photos on the other hard drive, and then deleting the existing catalog and photos. There are, however, a few risks in using that option, as not all data is included when using Export as Catalog. We'll discuss those limitations in more details in the Working with Multiple Machines section.

Also check...

"How does Export as Catalog work?" on page 305 and "Are there any limitations when importing and exporting catalogs?" on page 308

Export as Catalog is better suited to exporting work temporarily to another computer and then importing back into the main catalog later, rather than moving whole catalogs.

MOVING LIGHTROOM TO A NEW COMPUTER

When the time comes to move to a new computer or reinstall the operating system, it's essential that all of your files are backed up safely, as you wouldn't want to lose anything. Making a clone of the drive is

always a good plan if you have that option, just in case you find that you missed files from your backups.

How do I move my catalog, photos and other Lightroom files to a new computer?

Firstly, you need to make sure that all of the essentials are backed up—the catalogs, photos, preferences, presets, profiles, defaults, plug-ins and any other related files. We covered these in detail in the earlier Backup section. If you're wiping the hard drive in the process, rather than running both machines at the same time, it's even more important to make sure that you don't miss anything.

For extra security, you may choose to write most of your settings to XMP in addition to your catalog backups. To do so, select all of the photos in Grid view and press Ctrl-S (Windows) / Cmd-S (Mac). That stores your most crucial settings with the files themselves, which can be useful if you make a mistake.

It's a good idea to make sure that Lightroom's Folders panel shows a tidy hierarchy before you back up the catalog. This makes it very easy to relink the files if the relative folder location, or the drive letter for an external drive, changes. We covered those instructions earlier in the Library chapter. It's especially important if you're moving to a different operating system.

Once everything's safely backed up, we're ready to set Lightroom up on the new computer. There's no need to install Lightroom from the CD and then run the updates, as the downloads on Adobe's website are the full program. You can just download the latest version or trial, and then enter your serial number(s). If your license is an upgrade version, you may need the serial number from an earlier version as well as the Lightroom 4 serial number.

Transfer the files—the catalog, the photos, preferences and so forth—and place them in the same locations as they were on the old computer.

Also check...

"Making and Restoring Backups" section starting on page 290, "Where should I store my plug-ins?" on page 529 and "XMP" section starting on page 320

Also check...

"I have a long list of folders—can I change it to show the folder hierarchy?" on page 178

Also check...

"Lightroom thinks my photos are missing—how do I fix it?" on page 240 and "Plug-ins" section starting on page 526

If you're moving from Windows to Mac or vice versa, some of the new file locations will change. The locations for the preferences, presets and profiles, are listed in the Useful Information chapter.

Then it's time to open the catalog. Double-click on the *.lrcat catalog file to open it, or hold down Ctrl (Windows) / Opt (Mac) to show the Select Catalog dialog when launching Lightroom and navigate to the catalog.

You might find that there are question marks all over the photos and folders because they're no longer in the same location, but don't be tempted to remove them and re-import, and don't try to relocate by clicking on a thumbnail question mark icon as you'll create a bigger job. Instead, right-click on the parent folder and choose Find Missing Folder from the context-sensitive menu, and navigate to the new location of that folder. Relocate each top level folder in turn, until all of the photos are online.

Finally, you might find your plug-ins need reloading as the locations may have changed in the move. Go to File menu > Plug-in Manager and check whether all of the plug-ins have green circles. If any plug-ins are incorrectly loaded or missing, add them again at their new locations.

How do I move my catalog & photos from Windows to Mac or vice versa?

Also check...

"I have a long list of folders—can I change it to show the folder hierarchy?" on page 178

The process of moving your catalog cross-platform is exactly the same as moving to a new machine of the same platform. If you're transferring between platforms, it's even more important that you set Lightroom to show the folder hierarchy to make it easy to relink missing files, as Windows works with drive letters and Mac OS X works with drive names.

There's just one other main thing to look out for—the Mac OS can read natively Windows NTFS formatted drives, but can't write to them, and

Windows can't read or write to Mac HFS formatted drives. If you're going to use your external drives with a different operating system, you may need to reformat them at some stage, after having copied the data off safely to another drive, of course. If you're constantly moving between Mac and Windows, consider formatting transfer drives as FAT32, or using additional software such as NTFS for Mac (http://www.lrq.me/ntfsmac) and HFS for Windows (http://www.lrq.me/hfswin) that will allow either operating system to have read/write access regardless of drive format.

WORKING WITH MULTIPLE MACHINES

Many photographers today are working between multiple computers, most often a laptop and a desktop. Lightroom isn't networkable, but it does allow you to split and merge catalogs to move parts of catalogs easily between computers, and it allows you to work with offline photos on the road too.

How does Export as Catalog work?

Export as Catalog allows you to take a subset of your catalog—perhaps a folder or collection—and create another catalog from those photos, complete with your metadata, and the previews and original files too, if you wish. You can then take that catalog to another computer, and merge it back in to your main catalog later.

To split your catalog using Export as Catalog, you first need to decide which photos you want to include in the export. You can export any selected photos using File menu > Export as Catalog, or a folder or collection from the right-click context-sensitive menu, using the Export Folder/Collection as Catalog commands, and then in the Export as Catalog dialog, choose a location for your newly exported catalog.

You have the option to 'Include available previews', which will export the previews that have already been rendered. This is important if you're exporting a catalog subset to take to another computer, and you won't

Also check...

"Should I use one big catalog, or multiple smaller catalogs?"
on page 279

be taking the original files with you, otherwise you'll just have a catalog full of grey thumbnails.

The resulting catalog is a normal catalog, just like any other. If you've chosen to 'Export negative files', there will also be one or more subfolders containing copies of your original files, in folders reflecting their original folder structure. If you don't include the original files, and you take the catalog to another computer, there will be limitations, which we'll come back to in the following pages.

You can transfer that catalog to any computer with Lightroom 4 installed, and either double-click on it, hold down Ctrl (Windows) / Opt (Mac) on starting Lightroom, or use the File menu > Open Catalog command to open it.

Having finished working on that catalog, you can later use Import from Catalog to merge it back into your main catalog again.

What are the limitations of offline files?

If you choose not to take the originals when you're working on another machine, you'll still be able to do Library tasks as long as you have previews—labeling, rating, keywording, creating collections, etc., and you can also view slideshows. With those originals offline, you won't be able to do anything that requires the original files—working in the Develop module, exporting files, moving files between folders, and similar tasks—until the original files are available again. If you're going to want to zoom in on any of the photos, you'll need to render 1:1 previews before exporting the catalog, or take the originals along too, otherwise the previews may be too small.

How does Import from Catalog work?

Import from Catalog allows you to take a whole catalog, or part of it, and merge that into another existing catalog, enabling you to transfer photos between catalogs without losing your image data. If you've

taken part of your catalog out using Export as Catalog, it allows you to merge those changes back into your main catalog again.

First, open the target catalog that you want to merge into. Select File menu > Import from Another Catalog, and navigate to the source catalog, from which you want to pull the metadata. Lightroom reads the source catalog and checks it against the target catalog, resulting in this Import from Catalog dialog:

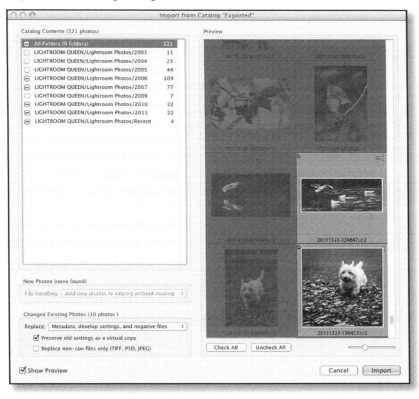

Depending on the choices you make, new photos are imported into the target catalog, either added at their existing locations if the original files are already on the same computer, or being copied to a folder of your choice in their current folder hierarchy.

Photos that exist in both catalogs are checked for changes, and only those that have updated metadata will be updated in the target catalog.

Also check...

"Snapshots & Virtual Copies" section starting on page 417

Photos that are identical in both catalogs are dimmed, as you won't need to update those.

Lightroom can either replace just the metadata and settings, or replace the original image files too. You also have the option to replace originals on rendered (not raw) files only, as you may have done additional retouching on other formats. Unless you've worked on the files themselves in another program, for example, retouching in Photoshop, then you can usually just copy the settings.

If you're concerned about accidentally overwriting the wrong settings, Lightroom can create a virtual copy with your current settings as well as updating the settings on the master.

Are there any limitations when importing and exporting catalogs?

I should give one word of warning about the catalog import/export process—a small amount of metadata is not included when importing and exporting catalogs. That includes:

- Any files that are stored in the selected folders, such as text documents which aren't referenced in Lightroom's catalog, will not be included in the exported catalog/folder.

- Your keyword list in the exported catalog would only include keywords that have been applied to those selected photos, and unused keywords would be purged.

- Publish Services settings and collections are tied directly to their original catalog and are not transferred by Export as Catalog.

- Some plug-ins store data in undefined areas of the catalog, which may not be transferred by Export as Catalog.

It's possible to transfer your full keyword list using the Metadata menu > Export/Import Keywords commands. There's also a workaround for transferring Publish Services collections between catalogs, using a

plug-in called LRVoyager. http://www.lrq.me/alloy-lrvoyager As with many things, it's simply a case of weighing the pros and cons.

I need to work on my photos on my desktop and my laptop— what are my options?

If you need to work on multiple machines, you have 3 main options:

- A single portable catalog—you place your catalog and photos on an external hard drive, and plug it into the machine that you're going to use at the time.

- Photos are stored in a network-accessible location, and your catalog is copied to each machine when changes are made, possibly automated using file synchronization software or Dropbox.

- Split and merge catalogs using Export to Catalog and Import from Catalog, ideally using one computer as a base (usually the desktop) and taking smaller catalogs out for use on the secondary computer (usually the laptop).

- Use XMP to transfer settings between computers—however some data isn't stored in XMP.

We'll consider the most common scenarios in greater detail…

How do I use a portable catalog with originals, for example, the whole catalog on an external drive with the photos?

If you regularly work between different machines and your entire collection of photos is small enough to fit on a portable hard drive, then the simplest solution is to move your entire catalog and all of its photos onto a portable external hard drive, which you can then plug into whichever machine you want to use at the time.

It does have disadvantages, for example, external hard drive speeds are usually slower than internal drives, so you'd want to choose a fast connection, such as the new Thunderbolt, eSATA or USB 3.0 connections

Also check...

"How does Export as Catalog work?" on page 305 and "Which of Lightroom's data isn't stored in XMP?" on page 321

Also check...

"Catalog Corruption"
section starting
on page 276

if possible. There's a slightly greater risk of corruption when the catalog is stored on an external drive, as they're more likely to become disconnected while you're working. You also need to consider your backup strategy, as small external drives are at a higher risk of being lost, stolen, or dropped. If you work on multiple platforms, you may need to relink the files each time you switch computers, as Windows uses drive letters whereas Mac OS X uses drive names.

How do I use a portable catalog without originals, for example, the whole catalog copied without the photos?

If your entire photo collection is too large to fit on an external drive, but you still want access to your catalog on multiple machines for metadata updates, moving only the catalog and its previews to the external drive is another possibility. Alternatively, you could copy the catalog onto the other computer, but if you have 2 working copies of the same catalog, it becomes a little harder to track. If you remember to copy the catalog back to the main computer before you swap machines, it works, or you can use Import from Catalog to merge the changes back again.

As the original files will be offline, the work you can do in Lightroom is more limited, but it works well for adding keywords or general browsing. You'll want to ensure that you've rendered at least standard-sized previews before copying the catalog, and if you plan on zooming in, you'll want 1:1 sized previews.

Also check...

"What's the difference
between Minimal,
Embedded &
Sidecar, Standard
and 1:1 previews?"
on page 333

Keeping the original photos on a network drive or NAS unit would allow you to access the originals from other computers on the same network, having copied the catalog, although the data transfer rate is often slower.

Can I share my catalog between 2 computers using Dropbox?

It is possible to keep your catalog in sync on 2 computers, by copying the catalog, the previews, and possibly even the photos themselves into your Dropbox folder, although there are a few things to be aware of...

- It's not supported by Adobe—if you do try this, make sure you keep good backups, as Dropbox has been known to cause problems with some file types and Lightroom's catalogs are largely untested in this situation. My personal catalog has been running on Dropbox for more than a year without issue, but that doesn't mean it's without risk.

- Make sure that the catalog isn't changed on 2 computers at once, as one of the catalogs would become a 'conflicted copy' in Dropbox. You need to allow time for the catalog to be completely downloaded, before you open it on the other computer.

- Other files would need synchronizing too—presets, custom camera and lens profiles, etc. We'll come to those instructions later in this section.

- Think about where you'll keep the photos. If they're on a server or shared drive that can be accessed from either computer, then your photos would always be accessible.

- While working in Lightroom, either pause Dropbox sync, or copy the catalog and previews to another location. If you don't, Dropbox will churn constantly, trying to stay up to date with all of the preview changes. The previews file/folder changes considerably, and would therefore use a lot of bandwidth uploading the changes each time. Alternatively, the latest Dropbox releases allow you to selectively sync files, so you could exclude the previews file/folder if the original photos will be accessible from both computers, although you would then need to build previews on each machine.

How do I upload and start editing on my laptop, and then transfer that back to the main catalog?

If you choose to upload and start editing your photos while out on a shoot, it's simplest to create a new catalog on the laptop, just for those photos. When the time comes to merge those into your master catalog

Also check...

"XMP" section starting on page 320

on your desktop, you can copy the catalog and the photos over to the desktop and use File menu > Import from Another Catalog to merge those photos into the main catalog.

If your editing has been limited to ratings or other data stored in XMP, you could alternatively write the settings to XMP sidecars next to the original files, copy just the files back to the desktop, and import those photos as usual. We'll come back to the limitations of XMP later in the chapter.

How do I export part of my catalog to another computer and then merge the changes back later?

Export as Catalog allows you to take a subset of your main catalog out with you, with or without the original files, and carry on working on the photos, merging the changes back into your main catalog later using Import from Catalog.

* Select the photos that you want to take with you, and use the File menu > Export as Catalog command to create a smaller catalog of those photos. Exporting directly to a small external hard drive is usually the simplest solution.

* Make sure you set it to 'Include available previews', and if you want to be able to work on the original files, for example, making changes in Develop module, select 'Export negative files' too.

* Moving to your laptop, plug in the external hard drive, open that new catalog that you've just created into Lightroom by double-clicking on the *.lrcat catalog file.

* Work as normal on the exported catalog.

* When you get back to your desktop computer, connect the external hard drive, or transfer the catalog back to the desktop computer, and select File menu > Import from Another Catalog.

* Navigate to the catalog you've been working on, select it and the Import from Catalog dialog will appear.

- As the photos will already be in your main working catalog, it will ask you what you want to do with the new settings—you can choose whether to just update the metadata or, in the case of retouched files, copy those back too.

- Once you've confirmed that the catalog has updated correctly, you can delete the smaller temporary catalog.

Can I use Lossy or Reduced Resolution DNG files to take smaller originals offsite?

If you're taking files offsite but have limited hard drive space, perhaps on a laptop, and you usually use DNG files, then the new Lossy DNG format could help. This workflow isn't supported by Adobe yet, so it's a manual process and may require a little trial and error to perfect.

As in the previous question, use Export as Catalog to export the chunk of catalog that you want to work on. If you haven't done any work on the photos in Lightroom yet, you could skip the export and simply create a new catalog on the laptop. When using Export as Catalog, either uncheck the 'export negative files' checkbox, or plan to overwrite them with the lossy files.

Then select the photos and go to File menu > Export. You'll need to select the DNG format and you may want to replicate the same folder structure, to save some work relinking files later. The easiest way to do that when exporting is to use the LR/TreeExporter plug-in (http://www.lrq.me/armes-lrtreeexporter). Select the DNG format, check the Use Lossy Compression checkbox, and perhaps even set a lower resolution in the Image Sizing panel. There's a screenshot on the next page.

Having copied all of the files to your external drive or laptop, you can open the catalog. If the photos are marked as missing, use Find Missing Folder to link Lightroom to the new Lossy DNG files. If you've created lower resolution DNG files, the previews may appear blurred. This is because Lightroom has the full resolution dimensions listed in the

Also check...

"How does Export as Catalog work?" on page 305 and "How does Import from Catalog work?" on page 306

catalog. To fix it, select all of the photos and choose Metadata menu > Write Metadata to Files and then Metadata menu > Read Metadata from Files, and the catalog will be updated. Writing the XMP data out before reading it back avoids overwriting any settings stored in the catalog.

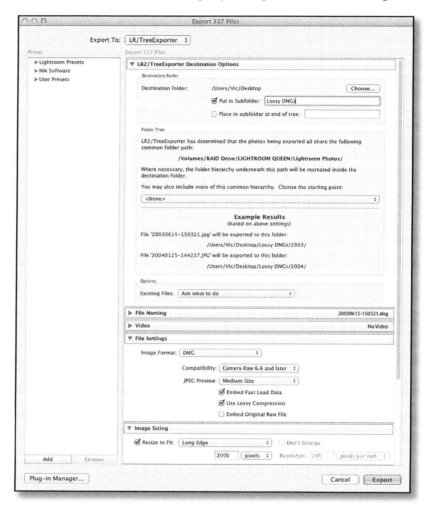

You can then work as normal—even on lower resolution DNG files, the settings (such as noise reduction) are calculated compared to the original resolution, so when you relink with the full resolution later, the calculations should still be accurate.

Once you've finished, you can plug the external drive back into the main computer, or copy the catalog back ready to merge your changes. Beware—when transferring your catalog back to the main computer, be careful not to replace the original photos, as you don't want to overwrite your full resolution lossless DNG files with the temporary lossy ones.

Go to File menu > Import from Another Catalog to transfer your settings back into the main catalog, using the 'Metadata and Develop settings only' option.

Also check...

"How does Import from Catalog work?" on page 306

Can I synchronize two computers?

Synchronizing two computers isn't quite so simple. If only one person is using Lightroom, the Export as Catalog and Import from Catalog options work very well, as does having the catalog on an external drive that can be used by either machine. Two people using two entirely different sections of the catalog, and then merging those back into the main catalog works too.

The glitch comes if two people are trying to work on the same photos in two different catalogs at the same time—for example, one person is keywording and the other adjusting Develop settings. When those catalogs are merged, those settings won't be merged together, to get both the keywords and the Develop settings. Instead, you'll get whichever was the latest change to be made, so if the Develop changes on catalog B were done last, then catalog B's settings will be imported into the main catalog, and catalog A's keywords would be overwritten. In that case, you could set the Import as Catalog dialog to create virtual copies of any photos with different settings, so you would have a master photo with the Develop Settings from catalog B and a virtual copy with the keywords from catalog A, and you would need to copy the settings between photos manually. It's a situation best avoided!

How can I use my presets on both computers?

Your presets, by default, aren't stored with the catalog, but you can transfer them manually so that they appear on each machine. It's easiest to allow file synchronization software to keep the entire Lightroom user settings folder synchronized between both computers, or in a network shared location.

If you only have a single catalog that you use on multiple machines, perhaps on an external hard drive, there's also the 'Store presets with catalog' option in Preferences > Presets tab. This option allows you to store the presets alongside the catalog itself, for use with that specific catalog on any machine. It does, however, mean that the presets will not be available to other catalogs on either computer. They may appear to go missing if that checkbox is unchecked, as it doesn't automatically copy the existing presets to the new location. Also, default settings, lens and camera profiles and email settings are not included.

If you do wish to manually copy your existing presets into the catalog-specific location, go to Preferences > Presets tab and press the Show Lightroom Presets Folder button while 'Store presets with catalog' is unchecked. An Explorer (Windows) / Finder (Mac) window will open, showing the presets in their global location. Leaving that window open, check the 'Store presets with catalog' checkbox and press the button again. That should open a second Explorer (Windows) / Finder (Mac) window showing the catalog-specific Lightroom Settings folder, and you can then drag your presets from the global folder to the catalog-specific one.

The slightly more technical, but more flexible, workaround involves using Dropbox (http://www.lrq.me/dropbox) and junctions (Windows) / symlinks (Mac) to keep the presets immediately updated on both computers. It works really well, particularly if those computers aren't on

Also check...

"Default File Locations"
section starting
on page 654

the same local network. You can also apply the same principle to the camera raw shared folders, such as camera and lens profiles, allowing those to be kept updated too.

How do I use symbolic links with Dropbox to keep my presets synchronized?

Having installed Dropbox according to the instructions on their website, you first need to copy the presets and profiles into the Dropbox folder. Personally I keep a 'Sync' subfolder in Dropbox, as I use this same principle for many different programs.

For both Operating Systems:

1. Close Lightroom.

2. Copy both the CameraRaw folder and the Lightroom folder to your Dropbox folder. The full paths are listed in the Default File Locations section later in the book.

3. Move, rename or delete the original folders.

Having copied the presets and other folders, it's time to create the symbolic links, so the instructions depend on your operating system...

Windows:

1. Download Symlink Creator (http://www.lrq.me/winsymlink). It's a small free program which will create a symbolic link without needing to understand DOS and the mklink command.

2. There's no installation needed other than unzipping the download. To avoid permissions issues, you'll need to right-click on the Symlink Creator.exe file and select Run as Administrator.

3. In the dialog, working from the top, select Folder symbolic link as the type of link.

4. In the Link Folder section, browse for the C:\Users\[your username]\AppData\Roaming\Adobe folder and give the link a

name exactly matching the original folder name—CameraRaw or Lightroom.

5. In the Destination Folder section, browse to the Dropbox folder that you want to link to.

6. Select Symbolic Link as the type of link, and press Create Link.

7. Repeat for any other folders.

8. Now restart Lightroom and check that it has found your presets and camera raw settings correctly.

9. Switch to the other computer and repeat these steps. If you had different presets on the other computer, you may want to merge them into your Dropbox location so that they're available on all computers.

Mac:

1. Download SymbolicLinker (http://www.lrq.me/macsymlink). It's a small free program which will create a symbolic link without needing to visit Terminal.

2. Install it according to the instructions included with the app.

3. Right-click on your CameraRaw or Lightroom folder and select Make Symbolic Link.

4. The new symbolic link will appear next to the folder, and will be called CameraRaw symlink or Lightroom symlink.

5. Drag the new symbolic links to the Macintosh HD/Users/[your username]/Application Support/Adobe/ folder, where the originals were stored.

6. Rename the symbolic links to remove the word symlink—you want to match the original name (CameraRaw or Lightroom) so that Lightroom opens follows your link.

7. Repeat for any other folders.

8. Now restart Lightroom and check that it has found your presets and camera raw settings correctly.

9. Switch to the other computer and repeat these steps. If you had different presets on the other computer, you may want to merge them into your Dropbox location so that they're available on all computers.

Once the setup is complete, Lightroom will be looking at the presets in the Dropbox folder, which should be updated whenever you add or edit a preset. If Lightroom is open on both computers at the same time, changes may not appear on the other computer until Lightroom is restarted.

Also check...

"Default File Locations" section starting on page 654 and "How do I show hidden files to find my preferences and presets?" on page 655

XMP

In some of the previous questions we've mentioned XMP, which stands for Extensible Metadata Platform. It's simply a way of storing metadata, such as Develop settings, star ratings, color labels, and keywords, amongst other things, with the photos themselves. XMP is based on open standards and the SDK is freely available, which means that other companies can also write and understand that same format, making your data available to other image management software. XMP is stored in the header of the file for most formats, or as sidecar files for proprietary raw files.

Why would I want settings written to XMP?

Any changes you make in Lightroom are stored within Lightroom's catalog, but that means that the changes aren't available to other programs, such as Bridge. If you want to make that data available to other programs, you need to write it to XMP.

Many use XMP data as an additional backup of settings in case your Lightroom catalog becomes corrupted, or more likely, you remove photos from the catalog by accident. If the data is written to XMP with the files themselves, Lightroom would then be able to read that data again when you re-import. It's also a handy way of transferring settings between catalogs, although not all data is stored in XMP.

On the other hand, writing changes back to the files does slightly increase the risk of file corruption, and means they will be seen as 'changed' by your backup software. If you use online backups, that could mean all of the adjusted photos being uploaded again each time you make a change. If the files are only XMP sidecars for proprietary raw files, that won't usually be a problem, but it may be a factor to consider for JPEG, TIFF, PSD or DNG files.

Also check...

"I gave my photos different color labels in Lightroom—why are they all white in Bridge? Or I labeled my photos in Bridge—why isn't Lightroom showing my color labels?" on page 194 and "Making and Restoring Backups" section starting on page 290

Which of Lightroom's data isn't stored in XMP?

The XMP specification limits the data that can currently be stored in XMP. Flags, virtual copies, collection membership, Develop history, stacks, Develop module panel switches and zoomed image pan positions are currently only stored in the catalog itself, and not the XMP sections of the files.

Where are the XMP files for my JPEG/TIFF/PSD/DNG files?

Although many users are used to seeing .xmp sidecar files next to their raw files, those are only produced for proprietary raw as the raw files are not fully publicly documented. Writing back to those non-public file formats can prevent some other software from reading them, so XMP metadata is written to a separate sidecar file.

The XMP for JPEG/TIFF/PSD/DNG is written to a section in the header of the file. Those changes don't affect the image data, and therefore it doesn't degrade the quality of the photo even if it's updated every time the metadata changes.

In Lightroom beta versions prior to the 1.0 release, XMP data was written to sidecar XMP files for JPEG/TIFF/PSD files, however that data couldn't be read by any other programs. The standard for interchangeable metadata is that it's written back to the original file where possible, so Lightroom has followed that standard in the release versions.

How do I write settings to XMP?

If you want to write settings to XMP, select the files in Grid view and press Ctrl-S (Windows) / Cmd-S (Mac) or go to Metadata menu > Write Metadata to Files.

You can also turn on 'Automatically write changes into XMP' in Catalog Settings > Metadata tab, which will update the XMP every time a change is made to the photo.

Should I turn on 'Automatically write changes into XMP'?

There's an argument for leaving auto-write turned on, however there can be a slight performance hit due to the constant disc writes every time you make changes to a photo. That said, it's much less noticeable than it was in early releases as there's now a few seconds delay before writing. There's a slightly higher risk of corruption, although still minimal, if the files are being updated constantly.

If you do decide to turn it on, a few suggestions:

* Making changes to large numbers of photos (i.e., thousands) may be noticeably slower with auto-write turned on, due to the sheer volume of individual files that need to be written.

* Avoid turning auto-write off and on again too often, as every time you turn it on, it has to update the files with all of the changes.

* When you first turn auto-write on, performance may drop considerably while it writes to XMP for all of the photos in the catalog. Once it's finished doing so, it should speed up again, so you're best just to leave it to work for a while.

If you do find it slows you down or you're concerned about potential corruption, but you still want the XMP updated, then consider the alternative—leave it turned off, and then when you finish a session, select the photos in Grid view and press Ctrl-S (Windows) / Cmd-S (Mac) to write the metadata manually.

What's the difference between 'Save Metadata to Files' and 'Update DNG Preview & Metadata'?

In the Metadata menu, when DNG files are among the selected photos, there are 2 different write options.

Save Metadata to File just updates the XMP metadata, as it would with any other kind of file.

Update DNG Preview & Metadata does the same, but it also updates the embedded preview in any DNG files, so viewing the DNGs in other programs will show the previews with your Lightroom adjustments applied, instead of the original camera previews.

Save Metadata to File	⌘S
Read Metadata from File	
Update DNG Preview & Metadata	

Should I check or uncheck 'Include Develop settings in metadata inside JPEG, TIFF, and PSD files'?

There's an extra option in Catalog Settings > Metadata tab with regard to XMP, called 'Include Develop settings in metadata inside JPEG, TIFF, and PSD files'. It simply controls whether Lightroom includes your Develop settings when it writes the other metadata. It was originally designed to stop Bridge CS3 from opening those photos into the ACR dialog, although more recent versions of both Bridge and Photoshop now have a switch to prevent that. Personally, I'd leave it turned on so that the data is stored with the files as well as in the catalog.

How do XMP files relate to the catalog?

All of the adjustments you make in Lightroom are stored in the catalog, and that database is always assumed to be correct, whether XMP settings exist or not. The XMP data is only read at the time of import, or when you choose to read the metadata using Metadata menu > Read Metadata from Files.

When you use that command to read the metadata from the files, you'll overwrite the information stored in the catalog with the information from the external XMP, and you can't do so selectively. If you're going to make changes to the XMP in another program, first write Lightroom's settings out to the XMP and then make the changes in the other software, so that when you read the metadata again later, Lightroom's settings are simply read back again, rather than being reset to default.

Can I view the content of my XMP sidecar files?

XMP sidecar files are stored in XML format, so they'll open in any xml or text editor in a readable format. Be careful that you don't corrupt them accidentally while editing, although you could recreate a corrupted XMP file by writing the metadata from Lightroom if you did make a mistake. The data is stored in blocks that look like this:

```
20111208-008.xmp
<x:xmpmeta xmlns:x="adobe:ns:meta/" x:xmptk="Adobe XMP Core 5.3-c007
1.136881, 2010/06/10-18:11:35    ">
 <rdf:RDF xmlns:rdf="http://www.w3.org/1999/02/22-rdf-syntax-ns#">
  <rdf:Description rdf:about=""
   xmlns:photoshop="http://ns.adobe.com/photoshop/1.0/"
   xmlns:tiff="http://ns.adobe.com/tiff/1.0/"
   xmlns:exif="http://ns.adobe.com/exif/1.0/"
   xmlns:aux="http://ns.adobe.com/exif/1.0/aux/"
   xmlns:xmp="http://ns.adobe.com/xap/1.0/"
   xmlns:xmpMM="http://ns.adobe.com/xap/1.0/mm/"
   xmlns:stEvt="http://ns.adobe.com/xap/1.0/sType/ResourceEvent#"
   xmlns:dc="http://purl.org/dc/elements/1.1/"
   xmlns:crs="http://ns.adobe.com/camera-raw-settings/1.0/"
   photoshop:LegacyIPTCDigest="80384AEB260636ABA8430E28112F958F"
   photoshop:DateCreated="2011-12-18T16:30:17Z"
   tiff:Make="Canon"
   tiff:Model="Canon EOS 5D Mark II"
   tiff:Orientation="1"
   tiff:ImageWidth="5616"
```

XMP has been updated on another program or computer. Why don't the changes show in Lightroom?

Lightroom will always assume its own catalog is correct, and ignores the contents of any external metadata.

If you want to force Lightroom to read the data from the XMP, go to the Metadata menu > Read Metadata from Files, and it will ask you to

Also check...

"Metadata Status Icon (6)" on page 156

confirm, as you'll be overwriting Lightroom's catalog with that external metadata.

If you've changed the XMP in another program, it should also show a metadata updated icon, showing that the metadata in the XMP is newer than Lightroom's own catalog.

Clicking on this icon should request confirmation:

Import Settings from Disk—replace Lightroom's data with the external XMP metadata

Cancel—don't do anything

Overwrite Settings—replace the external XMP metadata with Lightroom's data

If you've intentionally changed the metadata using another program, then you may want to select Import Settings from Disk, but if you're comfortable that Lightroom is correct, then Overwrite Settings will clear the warning and update the external XMP.

When resolving metadata conflicts, is there a way to preview what will happen?

If Lightroom tells you there's a metadata conflict, you have to decide which set of data to keep. The problem is, it doesn't tell you which data is different in each version, so you have to either remember which you last updated, or take a guess. The good news is there's a workaround, although it would be time-consuming if you have a large number of conflicts. If you create a virtual copy before reading the metadata, the

virtual copy will retain the Lightroom metadata and the master will be updated with the external metadata. You can then flick back and forth, comparing metadata and Develop settings, and decide which to keep. If you want to keep the data on the virtual copy, select Photo menu > Set Copy as Master before removing the other copy.

Lightroom says it can't write to XMP—how do I fix it?

If Lightroom says it can't write to XMP, check your operating system for the folder and file permissions—it's most likely that those files or folder are read-only, or the images are on a read-only drive, such as a Windows NTFS-formatted drive viewed on a Mac computer.

NETWORKING

Lightroom doesn't have network or multi-user capabilities, other than accessing photos that are stored on a network.

The SQLite database format that Lightroom currently uses isn't well suited to network usage—the file would be too easily corrupted beyond repair by something as simple as the network connection dropping at the wrong moment. That's not just an oversight—SQLite was chosen for its other benefits, such as the simplicity for the user, cost, and most importantly, speed of access.

Those decisions may change in the future, but for now, let's consider some alternative solutions.

Also check...

"Working with Multiple Machines" section starting on page 305

Can I share my catalog with multiple users on the same machine?

If you have multiple user accounts on the same computer, you can put the catalog and photos in a shared folder or on another drive that's accessible from both accounts, and all of the users will then be able to access that catalog. You may need to change the file/folder permissions

before it will work. Only one user can have the catalog open at a time, so if both users are logged in to the computer at the same time using Fast User Switching, the previous user will have to close Lightroom before the next user can open it.

Can one catalog be opened simultaneously by several workstations across a network?

The catalog has to be on a local hard drive, not a network drive, and can only be opened by one user at a time. If more than one person needs access, the best solution currently is to temporarily split the photos that each user needs into a separate catalog using Export as Catalog, work on them elsewhere, and then merge their changes back into the master catalog using Import from Catalog once they've finished. It only works if they're all working on different photos.

Is it possible to have the catalog stored on a Network Accessible Storage unit (NAS) but open it on a single machine?

Even single user network access is disabled as it's too easy to corrupt the catalog, so you can't work on the catalog while it's on the NAS. You could, of course, copy it to a local drive every time you want to work on it, and then copy it back again. It can be automated using File Synchronization software, but it's still a lot of data to constantly move around the network.

The photos can be on your NAS or other network drive, but if you're putting the photos on your NAS, be aware that NAS file access can be slower than internal or even external drives, depending on the connection speed, so that may slow Lightroom down too.

Also check...

"Can I share my catalog between 2 computers using Dropbox?" on page 310

Is it possible to use XMP files to allow some degree of sharing across the network?

Many people have asked whether it's possible to use XMP data stored with the files to allow basic sharing of settings across a network, so here's an overview of how it could work…

Each computer needs its own catalog, stored on a local drive, but the photos can be placed on a shared folder on the network in a few different configurations.

- The files are on Computer 1, and Computer 2 can access them.
- The files are on Computer 2, and Computer 1 can access them.
- The files are on networked storage that both computers can access.
- The files are on a server that both computers can access.

Import the photos into a catalog on each computer, with the Import dialog set to 'Add photos to catalog without moving.' This means that both computers are referencing exactly the same files.

On each computer, go to Catalog Settings > Metadata tab and turn on the 'Automatically write changes into XMP' checkbox. If 'Automatically write changes into XMP' is turned on, every time you make a change to the metadata of a photo, whether that's ratings, labels, Develop settings, etc., it gets written back to the XMP as well as to the catalog, but remember, certain data isn't stored in XMP. The write to XMP is usually delayed by about 10-15 seconds after the change to prevent unnecessary disc writes.

Also check...

"Which of Lightroom's data isn't stored in XMP?" on page 321

Now for the clever bit, when it comes to sharing files…

The metadata icon changes direction depending on whether the metadata is most up to date in your Lightroom catalog or in the XMP section of the file.

 Lightroom's catalog has updated metadata which hasn't been written to XMP, so you'd click on the icon to write to XMP. You shouldn't be seeing this icon, as you're automatically writing to XMP every time it changes.

 Metadata in the XMP file has been updated externally and is newer than Lightroom's catalog, so click on the icon to read from XMP.

 There's a metadata conflict, where both the XMP file and Lightroom's catalog have been changed. Click on the icon to choose whether to accept Lightroom's version or the XMP version.

The metadata is checked for updates whenever a file is made the active (most-selected) photo, or when you synchronize the folder, amongst other times.

So, 2 different scenarios…

Scenario 1…

Computer 1 & Computer 2 are both looking at the same folder of photos at the same time, working on rating the photos. As Computer 1 adds a 5 star rating to a photo, that's written to XMP after a slight delay. 2 minutes later, Computer 2 selects that photo, and after a few seconds, the updated metadata badge is displayed, showing that it's out of date. Click on that badge and press the Import Settings from Disc button to update Computer 2's view of that photo. It's not perfect—it's certainly not an instant solution—but it works for some people. Using Lightroom on Computer 1, and viewing those photos in Bridge on Computer 2 (to view, not change, otherwise you hit the same delays), is another alternative.

Also check...

"How does the Synchronize Folder command work?" on page 181

Scenario 2...

Computer 1 & Computer 2 both have the same photos in their catalogs, but are working on different sets of photos. When the person operating each computer sits down to start a job, they first right-click on that job's folder and choose Synchronize Folder to retrieve the latest settings from XMP. As they work, the settings are written back to XMP, so that the XMP always has the most up-to-date information. It makes no difference which computer last used those files, as the user reads from XMP each time they start. Because you're not working on the same photos at the same time, it largely prevents conflicts.

And finally, in either scenario, when someone later comes along on Computer 3 and adds those files to their catalog (also referenced at their existing location), the metadata will be automatically carried across from the XMP.

A few warnings...

This isn't particularly supported by Adobe, and if you decide to try it, you do so at your own risk. There isn't any known risk to your files, but you can never be too careful!

Fighting for the same files on the network will be slower than working from a local drive. Having 'Automatically write changes into XMP' turned on in Preferences can also decrease performance slightly.

If someone deletes, moves or renames files, it can get very complicated.

If you both write to XMP at the same time, one computer will overwrite the others settings.

If Computer 1 writes to XMP, then Computer 2 makes changes to the same file and writes to XMP without first reading Computer 1's changes, then Computer 1's changes will be overwritten in the XMP. They don't merge.

OFFLINE ARCHIVES

As your collection of photos grows, your working hard drives may eventually start to overflow. So how do you transfer the photos to offline archives? And where should you keep the settings? Should you use Export as Catalog to store the settings on the same hard drive or CD/DVD as the photos?

If you move the photos to offline storage, they can remain in your main catalog, even though they'll be marked as missing. If you update the links to point to the new location, you can search through those offline photos along with the rest of your current photos, and it will tell you where that photo is now stored. If you need to access the original file, perhaps to export a copy, you only need to plug that drive back into the computer and carry on working.

How do I archive photos to offline hard drives?

The easiest solutions for the working copy of your offline archives are external hard drives or NAS units, as they hold large amounts of data. Transferring photos to those offline hard drives is exactly the same as moving the files around on your computer, as we discussed earlier in the Moving Lightroom on the Same Computer section. Make sure you've rendered current previews before you disconnect the hard drive, so you can still browse with the photos offline. Once you disconnect those hard drives, the photos and their folders will be marked as missing with a question mark icon.

How do I archive photos to CD/DVD/Blu-Ray?

I would recommend that optical media only be used for a backup copy of your archived photos, and not your main working archive. Most optical media only has a lifespan of 3-10 years, they're limited in size, and it can become frustrating to keep swapping CD's or DVD's every time you need to use different files.

Also check...

"Moving Lightroom on the Same Computer" section starting on page 300

If you do decide to use CD's, DVD's or Blu-Ray, consider storing your photos in media sized folders from the outset, for example, if you're using DVD's, store the photos in folders of around 4.3GB. This concept is best-known as 'The Bucket System' created by Peter Krogh, and it makes it easier to track which photos are stored on which disc. If you're interested, you can find out more in The DAM Book (http://www.lrq.me/dambook).

To transfer photos to that optical media, the principle is the same as moving photos to another hard drive—in this case, burn the files to the disc and then update Lightroom's links. If you're going to wipe those photos from the hard drives, it's essential that you use burning software with verification, and burn multiple copies.

When you're burning the discs, put the photos and/or their folders inside a parent folder, named with the disc's reference number. The Mac version will see each disc as a separate volume, whereas the Windows version will see them all under the same drive letter, making it difficult or even impossible to work out which disc the photos are on.

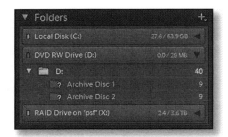

All that said, I strongly recommend copying all of your CD's and DVD's onto a hard drive and using that, perhaps keeping the optical media as an extra backup. For the small cost involved, you'll save hours of work and frustration!

Previews & Speed

Lightroom is a powerful program, offering far more than just basic raw processing, but that can also tax the most powerful of computer systems. Waiting for each photo to load before you can start working can be frustrating, so it's worth spending the time to set up your preferences in a way that will suit your own workflow.

PREVIEWS

We mentioned earlier in the Import chapter that Lightroom always creates its own previews, regardless of file type. Those previews allow you to apply Develop changes to the photos without affecting the original image data, and also allow you to view the photos when the originals are offline. Choosing the right preview settings for your own browsing habits is essential in keeping Lightroom running smoothly, so let's investigate the options.

What's the difference between Minimal, Embedded & Sidecar, Standard and 1:1 previews?

There are a number of options to choose from when importing your photos, and which you choose will depend on your own browsing habits.

Also check...

"Why do I have to create previews? Why can't I just look at the photos?" on page 91

Minimal shows the thumbnail preview embedded in the file. It's a quick option initially, but it's a very small low quality preview, usually with a black edging and about 160px along the long edge, so you then have to wait to for previews to render as you browse. Minimal previews aren't color managed.

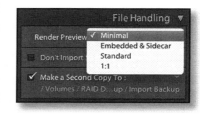

Embedded & Sidecar checks the files for larger previews (approx. 1024px or larger), showing you the largest embedded preview. It's still just a temporary option—Lightroom will build its own previews as soon as it can.

Standard builds a standard-sized preview used for browsing through the photos. You set the size and quality of these previews in Catalog Settings > File Handling tab, and we'll come back to those options in the next question. Standard-sized previews are definitely worth building before you start browsing, if not directly at the time of import. It will greatly speed up browsing performance if Lightroom isn't having to render previews on the fly.

1:1 previews are full resolution so they take up more space, but if you want to zoom in on your photos in the Library module, it will save Lightroom having to render 1:1 previews on the fly, which would slow your browsing experience. If you're concerned about the disc space that they take up, you can set in Catalog Settings for them to automatically delete after 1 day, 7 days, 30 days or Never, or you can discard 1:1 previews on demand by selecting the photos and choosing Library menu > Previews > Discard 1:1 Previews.

How do I render previews after importing the photos?

If you haven't rendered your chosen preview size at the time of import, or you want to refresh the previews as you've made Develop changes, select all (or none) of the photos in Grid view and choose Library menu > Previews > Render Standard-Sized Previews or 1:1 Previews. In early version 1 releases, rendering previews at the same time as importing was much quicker than rendering them later, but that no longer makes any difference, so you can render them at a time that suits you.

What size and quality should I set for Standard-Sized Previews?

In Catalog Settings > File Handling tab, you can set the preview size and quality. This is a per-catalog setting, so if you use multiple catalogs, you'll want to check each catalog.

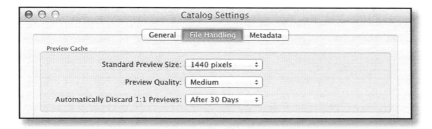

The settings you use will depend on your general browsing habits and on your screen resolution. As a guide, choosing a size about the width of your screen is a good starting point, or slightly smaller if you always leave the panels open.

The quality setting is, as with most things, a trade-off. High quality previews take up more space on disc as they're less compressed, but higher quality previews obviously look better.

When I choose Render 1:1 Previews from the Library menu, does it apply to the entire catalog or just the selected photos?

When you choose Library menu > Previews > Render Standard-Sized Previews or Render 1:1 Previews, it gives you a choice:

- If you have no photos selected, or all photos selected, it renders previews for all of the photos in the current view, whether that's a collection, a folder, a filtered view, etc.

- If you have more than 1 photo selected in Grid mode, it assumes you just want to apply to the selected photos.

- If you have just 1 photo selected, it asks whether you want to render just that one preview, or previews for all photos in the current view.

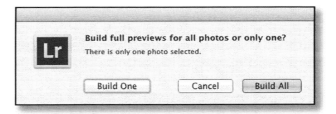

The previews folder is huge—can I delete it?

You can delete the previews without permanent damage, but Lightroom will have to rebuild the previews when you next view the photos, and if the files are offline, it will just show grey boxes until the files are next online and the previews can be rebuilt. If you find your previews are taking up too much space, consider using the Library menu > Previews > Discard 1:1 Previews command to throw away the largest preview size. Remember, if you've deleted the original files by accident, the Lightroom previews may be the only files you have left.

If I delete a photo, is the preview deleted too?

If you remove or delete a photo from within Lightroom, the preview will be deleted too. There's a slight delay in deleting the preview, just in case

you undo that remove command. They usually disappear at the next relaunch, if not before.

If you delete a photo using Explorer (Windows), Finder (Mac), or other software, but it's just marked as missing in Lightroom's catalog, the preview will remain until you remove the photo from the catalog.

I've discarded 1:1 previews—why hasn't the file/folder size shrunk?

Lightroom only deletes 1:1 previews that are more than twice the size of your Standard-Sized Previews preference. For example, if your Standard-Sized Previews preference is set to 2048 and your 1:1 preview is 3036, Lightroom will keep the 1:1 preview, whereas if your Standard-Sized Previews preference is set to 1024, the 1:1 preview would be deleted.

Can I move the previews onto another drive?

Officially the previews have to be next to the catalog. That said, it's technically possible move the previews onto another drive using a symbolic link (not a standard alias or shortcut). In the previous chapter we discussed about using symbolic links for keeping your presets updated on more than 1 computer, and the same principles can be applied to moving the previews to another drive.

If you do put the previews on another drive, make sure it's a fast drive, as you'll need good read speeds. Disk read speed makes a big difference when switching from one photo to the next, so avoid keeping previews on a network drive, and if they'll fit on an internal drive rather than an external hard drive, that'll help a bit too. And remember, this isn't an Adobe supported suggestion.

Also check...

"How do I use symbolic links with Dropbox to keep my presets synchronized?" on page 317

Also check...

"Lightroom thinks my photos are missing—how do I fix it?" on page 240

PREVIEW PROBLEMS

Viewing accurate previews of your photos is essential. Problems do sometimes occur, so you'll need to know how to fix them, even if they're not Lightroom's fault.

Why do I just get grey boxes instead of previews?

If there's a question mark in the corner of the thumbnail in Grid view as well as grey thumbnails, Lightroom simply hasn't been able to build the previews. The original file may have been renamed or moved outside of Lightroom, or the drive was disconnected before Lightroom was able to create the previews. If you reconnect the drive or update the link to the file, the previews should update.

If there aren't question marks in the corner of the thumbnails in Grid view, a corrupted monitor profile is the most likely cause, or the graphics card driver may need updating. We'll discuss corrupted monitor profiles in more detail in the next 2 questions.

It's also possible that the preview cache is corrupted, particularly if your catalog has been upgraded from an earlier version. We'll come back to that later in this section.

Everything in Lightroom is a funny color, but the original photos look perfect in other programs, and the exported photos don't look like they do in Lightroom either. What could be wrong?

Strange colored previews that don't match the exported photos in color managed programs are usually caused by a corrupted monitor profile. Lightroom uses the profile differently to other programs (perceptual rendering rather than relative colorimetric), so corruption in that part

of the profile shows up in Lightroom even though it appears correct in other programs. It often happens with the manufacturer's profiles that come with many monitors.

Check the Histogram on a grayscale photo. It should be neutral but corrupted profiles often create some weird color casts which also show on the Histogram. (Obviously you can't see the cast in greyscale printed copies of this book, but you know what a color cast looks like.)

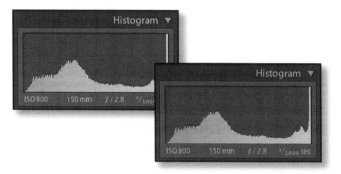

Ideally you should recalibrate your monitor using a hardware calibration device. If you don't have such a tool, put it on your shopping list, and in the meantime, remove the corrupted monitor profile to confirm that this is the problem.

How do I change my monitor profile to check whether it's corrupted?

Windows

1. Close Lightroom.

2. Go to Start menu > Control Panel > Color Management.

3. Click the Devices tab if it's not already selected.

4. From the Device pop-up, select your monitor. If you have more than 1 monitor connected, pressing the Identify monitors button will display a large number on screen for identification.

5. Check the 'Use my settings for this device' checkbox.

6. Make a note of the currently selected profile, which is marked as (default).

7. Click the Add button.

8. In the Associate Color Profile dialog, select sRGB IE61966-2.1 (sRGB Color Space Profile.icm) and press OK.

9. Back in the Color Management dialog, select the sRGB profile and click Set as Default Profile, and then close the dialog.

Mac OS X

1. Close Lightroom.

2. Go to System Preferences > Display.

3. Select the Color tab.

4. Press the Calibrate button and follow the instructions.

5. Turn on the Expert Options and calibrate to gamma 2.2.

Finally, restart Lightroom and check whether everything looks correct. If it does, you've confirmed that the previous monitor profile was the cause of the problem. You can temporarily leave sRGB as the monitor profile, as it's better than a corrupted one, but it would then be wise to calibrate your monitor accurately using a hardware calibration device.

How should I calibrate my monitor?

The only real way of calibrating a monitor is with a hardware calibration device. Software calibration is only ever as good as your eyes, and everyone sees color differently, but calibration hardware, such as the ColorMunki, i1 Display Pro, Spyder or Huey devices are now very inexpensive, and an essential part of every keen digital photographer's toolkit.

Most calibration software offers an advanced setting, so if it gives you a choice, go for a brightness of around 100-120 cd/m2, native white point for LCD monitor, and most importantly, an ICC2 Matrix profile rather than

an ICC4 or LUT-based, as those more recent profiles aren't compatible with many programs yet.

I'm often asked which I use personally—and the answer is the i1 Display Pro with BasICColor software (http://www.lrq.me/basiccolor) or EIZO ColorNavigator software.

The previews are slightly different between Library and Develop and Fit and 1:1 views—why is that?

The previews you see are rendered differently between the Library and Develop modules. Apart from the Develop module, Lightroom uses pre-rendered Adobe RGB compressed JPEGs for speed. That means there may be slight losses compared to Develop, particularly if your previews are set to Medium or Low Quality. Develop module, on the other hand, renders a preview from the original data and then updates it live as you make adjustments.

There's also a difference in the resampling methods used in the 2 modules, which can result in a significant difference in the preview display at less than 1:1 view. The Library module takes the largest rendered preview it has available, and resamples that preview to show smaller zoom ratios, whereas Develop works on the full resolution raw data.

Lightroom 1 and 2 didn't show noise reduction or sharpening at less then 1:1 view in Develop. In Lightroom 3, that became adaptive—it would only apply noise reduction to the Develop preview when it thought the noise would show—so it became a guessing game. In Lightroom 4, it's become far simpler—it's always applied. Just remember that lower zoom ratios aren't 100% accurate, and high sharpening and noise reduction values can be wildly inaccurate.

Also check...

"What size and quality should I set for Standard-Sized Previews?" on page 335

My photos have imported incorrectly rotated and distorted—how do I fix it?

Odd rotations and distortion appear from time to time, primarily with photos that have been edited or rotated in other programs.

If it doesn't correct itself automatically, select all of the affected photos in Grid view and write your current settings to XMP using Metadata menu > Write Metadata to Files or the shortcut Ctrl-S (Windows) / Cmd-S (Mac) so you don't lose them. Then read from XMP again using Metadata menu > Read Metadata from Files. If you then ask Lightroom to render updated previews using Library menu > Previews > Render Standard-Sized Previews, it fixes the majority of cases.

Lightroom says my preview cache is corrupted—how do I fix it?

There are a few clues that your preview cache may be corrupted. The most obvious is Lightroom showing an error message telling you that it's corrupted, or that it tried to repair it unsuccessfully. Alternatively you might find that Lightroom shows the wrong preview for some of your photos, some previews or thumbnails disappear when the photo is deselected, or the photo only shows in the Develop module.

To check whether a corrupted cache is the cause, and solve the problem, move or rename the previews folder (*.lrdata) and restart Lightroom. Select all of the photos and go to Library menu > Previews > Render

Also check...

"How do I find my catalog on the hard drive?" on page 271

Standard-Sized Previews and leave it to work, perhaps overnight as it will take a long time. Lightroom will rebuild the previews, and they should rebuild correctly as long as all of the photos are online.

Once you're happy they've all rebuilt, you can delete the previous previews folder (*Previews.lrdata) if you haven't already done so. I don't usually recommend deleting the old previews before rendering new ones, just in case there are any missing original files, and the previews are the only copy you have left. If you're comfortable that you still have all of your original files available, then you can delete the old previews before rendering the new ones.

SPEED TIPS

Working with Lightroom isn't like working with Photoshop or Elements, and the hardware requirements are different. In Photoshop or Elements, you'll usually be working with one or a few photos at a time, whereas with Lightroom, you work with much larger numbers of photos. Besides buying a fast new computer, there are some other speed tips which can help Lightroom run much more smoothly.

How can I get Lightroom to import faster?

Lightroom's import speed depends on two things—where the files are coming from, and the settings you choose in the Import dialog.

Importing using a card reader is usually faster than importing directly from the camera, particularly if you buy a good quality card reader with a fast connection. Importing directly from the hard drive is obviously faster still.

Setting the Import dialog to 'Add photos to catalog without moving' will be quicker than one of the Copy options, as Lightroom's not having to duplicate the files, but be careful to only use Add for files on your hard drive, and not those on memory cards.

If you usually convert to DNG while importing, but you're in a hurry, you can import the proprietary format initially and then run the conversion to DNG later when you have more time, swapping the proprietary raw files for DNG files automatically. Turn back to the DNG section in the Import chapter for those instructions.

Also check...

"How do I convert to DNG?" on page 120

How can I speed up browsing in the Library module?

If you're browsing in the Library module, your choice of pre-rendered preview size can make major improvements in the speed. There's a big difference between rendering previews that have never been built or that need updating, and loading ready-built previews from disc.

If the Loading overlay stays on the screen for a long time, Lightroom's likely rendering a preview for the first time, updating an old existing preview, or building a larger preview for your current zoom ratio—and you're having to wait for it!

`Loading...`

Either set Lightroom to render the previews when it imports, by selecting your chosen preview size in the Import dialog, or switch to Grid view, select the photos and go to Library menu > Previews > Render Standard-Sized Previews or Render 1:1 Previews, and leave it until it's finished. It will skip any photos that already have current previews, and you'll find browsing much quicker once it's finished rendering.

If you need to zoom into 1:1 view in the Library module (not Develop), and you're still seeing the Loading overlay for a long time, then you'll need to render 1:1 previews rather than Standard-Sized previews, either in the Import dialog or using the menu command noted above. If you rarely zoom in Library module, you're better off using Standard-Sized previews, as they'll take up less disc space and be slightly quicker to read from the preview cache.

Also check...

"What size and quality should I set for Standard-Sized Previews?" on page 335

Each time you make Develop changes, the previews have to be updated. If you've made Develop changes to the photos, for example, by applying a preset, and you don't want to wait for the previews to update one

Also check...

"How do I move or copy photos between folders?" on page 197

at a time as you browse through them, use the same Library menu > Previews > Render Standard-Sized Previews command to update all of the previews in one go.

How can I speed up moving files between folders?

If you're frustrated by the speed of moving photos, select them and start them moving as you would usually, but then select another folder or collection, and wait for the move to complete before switching back. The file move should run slightly quicker because Lightroom won't need to repeatedly redraw the continually changing Grid view.

It's taking forever to delete photos—should it really take this long?

Deleting files within Lightroom can take a bit longer than deleting directly in Explorer (Windows) / Finder (Mac), while it finds and deletes previews and updates the catalog too, but it shouldn't be a vast difference. If you're finding it slow, there are a few things you can do to help.

Empty your Recycle Bin (Windows) / Trash (Mac) regularly, as that's been known to slow deletion significantly, particularly on Windows.

If you're trying to delete photos that you don't want to keep, rather than doing them one at a time, consider marking them with a reject flag instead, so you can delete them all in one go later without interrupting your workflow.

And finally, if it still doesn't work, rebooting solves most slow delete issues.

How can I speed up browsing in the Develop module? And what are these Cache*.dat files?

We mentioned earlier that there's a difference between the way that the Library and Develop modules display previews. Library shows you lower

quality previews from the previews cache. Develop, on the other hand, assumes you need an accurate, rapidly changing view, so it first shows you the preview from the Lightroom preview cache, then does a quick read of the raw data, and then finishes loading properly, before it turns off the Loading overlay. You don't have to wait for the overlay to disappear before starting work on the photo. If you find the overlay distracting, you can turn it off by going to the View menu > View Options > Loupe tab and turning off the 'Show message when loading or rendering photos' checkbox.

Particularly with the size of camera sensors today, there's a lot of raw data to load and process each time you switch photos. Have you ever noticed, though, that when you adjust a photo in Develop module, move to other photos, and then come back to that first photo again, it loads much quicker than it did the first time? If you've only just viewed the photo, it may still be stored in RAM, but once it's disappeared from RAM, the Camera Raw cache, also known as the ACR cache, comes into its own.

When Lightroom reads the raw data the first time, it adds it into the shared Camera Raw cache in a partially processed state, with the initial demosaic and other background work already done. Those are the Cache*.dat files that you might see appearing. When you load a raw photo into the Develop module, it will first check that cache to see if the data is already there to reuse, which is much quicker than reading and processing the original raw file data. The cache isn't used for rendered files (JPEG/TIFF/PSD) as they don't need that early stage processing. When you choose to store Fast Load Data with DNG files, it stores that same partially processed data, so they aren't added to the ACR cache either, but those Fast Load DNG's show the same performance benefits.

By default, the Camera Raw cache is only 1GB in size, and when new data is added, the oldest data is removed. With only 1GB of space, that can happen quite quickly, so you're not seeing the benefit if you're processing large raw files. If you go to Lightroom's Preferences > File

Also check...

"The previews are slightly different between Library and Develop and Fit and 1:1 views—why is that?" on page 342

Also check...

"The default location of the Camera Raw Cache is…" on page 657 and "Should I convert to DNG?" on page 109

Handling tab, you can change the cache size to suit—up to a maximum of 200GB. In the past, bigger was better, however the cache format has changed for Lightroom 3.6 and later (and ACR 6.6 and later), with JPEG compression being applied to the cached data. This means that the cache files are significantly smaller, now measuring hundreds of Kb's instead of MB's. You can now fit a lot more cached images into the same amount of space, so it no longer needs to be as large. My cache is currently set to 10GB, which holds around 25,000 photos. You can also change the location of that cache, but make sure it's on a fast hard drive. The Camera Raw cache settings that you change in Lightroom also apply to ACR in Bridge/Photoshop, and can be changed in the ACR Preferences dialog too.

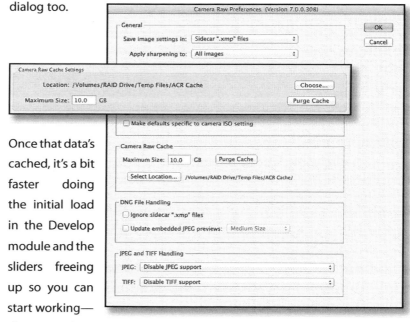

Once that data's cached, it's a bit faster doing the initial load in the Develop module and the sliders freeing up so you can start working— almost instantaneous on high end machines—although the Loading overlay may still show on screen while it does further processing. You'll notice the most significant difference on very large files, or those with significant amounts of initial processing. Of course, that's only helpful when Lightroom has recently read the raw file, and added it to the cache, and there isn't currently a menu command to pre-load the Camera Raw cache. All is not lost!

There's a trick to pre-loading the Camera Raw cache. In addition to actually viewing the photo in the Develop module, there's another obvious time when Lightroom has to read, and therefore caches, the raw data—namely, when rendering previews. If you haven't already rendered previews for your photos, simply using the Library menu > Render Standard-Sized Previews command will also pre-load the photos into the Camera Raw cache. Leave it to finish, and by the time you come back, even the Develop module should be moving through the photos at a much more comfortable speed.

Are there any other Lightroom tweaks to make it run faster?

As Lightroom's processing is improving with each Process Version, it becomes more processor intensive, so you will find that PV2012 is slightly slower than PV2010 and earlier. There are a few tweaks that may help though.

If you find Lightroom is feeling a little sluggish, select the File menu > Optimize Catalog command to perform database optimization. It's worth doing regularly, and any time you make significant database changes like importing or removing large numbers of photos.

A smaller preview area can make a noticeable difference, particularly in the Develop module, as a lower resolution preview can be shown, reducing the amount of processing needed.

The more things that Lightroom has to update, the more work it has to do, and therefore the slower it becomes. Closing the Histogram and Navigator panels and the small preview in the Develop Detail panel can help a little if you're struggling for speed, as can turning off the badges in the Grid view under View menu > View Options.

On older machines particularly, tools such as Auto Sync force Lightroom to update all of the selected thumbnails every time you make a change, whereas using Sync to apply all of the changes in one pass only has to update the thumbnails once.

Also check...

"What general maintenance will keep my catalogs in good shape?" on page 275 and "Should I turn on 'Automatically write changes into XMP'?" on page 322

In Develop, leaving Lens Corrections and Local Adjustments disabled while you're doing basic processing can make a noticeable difference, and even minor tweaks such as temporarily disabling the noise reduction, which is processor intensive, can help. Auto Mask on the Adjustment Brushes is another heavily processor intensive task, which can bring even fast machines to a crawl if used extensively.

Also, although it's improved greatly since the early Lightroom releases, 'Automatically write changes into XMP' in Catalog Settings can slow Lightroom down a little as it constantly writes to the external metadata. If you want to write to XMP but are concerned about a speed hit, wait until you've finished editing and then write to XMP manually.

Are there any hardware or operating system tweaks to make Lightroom faster?

There's no question, Lightroom loves good hardware, but it can still run on lower specification machines too. Always make sure you're running the latest stable Lightroom release as performance improvements have been made to most dot releases.

The system requirements have stayed largely the same as Lightroom 3, apart from the supported operating systems and 64-bit processor minimum on Mac. They're now listed as Intel Pentium 4 or AMD Athlon 64 (i.e., a processor with the SSE2 instruction set or later) for Windows, or Multicore Intel processor with 64-bit support on Mac. Both need at least 2GB of RAM and 1GB of hard drive space.

Let's be clear—those are minimum system requirements. It'll run—well, it'll walk! If you start trying to feed 21mp files into Lightroom using an old computer, don't expect it to be fast. If you're going to spend money on the latest cameras, bear in mind that your computer hardware may also require a helping hand to work with those new super-size files.

If you're working with existing hardware on Windows, check your graphics card. You don't need an expensive gaming graphics card to run

Also check...

"Why won't Lightroom 4 install on my computer?" on page 658

Lightroom, but you will benefit from the latest drivers that are available from the graphics card manufacturers. If you haven't checked recently, that's your first port of call for a free and easy performance fix.

Hard drives are another obvious place to look. For a start, you'll want plenty of space on your hard drives, particularly the boot drive, as your computer will get slower as you start to run out of space. While you're tidying up, make sure the Recycle Bin (Windows) / Trash (Mac) are emptied regularly as they can slow down some Lightroom functions even if they're not overflowing. If you're on Windows, regularly defragment your hard drives too.

Slow hard drive connections can also affect Lightroom's performance, due to the amount of data transfer when working with large files. Internal drives will usually be fastest. If you have to work from external drives, Thunderbolt, USB 3.0 and eSata will be faster than older Firewire or USB 2.0 connections. On a laptop, make sure you're running a 7200rpm drive instead of 5400rpm. Storing the application, catalog and previews, and the Camera Raw cache on an SSD can help make Lightroom feel a little smoother, but it's not a magic bullet. There's an excellent article on the subject of Lightroom and SSD's, which would be worth reading if you're considering upgrades. http://www.lrq.me/lyons-ssd

With traditional drives, ideally your catalog (and the previews alongside) should be on a different physical drive to the image files themselves—not just another partition of the same drive—as the drive heads have to move to read the data and splitting this onto two drives means the computer can literally read twice as much at the same time. Of course, that doesn't particularly apply to SSD drives as they don't have heads to keep searching around the drive for your data, although there is still a limitation on the physical amount of data that can be transferred at a time (6Gb connections are obviously better than the previous 3Gb ones).

If you're looking for new hardware, you may be wondering if Lightroom can make use of multiple cores—and yes it can. Processor intensive functions such as import, export, creating previews and making Develop

adjustments, amongst other things, can use up to 8 cores. The Core i7 Quad chips are a significant step up from earlier processors.

Lightroom also loves plenty of RAM, but bear in mind that you'll need a 64-bit operating system to really take advantage of large amounts of RAM. You're most likely to see improvement in the responsiveness of the Develop module when using the 64-bit version.

You can't change Lightroom's memory settings like you can in Photoshop, however you don't need to, as the technology is much newer. Lightroom doesn't have a separate virtual memory manager, but uses the operating system instead. Restarting the computer minimizes memory fragmentation—if Lightroom shows Out of Memory errors, it's running out of contiguous memory.

And finally, a little logic. Virus protection constantly scanning the same files that Lightroom's trying to use will slow you down. Consider excluding the catalog (*.lrcat), the previews file (*.lrdata next to the catalog), and the ACR Cache (check the Lightroom Preferences dialog for the location) from the live scan, and perhaps the photos themselves too.

The less you have running in the background, the better, particularly on older slower machines, and that includes those little system tray or menu bar programs that load on startup.

There's an official Adobe Tech Note, which may also be of interest, at http://www.lrq.me/adobespecs

Develop Module

When you're ready to start developing your photos, stop. Take some time first to evaluate what the photo actually needs. Is it too dark? Too light? Perhaps it's a little too yellow from indoor lighting? Is it flat and lacking in contrast? Is there noise that needs attention? Was your sensor dusty? Does the blue of the sky need enhancing slightly? Would it look better cropped? Would it be a stronger photo in black & white?

Once you've finished evaluating the photo, then you're ready to start developing. Don't try to do too much. One of the identifying marks of a new photographer is over-processing, which can distract the viewer from the photo itself. Just because sliders exist doesn't mean you have to adjust every single one.

RAW FILE RENDERING

In the Import chapter, we mentioned that some preferences, such as Auto settings or Import presets, can change the Develop settings of photos when they're imported. Those factors can apply to any type of file, whether raw or rendered, but there's another issue which only applies to raw files.

Also check...

"Why is Lightroom changing the colors of my photos?" on page 135

Why do my raw photos change color? When the first preview appears, it looks just like it did on the camera—how do I stop it changing?

A raw file isn't an image file like a JPEG or a TIFF. You can't look at it—there's nothing to see. You need some software to process it into a photo, and that software is called a raw converter. The initial preview you see in Lightroom is the JPEG preview, which is shown on the back of the camera and embedded in the raw file. That JPEG preview has the manufacturer's own processing applied in-camera, just as if you would set your camera to shoot a JPEG rather than a raw file format.

Each raw converter creates its own interpretation of the sensor's data, so Lightroom's rendering will not exactly match your camera manufacturer's rendering. There is no right or wrong—it's just different. Lightroom builds its own preview to show you how it will process your photo using its current settings.

So how do you get your file in Lightroom to look like that original camera JPEG preview? One of the major benefits of shooting in your raw file format is that you can tweak the photo to your own taste, rather than being tied to the manufacturer's rendering, but Adobe listened to the user's cries and created a profiling system which allows greater flexibility. That profiling system is called the DNG Profile Editor, and it allows the creation of detailed camera profiles. As well as being able to create your profiles, Adobe have created ready-made profiles to emulate the most popular in-camera JPEG rendering for many Pro-level SLR's. Although the name DNG Profiles makes it sound like they're limited to DNG files, these profiles can actually be used on proprietary raw files too.

You'll find these profiles in the Profile pop-up menu in the Calibration panel, installed automatically with each Lightroom update, and you can add your own profiles too. If you find a profile that you'd prefer to use as a starting point for all of your photos, you can also set it as the default, so that your newly imported photos automatically use that profile. Many choose to set Camera Standard as their default profile, so that the initial

Also check...

"If I shoot raw, can Lightroom understand the camera settings?" on page 79 and "Calibration Profiles & Styles" section starting on page 443

preview is closer to the camera rendering. We'll come back to creating your own profiles and setting default settings later in the chapter.

I set my camera to black & white. Why is Lightroom changing them back to color?

Only the manufacturer's own software, or those using the manufacturer's SDK, can understand and use many of the in-camera settings. We covered some of those settings earlier in the Import chapter. The data is stored as color raw data, without additional processing such as black & white applied.

The only parameter that is recognized and interpreted by all converters is white balance. If you had set your camera to Cloudy and have your raw software set to As Shot it would use the white balance set in the camera, but this is still an interpretation by the software programmers. Lightroom doesn't know if you had your camera set to black & white.

The beauty of shooting raw is that you have the ability to make the decisions later, without any reduction in quality. If you do need a record of what you were thinking at the time of shooting, shoot Raw+JPEG and import both photos into Lightroom. The JPEG will show the black & white or other picture style applied in the camera, and you can then adjust the raw file to match, if you want to do so.

How do other programs like iView, PhotoMechanic, Apple's Preview, Windows Explorer, Breezebrowser, etc., get it right?

If other programs show the same rendering as the manufacturer, it's because they're either showing the preview which is embedded in every raw file, or they're using the manufacturer's SDK (Software Development Kit) to process the raw data.

Lightroom could use the manufacturer's SDK rather than its own ACR engine, but then it would only have very basic controls, and it wouldn't be possible to add the other tools, such as the Adjustment Brush, that we now have available in Lightroom. It's all or nothing.

Also check...

"DNG Profile Editor" section starting on page 445 and "Defaults" section starting on page 414

Also check...

"Why is Lightroom showing different Kelvin values than I set in my camera custom white balance?" on page 361

Also check...

"If I shoot sRAW format, can Lightroom apply all the usual adjustments?"
on page 80

There are some hot pixels on my sensor in other programs, but I can't see them in Lightroom. Where have they gone?

If you're wondering where your hot pixels on your camera's sensor have gone, Lightroom automatically maps out hot pixels, as does ACR, however it only works on standard raw or mosaic DNG files, not sRAW.

PROCESS VERSIONS

Over the last few years there have been significant changes in Lightroom's processing algorithms to improve the image quality that it can produce.

As Lightroom's edits are stored nondestructively as text instructions, simply removing the old sliders or changing the effect of existing sliders would change the appearance of existing photos, as the intepretation of the stored values they represent would change, so they'd all need reprocessing each time major changes were made. To avoid this situation of significantly different rendering, Lightroom 3 introduced the concept of Process Versions named 2003 and 2010, often shortened to PV2003 and PV2010, and Lightroom 4 has now added PV2012 too. That simply refers to the date that each process engine was introduced, and tells Lightroom which algorithms to use.

Any photos set to an old process version show an exclamation mark in the lower right corner of the preview area in the Develop module, warning that you're not using the latest technology, but they should retain their existing appearance. That allows you to choose whether you want to update their processing or not, and also when you want to do so.

Which settings are affected by the process version?

Switching between Process Version 2003 and 2010 only affected Sharpening, Noise Reduction and Fill Light. All of the other slider values

were independent of the Process Version.

Process Version 2012 is a much more extensive change, including a completely new set of Basic controls, RGB point curves and new Local Adjustment sliders too.

Which process version should I use?

New photos default to PV2012, which generally has much better image quality, but PV2003 and PV2010 are still there for legacy reasons. You can switch new photos back to an older process version if you wish, although it's worth spending the time to learn to use the new PV2012 properly, rather than immediately switching back to your comfort zone. Existing photos can be upgraded to PV2012 when you have time to tweak their settings, or you can leave them with their current PV2003 or PV2010 settings.

How do I switch between process versions?

To update a photo to PV2012, click on the warning exclamation mark to the lower right of the preview in Develop. That shows a dialog asking whether to review the changes with a before/after preview. It also gives you the option of updating all of the photos currently shown in the Filmstrip. Holding down Alt (Windows) / Opt (Mac) while clicking on that exclamation mark will skip the dialog and only update the selected photo.

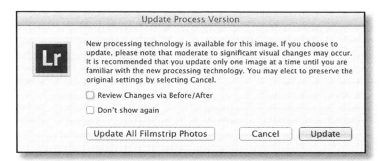

Also check...

"Can I synchronize my settings with other photos?" on page 467 and "History & Reset" section starting on page 421

If you decide to update your entire catalog, select All Photographs in the Catalog panel, disable all filters, select all of the photos in Grid view and then go to Photo menu > Develop Settings > Update to Current Process (2012) in the context-sensitive menu. But stop! We'll come back to that in the next question, as you could create a lot of work for yourself!

If you choose the before/after preview, and you decide you want to stick with the PV2010 rendering for now, you can revert to PV2010 using Ctrl-Z (Windows) / Cmd-Z (Mac) or by selecting the previous state in the History panel.

There are a few other options for updating or reverting the Process Version. You'll find it under the Settings menu > Process in Develop module, and in the Calibration panel, where Sync and Auto Sync can apply your choice to multiple photos in one go. You'll find it in the Library module too, under Develop Settings in the right-click context-sensitive menu.

Should I update all of my photos to PV2012? Or, why has updating my photos to PV2012 spoiled their appearance?

Lightroom attempts to preserve the appearance of photos when updating to PV2012, but it's such a significant change in processing that it's only a rough estimate—and sometimes it's a very rough estimate! Any photos that you update from a previous version are likely to need reprocessing using the new controls, so only press the Update All Filmstrip Photos button if you're happy to reprocess all of the photos, or if you haven't processed them yet. If you're unsure, update them one at a time or leave them set to their existing Process Version.

How do I find photos set to older process versions?

To find photos that are still set to PV2003 or PV2010, go to Library menu > Find Previous Process Photos, and Lightroom will create a temporary collection in the Catalog panel. It won't update live, but you can force

the collection to update at any time by selecting that menu command again, or you can clear it by right-clicking on the collection.

To find only unedited photos, create a smart collection set to 'Has Adjustments is false'. Selecting them all and pressing Reset in the Quick Develop panel will update them all to PV2012 in one go..

Why are my new imports set to PV2003 or PV2010 instead of the most recent process version?

If the newly imported files already have settings—for example, as a result of XMP sidecar files with settings from a previous Lightroom or ACR version, or a preset with the process version checked being applied—then they will be set to that process version instead of the current PV2012.

Also check...

"How do I create smart collections?" on page 235

WHITE BALANCE

The White Balance sliders at the top of the Basic panel adjust for the color of the light in which the photo was taken. Our eyes automatically adapt to the changing light, but cameras don't, which can result in a color cast on your photos. You don't necessarily want to neutralize the white balance on every photo though. If you look outside on a cold winters day, the light is cool and blue, but during a beautiful sunset, it's warm and orange. If you neutralize those photos, you lose the atmosphere.

If the photo is too yellow or warm, you move the Temperature slider to the left to compensate, and if it's too blue or cold, you move the slider to the right. The Tint slider adjusts from green on the left to magenta on the right. The White Balance Eyedropper, or White Balance Picker, will allow you to click on a neutral point in the photo to automatically neutralize any color cast, and you can tweak the sliders to taste from that starting point. As you float over the photo with the

Eyedropper selected, watch the Navigator panel. The preview will automatically update to show you a preview of your white balance adjustment.

Where should I be clicking with the White Balance Eyedropper?

To set the white balance using the Eyedropper, ideally you want to click on something that should be light neutral, which may have a color cast if the white balance is incorrect. Clicking with that Eyedropper tool attempts to neutralize that point.

You need to choose something bright for the best accuracy, but don't choose something so bright that any of the channels are clipped. Specular highlights, which are highlights with no detail, are no good either, however nice and white they look! If any channels are clipped, you'll get a weird result, if it works at all.

You need to be careful about the color that you choose. Remember that white objects will take on a color cast if they get reflected light from another object—so a glossy white hat outdoors under a clear blue sky should probably appear slightly blue, not white. Inside, paintwork that should be white often goes slightly yellow over time, so making that neutral may make the rest of the photo a little too blue.

Having set the white balance in the right ballpark, you may then need to tweak it further using the sliders.

The White Balance Eyedropper disappears every time I click anything—how do I keep it turned on?

While you have the White Balance Eyedropper active, there's an Auto Dismiss check box in the toolbar. With that checkbox unchecked, the Eyedropper will remain on screen until you intentionally dismiss it by pressing W or returning the Eyedropper to its base. If you can't see the toolbar beneath the photo, press T.

Why don't the Temp and Tint sliders have the proper white balance scale when I'm working on JPEGs?

When working on rendered files, such as JPEGs, you'll notice that the White Balance sliders no longer show Kelvin values. That's because they wouldn't mean anything. On JPEGs, Lightroom is just shifting colors from a fixed point, as the white balance has already been set and applied in camera. Raw files can use a Kelvin scale as you're actually shifting the white balance setting that is being applied to the raw data.

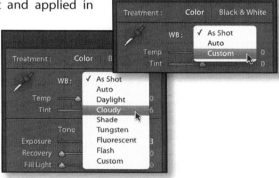

Also check...

"Shooting Raw, sRAW OR JPEG" section starting on page 77

Where have the other White Balance presets gone, such as Cloudy and Flash?

When working with raw files, there are a number of White Balance presets for common lighting conditions. These aren't available for other file formats, such as JPEG, as the white balance has already been set and applied in camera.

Why is Lightroom showing different Kelvin values than I set in my camera custom white balance?

If you set a custom white balance in the camera of 5000k, that same As Shot white balance may show in Lightroom as 5200k Temp and -5 Tint. That's not a bug, and Lightroom is respecting your custom white balance, but the numeric values may differ. Most cameras store white balance values as the camera color space co-ordinates rather than as a Kelvin value, and the resulting Temperature and Tint numeric values will

depend on the profile and raw converter used. The appearance of the color temperature is matched, not the numeric Kelvin value.

Can I change the eyedropper averaging?

The eyedropper averages over the area you can see in its loupe, so there are 2 ways you can affect the sampling area. When you zoom out, you're sampling a larger area than when you're zoomed in, which is particularly useful for noisy photos. Also, you can change the loupe scale using the slider on the toolbar, to change from a 5x5 pixel area up to a 17x17 pixel area.

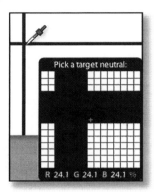

How do I adjust for an extreme white balance, under 2000k or over 50000k?

Lightroom's White Balance sliders only run from 2000k to 50000k Temp and -150 to 150 Tint. Usually that will be a large enough range, but some extreme lighting or infrared shots can fall outside of that range. If you open the DNG Profile Editor, which we'll come back to at the end of the chapter, you can create custom profiles for those extreme white balances.

BASIC ADJUSTMENTS

Most of your image adjustments will be performed in the Basic panel.

If you previously used Lightroom 3 or earlier, or Adobe Camera Raw, one of the first things you'll notice in the Develop module is that the Basic panel has changed dramatically. It's been completely rewritten for Lightroom 4, for a number of reasons:

- It's easier for newer users to understand.

Also check...

"DNG Profile Editor"
section starting
on page 445

- The powerful new tone-mapping controls allow you to extract more detail from your photos.

- It removes the halos and artifacts that were present in earlier versions of Fill Light, Recovery and Clarity.

- It's consistent between raw and rendered (i.e. JPEG) photos, whereas previous versions had different defaults, meaning that presets can now be shared more easily.

- The photos just look better with the new rendering!

This new rendering is called Process Version 2012, or PV2012.

As everyone learns differently, we're going to demonstrate the effect of the sliders in four ways:

- A B&W raw photo, so we're not distracted by the color.

- The photo's histogram.

- A grey 21 step wedge/gradient.

- A curve based on sRGB measurements from the 21 step wedge.

Bear in mind that it's only a guide as to the general range and shape of each slider, and the actual measurements and slider values will vary depending on each photo, as the new processing is image-adaptive.

The limitations of printing presses will affect the reproduction in printed form, so if you're reading this in printed form, do check the examples in the complimentary PDF version on a calibrated monitor. Better still, if you'd like to try some of these tests for yourself, you can download these files from http://www.lrq.me/stepwedge

As a baseline for comparison, these are the images with everything set to 0.

Also check...

"Process Versions"
section starting
on page 356

Everything set to 0

I'm upgrading from a previous Lightroom version and I'm in a hurry—can you summarize the changes to the Basic panel?

We'll examine the sliders in greater detail in the following pages, but there's nothing like a quick summary, whether as a reminder once you've finished reading, or as a general overview before you start. These are the main points to remember, whether you're upgrading from a previous version of Lightroom or you're just starting to use Lightroom for the first time.

- Forget everything you know about developing photos in Lightroom or Adobe Camera Raw, and treat the new PV2012 sliders like a new program. Don't try to translate 'which slider replaces Fill Light' because the thinking behind them is completely different and you'll slow yourself down.

- All of the sliders now work the same direction—moving to the left darkens, moving to the right lightens.

- Work from the top down, even if you've always used another slider order. They're in that order for a reason. You might go back and tweak slightly, but because the sliders are image-adaptive and some base their range on earlier sliders, you'll find yourself bouncing all over the place if you insist on using a different order. Of course there are always exceptions!

- Ignore the numerical values as the sliders adapt to each individual photo.

- Whereas in the past you'd use Exposure to set the white point, now you use it to set the midtones/overall brightness, and don't worry if that blows out highlights. That's the hardest change to get used to. Keep an eye on the Navigator panel when setting Exposure, as it's easiest to judge the overall brightness on a smaller preview.

- Once you've got the overall midtone brightness about right, tweak Contrast, again focusing on midtones. You'll fix the

New PV2012 Basic panel

highlights and shadows separately. Even if you didn't use the Contrast slider in the past, you will need to use it now.

- Just using Exposure and Contrast may be enough on many photos—you may not need to adjust the following sliders.

- After adjusting Exposure and Contrast, Highlights adjusts lighter tones and Shadows adjusts darker tones. In most cases, you'll move Highlights to the left to recover highlight detail and Shadows to the right to add shadow detail. If you go too far (50+), it can start to get a tone mapped HDR type look, which is why you need to get Exposure right (or close) first. If you get that right, the others fall in nicely.

- Finally, the Whites and Blacks sliders affect the clipping point. Most photos will not need those clipping sliders adjusted.

- Clarity is also completely different. The halos are gone, but you'll need much lower values than you used previously because the range of the slider is greater.

Having done the whirlwind tour of the new PV2012 Basic sliders, let's study each individually…

What does the Exposure slider do?

The Exposure slider sets the overall image brightness, and it uses the same f-stop increments as your camera, so +2.0 of Exposure is the equivalent of opening the aperture on your camera by 2 stops.

If you used Lightroom 3 or earlier, it's almost a cross between the old Exposure slider and Brightness, except it's smarter than both.

Exposure +2.0

Exposure -2.0

The new Exposure slider knows where the highlights of your image are, and it rolls off the highlights smoothly in a film-like fashion, to avoid harsh digital clipping.

It's important to get the Exposure setting right before moving on to the other sliders, as the range of other sliders are affected and they won't work as well if your Exposure is set incorrectly.

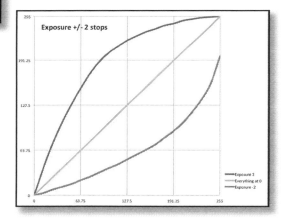

How do I decide where to set the Exposure slider?

After many years of using the PV2003/PV2010 Exposure slider to set the white clipping point, it's time to learn to break those rules. With PV2012, you need to set the Exposure slider for the overall image brightness—the midtones—and initially ignore any highlights that clip. Old habits die hard, however, so how do you know where to set the Exposure slider? Try these tips:

- Set Exposure as if it's the only control you have available. If there weren't any other sliders, how bright would you make the photo?

- It's far easier to judge the overall brightness when you're looking at a small preview, as you won't get distracted by the details. Either zoom right out or glance at the Navigator panel while setting the Exposure.

- Your eyes adjust to the original camera exposure, making it difficult to judge the correct exposure. It can help to confuse your brain by swinging the Exposure slider to the left and right (darker and lighter) and then settle somewhere in the middle, wherever it looks right.

Contrast+100

What does the Contrast slider do?

The Contrast slider is a standard S-curve which lightens the highlights and darkens the shadows to increase midtone contrast, or vice versa. Even if you never previously used the Contrast slider, perhaps preferring curves, you'll need to use it now. Curves still have their place for fine tuning, but the new controls are designed to do the 'heavy lifting' with curves being applied later in the processing pipeline, if they're needed at all.

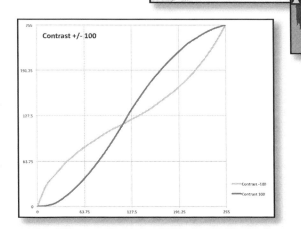

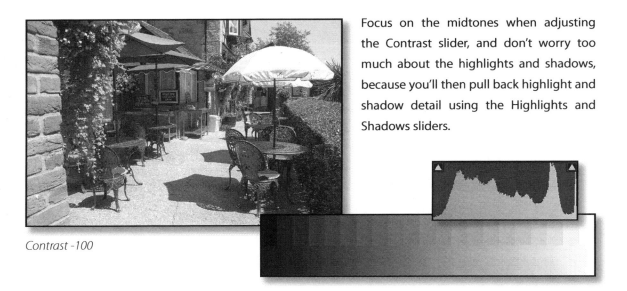

Focus on the midtones when adjusting the Contrast slider, and don't worry too much about the highlights and shadows, because you'll then pull back highlight and shadow detail using the Highlights and Shadows sliders.

Contrast -100

What does the Highlights slider do?

You can see from the examples, especially the curve, that the Highlights slider is masked to adjust only the brighter tones in the photos and barely touches the darker tones. It's generally intended to be used as a minus figure, moved to the left to pull back highlight details. You can move up to around 50 in either direction and still have a fairly natural looking result, whereas beyond 50 starts to get an HDR type look.

What does that mean in practice? Having set the overall image brightness to look just right using Exposure, you can selectively pull back highlight detail without impacting the shadows or destroying the midtone contrast. In the case of our sample photo, it means that we can pull back the detail in the white parasol and concrete floor. In other photos, Highlights would affect fluffy clouds in the sky, detail on a bride's dress, and other highlight areas.

There are similarities to the Recovery slider in PV2003/2010, which also attempted to recover lost highlight detail, however the new Highlights slider does so much more effectively and without introducing a color shift.

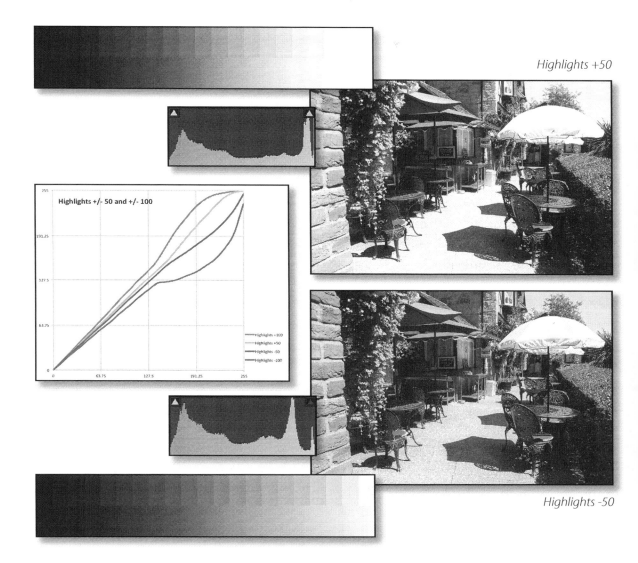

Highlights +50

Highlights -50

What does the Shadows slider do?

The Shadows slider is basically the opposite of the Highlights slider.

You can see from the examples, especially the curve, that the Shadows slider is masked to adjust only the darker tones in the photos and barely touches the lighter tones. It's generally intended to be used as a plus figure, moved to the right to pull back shadow details. As with

Highlights, you can move up to around 50 in either direction and still have a fairly natural looking result, whereas beyond 50 starts to get an HDR type look.

Shadows +50

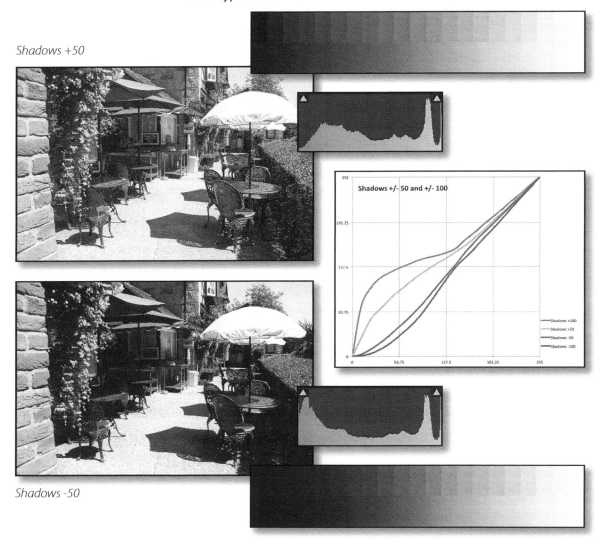

Shadows -50

What does that mean in practice? Having set the overall image brightness to look just right using Exposure, you can selectively pull back shadow detail without impacting the highlights or destroying the midtone contrast. In the case of our sample photo, it means that we can

pull back the detail in the shaded area to the left and in the bushes. In other photos, Shadows would affect shadowed areas on people's faces, detail in a groom's suit, and other darker areas.

There are similarities to the Fill Light slider in PV2003/2010, which also attempted to recover shadow detail, however the new Shadows slider doesn't reach as far into the brighter tones, and doesn't create the halos that could result from higher Fill Light values. Some photos benefited from the halos, but the majority of photos look better with Shadows in PV2012.

Why doesn't the Highlights or Shadows slider seem to do much?

We said earlier that the Exposure slider needs to be about right, as it affects the range of the other sliders. Let's illustrate that using Highlights, and setting the Exposure 2 stops higher than it should be. You can see from the curve that the range of the Highlights slider is much more limited than it is when the midtones are set correctly. That doesn't mean that Exposure at 0 is necessarily the 'correct' value for your photo. If your photo is underexposed, +2 Exposure might be just right, and +4 would be too high.

As a guide, if Highlights doesn't seem to be doing much, Exposure is probably too high, and if Shadows doesn't seem to be doing much, Exposure is probably too low.

Exposure 0 and +2.0 combined with Highlights +50, -50

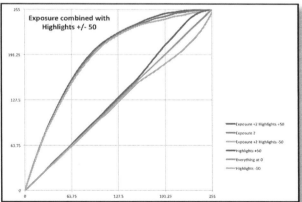

What do the Whites and Blacks sliders do?

The Whites and Blacks sliders affect the clipping point and roll off at the extreme ends of the tonal range. They're not intended to make major tonal adjustments, but just for fine-tuning the effect of the earlier

adjustments. Most photos won't require any adjustments to these sliders.

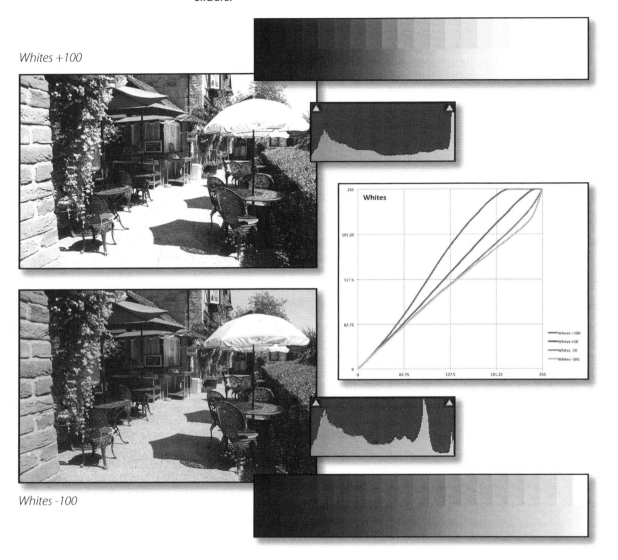

Whites +100

Whites -100

Unlike the masked Highlights and Shadows sliders, they affect the full range of tone to avoid affecting the contrast relationships between other tones. Brightening the whitest point by moving the Whites slider to the right allows you to clip highlights that would otherwise be protected by

the Exposure slider's gentle roll off, whereas moving to the left brings a little more contrast into the brightest highlights, and the opposite obviously applies the Blacks slider.

You'll notice a slight difference between raw and rendered photos, as the raw photos have additional data available at either end of the tonal range, whereas clipped blacks and whites on rendered photos remain pure black or white.

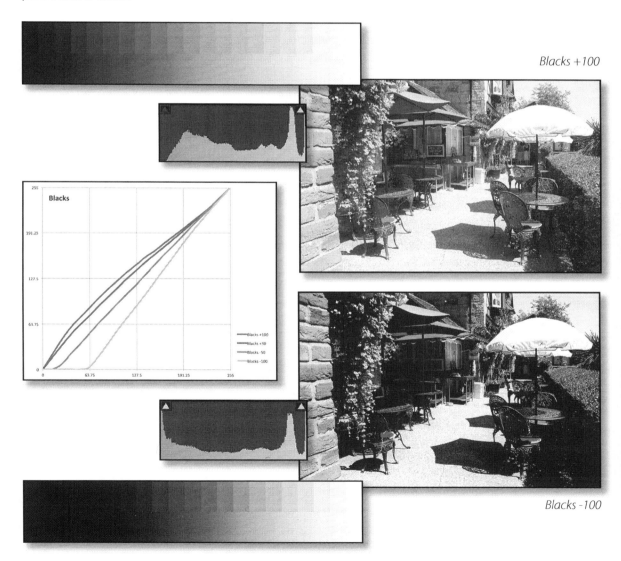

Blacks +100

Blacks -100

I've heard that the new sliders are 'adaptive'—what does that mean?

You may have heard the terms 'image adaptive,' 'intelligent,' 'tone-mapped' and 'masked' when talking about the new Basic sliders.

The Exposure slider in PV2003/2010 used to clip overexposed highlights, resulting in a harsh digital look, whereas the new PV2012 Exposure slider calculates where the highlights of your image are, and intelligently protects them.

Other controls, like Highlights, Shadows and Clarity do their calculations using masks computed from the image itself. That limits the range of the adjustments to particular tones in a photo, for example, Highlights barely affects the lower 50% of tones.

Whites and Blacks are also aware of the content of the photo, and the range of those sliders adapts accordingly. For example, a foggy scene may only contain data in the very lightest tones of a photo. The Blacks slider knows that, mapping −100 to pure black, stretching the range of the tones. That becomes even more useful when working with old scans of faded photos.

Light step wedge with everything at 0

Light step wedge with Blacks -100

It also means that the values you use for each photo will vary. +50 on a slider will have a different effect on different photos, depending on the image content and the other settings, so don't focus too much on the numerical values—focus on the photo itself.

Why are the sliders in the wrong order?

Some users have said that they'd prefer the sliders to be placed in

a different order—perhaps Exposure, Contrast, Whites, Highlights, Shadows, and then Blacks, or in the same order as the Histogram. So why are they placed in such an odd order? There are a couple of reasons, but their order is primarily based on the intended workflow.

The sliders are grouped in pairs. Some photos will only need Exposure and Contrast adjustments. Others may also need Highlights and/or Shadows adjustments, but many will never need Whites or Blacks adjustments if the previous sliders are set correctly.

Also, some of the sliders adapt their range based on the earlier sliders, so while it's possible to bounce around and use the sliders in whichever order you like, you'll usually find a top-down workflow to be most efficient.

Also check...

"Process Versions" section starting on page 356

Why do I have Exposure, Recovery, Fill Light, Blacks, Brightness and Contrast instead of Exposure, Contrast, Highlights, Shadows, Whites and Blacks?

The sliders change depending on the process version selected for each photo. PV2003 and PV2010 had Exposure, Recovery, Fill Light, Blacks, Brightness and Contrast as their Basic panel sliders, and photos that are set to PV2003/2010 will display those sliders, whereas the basic adjustments have been completely rewritten for PV2012, with a new set of sliders. Turn back to the Process Version section to learn more about process versions and updating photos.

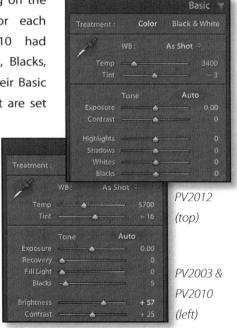

PV2012 (top)

PV2003 & PV2010 (left)

How do the new sliders behave with raw vs. rendered photos?

In previous versions of Lightroom, raw photos had different default settings—Brightness of 50, Contrast of 25, and a Medium Contrast tone curve—whereas rendered photos, such as JPEGs, were all set to 0. That caused problems with applying presets and synchronizing settings.

The new Process Version 2012 sliders use defaults of 0, regardless of the file type, which makes that much simpler. The sliders behave much more similarly too, although the additional data available in raw files gives them a slightly different feel in places. For example, when you decrease the Exposure slider, there is additional highlight data which can be pulled from a raw file, whereas a rendered file has no recoverable data above its whitest point.

How do I turn off the auto highlight recovery to blow a white background?

Although highlight recovery is now invoked automatically, you can still blow out intentional white backgrounds by dragging the Whites slider to the right. If the photo was correctly exposed with the whites already close to clipping, a small value such as 15-25 should be enough to blow the white background without having a noticeable impact on the overall exposure. Higher values will affect the overall exposure slightly, so if you're doing a large number of white background photos, you may want to break the top-down rule and increase the Whites before adjusting the other sliders.

What does the Clarity slider do?

Clarity adds local area contrast, concentrating primarily on the midtones, which helps to lift the photo off the page or screen. The effect of the Clarity slider in PV2012 is very different to the effect in PV2010. It's much stronger, so you'll need lower values than you may have been used to using in Lightroom 3, and it no longer adds the halos that were often present in the PV2010 version.

As a general rule, it's best to use a low setting for portraits, if you use it at all, as it can accentuate lines and wrinkles. Slightly higher values are brilliant on architecture and landscapes, adding a distinctive crisp feel. Set to a negative amount, it adds a gentle softening effect, which is particularly effective on close-up portraits.

In this screenshot Clarity is set to 100, just to show the effect, but there are very few photos that would benefit from such a high setting:

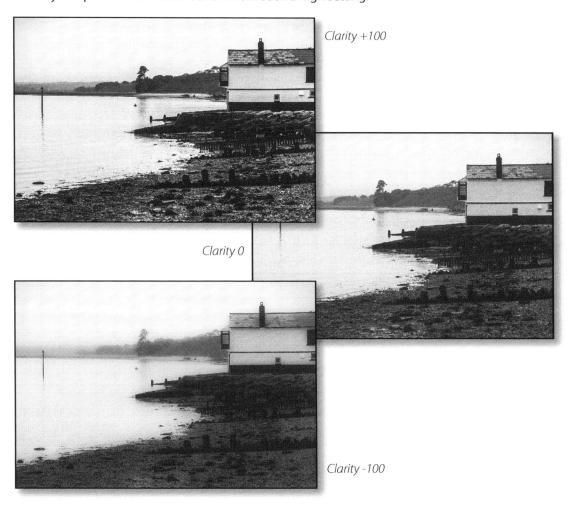

Clarity +100

Clarity 0

Clarity -100

Here Clarity is set to -100. The same image is used to show the difference, however negative values work best on faces:

Clarity doesn't try to increase saturation, so if you use high Clarity values, you may find that the colors start to look a little muted. Adding a little vibrance or saturation can make it look more natural.

What's the difference between Vibrance and Saturation?

Saturation is quite a blunt instrument which adjusts the saturation of all colors equally, which can result in some colors clipping as they reach full saturation.

Vibrance is far more useful as it adjusts the saturation on a non-linear scale, increasing the saturation of lower-saturated colors more than higher-saturated colors, which also helps to prevent skin tones from becoming over saturated.

WORKING WITH SLIDERS & TARGETED ADJUSTMENT TOOL

We've already mentioned some of the slider adjustment options earlier in the Workspace chapter, for example, you can drag the panel to become wider, which will lengthen the sliders, making them easier to adjust. There are a few more tips that only apply in the Develop module.

The slider movements are too coarse—how can I adjust them?

If you hover over the slider without clicking, you can use the up and down keys to move the slider. Adding Shift moves in larger increments or Alt (Windows) / Opt (Mac) decreases the increments.

Also check...

"Moving Sliders"
on page 164

If you click on a slider label, that slider becomes highlighted, and using the + / – keys adjust that slider. Adding modifier keys changes the increments, so adding Shift again moves in larger increments, and Opt (Mac only) moves in smaller increments. The ; key highlights the Exposure slider, and the , and . keys move up and down through the sliders, selecting each in turn.

For speed, I choose to use a Wacom Graphics Pen in one hand to float over the sliders, and a Contour Shuttle Pro 2 dial programmed to up/down keys when I turn the dial, with the buttons programmed to other useful shortcuts.

You can purchase a Shuttle from http://www.lrq.me/shuttlepro and download my settings from: http://www.lrq.me/shuttlesettings

This is my current Shuttle setup for speedy Develop processing:

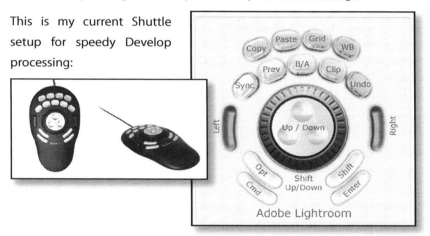

How do I apply Auto settings to individual sliders?

Holding down Shift and double-clicking on the slider label sets the slider to its Auto position without adjusting the other sliders. You'll also find an Auto button in the Basic and B&W panels, and an Auto Tone command under the Settings menu with the shortcut Ctrl-U (Windows) / Cmd-U (Mac).

Does it matter in which order I apply sliders?

The sliders are applied in an independent order behind the scenes, regardless of the order you use to adjust them, but some sequences are more efficient than others.

Moving from top to bottom will usually work best, particularly for Process Version 2012. The main exception is the camera profiles in the Camera Calibration panel, which are worth selecting before you start

Also check...

*"Calibration Profiles
& Styles" section
starting on page 443*

developing your photo, as they will significantly change the look of the photo.

For PV2012, the range of the sliders is affected by the earlier slider values. For example, the range of the Highlights and Shadows sliders are affected by the Exposure slider. The Whites and Blacks depend, not only on Exposure and Contrast, but also on the Highlights and Shadows sliders. The same generally applies to adjusting curves after setting the Basic panel settings. It's possible to use them in a different order, but you'll save yourself a lot of time and bouncing around if you work from the top down.

If your photo is very over or underexposed, you'll need to roughly adjust the Exposure slider before you can set the white balance, and once you've got the white balance right, you may then need to go back and adjust the exposure of the photo further, as an incorrect white balance can shift the overall exposure. From there, work down the rest of the Basic panel.

If you're converting a photo to black & white, first set the white balance while it's still in color, as an incorrect white balance can create a muddy black & white.

The one exception is Spot Removal, which does take the order into account when applying overlapping spots.

How do I use the TAT, or Targeted Adjustment tool?

Appearing in the Tone Curve, Hue, Saturation, Luminance and B&W panels, the Targeted Adjustment tool, or TAT for short, allows you to directly control the sliders by dragging on the photo itself. It means you can concentrate on the photo itself rather than the sliders. Particularly when adjusting HSL or B&W, it saves you having to work out which sliders you need to adjust for a specific color. This rather unobtrusive little tool is a real gem!

If you select the TAT tool from the Tone Curve panel, and click and drag upwards on an area of the photo, that area will get lighter, as the Tone Curve for that particular spot on the histogram is affected. If you prefer, rather than clicking and dragging, you can float over an area on the photo, and use the Up/Down keys to make adjustments. Once you've finished, just press Escape or return the tool to its base.

Also check...

"What is the HSL panel used for?" on page 384

Why are some slider values dimmed?

You may notice that some sliders are a brighter white than others. The sliders that are set to their default settings are grey, and once you change the slider value from the current default setting, then the value becomes bright white. It's a quick way of identifying which sliders you've used.

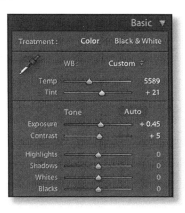

TONE CURVES

Tone Curves are primarily used for adjusting contrast in specific tonal

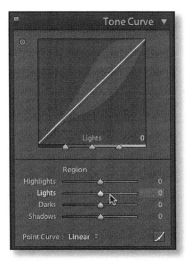

ranges. The steeper the curve, the higher the contrast becomes. For example, the most popular shape curve is an S shape, which increases contrast by lightening the highlights and darkening the shadows. The area in the middle becomes steeper and higher contrast, and the highest highlights and darkest shadows become shallower, holding some of the detail.

How do I use the standard Parametric Tone Curve?

The Parametric Tone Curve is the default view, and it allows you to adjust the curve of the photo while still protecting the photo from extremes. You can drag the curve itself, move the sliders, or use the TAT tool to adjust the curve while concentrating on the photo itself. As you drag each area, the grey highlighted section shows the limits of movement of that slider.

What do the three triangular sliders docked at the base of the Tone Curve do?

The three triangles at the bottom of the Parametric Tone Curve adjust how much of the tonal range is affected by each of the sliders for Shadows, Darks, Lights and Highlights. Double-clicking on any of those triangular sliders resets the slider to its default position.

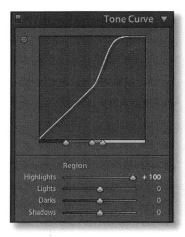 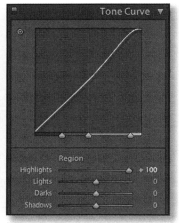

How do I use the Point Curve?

Lightroom also offers a custom Point Curve interface for advanced users, which allows much more extreme curves. Press the small button next to the Point Curve pop-up menu and you can edit the Point Curve directly, creating some of the weirdest curves imaginable.

Point Curves are not necessarily an alternative to the Parametric curves. You may be more comfortable with one or the other, but both curves are active at the same time and the effect is cumulative.

For PV2012 photos, you can also now access RGB curves in the same interface. The RGB curves are particularly useful for adjusting colors in rendered files. Where color casts differ between the highlights and shadows—perhaps where the overall color is correct but the shadows have a magenta tinge—general white balance adjustments would be unable to fix it, but RGB curves allow you detailed control.

The TAT tool allows you to create additional points on the Point Curve, and dragging those points on the Point Curve interface adjusts them. You can't use the keyboard to adjust the points, but if you hold down the Alt (Windows) / Opt (Mac) key while moving the points, it allows you to adjust with much finer movements.

Where have the Tone Curve sliders gone?

If you're missing the Tone Curve sliders, you're viewing the Point Curve interface, so press the Point Curve button to return to the Parametric Curves.

Which PV2012 Point Curve is the equivalent of Strong Contrast in PV2010 for raw photos?

In PV2010, the point curve default was Linear for rendered photos (i.e. JPEGs) and Medium Contrast for raw photos. That made it difficult to create presets that were suitable for both rendered and raw formats.

In PV2012, the point curves for raw photos have all been downgraded, so that both raw and rendered have Linear as their default in the Tone Curve panel, and the extra curve is applied behind the scenes. Photos that were set to Medium Contrast are switched to Linear when the process version is updated, and photos that were set to Strong Contrast become a custom point curve which is very similar to the new Medium Contrast.

HSL, COLOR, B&W & SPLIT TONING

The HSL, Color, B&W and Split Toning sliders can look slightly daunting to start with, as there are a multitude of sliders. They allow for much finer adjustments of specific colors in your photos and creative monochrome effects too. Often a color in your photo will be affected by more than one slider, so try experimenting with the TAT tool and see how they interact.

What is the HSL panel used for?

H stands for Hue, which is the color. S stands for Saturation, which is the purity or intensity of the color. L stands for Luminance, which is the brightness of the color.

The HSL panel allows you to adjust the colors in your photo, and the tinted sliders show which way the colors will shift. For example, if you have some grass in your photo, moving the Green slider to the left will make that grass more yellow, without affecting the reds significantly. If someone's skin is

too pink, and the rest of the photo is perfect, you may need to adjust a few of those sliders, including the Magenta and Red sliders. Rather than having to work out which colors to shift, the TAT tool allows you to drag directly on the photo and it will choose which sliders need to be adjusted.

My favorite use of the TAT tool and the HSL panel is for a quick blue sky fix. When brightening a photo causes those beautiful blue skies and white fluffy clouds to become too light, try setting the HSL panel to Luminance, selecting the TAT tool, and dragging downwards on the blue sky to darken the sky and maybe then switch to Saturation to increase the blue too. Don't go too far, as you'll start to introduce noise, but it's a very quick fix.

Also check...

"How do I use the TAT, or Targeted Adjustment tool?" on page 380

What's the difference between the HSL and Color panels?

There is no difference in the functionality of the HSL and Color panels—they're the same tools laid out differently.

How do I create a Black & White photo?

If you just want an idea of how your photo would look in black & white, press the V key on your keyboard, which toggles between the Color and Black & White choices at the top of the Basic panel. If you like it, then you can start adjusting the way the colors are mixed.

In the B&W panel, the sliders are set to Auto positions by default, and those are often a good starting point. You can adjust those sliders manually, or you can pick up the TAT tool and drag different areas on the photo to make them darker or lighter. For example, dragging that TAT tool downwards on the sky will darken the blue tones, giving a more dramatic contrast against the clouds. You may also want to switch back to the Tone Curve panel and adjust the curve to increase the contrast. Some photos look far better in black & white than they do in color, and photos that are very underexposed or overexposed often can be rescued by black & white conversion.

How do I use the Split Tone panel?

The Split Tone panel is primarily designed for effects such as softly toned black & whites and cross-processed looks. There are 2 pairs of Hue and Saturation sliders—one for the Highlights and one for the Shadows. If you click on the color swatch, you can also select your tint from the Color Picker, and you'll see both sliders move to match your selected tint. The slider in the middle balances the effect between the Highlights and the Shadows. If you're just starting to experiment with cross-processing and toned black & whites, there are many free presets that may give you a few ideas.

Also check...

"Where can I download Develop presets?" on page 405

How do I create a Sepia photo?

To create a great sepia or softly-toned black and white photo, you again use the Split Tone panel. A hue of around 40 to 50 gives a lovely soft brown tone, and then adjusted the saturation slider in that panel to increase or decrease the strength of the effect. If you check the Presets panel on the left, there's a preset in the Lightroom B&W Presets folder called B&W Creative—Sepia Tone to get you started.

Also check...

"Local Adjustments— Graduated Filter & Adjustment Brush" section starting on page 458

Why is Lightroom adding a colored tint to my Black & White photo?

If you change a photo to Black & White and there still appears to be a colored tint, there are a couple of places to look. The obvious one is the Split Tone panel, but Local Adjustments is the other place to look as an existing brush stroke or gradient may be applying a tint. You could press Reset on the Brush and Graduated Filter tools to remove any existing adjustments, or you could select each pin in turn and ensure that the Color rectangle is white with an X.

ADJUSTING MULTIPLE PHOTOS

One of Lightroom's greatest strengths is its ability to batch process photos quickly, copying settings across multiple photos. Even if the photos are not identical, synchronizing a custom white balance across photos taken in similar lighting can give you a good starting point and helps to keep the processing consistent across the whole batch.

If you mix PV2003/2010 photos with PV2012 photos when synchronizing settings, be aware that there may be unexpected results, because they

Also check...

"Process Versions"
section starting
on page 356

include completely different sliders. If you're synchronizing all of the sliders, checking the Process Version checkbox in the Copy or Sync dialog will apply the correct settings. If you're only synchronizing specific sliders, the result will depend on which sliders are selected and whether they have the same effect in both process versions.

How do I copy or synchronize my settings with other photos?

As with most things, Lightroom gives a number of different options, so you can choose the one that suits you best at the time:

Copy/Paste option

Copy and Paste allows you to select which settings to copy to the new photo, and they stay in memory until you copy different settings or close Lightroom, so you can apply the same settings to other photos later.

1. Adjust the first photo, which will become the source of your settings.

2. Press Ctrl-Shift-C (Windows) / Cmd-Shift-C (Mac) to show the Copy Settings dialog, or use the Copy button at the bottom of the left hand panel in the Develop module.

3. Select the checkboxes for the slider settings that you want to copy to the other photo.

4. Move to the target photo.

5. Press Ctrl-Shift-V (Windows) / Cmd-Shift-V (Mac) to paste those settings onto the selected photo, or use the Paste button at the bottom of the left hand panel.

Previous option

The Previous option copies all of the settings from the most recently selected photo to the next photo you select.

1. Adjust the first photo.

2. Move on to next photo.

3. Press Ctrl-Alt-V (Windows) / Cmd-Opt-V (Mac) to apply all of the settings from the previous photo, or use the Previous button at the bottom of the right hand panel.

There's one exception—if you're moving from a photo with no crop, to a photo with an existing crop, the crop will not be reset. If you use Previous, watch out for Red Eye Reduction and other local adjustments which are copied over too, as they can end up being small grey dots in strange places if the photos aren't identical.

Also check...

"What's the difference between the selection shades of grey?" on page 158

Sync option

Sync uses the data from the most-selected or active photo, and pastes it onto all of the other selected photos. That's why there are 3 different levels of selection, as we mentioned early in the Workspace chapter.

1. Adjust the first photo, which will be the source of the settings.

2. Keeping that photo active (most-selected), also select the other photos by holding down Ctrl (Windows) / Cmd (Mac) or Shift key while clicking directly on their thumbnails, rather than the cell borders.

3. Ctrl-Shift-S (Windows) / Cmd-Shift-S (Mac) shows the Sync Develop Settings dialog so you can choose which settings to Synchronize, or use the Sync button in the Develop module or Sync Settings in the Library module to do the same.

Holding down the Alt (Windows) / Opt (Mac) button while pressing the Sync button, or using Ctrl-Alt-S (Windows) / Cmd-Opt-S (Mac), will synchronize the settings but bypass the dialog. If you're bypassing the dialog, make sure you've got your chosen settings checked the first time, as it will use the last used checkbox settings.

Auto Sync option

The Auto Sync behavior matches the behavior of ACR—when you have multiple photos selected, any slider adjustments

are applied to all of the selected photos. It can be slow for large numbers of photos, particularly when used with the Crop or Straighten tools.

1. Select multiple photos.

2. Toggle the switch next to the Sync button so that the label changes to Auto Sync.

3. As you adjust the photos, all of the selected photos will update with any slider adjustment at the same time.

Auto Sync is powerful but dangerous, as it's easy to accidentally apply a setting to multiple photos without realizing that they're all selected. It gets particularly confusing if you often switch between standard Sync and Auto Sync, so you may find it easiest to leave it turned on at all times, or at least leave the Filmstrip visible so you can see the number of photos that are selected.

When you have Auto Sync turned on, you can still use the keyboard shortcuts for the other sync options such as Previous, Paste or standard Sync, but they will apply to ALL selected photos, not just active (most-selected) photo, as Auto Sync will still be active.

Why won't my white balance sync?

The white balance is perfect on photo A, so you sync the settings to photo B… but it doesn't change. So you try it again… and it still doesn't change. Why?

'As Shot' is the key. If photo A is set to As Shot white balance, photo B will also be set to As Shot, not the same numerical values. To solve it, select Custom from the white balance pop-up, or shift the values slightly, and then sync with photo B, and your numerical values will be copied.

Also check...

"White Balance" section starting on page 359

What does 'Match Total Exposures' in the Settings menu do?

Match Total Exposure is intelligent adjustment of the exposure value on a series of photos. Where photos were shot in the same lighting, but on

Aperture Priority/AV, Shutter Priority/TV or Program, it results in varying camera exposure settings. This clever command calculates and adjusts the exposure on all selected photos to end up with the same overall exposure value. It doesn't adjust for the sun going behind a cloud though!

To use it, correct a single photo, then select other photos taken at the same time. In the Develop module, go to Settings menu > Match Total Exposures, and the photos will all be adjusted to match the overall exposure of the active (most-selected) photo, taking into account the variation in camera settings. You'll also find it in the Library module under Photo menu > Develop Settings.

Can I make relative adjustments, for example, brighten all selected photos by 1 stop?

You can't make relative adjustments directly within the Develop module, but you can do so using the Quick Develop panel in the Library module, which we mentioned in that earlier chapter.

Select the photos and make sure you're viewing the Grid view, so that your changes apply to all selected photos. Press the buttons in the Quick Develop panel and the photos will change relative to their existing settings, rather than Sync, which would set everything to the same fixed slider value.

BEFORE / AFTER VIEWS

There's nothing better than seeing the results of your hard work, so Lightroom offers before and after previews to compare your photo with an earlier rendering.

Can I see a Before / After preview?

If you press the \ key, the preview toggles between a before/after view

Also check...

"Quick Develop"
section starting
on page 238

Also check...

"Keyboard Shortcuts"
chapter starting
on page 671

of the whole photo. When you click the Before / After Previews button in the toolbar—the one with a Y on it—you'll see other options, such as side-by-side, top-and-bottom and split-view previews. Logically the keyboard shortcuts for those previews are all variations on the letter Y too, and you'll find those listed in the Keyboard Shortcuts chapter.

| Before/After Left/Right |
| Before/After Left/Right Split |
| Before/After Top/Bottom |
| Before/After Top/Bottom Split |

How do I select a different history state for the Before view?

By default, the Before view is the last 'Read from Metadata' state which is usually when the photo was imported, but you can choose any history step or snapshot to be the Before view. Right-click on the history step or snapshot, and choose Copy History Step Settings to Before or Copy Snapshot Settings to Before. If you have the Before view on screen, you can also drag a history state or snapshot from the History or Snapshot panel directly onto the preview, rather than going through the right-click menu. The key is dragging, rather than just clicking on the history or snapshot state, as clicking would change the After view instead of the Before view.

Also check...

"History & Reset"
section starting
on page 421 and
"Snapshots & Virtual
Copies" section
starting on page 417

If you want to update a whole set of photos to show their current state as Before, but don't want to do it by hand on every photo, there's a quicker solution…

1. Go to Grid view.

2. Select the photos, and press Ctrl-S (Windows) / Cmd-S (Mac) to write the settings to the files. If you have 'Automatically write to XMP' turned on in preferences, you can skip this step.

3. Once it's finished, with those photos still selected, select Metadata menu > Read Metadata from Files.

4. That automatically updates the Before state to the current settings, but it only works with master photos and not virtual copies.

Also check...

"Panel Switches"
on page 165

Can I turn off the effect of a whole panel's settings, to see the preview with and without those settings?

Most Develop panels have a toggle switch to the left of the panel label, which allows you to temporarily disable any panel for that specific photo only, without resetting the slider values. That also applies to the Spot Removal, Red Eye Correction, Graduated Filter and Adjustment Brush tools, which have a switch at the bottom left of their options panel.

When you disable a panel, it will not only affect the preview but also any photos you export.

HISTOGRAM & RGB VALUES

A Histogram, shown in the top right panel, is a bar graph showing the distribution of tonal values. It runs from the blackest shadow on the left to the brightest highlight on the right, and vertically it shows the number of pixels with that specific tonal value.

There's no such thing as a 'correct' histogram, but an average photo with a wide range of tones will usually fill the whole width, so understanding how to read it can help you set the exposure, especially on the back of the camera.

A photo that is primarily light, for example, a white dog against snow, will show most of the data on the right hand side of the histogram. That's entirely normal, just as a photo taken in fog is unlikely to have any dark black pixels.

On the other hand, if you have an average photo, where you'd expect to have tones running from pure white to pure black, and you find the histogram stops half way across, then you know the photo is underexposed and lacking in contrast.

You can click and drag directly on the Histogram to move those tones to the right, and the highlighted slider will move as you do so.

If the last pixel on the left or the right spikes, it means that those pixels are no longer holding detail in your photo. Those are called clipped highlights or shadows, or you may hear them referred to as blown highlights and blocked shadows. If it's an area where you're not expecting to see detail, for example, a window in the background of an indoor shot, then it's not necessarily a problem, but if it's on someone's skin, you'll need to pull that back the other way.

Is it possible to see clipping warnings? Or, why are there red and blue areas on my photos?

The triangles in the top-left and top-right corners of the histogram turn the clipping warnings on and off, and also change color when a channel is clipped. Clipping means that there's no detail in that channel at your current settings.

They're turned on and off by clicking directly on those triangles, or by using the keyboard shortcut J to turn both on and off at the same time. They can also be accessed temporarily by holding down the Alt (Windows) / Opt (Mac) key while dragging the Exposure, Highlights, Shadows, Whites or Blacks sliders for PV2012, or Exposure, Recovery or Blacks sliders in PV2010.

Why does the Histogram look different when I open the exported sRGB photo in Photoshop? Why are my highlights clipping in Photoshop but not in Lightroom?

The histogram in Lightroom, and therefore the clipping warnings, are working in the internal MelissaRGB color space, which is a much larger color space than sRGB. We'll come back to color spaces in the Export chapter.

A color which is still within gamut (or range of available colors) in MelissaRGB or ProPhotoRGB, may therefore have slipped out of gamut when changing to a small space, such as sRGB, resulting in clipping. You'll mainly notice it on highly saturated colors, which clip when you convert to a smaller color space.

Let's illustrate with this fire truck... the saturated reds make it clear to

see the difference. We'll look at the histogram and clipping, in addition to the photo.

First we have Lightroom's default histogram, with clipping warnings turned on. The black preview without any clipping warnings shows that no colors are clipping in Lightroom's working space.

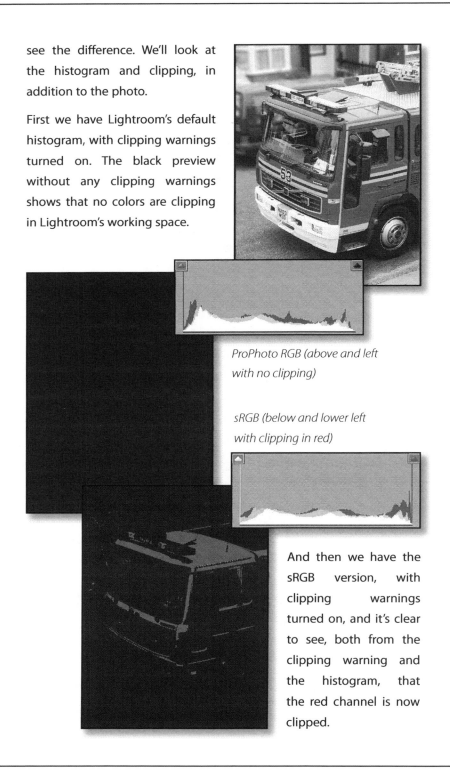

ProPhoto RGB (above and left with no clipping)

sRGB (below and lower left with clipping in red)

And then we have the sRGB version, with clipping warnings turned on, and it's clear to see, both from the clipping warning and the histogram, that the red channel is now clipped.

If you know you're going to export to a smaller color space, you can preview how it will look, and whether any colors will clip, by using Lightroom 4's new Soft Proofing tool. We'll investigate that in the next section.

Can I view RGB values using a normal 0-255 scale?

Underneath the Histogram, Lightroom shows the RGB values for the pixel beneath the cursor. Those are shown in percentages, rather than a 0-255 scale, because 0-255 is an 8-bit scale and Lightroom works in 16-bit. As in the 0-255 scale, equal numbers are neutral, so 50% 50% 50% is neutral grey.

When you turn on Soft Proofing, the RGB values are switched to the 0-255 scale, as you're simulating an output color space.

SOFT-PROOFING

Soft proofing attempts to simulate, on your calibrated monitor, how the photo will look with your chosen printer/paper/ink combination. You can then adjust the photo for that specific output without creating numerous test prints.

I don't have a printer—is soft proofing useful to me?

Even if you don't print to a locally attached printer, such as an inkjet printer, soft proofing can still be useful. If you send prints to an offsite lab, they may be able to provide their printer profile for soft proofing purposes.

If you only ever show your photos on a screen—perhaps on the web— soft proofing can show how your photos will look in the smaller sRGB color space. As we saw earlier with the fire truck, colors that are within Lightroom's working space may clip when converting to sRGB. Soft

proofing allows you to preview that effect, and the histogram and RGB numbers are also updated to reflect your proof profile.

How do I turn on soft proofing?

To turn on soft proofing, either check the Soft Proofing checkbox in the toolbar or press the S key. You'll see the Histogram panel change to a

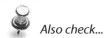

Soft Proofing panel with additional options, and the background surrounding the photo will change from mid-grey to paper white.

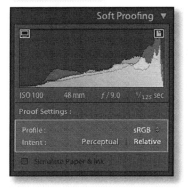

How do I select the profile for soft proofing?

In the Soft Proofing panel, which has replaced the Histogram panel, select your chosen profile from the Profile pop-up menu.

How do I add additional profiles for soft proofing?

If your chosen profile doesn't appear in the pop-up, select Other at the bottom of the Profile pop-up and put a checkmark next to the profiles in the Choose Profiles dialog. They'll then appear in the Profile pop-up, ready for selection.

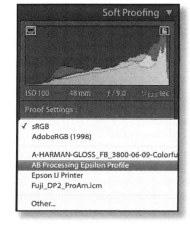

Why can't Lightroom find my profile?

Your profile needs to be installed on your computer before Lightroom will be able to use it. We'll come back to installing profiles in the Print chapter.

If your profile is correctly installed, but it still doesn't appear in the Choose

Also check...

"How do I get Lightroom to see my custom printer profile?" on page 621

Profiles dialog, then it may be an unsupported profile. Lightroom's limited to RGB profiles only, so it won't work with CMYK profiles, Greyscale profiles, or some other non-standard profiles designed for Printer RIPs (Raster Image Processor).

Some RGB profiles don't conform to the ICC Specification, and they may be ignored too. Running Profile First Aid in ColorSync Utility on a Mac can often repair those profiles, making them available in Lightroom. I'm not aware of any free Windows software that will run an ICC profile repair.

Should I select Perceptual or Relative Colorimetric?

When you've selected your profile, you'll notice that there are additional options such as the rendering intent. The rendering intent options only apply to output spaces, not working spaces like sRGB, AdobeRGB and ProPhotoRGB.

Perceptual squeezes all of the colors into the smaller color space while trying

Profile: AB Processing Epsilon Profile
Intent: Perceptual Relative

to retain their relationship to each other. That means that all of the color values shift but it should still be perceived as natural. Perceptual rendering intent is good for highly saturated photos with a lot of out-of-gamut colors.

Relative Colorimetric leaves most of the colors alone, and just clips the out-of-gamut colors to the closest reproducible colors. It's usually a better choice if a photo is mostly within gamut, as it only shifts those out-of-gamut colors.

So which should you choose? If you're exporting the photo using the Export dialog, use Relative Colorimetric, as the Export dialog doesn't give you a choice of rendering intent. If you're printing through Lightroom, the Print module does give you a choice. In that case, there isn't a simple answer, as it depends on the photo, so try both and see which looks best.

Should I check 'Simulate Paper & Ink' when viewing my soft proof?

Simulate Paper & Ink simulates the reduction in contrast caused by dull white paper and dark grey black ink, so it's also known as the 'Make the Photo Look Rubbish' checkbox. Your eyes adapt to the color and brightness of the whitest object in your view, making the soft proof look dark and flat.

To solve this, remove all other white/light reference points from your view and switch to Lights Out by pressing the L key. Your eyes will then adjust to the soft proof version and you can adjust the photo accordingly. With Lights Out, however, it's obviously impossible to adjust the photo, so when you're ready to start making adjustments, you'll need to disable Lights Out by pressing the L key again.

You'll find 1:8 and 1:16 zoom ratios on top of the Navigator panel which allow you to zoom out further, surrounding the photo with a larger area of paper white, while still being able to adjust the photo using the Develop controls.

Can I change the background color surrounding the photo while soft proofing?

By default, the background surrounding the photo shows a paper white, but the accuracy of that paper white depends on the quality of the profile. If it's wrong, you can switch to an alternative background by right-clicking in the background area. There's a range of shades of white and grey available, so you can select one which more closely matches the paper. Your chosen color will also be used for the background when using Lights Out mode.

What's the difference between Destination Gamut and Monitor Gamut warnings?

In the top corners of the histogram, the clipping warning buttons are

replaced by gamut warning buttons. When you click to enable them, out of gamut areas of your photo are highlighted in blue, red or purple. If either out of gamut warning is showing, it's simply telling you that you're not seeing an accurate preview of those colors.

Blue shows that a color is outside of the monitor gamut, which means that even if the color is printable, you won't get a good print-to-screen match because the monitor can't display that particular color accurately.

Red shows that a color is outside of the destination gamut, which means that it is printable and will be remapped by the output profile.

Purple is out of both gamuts.

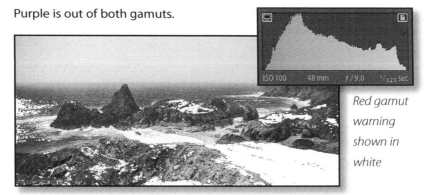

Red gamut warning shown in white

What should I do if some colors are out of gamut?

If the colors are showing as out of gamut, it doesn't necessarily mean that you need to do anything about it. It's simply information that the final print won't exactly match the screen preview in those areas.

Desaturating the photo, or locally desaturating the out-of-gamut colors, are traditionally suggested as a solution, however a good quality profile will usually do a far better job of pulling those colors back into gamut.

How should I adjust the photo while viewing the soft proof?

So if you're not reducing the saturation on out of gamut colors, what is the point of soft proofing?

Also check...

"Before / After Views"
section starting
on page 391

The aim is to compensate for the losses in printing, to make the print look closer to the original. Often that's a difference in contrast and brightness, rather than color.

To do so, put the original photo on screen next to the soft proof preview, using the Before/After preview, and try to adjust the soft proof to more closely match the original. You're simply trying to make the soft proof—and therefore the finished print—look better.

How do I compare my proof adjusted photo with the original?

We discussed the Before/After views earlier in the chapter, but they become particularly useful when soft proofing, as they allow you to compare your original intended rendering with the soft proofed copy. To turn it on, press the Before/After Preview button in the toolbar or press the Y key. Other views are also available when you click on the arrow next to the Before/After Preview button.

What is 'Saved State' when using Before/After preview with soft proofing?

There's an additional pop-up in the toolbar which allows you to select the Before state.

When you're working with a virtual soft proof copy, the Before state defaults to the Master photo, so you're automatically comparing against your primary Develop settings, which weren't adjusted for a specific output. You also have the option to compare against other virtual copies of the photo.

When you're working with an original photo that you've turned into a proof, it defaults to Saved State. Saved State is the normal Before view, so by default that would be the starting point—the time of import for a standard photo or creation state for a virtual copy. If you've done a Read Metadata from File, that would also update the Saved State.

You can change the Saved State by dragging a history state or snapshot onto the Before preview, or right-clicking on the history state or snapshot and choosing Copy History State/Snapshot Settings to Before.

Also check...

"How do I select a different history state for the Before view?" on page 392

How do I save my photo after adjusting it for a specific profile?

Just below the histogram, there's a Create Proof Copy button, which creates a virtual copy of your photo for soft proofing. It means that your original settings, which were suitable for any kind of output, remain untouched, and your profile-specific adjustments are stored separately.

If you start editing a photo without first creating a proof copy, Lightroom will ask if you want to create a virtual copy for the soft proof, or whether you want to edit the original photo. We'll come back to virtual copies in more detail later in the chapter.

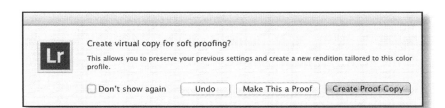

How can I tell which profile I used for a particular photo?

If you allow Lightroom to create a virtual copy for the soft proof, it will enter the name of the profile in the Copy Name metadata field, and that updates if you switch to a different profile. You can view the Copy Name in the Metadata panel, the Grid view thumbnails, the Info Overlay or along the top of the Filmstrip.

Folder : 2007 78 photos / 1 selected / **20070701-153340.dng / AB Processing Epsilon Profile** ▾

Also check...

"Snapshots & Virtual Copies" section starting on page 417 and "Can I rename virtual copies?" on page 418

Also check...

"How do I change the filename while exporting?" on page 490

Can I export a soft proof adjusted version with a note to say which profile I was using?

Lightroom doesn't store the name of the profile in XMP, however you can rename the file when exporting, and include the Copy Name field in the new filename. Filename-CopyName would result in a filename such as IMG_003-sRGB.jpg. Remember that Export always uses Relative Colorimetric as the rendering intent.

How do I find all my soft proof copies?

In the Smart Collection criteria, you'll find 'Is Proof,' which will find all of your soft proof adjusted photos, whether they're virtual copies or original photos that were made into proofs.

Finding all of the proofs with a specific profile isn't quite so easy, but using a Smart Collection to search for a profile name in the Copy Name field can work, as long as your proofs are all virtual copies.

PRESETS

A Develop preset is simply a combination of Develop settings saved for use on other photos, and a whole community has sprung up, sharing

and selling Lightroom Develop presets. They can offer a good starting point for your post-processing, or more often, some weird and wonderful effects. Some examples are included by Adobe, and you'll find them in the Presets panel on the left of the screen.

Where can I download Develop presets?

There are many sources of free and commercial presets, or you can create your own. I keep a list of Develop preset websites at http://www.lrq.me/links/develop-presets for your easy access.

And the Lightroom Exchange is a great place to find all sorts of new plug-ins, presets and other goodies: http://www.lrq.me/lightroomexchange

How do I install Develop presets?

If you're installing presets from a single folder, the automatic method is quick and easy. If you're installing lots of presets in one go, perhaps because you've bought a whole set, and they're organized into multiple folders, then the manual installation may be quicker.

Automatic installation

1. Unzip the presets if they're zipped.

2. Go to Develop module Presets panel, right-click the User Presets folder and choose Import.

3. Navigate to the folder of presets, select them and press the Import button.

Manual installation

1. Unzip the presets if they're zipped.

2. Find the Develop Presets folder in Explorer (Windows) / Finder (Mac) by going to Preferences > Presets panel and pressing the Show Lightroom Presets Folder button.

3. Drag the presets into that folder, still in their folders if you'd like to keep them organized in the same way.

4. Restart Lightroom.

Also check...

"The default location of the Presets is…"
on page 656

Also check...

"How do I copy or synchronize my settings with other photos?" on page 388 and "Quick Develop" section starting on page 238

How do I preview and apply presets to my photos?

If you want to see what your preset will look like, without having to apply it to a photo and then undo it again, you can watch the Navigator panel as you float over the presets in the Presets panel. The small Navigator preview will update with your preset settings, allowing you to easily find the effect you're looking for.

To apply your preset in the Develop module to the currently selected photo, you can just click on the preset in the Presets panel. To apply it to multiple photos, it's easiest to select all of the photos in Grid view and choose your preset from the Quick Develop panel or from the right-click > Develop Settings menu. Anything you do in Grid view applies to all of the selected photos. If you want to stay in Develop module, you can apply the preset with Auto Sync turned on, or you can apply to one photo and then use Sync to copy the settings to the rest of the photos.

How do I create my own Develop Presets?

To create your own preset, adjust a photo to the settings that you want to save as your preset. Press the + button on the Presets panel to show the New Develop Preset dialog.

Check or uncheck the sliders you want to save in your preset. If a checkbox is unchecked, that unchecked slider won't be affected when you apply your preset to another photo. For example, if your preset is just for Sharpening settings, uncheck the other checkboxes, otherwise you may accidentally change the exposure and other settings.

Name the preset and choose a folder to group similar presets together, and then press the Create button. Your preset will now appear in the Presets panel for use on any photos.

If you later need to update a preset, repeat the process, but instead of pressing the + button to create a new preset, right-click on an existing

preset and choose Update with Current Settings. You'll need to make sure you've selected the correct checkboxes again.

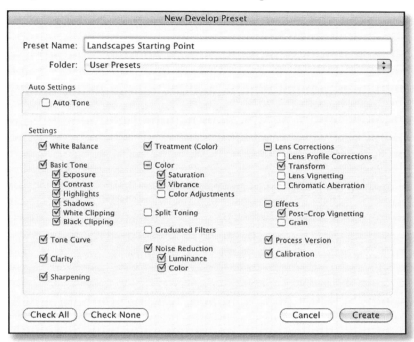

Also check...

"The default location of the Presets is…" on page 656

How can I organize my presets into folders or groups?

Many users are now overflowing with presets that they've created or downloaded, and it can be difficult to find the one you're looking for. You can create folders for the presets by right-clicking on any existing user preset or preset folder and choosing New Folder. Once you've created folders, it's simply a case of dragging and dropping the presets into a logical order. If you have hundreds of presets, you might find it useful to group your most often used presets in a single folder, rather than having to scroll through them all.

How do I rename Develop presets?

To rename a preset, go to the Presets panel, right-click on the preset and select Rename. Renaming the preset file manually in Explorer (Windows)

/ Finder (Mac) doesn't work because the preset name is embedded in the file itself. It's possible to edit the preset with a text editor, but a minor error could corrupt the preset, so be careful!

How do I remove the default Develop presets?

The default presets included with Lightroom are embedded in the program files. If you don't want to use them, just close the folders and ignore them, rather than digging around in the program files to try to find them.

How do I uninstall Develop presets?

To delete a preset, go to the Presets panel, right-click on the preset and choose Delete. You can also navigate directly to the Develop Presets folder via the Preferences dialog > Presets tab > Show Lightroom Presets Folder button, and delete/move multiple presets in one go, and then restart Lightroom. I keep a 'Spare Develop Presets' folder next to the main Develop Presets folder for the presets I uninstall but may want to reinstall in future, which helps to reduce the clutter.

Where have my presets gone?

If you have Store Presets with Catalog checked in the Preferences dialog > Presets tab, your presets are stored in a folder next to the catalog rather than in the global location. That means that they're only available to that single catalog.

That option works well if you use a single catalog, and that catalog is used on multiple different machines, as your presets will always go with you. It's also useful if you do a number of very different styles of

photography, each with their own catalog, and your presets are specific to that particular style of photography.

That preference also causes some complications. The presets are not copied to or from that location automatically by checking or unchecking that checkbox, so you have to transfer them manually. Also, if your preferences have to be deleted and the checkbox reverts to the unchecked state, or you switch language, your presets can appear to have mysteriously gone missing. If you're using Store Presets with Catalog to work between multiple computers, also remember that camera and lens profiles are not included, and neither are defaults and preferences.

If there isn't a specific reason why you need the presets stored with the catalog, I'd recommend leaving it unchecked. If you want the presets synchronized with multiple computers, file synchronization software or Dropbox (http://www.lrq.me/dropbox) are a good alternative.

Also check...

"The default location of the Presets is…" on page 656 and "How do I use symbolic links with Dropbox to keep my presets synchronized?" on page 317

Can I apply multiple presets to the same photo, layering the effects?

Presets only move a slider to a new position, and they don't calculate relative to the current slider settings. If Preset A only adjusts, for example, the Exposure and Contrast sliders, and Preset B only adjusts the Vibrance slider, then they can be applied cumulatively. If the presets change the same sliders, for example, Preset A sets the Exposure to -1 and then Preset B sets the Exposure to 0, then the changes made by the first preset will be overwritten by the second preset.

I have some Develop presets that I use in ACR in CS5—can I use them in Lightroom?

Lightroom's presets are saved in a Lightroom-only format (*.lrtemplate), so they're not directly interchangeable. If you want to be able to use an ACR preset in Lightroom, apply that preset to a raw file, and then

import that raw file into Lightroom. Once in Lightroom, you can save the settings as a Lightroom Develop preset for future use. The same works in the opposite direction, sharing Lightroom presets with ACR, and it's quicker than writing down all of the settings and entering them manually.

Why do my presets look wrong when used on JPEG/TIFF/PSD files, even though they work on raw files?

For photos set to PV2003 or PV2010, the processing on JPEG/TIFF/PSD files is completely different from the processing on a raw file, as raw files are linear and rendered files aren't. JPEGs start at 0 and are set to Linear for the Tone Curve, whereas raw files start with 50 Brightness, 25 Contrast, 5 Blacks, a Medium Contrast Tone Curve and some Sharpening and Noise Reduction too. That means that the presets can have a different effect, for example, a preset that sets the Tone Curve to Strong Contrast will be much stronger on a JPEG than it will on a raw file. Your best option in that case is to create two sets of presets which give a similar result if you use those specific sliders—one set for raw files, the other set for everything else. Alternatively, you can update the photos to the newest process version, which has solved the problem.

PV2012's defaults are set to 0 and linear regardless of file format, and the extra adjustments are done behind the scenes. This means that the same preset can be applied to either raw or rendered photos, with a very similar result. It's not always identical as raw files have more latitude for adjustment, but it's very close.

Also check...

"Process Versions"
section starting
on page 356

How are presets affected by the process version? Or, why aren't my presets working properly?

The slider changes in Lightroom 4 and PV2012 can complicate existing Lightroom presets. Whether they'll work—or how they'll behave—depends on how they were created and which settings were included.

There are a few different behaviors that are possible:

- Presets that don't include a process version setting, and only adjust sliders that behave the same way in all process versions, will work as expected. So a preset which only changes sharpening, or split toning, for example, will be fine.

- Presets that don't include a process version setting, but do adjust sliders that have changed, may behave unexpectedly. So if you've processed a photo in PV2012 and apply a preset that adjusts Brightness, nothing will happen. The same works in reverse, so if you try to apply an Red tone curve to a PV2010 photo, it will be done in the background and nothing will visually change.

- Presets that include a process version setting will switch the photo to that process version. If you've finished editing a photo, and are only expecting the preset to change to sepia tone, for example, you may be a little surprised when it also changes the exposure because it's switched back to PV2010 and the old sliders.

So how do you know whether your presets include process version settings? You could try applying them to multiple different photos, but there's an easier way. The .lrtemplate preset files are XML files, so they can be opened with a basic text editor like Notepad (Windows) / TextEdit (Mac) or with an XML editor.

When you open a PV2010 preset with everything checked, and also a PV2012 preset with everything checked, you'll be able to see all of the possible settings listed. The ProcessVersion line will say 5.0 for PV2003, 5.7 for PV2010, 6.7 for PV2012.

There are a number of ways you can solve the problem caused by the multiple different process versions…

- For presets that include only sliders that haven't changed (no Basic panel or point curve), you can simply remove the

```
s = {
    id =
    "A1940DDF-C094-4247-B89F-BCD32548BCE8",
    internalName = "2012 New Sliders",
    title = "2012 New Sliders",
    type = "Develop",
    value = {
        settings = {
            Blacks2012 = 0,
            Clarity2012 = 0,
            Contrast2012 = 0,
            Exposure2012 = 0,
            Highlights2012 = 0,
            ProcessVersion = "6.7",
            Shadows2012 = 0,
            ToneCurveName2012 = "Linear",
            ToneCurvePV2012 = {
                0,
                0,
                255,
                255,
            },
            ToneCurvePV2012Blue = {
                0,
                0,
                255,
                255,
            },
            ToneCurvePV2012Green = {
                0,
                0,
                255,
                255,
            },
            ToneCurvePV2012Red = {
                0,
                0,
                255,
                255,
            },
            Whites2012 = 0,
        },
        uuid =
    "BAF7EAE0-E086-4D3C-B10E-99488FB4D79D",
    },
    version = 0,
}
```

The anatomy of a PV2012 preset

ProcessVersion line, and they should behave as expected, at least for now. Of course, that may change in future releases.

- For presets that include changed sliders, you can create a new set of presets for PV2012, in addition to your existing sets, so you'd have:

 - PV2003/2010 for raw files

 - PV2003/2010 for rendered files

 - PV2012 for raw or rendered files

You'd then select the applicable preset for your selected photo, depending on the current process version and file type.

- For the adventurous, there's one more option—hand editing the presets to create a combined PV2003/2010 raw and PV2012 raw/rendered preset. PV2003/2010 rendered presets would still need to remain separate if they use Brightness, Contrast or Point Curve, as there were different starting points for those sliders. So how would you do that?

As you look through the PV2012 preset, you'll note that specific lines include 2012 in their title. They are: Blacks2012, Clarity2012, Contrast2012, Exposure2012, Highlights2012, Shadows2012, ToneCurveName2012, ToneCurvePV2012, ToneCurvePV2012Blue, ToneCurvePV2012Green, ToneCurvePV2012Red, Whites2012. That's all of the sliders that behave differently in PV2012, and you can use that to your advantage.

If you create both a PV2010 and PV2012 version of the preset, you can then open both in a text editor and copy the PV2012 lines into the other preset and remove the ProcessVersion line. That preset will then contain settings for either process

version, and should apply as expected without switching the process version automatically.

Let's try it…

1. Select a raw photo and press Reset.

2. Apply your PV2010 raw preset to that photo, or adjust it to your chosen PV2010 settings.

3. Save your chosen settings as a new preset, perhaps with an identifying word such as 'combined' in the name.

4. Create a virtual copy and update it to PV2012.

5. Adjust the virtual copy to match the master, only adjusting the Exposure, Contrast, Highlights, Shadows, Whites or Blacks sliders, or the Point Curve.

6. Save only those sliders as a PV2012 preset. It's only temporary.

7. Open both presets into a text editor.

8. Copy the lines containing 2012 from the 2012 preset and paste them into the combined preset. You can add them at the end as long as they're within the curly brackets. It's not concerned about alphabetical order.

9. Remove the ProcessVersion line if it's there, and save your combined preset.

10. Restart Lightroom.

11. Now reset the previous master and virtual copy, setting one to PV2010 and one to PV2012.

12. Apply your combined preset to both photos and check you get the correct results for each version.

13. Repeat for any other presets.

Also check...

"How do I use the Painter tool to quickly add metadata?" on page 192

Is there a way to add a keyboard shortcut to a preset?

You can't apply presets using a keyboard shortcut, but you can use the Painter tool to apply Develop presets quickly, which we covered in the Library chapter.

If you're a high volume user who is particularly keen on using keyboard shortcuts for as many commands as possible, including applying presets and other commands for which standard keyboard shortcuts aren't available, you could consider some of the commercial hardware devices, such as custom keyboards designed specifically for Lightroom. There are details at http://www.lrq.me/links/lr-keyboards

Can I fade the effect of a preset?

Lightroom doesn't offer a fade or opacity control for presets, but you could create multiple versions of your presets, with different strengths of settings. Alternatively there is a plug-in which offers allows you to fade your presets on the fly. You can download it from http://www.lrq.me/presetfader

DEFAULTS

Default settings are automatically applied whenever you import photos. Adobe set default settings, but you can change those to suit your own taste. The defaults you set in Lightroom are also used for ACR, and vice versa.

Why would I change the default settings instead of using a preset?

You can set new default settings for your photos, and those settings will automatically apply to any newly imported photos that don't have existing settings stored in XMP. It won't overwrite any existing settings

stored in the files, whereas a preset would override those existing settings.

The default settings will also apply any time you press the Reset button. The defaults can be set either by camera model or ISO, or by both combined too.

How do I change the default settings?

Go into Preferences > Presets panel and decide whether you want 'Make defaults specific to camera serial number' and 'Make defaults specific to camera ISO setting' turned on or off.

Also check...

"What Develop settings, metadata and keywords should I apply in the Import dialog?" on page 92

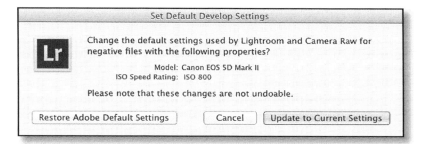

Select a photo. Ensure that it's updated to PV2012 and set your new settings. It's a good idea to press Reset first, so that you only change the defaults that you intend to change.

1. Go to Develop menu > Set Default Settings.

2. Press Update to Current Settings.

3. Repeat with a sample photo from each camera, and each combination of ISO/Serial Number if those options were selected in Preferences.

Although that dialog gives the warning that the changes aren't undoable, you can return to that dialog at any time to restore the Adobe's own default settings.

How do I set defaults that will work correctly for PV2010 and PV2012?

If you regularly double-click on a slider label to reset a slider to its default setting, and you're still working on some PV2010 photos, then you may want to update the default settings to contain both PV2010 and PV2012 slider defaults. To do so, select a photo and set it to PV2010. Choose your default PV2010 settings, and then update the photo to PV2012. Edit the additional PV2012 sliders, and then follow the instructions in the previous question to set your defaults. When you press the Reset button, photos will automatically be updated to PV2012 and their applicable defaults, however when you double-click on a PV2010 slider label, you'll get the default settings you intended for PV2010 too.

Why would I want different defaults for each ISO and serial number combination?

Lightroom always sets defaults for the camera model and file type combination, and it shows that combination in the Set Default Develop Settings dialog. In Preferences dialog > Presets tab, there are additional checkboxes to make defaults specific to the camera serial number or ISO too. For example, you might like to use different ISO defaults to apply different noise settings for different ISO ratings. Serial number might be used for different sharpening for different cameras, because the lens you always use on one body is softer than the other identical model, or something along those lines.

Which settings should I use as the defaults?

Your default settings are a matter of personal taste, but Adobe's own defaults are a good starting point for most people. You might prefer a different camera profile, or a higher contrast or sharpening setting, but you can choose, and if you change your mind, you can change your defaults again.

SNAPSHOTS & VIRTUAL COPIES

If you wanted to try a different version of a photo in a pixel editing program, such as Photoshop, you'd have to duplicate that photo on the hard drive, taking up more space on your hard drive. Lightroom offers 2 virtual options that don't require their own copy of the original file. Those options are virtual copies, often shortened to VC's, and snapshots, and there's a crossover in the 2 concepts, so you can decide which works best for you.

To create a virtual copy, you can right-click on a photo and choose Create Virtual Copy from the menu or use the Ctrl-' (Windows) / Cmd-' (Mac) shortcut. It will appear as a separate photo, and you can filter to find those virtual copies using the Attribute filters on the Filter bar. You can also create virtual copies when you're creating a collection—select the photos and create a new collection, and in the dialog you'll find a 'Make new virtual copies' checkbox.

To delete a virtual copy, you just press Delete, like any other photo.

To create a snapshot, click on the + button on the Snapshots panel and give it a name, unless you like the date/timestamp it sets by default. Like presets, you can update it with the current settings from the right-click menu.

Also check...

"Sorting, Filtering & Finding Photos" section starting on page 223

Why would I want to use virtual copies?

A virtual copy is a duplicate of an existing photo, but it's virtual—it doesn't take up additional space on the hard drive, with the exception of the preview.

You can do almost anything to a virtual copy that you can do to a master photo, for example, you can give it a different star rating, label, keywords, or other metadata. Virtual copies are treated as if they're separate photos, so they will show in Grid view alongside the master

and any other virtual copies. Most use virtual copies to keep variations of photos—perhaps a color version, a black and white version, a special effect version, and a few different crops.

Information about virtual copies is only stored in the catalog and not in XMP, so if you need image variations that are stored in XMP, consider snapshots as an alternative.

How can I quickly identify virtual copies?

The corner of every virtual copy's thumbnail is 'peeled back' to identify it in the Grid view or Filmstrip. If you need to find all of your virtual copies, you can select them in the Attribute Filter bar and your view will be filtered to only show VC's.

When would I use a snapshot instead of a virtual copy?

A snapshot is a special history state, which captures the slider settings at the moment of its creation. You can make changes to your photo, save it as a snapshot, make more adjustments, and then easily go back to the earlier snapshot state, even if you clear the History panel.

A photo can only be in a single snapshot state at any one time, and is treated as a single photo, unlike virtual copies, where each copy is treated as a separate photo. A photo with multiple snapshots will only appear as one photo in Grid view, and there's no way of telling that there are multiple versions from the Grid view.

Snapshot states are saved in XMP, but virtual copies are not. If you create a snapshot on a virtual copy, that snapshot is available to the master and the other virtual copies, but unlike virtual copies, snapshots are also written to XMP.

Can I rename virtual copies?

If you rename a virtual copy, the name of the master will change too—after all, it's virtual. When you export the virtual copies, they can have

Also check...

"Which of Lightroom's data isn't stored in XMP?" on page 321

different names from the originals as if they're individual photos, and you have some control over that naming while still in the Library module.

In the Metadata panel of a virtual copy is a Copy Name field, which defaults to Copy 1, but you can change to an alternative name of your choice, for example, Sepia. You can update a series of photos in one go by first selecting them and then editing that field.

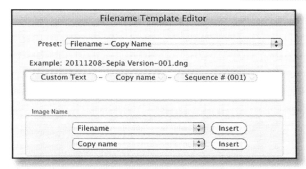

In View menu > View Options, you can set the thumbnails to show variations of filename including the Copy Name field.

Options such as 'File Name and Copy Name' will show both, whereas 'Copy Name or File Base Name' will show the Copy Name unless the Copy Name field is blank, in which case it will show the existing filename. You can do the same in the Loupe View Info Overlay too.

If you've updated the copy name on your virtual copies, you can also use that copy name when you export. You'll find 'Copy Name' as an option in the Filename Template Editor. For example, if you've set Sepia in the Copy Name field, you could use Original Filename_Copy Name tokens to create 'IMG_003_Sepia. jpg.'

Also check...

"How do I change the filename while exporting?" on page 490

Can I convert virtual copies into snapshots and vice versa?

Although there's a crossover in the two concepts, there isn't a really easy way to switch between the two.

If you're viewing a virtual copy, creating a snapshot will make that snapshot available to all of the other versions of that photo, and it will be written to XMP. That can be time consuming if you need to create snapshots for lots of photos, but Matt Dawson's Snapshotter plug-in can automate the process. http://www.lrq.me/photogeek-snapshotter

If you're viewing a snapshot, creating a virtual copy will take that snapshot state.

Can I swap virtual copies for masters and vice versa?

If you need to swap a single virtual copy for its master, you can select Set Copy as Master from the Library menu. If you want to do a whole batch of photos, it's not quite so simple. The closest you'll get to batching that process would be to export the virtual copies to another folder, with the file format set to Original, and then import those new files into your catalog. You'd only have data that's stored in XMP, but it may be a good compromise in some circumstances.

What do Sync Copies and Sync Snapshots do?

Under the Settings menu, there are two additional sync options which apply to virtual copies and snapshots. Sync Copies and Sync Snapshots allow you to sync settings from your current rendering to all of that photo's virtual copies or snapshots in one go. For example, if you've created different versions for different crop ratios, and then you update the Process Version or change the sharpening, you might want to update all of your other versions of that photo too. As with synchronizing multiple photos, watch for unexpected changes resulting for mixed Process Versions.

Also check...

"How do I copy or synchronize my settings with other photos?" on page 388 and "Should I update all of my photos to PV2012? Or, why has updating my photos to PV2012 spoiled their appearance?" on page 358

HISTORY & RESET

Thanks to its database, Lightroom is able to keep a list of all of the steps you've taken to get to the current settings. Unlike Photoshop, that history remains in the catalog indefinitely, even if you close Lightroom. You can come back months later and pick up where you left off, or go back to an earlier history state and carry on processing from there.

There will also be times when you want to remove the Develop adjustments and start from scratch, so there are reset options for individual sliders, panels, and all settings too.

How do I reset a single slider or panel section to its default setting?

To reset a single slider to its default setting, double-click on the slider label. If you want to reset a whole section within a panel, hold down Alt (Windows) / Opt (Mac) and the panel label will change to a Reset Section button, or double-clicking on that same panel label without holding down the Alt (Windows) / Opt (Mac) buttons will do the same.

How do I reset photos back to their default settings?

To reset all of the settings back to default, press the Reset button at the bottom of the right hand panel in the Develop module. You'll also find it in the Library module in the Quick Develop panel and the right-click menu, which allows you to easily reset multiple photos in one go, or you can reset one and sync that across the rest of the photos.

If you've changed the default settings, you can reset the photo to Adobe's default settings by holding down Shift to change the Reset button to Reset (Adobe).

Also check...

"Defaults" section starting on page 414

If I don't like the last adjustment I made, can I just undo that step, rather than resetting everything?

You can press Ctrl-Z (Windows) / Cmd-Z (Mac) multiple times to step back through each and every action. That affects most actions, not just the history states for the currently selected photo, so it will step back through module changes, selecting photos, etc. There are a few actions that can't be undone using those shortcuts, such as deleting photos from the hard drive, but the dialogs always warn if an action is not undoable using that shortcut.

The History panel contains a record of the changes you've made to each

individual photo, so you can go back to an earlier point when you were happy with the settings. You can try different settings without worrying, and then return to your earlier state if you don't like the result of your experiment. Just click on the history state that you were happy with, and continue editing—a new history will be written from that point on, replacing the steps that followed.

How long do the adjustments stay in the History panel?

Also check...

"Which of Lightroom's data isn't stored in XMP?" on page 321

The list of history states stay in the History panel for as long as the photo stays in the catalog and you don't press the Clear button, which is the X in the corner of the History panel. It doesn't matter if the photo is shown as missing and then you relink it, as long as you don't remove it from Lightroom's catalog. History states can't be saved to XMP—only the current settings are saved—so if you remove the photo from the catalog, the history of Develop changes will be lost.

DETAIL—SHARPENING & NOISE REDUCTION

Most digital photographs require some degree of sharpening, and although camera sensors are improving, most high ISO photos also benefit from noise reduction. Since the sharpening and noise reduction improvements made in version 3, Lightroom can now compete with specialized noise reduction software, such as Noise Ninja and Neat Image.

Why are my pictures softer and noisier than in other programs?

When Lightroom's sharpening and noise reduction sliders are at 0, those tools are turned off completely, whereas many other programs apply additional sharpening and noise reduction behind the scenes, even with their tools set to 0.

What is multiple pass sharpening?

Lightroom's sharpening is based on Bruce Fraser's multiple pass sharpening techniques. You can read more about his techniques at:

http://www.lrq.me/fraser-twopass

http://www.lrq.me/fraser-sharpworkflow

Sharpening in Lightroom's Develop module is designed to be Capture sharpening, intended to offset the inherent softness caused by digital capture and the demosaicing that's done by the raw converter.

Creative sharpening is usually applied to specific parts of the photo, for example, the eyes in a portrait. Clarity and the sharpening in the Local Adjustments would be classed as creative sharpening.

Output sharpening is the last stage, depending on whether the photos will be viewed on screen, inkjet print, photographic print or a variety of other presentation options. The sharpening applied in the Export dialog or Print module would be classed as output sharpening, as it's calculated based on the output size and type.

Also check...

"Which Print Sharpening option do I choose?" on page 617

How do the sharpening sliders interact?

Amount is quite logically the amount—like a volume control. It runs from 0-150, with a default of 25. The higher the value, the more sharpening that is being applied. You won't usually want to use it at 150 unless you're combining it with the masking or detail sliders which suppress the sharpening.

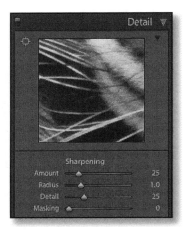

Amount mask

Radius affects the width of the sharpening halo, as it would for USM (Unsharp Mask in Photoshop). It runs from 0.5-3, with a default of 1.0. Photos with fine detail need a smaller radius, as do landscapes, but a slightly higher radius can look good on portraits.

Detail and Masking are dampening controls, allowing you to control which areas get the most sharpening applied and which areas are protected, but there's a difference in the way they behave.

Detail builds a very detailed mask, so it's very good at controlling sharpening of textures. Low values suppress the edge halos that

Radius mask

Detail mask

you're creating when you're sharpening whereas higher values sharpen everything equally, so a low setting is ideal for protecting larger smoother areas, such as portraits or sky. You may want a slightly higher setting for landscapes or other shots with lots of fine detail, where you're wanting to sharpen details like the leaves on the trees. The default of 25 is a good general sharpening setting. As you increase Detail, you'll usually need to turn the Amount slider down, and vice versa.

Masking creates a much softer edge mask from the image, protecting pixels from sharpening. It runs from 0-100, with a default of 0 (no masking). At higher values it's particularly good for close-up portraits, allowing higher sharpening settings for the eyes, but still protecting the skin from over-sharpening.

Masking mask

Holding down the Alt key (Windows) / Opt key (Mac) while moving the sharpening sliders shows a grayscale mask of the effect, which can help you determine the best value for each slider individually, for example, when using the Masking slider, the white areas of the mask will be sharpened and the black areas won't.

How do I use the different Noise Reduction sliders?

Just because there's an array of noise reduction sliders doesn't mean you need to use them on every photo. Most photos will only require the Luminance and Color sliders. The other sliders are there for more extreme cases, and can be left at their default settings most of the time.

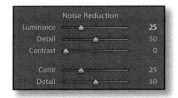

The Luminance slider controls the amount of luminance noise reduction applied, moving from 0, which doesn't apply any noise reduction, through to 100 where the photo has an almost painted effect. The Color slider tries to suppress color noise blobs without losing the edge detail.

The other sliders will only make a real difference to extremely noisy images, such as those produced by the highest ISO rating that your camera offers, or where a high ISO file is extremely underexposed. You're unlikely to see a difference at lower ISO ratings, for better or for worse, so in most cases you won't need to change those settings from their defaults.

The Luminance Detail slider sets the noise threshold, so higher values will preserve more detail but some noise may incorrectly be identified as detail. The Luminance Contrast slider at 0 is a much finer grain than 100. Higher values help to preserve texture, but can introduce a mottling effect, so lower values will usually be preferred. The Color Detail slider refines any fine color edges. At low values it reduces the number of color speckles in those edges but may slightly desaturate them, whereas at high values, it tries to retain the color detail but may introduce color speckles in the process.

If you're looking for an Auto setting, 25 on both the Luminance and Color sliders, with the other sliders at their defaults, will often be a good balance between detail and noise. The values automatically adapt depending on the camera and ISO rating when used with raw files. It's a matter of personal taste, so you might prefer a different value.

Can I apply or remove sharpening or noise reduction selectively?

Sharpening and Noise Reduction are two of the controls available in the Adjustment Brush. Sharpening gives you the ability to 'paint in' sharpening over a selected area, such as the eyes in a portrait, and also to selectively reduce sharpening which has been applied globally. Local noise reduction allows you to selectively increase or decrease the global noise reduction, perhaps because the noise is more noticeable where you've lightened the shadows. We'll come back to the Adjustment Brush later in the chapter.

0 to -50 on the Local Adjustment sharpening reduces the amount of sharpening applied by that global sharpening. Beyond -50 starts blurring the photo with an effect similar to a lens blur, but that is very processor intensive, so don't be surprised if Lightroom starts to slow down.

The Local Adjustment Sharpening is directly tied to the Sharpening sliders in the Detail panel, so the Radius, Detail and Masking settings from the Detail panel are combined with the Amount set in the Brush options panel. This also gives you the ability to remove sharpening that's been applied by the main sharpening Amount slider in the Detail panel.

The Local Adjustment Noise Reduction is luminance noise reduction only. You'll need to use the global Color Noise sliders in the Detail panel to reduce color noise.

LENS CORRECTIONS

Camera lenses can show different defects at different settings, including vignetting around the corners, barrel and pincushion distortion and chromatic aberration. Lightroom offers lens correction tools to correct for those defects, as well as new perspective corrections.

Also check...

"Why does a negative Noise brush add more noise? And why would you want to add moiré?" on page 468

How do I apply lens corrections to my photo?

Applying lens corrections in Lightroom is often as simple as checking the Enable Profile Corrections checkbox in the Lens Corrections panel. Lightroom will check the EXIF data in the file and try to identify the lens. If it finds the right profile, the pop-up menus below will automatically populate, and you're done. If Lightroom can't find the right profile, then you can help by selecting the lens details in the pop-up menus below.

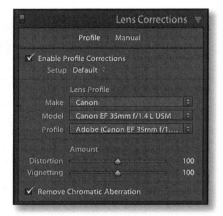

Why is the lens profile not selected automatically?

The EXIF 2.3 official standard for recording lens information in the metadata is only just starting to come into effect, and therefore it isn't always clear which lens was used. Lightroom uses all of the information available to make an educated guess, but if it's not sure it leaves you to select the profile. Once you've chosen the lens, you can set that as a default for that camera/lens combination, so you don't have to select it on every photo in future.

How do I set a default lens profile?

If your lens isn't automatically recognized by Lightroom, you'll need to set a default lens profile. That default will include the lens details selected in the pop-up menus and the Amount sliders below.

1. Open a photo taken with the camera/lens combination.

2. Go to the Lens Correction panel and check the Enable Profile Corrections checkbox.

3. Select the lens make, model and profile from the pop-up menus.

4. (Optional) Adjust the Amount sliders.

5. Go to the Setup pop-up menu and select Save New Lens Profile Defaults.

In the Setup pop-up menu, what's the difference between Default, Auto & Custom?

Auto leaves Lightroom to search for a matching profile automatically. If it can't find a matching profile, either because the profile doesn't exist yet, or because it doesn't have enough information in the photo's EXIF data, the pop-ups will remain blank.

Default does the same, but also allows you to customize the settings for specific lenses. For example, if Auto can't find a lens because it doesn't have enough information, you can select the correct profile from the pop-up menus below and save it as a default for the future. From that point on, whenever you select Default for a photo with that camera/lens combination, it will apply your new default lens setting. It's also useful if you have multiple profiles for a lens—perhaps one provided by Adobe and one you've created yourself—and you want to automatically select one of those profiles.

Custom shows that you've manually changed the profile or one of the Amount sliders.

How do the Amount sliders interact with the profile?

The Amount sliders below the profiles act as a volume control, increasing or decreasing the amount of profiled correction that's being applied. 0 doesn't apply the correction at all, 100 applies the profile as it was created, and higher values increase the effect of the correction.

Can I use the profiled lens corrections to correct the vignette without removing the distortion, or vice versa?

There are some situations where you might want to use some of the profiled correction, but not all of it. For example, with a fisheye lens, you might want to remove the vignette automatically, but keep the fisheye effect. To do so, reduce the Distortion Amount slider to 0 but leave the Vignette Amount slider at 100.

Why have the lens corrections created new vignetting instead of fixing it?

If you're working on existing older files, you may have previously fixed vignetting in the Manual tab. Applying a profiled lens correction doesn't reset any existing manual settings. Switch to the Manual tab and reset those settings or create a Develop preset to reset them to 0.

Can I correct multiple photos in one go?

You can synchronize or copy and paste lens correction settings just like any other Develop sliders, and you can save them in presets and defaults.

Can I turn on the lens corrections by default?

If you want the profiled lens corrections applied to all of your newly imported photos automatically, first set your photo to its normal default settings, and then check the Enable Profile Corrections checkbox and make sure the Setup pop-up menu is set to Default. Finally, go to Develop menu > Set Default Settings to set the default for that specific camera.

You only need to set these defaults once per-camera, unless you have it set to use different defaults for each ISO/Serial Number set in Preferences. Turn back to the Defaults section if you need more information on changing default settings.

Also check...

"How do I copy or synchronize my settings with other photos?" on page 388 and "Defaults" section starting on page 414

It's crucial that you set the Setup pop-up menu to Default rather than Custom when setting defaults. If you have it set to Custom and you use a Canon 24-105mm profile when you create the Develop default, it will mistakenly apply that Canon 24-105mm profile to any photos shot with that camera, even if you were using another lens. If you correctly choose Default, Lightroom will automatically load your per-lens default, even when you switch lenses.

Also check...

"How do I create a Lens Profile using the Lens Profile Creator?" on page 438

What are my options if my lens profile isn't available?

If your lens doesn't appear in the Lens Profile pop-up menus, you have a number of different options:

- Switch to the Manual tab and adjust the sliders manually.

- Wait for Adobe to create a profile for that lens—lens profiles are being added gradually, at the same time as new camera support.

- You can build your own profiles using the free Adobe Lens Profile Creator tool. We'll come back to that option a little later.

- You can also search the community-created profiles using the free Adobe Lens Profile Downloader tool.

How do I use the Lens Profile Downloader?

The Lens Profile Downloader is included with the Lens Profile Creator, which you can download from http://www.lrq.me/lensprofilecreator It allows you to browse profiles created by other users, and then download those profiles to your computer to use with Lightroom, ACR and Photoshop.

When you first open the Lens Profile Downloader, the grid will be blank. Select your brand of camera from the first pop-up menu, and it will then contact the web server to download a list of available user profiles.

You can browse the full list of profiles for your camera brand, or you can select the lens model from the next pop-up menu to filter the list. If you type in the Lens Model field, it will become a text search, for example,

typing 17 would find lenses including 17-40, 17-55, and 10-17. As some of the lens naming is slightly inconsistent, that can help you to find your specific lens.

The Lens Profile Downloader also allows you to filter the list by camera model, but that information is the lowest priority. The crop factor, on the other hand, is very important. You need to select a profile that was created on a sensor with the same crop factor or smaller, so selecting the crop factor of your camera will show any profiles that are suitable. If a profile is created using a camera with a 1.6 crop factor, then only the central portion of the lens, marked by the

inner rectangle, will have been profiled. Using that profile with another 1.6 crop camera will work well, but as the rest of the lens information outside of that line will be missing, you wouldn't be able to use it with a full frame camera. Adobe's own profiles are created on a

full frame camera, because smaller crop factors are simply using a smaller portion of the lens and the corrections can therefore be calculated.

You'll also note that the profiles specify Raw or JPEG, which refers to the file format used when creating the profiles. The processing applied by the camera to non-raw formats can affect the corrections needed, for example, some cameras apply distortion correction and many apply processing that reduces the lens vignetting and chromatic aberration. If you apply a raw profile to a rendered file (i.e. a JPEG), you may get an unexpected result as it tries to correct for a defect which has already been corrected, so Adobe recommend using a profile creating using the same file format. You may also have noticed that some of Adobe's own profiles are only available on raw files and not on JPEGs. There are unofficial ways of making a raw profile available for use with JPEGs by editing the profile with a text editor, but creating your own profile or downloading one created using JPEGs would give a more accurate result in that situation.

As time goes by, and more user profiles are added to the database, the list of available profiles for each lens will increase. There is a rating system, which allows users to mark the quality of those profiles, which will help you to select the best user profile available. If you click on the Rating column header, the profiles will be sorted in ascending order.

Once you select a profile from the list, the metadata about that profile shows in the panel on the right. The Profile Set pop-up menu allows you to see the sets of images used when creating the profile. You'll also see notes that other users have left regarding that particular profile, which can help you to decide whether you wish to try it yourself. If you sign in using your Adobe ID, you can add ratings or comments on the profiles that you've tried.

When you press the Download button, it should automatically download the profile directly to the correct location buried amongst your computer's user files, and the Lens Profile Downloader will update

to show that you have installed that profile. The Download button will change to Delete, so if you find that the profile isn't suitable, you can easily remove it again. If Lightroom is open while you're downloading, your new profile won't be available for use until you close and reopen Lightroom, but then it will appear in the Lens Corrections pop-up menus like any other profile.

Why is the lens profile available for some photos and not others, all from the same camera?

If a lens profile is usually available for your camera and lens combination, check the format of your selected photo. Many of the lens profiles are for raw files only, and don't include the data necessary for use on rendered (i.e. JPEG) files.

What do the Manual Transform Lens Corrections sliders do?

The Distortion slider corrects for barrel or pincushion distortion if you don't have a profile for that lens.

The Vertical and Horizontal sliders adjust for perspective.

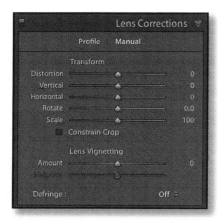

The Rotate slider adjusts for camera tilt.

The Scale slider interpolates the data to pull back pixels which have been pushed out of the frame or remove blank areas of the photo caused by the previous corrections.

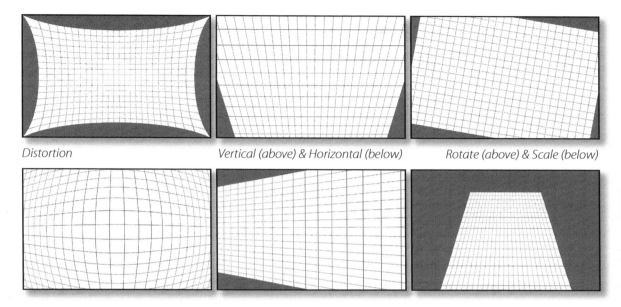

Distortion *Vertical (above) & Horizontal (below)* *Rotate (above) & Scale (below)*

How is the Rotate slider different from Straighten in the Crop options?

The Rotate slider in the Manual Lens Corrections is applied at a much earlier stage in the processing than the crop, with a different result. Rotate pivots on the center of the uncropped photo instead of the center of the crop. In the attached screenshot, the same grid was rotated using the Rotate slider and the Straighten slider and the same -100 Vertical transform applied, but then a small crop was taken from a corner, and you can see the difference.

Lens Correction Rotate slider *Rotated using Crop tool*

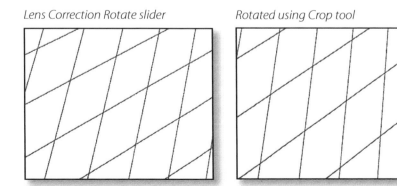

Also check...

"Cropping" section starting on page 450

The detail to remember is that if you're using the Manual Lens Corrections to correct perspective, and your camera wasn't level, use the Rotate slider in the Manual Lens Corrections to level the camera, rather than Straighten in the Crop tool.

How is the Scale slider different to cropping?

If one of your perspective adjustments has pushed some of the photo out of the frame by your Lens Correction adjustments, the Crop tool can't bring those pixels back. The Scale slider adjusted to the left can bring back that pixel data and adds grey padding for blank areas. Scale also interpolates data to match your original pixel dimensions, whereas the Crop tool only crops away existing pixels.

Scale at 0 *Scale at -50*

What does the 'Constrain Crop' checkbox do?

The Constrain Crop checkbox in the Lens Corrections panel > Manual tab and the Constrain to Warp checkbox in the Crop options panel both do the same thing—they simply prevent you from including blank grey pixels in your crop. It means that you can crop your photo without having to be too careful to avoid including blank areas. If you uncheck those boxes, it doesn't reset the crop automatically.

Why doesn't the Lens Correction Vignette adjust to the Crop boundaries?

The vignette in the Lens Corrections panel is for correcting lens vignetting, not for effect, and therefore isn't affected by the cropping,

however in the Effects panel there is a Post-Crop Vignette with additional options.

How do I fix Chromatic Aberration?

Chromatic aberration refers to the little fringes of color that can appear along high contrast edges, where the color wavelengths have hit the sensor at different points. It's most noticeable around the corners on photos taken with lower quality wide angle lenses.

In Lightroom 4, correcting for Chromatic Aberration has become much simpler—it's a single checkbox in the Lens Corrections panel. It no longer needs a lens profile or manual adjustment of sliders, as it calculates the correction from the image itself. It works surprisingly well!

Pink chromatic aberration on front of seagull's head & chest

Chromatic aberration removed

Purple fringing, or blooming, isn't a lens problem, but a sensor problem. It occurs when too much light hits the sensor and that affects the surrounding pixels too, so it usually shows up against the edges of specular highlights.

If you're having trouble removing leftover chromatic aberration or purple fringing, there are a couple of other things you can try. The All Edges option in the Defringe pop-up menu under the Manual Lens Corrections tab slightly desaturates the edges, which can often help.

Also check...

"How do I create my own Develop Presets?"
on page 406

Alternatively, select the Adjustment Brush and set the Moiré Removal slider to a + value. Brush over the remaining fringe, being careful not to get too close to any colors you wish to keep, and it will usually remove any residual fringing.

Can I save Manual lens corrections as defaults for lenses?

If you've used the Lens Corrections Manual tab to correct a lens that doesn't have a profile, you can save those settings as a standard Develop preset in the Presets panel.

When in my workflow should I apply lens corrections?

It doesn't make any difference to the end result, whether you apply Lens Corrections before or after other settings, as they still go through the processing pipeline in their normal order, rather than the order that you've moved the sliders.

There can be noticeable differences in UI (user interface) response speeds, particularly when combining Lens Corrections with the Spot Removal or Local Adjustment tools, which may affect the order in which you choose to apply settings, although you'll probably need to adjust the crop after applying Lens Corrections.

How do I turn off the grid overlay?

You can't turn the lens correction grid off, but it only appears when you float over the Lens Corrections sliders.

How do I create a Lens Profile using the Lens Profile Creator?

If your lens isn't currently supported by Adobe, you can build your own profile using the free Lens Profile Creator tool which you can download from Adobe Labs: http://www.lrq.me/lensprofilecreator

At first glance, the Lens Profile Creator looks quite complicated with its checkerboard targets and shooting multiple times with different focal

lengths, but don't worry, it's easier than it sounds. There are extensive instructions with the Lens Profile Creator download, so we won't go into detail, but the basic idea is that you print the target and then photograph it multiple times, and feed the resulting files into the software. It's a good idea to mount the checkerboard target onto board or glass to keep it flat, but you don't have to have a complex studio lighting setup. Shooting outside in daylight works well if you don't own studio lights. A tripod is useful to keep the target close to the edge of the frame without clipping, but the software will compensate for variations in camera position and angle.

You have to have an absolute minimum of 3 images to create a profile, but ideally you would divide the sensor into 9 imaginary portions, photographing the target in the center of the lens and then around the outer edges of the lens, with each checkerboard filling 1/4 to 1/2 of the overall sensor size. If you were to layer all of the resulting images on top of each other, you would find that the targets would overlap and cover the entire frame, providing the Lens Profile Creator with enough information to accurately profile the lens at that focal length. If you're using a zoom lens, you'll need to repeat that process using at least the minimum and maximum focal lengths, and then the software can then interpolate the settings in between. Even that basic lens profile will be an improvement in most cases, but if you're a more advanced user, you can really go to town and shoot numerous sets of images at different combinations of focal length, aperture and focus distance, which results in a more accurate profile.

Once you have your sets of images, it's time to create the profile. Again, there are instructions with the software, but it involves a few basic steps—load the sets of images into the Lens Profile Creator software, enter the camera and lens information, enter a few measurements from the chart, and finally, leave the software to generate the profiles. Adobe include a set of sample images in the download, so you can test the software and see how easily it works. Once it's finished, you can save your LCP (Lens Correction Profile) and restart Lightroom to make your

Also check...

*"Your custom Camera
Raw & Lens Profiles
should be installed
to the User folders…"
on page 657*

new profile available for use on your photos. You can also save the project file that you've created, so that you can go back and add additional sets of images later. If Adobe later create a profile for your lens, both will be shown in the pop-up menus.

Does it matter which camera body is used when creating a lens profile?

When creating a lens profile, use the largest sensor size available, for example, if you have a Canon 5D Mk2 with a full frame sensor and a Canon 7D with a cropped sensor, use the full frame. The lens profiles can compensate for smaller sensor sizes but can't create data for larger sensors, and other differences between camera bodies have a minimal effect on the lens profiles.

Why can't Lightroom find my custom profiles?

In Lightroom 3, camera and lens profiles could be stored in 2 locations—an AppData (Windows) / Application Support (Mac) folder which was shared with ACR and was available to all users, or your own user account's Application Data folder.

The old shared locations were:

Windows Vista or 7—C: \ Users \ All Users \ Adobe \ CameraRaw \ CameraProfiles \ —or the same location but in a LensProfiles folder

Mac—Macintosh HD / Library / Application Support / Adobe / CameraRaw / CameraProfiles / —or the same location but in a LensProfiles folder

Lightroom 4's profiles have moved and they're now stored with the program files (Windows) / app (Mac). This means that any profiles you placed in the old shared CameraRaw folder will no longer be found by Lightroom 4. If you didn't copy any custom profiles to those folders manually, you don't need to do anything. If you did have custom profiles

Also check...

*"Your custom Camera
Raw & Lens Profiles
should be installed
to the User folders…"
on page 657*

in that shared location, you'll need to move them to your own user account's CameraRaw folder.

EFFECTS—POST-CROP VIGNETTE & GRAIN

Vignetting is the darkening or lightening of the corners of a photo. Although traditionally it's caused by the camera lens, it's become popular as a photographic effect. The Vignette adjustments in the Lens Corrections panel is designed for fixing the lens issues, whereas the post-crop vignette in the Effects panel is designed for effect. There's also a Grain effect, designed to simulate traditional film grain, which is much more natural than digital noise.

What's the difference between Highlight Priority, Color Priority and Paint Overlay?

The pop-up menu in the Effects panel gives a choice of 3 different post-crop vignettes, which all fit within the crop boundary, rather than the original lens correction vignette which is designed for correcting lens problems.

Highlight Priority is the default and imitates a traditional lens vignette with the colors remaining heavily saturated throughout.

Color Priority retains more natural colors into the vignette, with smoother shadow transitions.

Paint Overlay is the post-crop vignette from Lightroom 2, which adds a plain black or white overlay.

How do the Post-Crop Vignette sliders interact?

Amount logically affects the amount, with -100 being very dark and +100 being very light.

Midpoint controls how close to the center of the photo the vignette affects, ranging from 0 affecting the center and 100 barely touching the sides.

Roundness runs from -100 which is almost rectangular, to +100 which is circular.

Feathering runs from 0 to 100, with 0 showing a hard edge, and 100 being very soft.

Highlights runs from 0, which has no effect, to 100, which makes the highlights under a dark vignette brighter, allowing you to darken the edges without the photo becoming too flat and lacking in contrast.

To easily see the effect of each slider, try applying them to a plain grey image file, or set the Feather slider to 0 to preview the other sliders.

How do the Grain sliders interact?

Amount obviously affects the amount of grain applied. The noise is applied equally across the photo, giving a much more film-like quality than digital noise, which tends to be heavier in the shadows.

Size affects the size of the grain, just as grain on film came in different sizes, and it gets softer as it gets larger.

Roughness affects the consistency of the grain, so 0 is uniform across the photo, whereas higher values become rougher.

Why does my grain not always look exactly the same in the exported file as in the Develop preview?

Grain is very sensitive to resizing, sharpening and compression, so you'll need to view it at 1:1 view in Develop to see an accurate preview.

Also check...

"The previews are slightly different between Library and Develop and Fit and 1:1 views—why is that?" on page 342

CALIBRATION PROFILES & STYLES

In the Camera Calibration panel, you'll notice a Profile pop-up menu. It contains the profiles that we mentioned in the Raw File Rendering section at the beginning of the chapter.

The Adobe Standard profiles are the new default profiles and replace the old ACR X.X profiles. The Camera Style profiles emulate the manufacturers own standard rendering and Picture Styles, giving a closer match to the default camera JPEG file. There is no right or wrong rendering. It's down to personal choice, and may vary depending on the photo.

Also check...

"Raw File Rendering" section starting on page 353 and "DNG Profile Editor" section starting on page 445

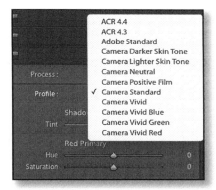

How do I install and use the profiles?

The profiles are automatically installed with each Lightroom update. Once installed, the profiles appear in the Profile pop-up menu in the Camera Calibration panel, ready for you to select on each individual photo.

Which are the profiles for my camera?

Any of the profiles in the Profile pop-up menu are the correct profiles for your camera. It won't show you profiles for other cameras.

They use standard names such as Camera Standard so that you can save them in presets which can be applied to multiple different camera models. Your camera model might use a slightly different naming

system, but Camera Standard is the camera's default picture style, and others such as Portrait and Landscape are options on most cameras.

Adobe have only created camera emulation profiles for specific cameras—primarily Canon and Nikon. If your camera doesn't have other profiles listed, other than Adobe Standard, then you could use the DNG Profile Editor to create your own emulation profiles.

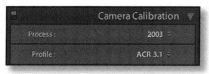

Why does my Nikon D300 have D2X profiles?

Nikon cameras other than the D2X may also show D2X Styles in the Profiles pop-up menu. That simply refers to their D2X style, not the camera of the same name. It's Nikon's naming convention!

Why does the profile pop-up menu just say 'Embedded'?

Camera profiles are only available for raw files, so JPEG/PSD/TIFF format files will only show Embedded in the list of profiles.

Why do I only have Matrix listed?

If the only option in your Profile pop-up menu says Matrix, it means that all of the other profiles are missing from your system, and it's reverted to the old ACR X.X profiles. Reinstalling Lightroom or ACR should also reinstall the profiles.

Also check...

"If I can use all of Lightroom's controls on JPEG files, why would I want to shoot in my camera's raw file format?" on page 78

The ACR version number in the Calibration section is an old version—how do I update it?

Older numbers, such as 3.1, are the version of ACR that was current when the camera support was officially released. It doesn't relate to your current ACR or Lightroom version number.

DNG PROFILE EDITOR

Everyone has their own preferences for raw conversion. Some like the manufacturer's own rendering and others like a variety of different raw converters. Often you hear people say 'I prefer the colors from XXX raw converter' or 'Why doesn't my raw file look like the camera rendering?'

In the past, there was no way of accurately replicating a look from another manufacturer, but that's now changed. Using the free standalone DNG Profile Editor, it's possible to create complex profiles that can closely match the color rendering of any camera manufacturer or raw converter using Lightroom, while enjoying all of the other tools that Lightroom has to offer.

Why is the DNG Profile Editor better than the Calibration sliders?

The original Calibration sliders didn't allow for different adjustments for different saturations of the same color, so when you adjusted, for example, the reds, you affected all of the reds in the photo. The new DNG Profile Editor allows you to separate those saturation ranges, adjusting each in a different direction.

For example, reds with low saturation values, such as skin tones, may be too red and the reds with high saturation values, such as a fire truck, may be too orange. That couldn't be corrected with any combination of the previous sliders, and yet can be easily adjusted with the DNG Profile Editor.

Can I use the profiles on proprietary raw files, not just DNG?

It's called the DNG Profile Editor because the profile format is described in the new DNG specification. The DNG Profile Editor itself only reads DNG files, but the resulting profiles can be used on any raw file format.

Also check...

*"Raw File Rendering"
section starting
on page 353*

Why doesn't it use ICC profiles?

The DNG Profiles are much newer technology than ICC profiles, and offer a better result. They're much smaller than full ICC profiles, which allows for multiple profiles to be embedded in DNG files without noticeable file size increases, which could otherwise quickly add up over a volume of files. They also allow two calibrations to be included, interpolated by color temperature, which ICC profiles can't do.

Where do I download the DNG Profile Editor?

The DNG Profile Editor is officially still in beta, and is therefore hosted on Adobe Labs, however it's as stable and 'finished' as a final release. You can download it from the Adobe Labs website at: http://www.lrq.me/dngprofileeditor

How do I use the DNG Profile Editor? It looks complicated!

Adobe isn't expecting everyone to use the DNG Profile Editor to create their own profiles, but the facility is available for those who do wish to use it. It's far easier than it looks.

There's a comprehensive tutorial with the download, so we'll just go through the basic idea, and a few extra tips:

1. Correct the white balance before you start, if you haven't done so already. A right-click switches the cursor from a standard Eyedropper to the White Balance Eyedropper, and the white balance values will be shown in the photo window title bar.

2. If you have a ColorChecker Chart, you might like to use that as a starting point. Using the Chart tab, you can run an automatic profile creation. The settings created automatically from your 24-patch ColorChecker Chart will appear as if you had created the color control points manually. You can either accept these adjustments and save the profile, or you can go on to tweak further. It also allows you to shoot 2 different lighting conditions

(2850K and 6500K) and create a single profile with both sets of adjustments, ready for interpolation between the two.

3. You can create additional color control points by clicking on the photo or on the Color Wheel. You can use color control points to fix specific colors to stop that color from changing, as well as creating color points to shift the colors.

4. The color control points then appear in the Color List Box to the right of the Color Wheel.

5. The checkbox to the left of your new color rectangle enables and disables the adjustment, showing as black when enabled. It's useful for previewing the changes to specific colors.

6. The icon to the right of the color rectangle removes that color control point, as does Alt-clicking (Windows) / Opt-clicking (Mac) on the color control point on the Color Wheel. You can select a different color control point by either clicking directly on the point on the Color Wheel, or by clicking on the color rectangle in the Color List.

7. Adjust the sliders below the Color Wheel, and you'll see the photo preview update live based on your adjustments.

You'll also see the color rectangle in the Color List Box split in half, showing the before and after color.

8. In addition to adjusting the colors on the Color Wheel, you can also adjust the other panels such as the Tone Curve. The Tone Curve adjustments will be relative to the base tone curve you select. You won't usually need to use the Color Matrices panel.

9. Once you've finished, save your Profile Recipe by selecting File menu > Save Recipe. That doesn't create the profile—it just saves your current list of changes so that you can come back and change it again later without having to start again.

10. When you're ready to save your profile, use File menu > Export Profile. Profiles will be saved with a .dcp extension, and are usually camera-specific. Save the profile into the Camera Profiles directory, and then you'll need to restart Lightroom/ACR before the new profile will be become available for use.

A few other quick hints:

You can have multiple photos open at the same time, and the previews will all update, so you can see how your changes will affect a variety of different photos.

If you have multiple photos from different cameras open at the same time, all of the photos will still update based on your current profile settings. You can save the profile for use with both cameras—the File menu > Export Profile command is updated to the name of the currently selected photo (i.e. Export Canon EOS 5D Profile)

You can load any other profile as a starting point, including the camera emulation profiles, and then tweak to your taste, or you can start from a blank canvas. To load another profile as a starting point, select your profile from the Base Profile pop-up menu, and all adjustments will be made relative to that profile.

Also check...

"Your custom Camera Raw & Lens Profiles should be installed to the User folders..."
on page 657

Is there a simpler way of creating a DNG Profile for my camera?

If you have a 24-patch ColorChecker Chart, there's a Lightroom export plug-in which can automatically create a DNG Profile, without you having to even open the DNG Profile Editor. You can download the ColorChecker Passport plug-in from http://www.lrq.me/xritepassport after filling out their website registration form.

CROPPING

In an ideal world, you'd have the time to make sure a photo was perfectly composed in the camera at the time of shooting. Unfortunately, very few of us live in an ideal world all of the time, and by the time you've perfected the shot, you'll have missed the moment. Many photos benefit from cropping and straightening during post-processing, so Lightroom provides the tools to do so, without having to switch to a destructive editor such as Photoshop.

You can go directly to the Crop tool from any module by pressing the R key, or you'll find it in the Tool Strip beneath the Histogram. You can either drag the edges or corners of the crop bounding box or select a preset crop ratio from the Crop options panel.

Why does the crop go in the wrong direction when I try and move the grid around?

Lightroom's crop is completely opposite to Photoshop's traditional crop. It does take some getting used to, but most seem to feel it's actually better once you do get used to it. Unlike Photoshop CS5 and earlier, when you rotate the crop, the resulting cropped photo remains level

instead of having to turn your head to see how the photo will look once it's cropped.

Think of it as moving the photo underneath the crop overlay, rather than moving the grid. And you can turn the grid off by pressing H if you find it distracting.

How do I crop a vertical portion from a horizontal photo?

To change the crop orientation, drag the corner of the crop diagonally until the long edge becomes shorter than the short edge and the grid flips over, or just press the X key.

Alternatively, unlock the ratio lock in the Crop options panel and adjust to the crop of your choice. You can also drag a crop freehand, as long as any existing crop has been reset, just as you would in Photoshop.

Can I zoom while cropping?

You can't zoom while in Crop mode, but if you need a larger preview, select the Crop tool and then press Shift-Tab to hide all of the side panels. It's particularly useful when straightening a photo.

Also check...

"Panel Groups & Panels" on page 146

How can I change the default crop ratio?

You can't change the default crop ratio, but there are two easy workarounds. Either go to Grid view, select the photos and choose the ratio you want from the Quick Develop panel, or crop the first photo in normal Crop mode, and synchronize that with all of the other photos. Either way, it's intelligent enough to rotate the crop for the opposite orientation photos, but beware, as either option will reset any existing crops. Once you've done that, your chosen ratio will already be selected in the Crop options panel and you can go through the photos and adjust the crop as normal.

How do I set a custom crop aspect ratio?

In the Aspect pop-up menu, which you'll find in the Crop options under the Tool Strip, you can select 'Enter Custom' and choose your own fixed crop ratio, or you can unlock the crop ratio by clicking on the padlock icon and draw a custom crop.

How do I fix my crop ratio so it doesn't change when I resize it?

The crop ratio lock icon in the Crop options panel fixes the crop to your chosen aspect ratio. For example, if you've selected a 4x6 ratio and then

drag to change the crop, the crop lock would keep the 4x6 ratio, whereas unlocked would switch to a custom ratio.

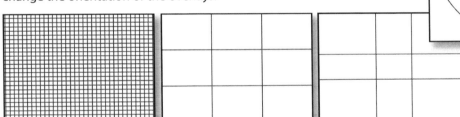

How do I delete a custom crop aspect ratio?

You can't delete custom crop ratios manually, but they work on a rolling list of 5, so only your most recent 5 custom ratios remain in the list, and as you add a new one, the oldest one is removed from the list.

How do I set my crop grid back to thirds or bring the Crop Overlay back when it goes missing?

Press O to cycle through a variety of useful overlays—Grid, Thirds, Diagonal, Triangle, Golden Ratio and Golden Spiral—and Shift-O to change the orientation of the overlays.

Is it possible to change the Crop Overlay color?

You can't change the Crop Overlay color, but you can enter Lights Out mode by pressing the L key twice to get a better view of the crop as you adjust it. Press L again to switch back to the normal view.

How do I straighten or rotate a photo?

With the Crop tool selected, click on the Straighten tool in the Crop options panel under the Tool Strip. You can also access it by holding down the Ctrl key (Windows) / Cmd key (Mac) while the Crop tool is selected. Click on the horizon and still holding down the

Also check...

"Lights Out" on page 163

Also check...

"Tethered Shooting & Watched Folders" section starting on page 137

mouse button, drag along the line of the horizon. Lightroom will automatically rotate the photo to straighten the horizon line you've just drawn.If you prefer, you can manually adjust the degree of rotation by moving the Straighten slider in the Crop options panel, perhaps in conjunction with the

Overlay Grid. Or, as you hover around the outside edge of the crop boundary, the icon will change to a curved double-headed arrow, showing that you can drag to rotate up to 45 degrees in either direction.

Can a crop be saved in a preset?

You can't save a crop in a preset, but there are a couple of alternatives— select the photos in Grid view and choose your crop ratio in Quick Develop to apply it to multiple photos, or for tethering, applying the crop to one photo and then using the Previous setting, as we mentioned in the Import chapter.

Is there a way to see what the new pixel dimensions will be without interpolation?

If you go to View menu > View Options, you can set the Info Overlay to show Cropped Dimensions, which is the cropped pixel dimensions without any resampling. Every time you let go of the Crop edge, the dimensions will update.

Also check...

"Loupe View, Info Overlay & Status Overlay" on page 152

SPOT REMOVAL—CLONE & HEAL TOOLS

The Spot Removal tools are called spot removal for a reason. It is possible to do fairly complex retouching with multiple overlapping spots, but that's not what it was designed for. As Lightroom is a metadata editor,

it has to constantly re-run text instructions, so it gets slower with the more adjustments that you add. The tools are designed for removing spots such as sensor dust, and detailed retouching is quicker and easier in a pixel editing program, such as Photoshop or Elements.

How do I retouch a spot?

To use the Spot Removal tools, select it from the Tool Strip beneath the Histogram. In the options panel below, you'll note that you have a choice of Clone or Heal. Heal works like the Healing Brush in Photoshop, intelligently blending the pixels, and Clone works like Photoshop's Clone tool, picking up the pixels and dropping them in another location. For most spots, the Heal option works best, particularly in clean areas such as sky. If you're trying to retouch a spot along an edge in the photo, for example, a roofline against the sky, the Heal tool can smudge, in which case the Clone option may work better.

If you click once on the photo, Lightroom will intelligently search for the most suitable source of replacement pixels. If you want to choose the source yourself, click on the spot and drag to that chosen source without letting go of the mouse button.

If you zoom into 1:1 view to do retouching, start in the top left corner and then you can use the Page Down key to work through the photo. It divides the photo up into an imaginary grid, and when you hit the bottom of the first column, it automatically returns to the top of the photo and starts on the next column. By the time you reach the bottom right corner, you'll have retouched the entire photo without missing any spots.

How do I adjust the brush size or the size of an existing spot?

In the Spot Removal options panel under the Tool Strip is a brush size slider, or you can use the [and] keyboard shortcuts or your mouse scroll wheel to adjust the size. You can readjust an existing spot by clicking on

it to make it active and using those same controls. Alternatively, if you hover over the edge of an existing spot, the cursor will change and you can then drag that edge to adjust the size.

How do I adjust the opacity of an existing spot?

If you click on the spot to select it, and then adjust the Opacity slider in the Spot Removal options panel, you can fade the effect of the retouching.

How do I move or delete an existing spot?

When you hover over the center of an existing spot or retouching source

spot, the cursor will change, and you can then drag to move that spot. If you need to delete a spot, click on it to make it active, and then press the Delete key on your keyboard.

Can I copy or synchronize the clone/heal spots?

You can copy or synchronize clone/heal spots in the same way as you synchronize any other settings, using Copy/Paste or Sync, that we covered earlier in the chapter. This is particularly useful when using the spot tools to remove sensor dust in a clear area of sky, as it's intelligent enough to adjust for orientation.

Also check...

"How do I copy or synchronize my settings with other photos?" on page 388

RED EYE REDUCTION TOOL

Red eye in photography is caused by light from a flash bouncing off the inside of a person's eye. Although many cameras now come with red eye reduction, those pre-flashes tend to warn people that you're about to take a photograph, and can lose any spontaneity. Lightroom's Red Eye tool can fix red eye very easily, so you can safely turn that camera setting off.

How do I work the Red Eye Reduction tool?

To remove red eye, select the Red Eye Reduction tool from the Tool Strip beneath the Histogram and drag from the centre of the eye, to encompass the whole eye. It will automatically search for the red eye within that area and once it locks, you can adjust the sliders to change the pupil size or darken the retouching.

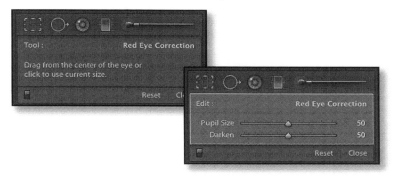

Lightroom's Red Eye Reduction tool can't lock on to the red eye—is there anything I can do to help it?

If the Red Eye Reduction tool can't lock on to the red eye, try temporarily increasing the red saturation in the HSL panel and try again. Once it locks, you can set the HSL panel back to its previous settings.

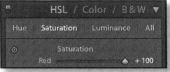

Also check...

"What is the HSL panel used for?"
on page 384

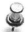 *Also check...*

"How do I copy or synchronize my settings with other photos?" on page 388

Why doesn't the Red Eye Reduction tool work properly on my dog's red eye?

Animals have different colored red eye, so the tool can't find the red it's looking for. As an alternative, try the Adjustment Brush, set to lower exposure and a suitable color.

Why are there grey dots on my photo?

When you press the Previous button to copy settings from the previous photo, your red eye correction spots are copied too. That can result in strange grey dots appearing, and people's eyes are rarely in the same place on subsequent photos. You can remove it by selecting the Red Eye Reduction tool, clicking on the grey spot and press the Delete key. Remember to watch out for it when using the Red Eye tool and Previous button together.

LOCAL ADJUSTMENTS—GRADUATED FILTER & ADJUSTMENT BRUSH

Most of Lightroom's controls are global, which means that they affect the entire photo. The Local Adjustments allow you to paint a mask on the photo, either by means of a brush or gradient, and apply adjustments just to that masked area.

The Local Adjustments can make localized changes to Temperature, Tint, Exposure, Contrast, Highlights, Shadows, Clarity, Saturation, Sharpness, Noise Reduction, Moiré Reduction and apply a Color Tint for PV2012 photos. Older PV2010 photos only have access to Exposure, Brightness, Contrast, Saturation, Clarity, Sharpness or Color Tint, but updating them to PV2012 gives access to all of the sliders.

For example, the Exposure adjustment is similar to dodging and burning in Photoshop or in a traditional darkroom. Settings such as Sharpness, Clarity and Noise Reduction can be used for softening skin on portraits.

White Balance or Color are useful when adjusting for mixed lighting situations. Settings can be combined, so a combination of perhaps Exposure, Highlights, Saturation, Clarity and a blue tint can make a dull sky much more interesting. If you regularly use the same combination of sliders, you can save their settings using the Effect pop-up menu in the options panel.

PV2003
or
PV2010
(left)

PV2012
(right)

Why would I use the Graduated Filter & Adjustment Brush rather than editing a photo in Photoshop?

When you edit a photo in Photoshop, you have yet another large photo file to store, whereas using Lightroom's Local Adjustments stores the adjustment information nondestructively in metadata. That leaves you with a tiny amount of text information which is stored as part of the catalog, and you can always go back and change your adjustments without damaging the original file.

This doesn't mean that Lightroom entirely replaces Photoshop—there are still many pixel based adjustments that would require Photoshop—however it does mean that you can make many more adjustments within Lightroom's own interface and save them nondestructively without vast storage requirements.

Because Lightroom has to constantly re-run text instructions, rather than applying them destructively to the original pixels immediately, it can be slower when there are lots of adjustments, so there's a fine line, depending largely on your computer hardware.

How do I create a new brush mask?

When you select the Adjustment Brush, it will automatically be ready to start a new mask. Select your brush characteristics and the effect you want to apply then simply start painting!

For example, the following screenshots show the Amount set to Exposure. +4.0 brightens the exposure by +4.0 as in the white screenshot, +1.0 brightens the exposure by +1.0 as in the grey screenshot, and -4.0 darkens the exposure by -4.0, as shown in the black screenshot.

Also check...

"How do I show the mask I've created?" on page 465

In some cases, you may find it helpful to paint with the slider turned up higher than your intended result, or with the mask overlay turned on (press O), in order to clearly see where you're painting, and then turn it down again when you've finished painting. Holding down the Shift key whilst you paint will draw the stroke in a straight vertical or horizontal line.

What do Size and Feather do?

Size logically affects the size of the brush, and Feather is the hardness of the brush edge. You can see the effect of the feathering set to 0 (top, hard), 50 (center), and 100 (bottom, soft).

The brush cursor changes depending on the size of the brush and the amount of feathering, with the cursor screenshot at the top showing feathering at 0, and the cursor screenshot below showing the same size brush but with the feathering setting at 100.

You can also use the [and] keys to increase and decrease the size of the brush, and Shift-[and Shift-] keys to increase and decrease the feathering.

What's the difference between Flow & Density?

Flow controls the rate at which the adjustment is applied.

With Flow at 100, the brush behaves like a paintbrush, laying down the maximum effect with each stroke. You can see this in the screenshot to the right, where the effect is applied equally with each stroke.

With Flow at a lower value such as 25, the brush behaves more like an airbrush, building up the effect gradually. Each

stroke adds to the effect of the previous strokes, giving the effect shown in the screenshot to the left, where areas that have multiple brushstrokes are stronger than those with a single stroke.

Density controls the maximum strength of the stroke. Regardless of how many times you paint that stroke or the settings used, it can never be stronger than the maximum density setting. In the screenshot overleaf,

the top line—the one that you can't see—is set to 0. The center line is set to 25 and the bottom line is set to 100. Unless you need the Density control for a specific purpose, I would suggest leaving it set at 100.

To fully understand these controls, try creating a single 50% grey file and testing different combinations of sliders. It's easier to see the differences when you're not distracted by an image.

Is the Adjustment Brush pressure sensitive when used with a graphics pen tablet?

The pressure sensitivity on your graphics pen tablet controls the opacity of the stroke.

What does Auto Mask do?

Auto Mask confines your brush strokes to areas of similar color, based on the tones that the center of the brush passes over, helping to prevent your mask spilling over into other areas of the photo. It's very performance intensive so it may slow Lightroom down, and it can also result in some halos, for example, trying to darken a bright sky with a silhouette of a tree in the foreground may leave a halo around the edge of the tree.

Auto Mask actually works better in reverse—use a large brush without Auto Mask to paint a large area first, and then turn Auto Mask on while erasing areas of your mask.

Why are there speckles in the brushed area?

If you find speckles or dots in the brushed area, try turning off Auto Mask and painting the area again. Auto Mask can miss some odd pixels resulting from noise in the photo.

How can I tell if I'm applying a color tint when using the Adjustment Brush?

When no is tint being applied, the Color icon changes and shows a cross instead of a color.

Can I select a color tint from the photo itself?

To select a color tint from the photo, first click on the Color icon to bring up the Color Picker. Click in the Color Picker and while holding the mouse button down, drag the cursor onto the photo itself. As you drag across the photo, Color Picker will update live to reflect the color beneath your cursor. When you release the mouse button, the color under the cursor will be selected in the Color Picker.

To find a complimentary color to remove a tint, select the color as above, but then click in the Hue field in the Color Picker and type a value 180 degrees from the current value, keeping within the limits of 360 degrees.

For example, if the current value is 30, adding 180 will make it 210, but if the current value is 330, you would have to remove 180 to make it 150.

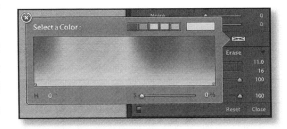

Can I brush on a lens blur effect?

If you set the Sharpening slider to between -50 and -100, it applies a blur similar to a lens blur. It is very processor intensive, so it can be slow.

If I apply sharpening using the Adjustment Brush, where do I adjust the Radius, Detail and Masking?

The Adjustment Brush sharpening is tied to the main settings in the Detail panel, so the Radius, Detail and Masking settings will be identical

Also check...

"Detail—Sharpening & Noise Reduction" section starting on page 423

across the photo. The amount of sharpening is independent for the Adjustment Brush, allowing you to apply global sharpening using the Detail panel, and then applying heavier sharpening using the Adjustment Brush, or vice versa.

Where have my mask pins gone?

Under View menu > Tool Overlay, you have the option to Auto Show which only shows the pin when you float the mouse nearby, as well as Always Show, Show Selected and Never Show. You'll also find those options on the toolbar while the Adjustment Brush is active.

As a quick shortcut, the H key hides the pins, so press H again to return them. It toggles between Auto Show and Never Show.

How can I tell whether I'm creating a new mask or editing an existing mask?

When you select the Adjustment Brush or Graduated Filter tool, Lightroom will automatically be ready to start a new mask, so to

edit an existing mask you must first click on the mask pin.

You can check whether you're in New or Edit mode by looking at the top of the Adjustment Brush options panel or by checking which pin is currently selected.

How do I reselect and edit an existing mask?

The mask pins have 2 states—selected or not selected, or active and inactive. Not selected is shown by a white pin, and clicking on the pin will select that mask, turning the pin black. Once

your existing mask is reselected, you can adjust the sliders to change the effect, or go back and edit the mask itself.

If you select an existing pin, the Adjustment Brush options panel will automatically switch into Edit mode and you can make additional brush strokes, erase existing brush strokes, and adjust the effect. You can temporarily switch to the Erase tool by holding down the Alt (Windows) / Opt (Mac) button while you paint.

How do I show the mask I've created?

Making sure the mask is selected, press the O key to toggle the mask overlay on and off, or float over the pin and the mask overlay will appear.

Can I change the color of the mask overlay?

To change the mask overlay color, first press O to show the overlay, and then press Shift-O to cycle through a series of different overlays (red, green, lighten and darken) until you find an overlay that can be clearly seen against your photo.

How do I create a new gradient mask?

When you select the Graduated Filter tool, it will automatically be ready to start a new mask. Select the effect you wish to apply, click at your gradient starting point, and drag to your gradient end point before releasing the mouse button.

You can hold down the Shift key while creating the gradient to constrain it to a 90 degree angle, and holding down the Alt (Windows) / Opt (Mac) key will start the gradient from the middle instead an edge.

Having created the gradient, you can go back and adjust both the rotation and length of the gradient, as well as the effect that you're applying.

How do I adjust an existing gradient?

To adjust an existing gradient, re-select it by clicking on the pin, just as you would with a brush mask. The gradient lines will appear, allowing you to make adjustments. You'll find you have more control if you move to the outer ends of the lines.

When you float over the central line—the one with the pin—the cursor will change to a double-headed arrow, enabling you to adjust the rotation of the gradient. If you want to reverse the gradient, you can just press the ' key.

When you float over the outer lines—the ones without the pin—the cursor will change to a hand tool, enabling you to adjust how far the gradient stretches.

How do I fade the effect of an existing mask?

Clicking the disclosure triangle to the right of the Presets pop-up menu, you can switch between a basic Amount slider and the more advanced slider mode.

The Amount slider increases or decreases the strength of all of the adjustments on the selected mask, so if you adjust the Amount having made adjustments to multiple sliders, all of the sliders will be adjusted by the same percentage of change. When applied to multiple sliders, you could call it a 'fade' slider.

You can access the same Amount control without having to switch back to that basic mode—simply click on the pin and while holding the mouse button down, drag left and right and you'll see all the sliders move.

Can I layer the effect of multiple masks?

You can create as many different masks as you like, and they can be overlapped and layered, with the effect being cumulative.

Can I invert the mask?

You can't invert the mask, however you can use a large brush to paint over everything, and then use a small brush to erase from that mask. For example, you can paint the entire photo using a -100 Saturation brush to make it Black & White and then erase to show a small amount of the original color photo below.

Can I synchronize my settings with other photos?

You can copy or synchronize Local Adjustments in the same way as you synchronize any other settings.

Can I save my Adjustment Brush strokes in a preset?

If you've created, for example, a brushed edge effect, you may want to apply that later to other photos. Lightroom doesn't allow you to save brush strokes in a preset, but you can sync the settings across multiple photos. If you keep a folder of plain JPEGs, they can be used to store those brushed vignettes to sync to other photos in the future, and they're easily identified without having to search through all of your photos.

Why is nothing happening when I brush over the photo?

If you're brushing over the photo and nothing seems to be happening, it's usually because either the Flow or Density sliders are set too low. If those are both set to 100, try turning on the mask overlay by pressing O, or move one of the sliders to an extreme value such as Exposure +4 so you can see where you're brushing.

Also check...

"How do I copy or synchronize my settings with other photos?" on page 388

How do I fix Moiré?

Moiré is a rainbow-like pattern which is often seen when photographing fabrics. It's caused by 2 patterns combining—in this case, the weave in fabric and the grid of the camera sensor—which creates a new pattern.

The Moiré Removal slider in the Adjustment Brush allows you to paint the moiré rainbow away. It can only usually remove the color rainbow, not any luminosity changes, but it works very well. It will work on both raw and rendered photos, although the additional data in a raw file means that it is far more effective on raw files.

To use it, select a plus value on the Moiré slider, ensure that you've turned off Auto Mask, and brush over the pattern. If you cross a boundary of another color in the photo, it can blur or smudge, so it's best to use a hard edged brush (feather=0) and be careful where you brush. That will get the cleanest result without any side effects. If you set the Moiré slider to a negative value, it won't do anything—it's only used to reduce the effect of another brush stroke which already has positive Moiré removal applied.

Moiré (above)

Moiré removed (right)

Why does a negative Noise brush add more noise? And why would you want to add moiré?

The Noise slider in the Local Adjustments panels should be called Noise Reduction, but there's not enough space, particularly in some languages. When you paint with a negative noise value, it doesn't add noise, but it reduces or removes any global noise reduction that you've applied or other noise reduction brushstrokes. The same applies to the Moiré slider, which allows you to reduce the amount of moiré removal applied by another brushstroke, if it's a little too strong.

Also check...

"Detail—Sharpening & Noise Reduction" section starting on page 423

Editing in Other Programs

Lightroom is a parametric editor, which means that it runs text instructions rather than directly editing the pixels, so it's nondestructive. It's designed for the management and processing of large numbers of photos, and not as a replacement for Photoshop. Lightroom can do spot removal and localized tonal adjustments, but pixel editors, such as Photoshop and Elements, are still better suited to more detailed retouching. Lightroom therefore integrates with both Photoshop and Elements, as well as other image editing software.

EDITING IN OTHER PROGRAMS

Using the Edit in commands in the right-click menu, you can open the photo directly into Photoshop when using a matching version of ACR, or by means of an interim TIFF or PSD file for older versions of Photoshop, Elements or other software.

How do I change my Edit In file settings?

Your External Editor settings are chosen in the Preferences dialog > External Editing tab. In that dialog, you choose the file format, color space, bit depth, resolution and compression, as well adding additional External Editors. We'll come back to some of those terms in more detail in the Export chapter.

Also check...

"Export" chapter starting on page 487

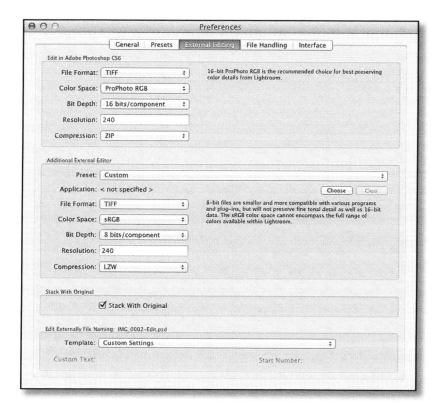

In the Edit in options, should I choose TIFF or PSD?

In terms of functionality, there's no longer a difference between the TIFF and PSD formats—you can save everything to a TIFF that you can to a PSD. TIFFs are more efficient when updating metadata and they're compatible with a wider range of software, so Adobe are generally recommending TIFFs now, but both are lossless formats, so it's largely down to personal choice.

Can I have more than two External Editors?

While there are only two main External Editors, you can create additional presets using the same Preferences > External Editing dialog.

The Primary External Editor automatically selects the most recent full version of Photoshop, or if it can't find Photoshop, then it selects the latest version of Elements. It takes the main shortcut Ctrl-E (Windows) / Cmd-E (Mac).

You can create as many Additional External Editors as you like, and they will appear in the Edit in Menu. Simply press the Choose button in the Additional External Editors section, navigate to the program you want to add, and select the .exe file (Windows) / application (Mac). Decide on your other settings, and then select Save Current Settings as New Preset from the pop-up menu. For each new External Editor you wish to add, repeat that process. Each time you use Save Current Settings as New Preset, your new External Editor will be added to the list. They will then appear in the right-click > Edit in menu, ready to use.

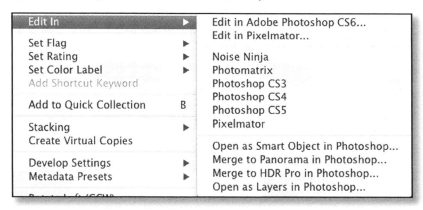

When you close the dialog, the preset selected in that pop-up will become the main Additional External Editor shown at the top of the list, and assigned the secondary keyboard shortcut, which is Ctrl-Alt-E (Windows) / Cmd-Opt-E (Mac).

If you need to change one of your External Editors, return to the Preferences dialog > External Editing tab and select the preset from the

Also check...

*"Saving Presets in
Pop-Up Menus"
on page 166*

pop-up menu. You can then edit the settings, perhaps changing the file format or color space, and go back to the pop-up and select Update Preset from the listed options.

Can I change other External Editor settings, such as a custom subfolder and a different filename for each editor, or a different file format?

The options for External Editors are limited to those available in the Preferences dialog. If you'd prefer to use a subfolder for your edited photos, or other options which aren't available for External Editors, you can use Export presets instead.

Go to the Export dialog, and select the options of your choice, for example:

Export Location—Same folder as original photo > Put in Subfolder called Edited. Make sure you select Add to this Catalog if you want the resulting photo imported automatically, as it would be with standard External Editors.

Rename to—Filename-Custom Text with the custom text set to NikSilverEfex, if you want different file naming depending on the editor used. That would result in a YYMMDD-HHMM.dng file becoming YYMMDD-HHMM-NikSilverEfex.tiff.

Image Format—TIFF 16-bit or another rendered file format of your choice.

The important bit is the Post-Processing section at the end. Set it to After Export: Open in Other Application and navigate to the program. Select the exe file (Windows) / application (Mac).

Also check...

*"Can I save my Export
settings as a preset?"
on page 531*

Finally, save your settings as a preset and cancel out of the Export dialog.

When you right-click on a photo, rather than selecting Edit In from the context-sensitive menu, go down to Export and your new preset will be listed there.

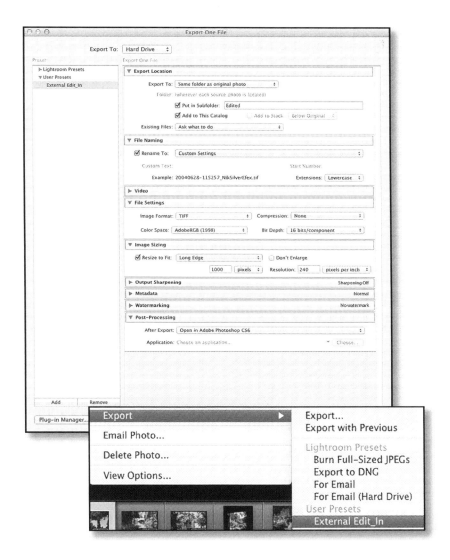

How do I get Lightroom to use a different version of Photoshop?

If you have multiple versions of Photoshop installed, Lightroom should use the most recent full version of Photoshop. For example, if you had Photoshop CS5 installed, and then you install Photoshop CS6, Lightroom will update to show Photoshop CS6 as its primary external editor.

If you want to use a different version of CS6, for example, the 32-bit version on Windows, you can just make sure your chosen version is already open when you select Edit in Photoshop. Lightroom won't open the 64-bit version if the 32-bit version is already in use, which is useful if some of your Photoshop plug-ins haven't updated to 64-bit yet.

Lightroom can't find Photoshop to use Edit in Photoshop—how do I fix it?

When Lightroom starts up, it checks to see whether Photoshop or Photoshop Elements are installed, and if it can't find them, then the Edit in Photoshop menu command is disabled.

If you install a new version of Photoshop, and then uninstall an earlier version, the link can get broken by the uninstall. Uninstalling and reinstalling Photoshop will usually solve it, or you can fix it by editing the registry key (Windows) or deleting Photoshop's plist file (Mac). There's more information on the official Adobe tech note at: http://www.lrq.me/fixphotoshoplink

Of course, you may be able to take the easy course and add it as an Additional External Editor, however you would be missing out on some of the direct integration which comes with matching ACR versions. We'll go into detail in the next question.

Can I open the raw file into another raw processor?

Lightroom sends TIFF/PSD files to its Additional External Editors, rather than the raw data, which is ideal for most pixel editing software, but there may be occasions when you want to open a photo into another raw processor. On those occasions, you can right-click on the photo, choose Show in Explorer (Windows) / Show in Finder (Mac) and then open into your raw processor. Alternatively, you can export as Original format, with the raw processor set as the Post-Processing Action, however that will result in an additional copy on your hard drive.

John Beardsworth has made it far easier with his Open Directly plug-in, which takes the original file and opens it into the software of your choice (http://www.lrq.me/beardsworth-opendirectly). It will pass the original file to any other software, so it's not just limited to raw processors, but can also be used for passing video files to video editing software.

Also check...

"Managing & Editing Videos" section starting on page 218 and "Raw Files" diagram on page 486

Why isn't Lightroom creating a TIFF or PSD file according to my preferences?

If you open a photo directly into Photoshop when it's set as the Primary External Editor, allowing ACR to render the file, then the file won't be saved until you choose to save it. If you choose not to save the file, you don't have to worry about going back to delete the TIFF or PSD. This only works with matching ACR versions, or when you select Open Directly in the ACR mismatch dialog. We'll come back to that dialog on the following pages.

When you do press Ctrl-S (Windows) / Cmd-S (Mac) in Photoshop, or go to File menu > Save, it will create the TIFF or PSD file according to your Lightroom preferences. You don't need to use Save As to create the TIFF/PSD file.

Where does Edit in Photoshop save the edited file?

When you press Ctrl-S (Windows) / Cmd-S (Mac), the file will be saved to the same folder as the original photo, and it will appear in your Lightroom catalog automatically. There may be differences in behavior with the other Photoshop options, such as Open as Smart Object in Photoshop.

When in my workflow should I use Edit in Photoshop or other External Editors?

Lightroom's Develop adjustments work best on raw files, because they have the largest amount of data available. For that reason, it's best to do most, if not all, of your Lightroom adjustments in Lightroom before using Edit in Photoshop to do your retouching. The same would apply to most other External Editors.

There are a couple of exceptions, however. You may prefer to leave cropping until after your external edits, leaving you the flexibility to crop in multiple different ratios without having to repeat your retouching and other edits. If the photo is going to be in both B&W and color, you may also want to leave it in color until after the retouching has been completed.

How do I open my layered file back into Photoshop without flattening it?

Lightroom doesn't understand layers—it's a different tool for a different job. That means that when you apply Develop changes to a layered photo, that layered photo must be flattened to apply the changes, losing your layers in the process. Of course, that doesn't have to be done until the final export.

If you need to open the photo back into Photoshop to make further adjustments to the layers, perhaps for additional retouching, choose the Edit Original or Edit a Copy options, rather than Edit a Copy with

Lightroom Adjustments. That will open the layered file into Photoshop without your Develop adjustments, and when you bring the file back into Lightroom, your Develop adjustments will still be laid nondestructively over the top.

Also check...

"Rendered Files (JPEG/ PSD/TIFF)" diagram on page 485

What's the difference between Edit Original, Edit a Copy, or Edit a Copy with Lightroom Adjustments?

If you're passing a rendered file to Photoshop—a TIFF, a PSD, or a JPEG— then there will be a dialog asking how you want to handle that file.

Edit Original opens the original file into Photoshop. It's useful if you spot a little retouching that you missed.

Edit a Copy creates a copy of the original file, in the same format, and opens that into Photoshop. It allows you to edit the photo without overwriting your previous file.

Edit a Copy with Lightroom Adjustments passes the image data and the settings to ACR to open directly into Photoshop, or creates a TIFF/PSD if you're using Elements. If there's a mismatch in ACR versions, it shows the same ACR Mismatch dialog as a raw file, with the same results.

What do the other options in the Edit In menu do?

Using Edit in Photoshop as the primary External Editor, you can open the file or multiple files directly into Photoshop CS3 10.0.1 or later without first saving an interim TIFF or PSD file, although you may get unexpected results if you're not using a fully compatible version of ACR, which we'll discuss in the next section. The older the Photoshop version, the more unexpected the results will be.

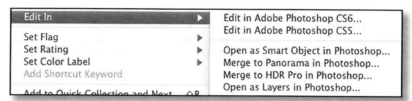

Open as Smart Object in Photoshop allows you to edit the Develop settings in the ACR dialog while in Photoshop, although those Develop settings won't then be updated on the original file in your Lightroom catalog, but will remain with the edited copy.

Merge to Panorama in Photoshop and Merge to HDR in Photoshop only become available when you have multiple photos selected. Merge to Panorama opens the files directly into the Photomerge dialog in Photoshop, allowing you to create panoramic photos, and Merge to HDR opens the files directly into the Merge to HDR dialog in Photoshop to create HDR photos. The resulting photos are automatically added to your Lightroom catalog when you save them.

And finally, Open as Layers in Photoshop also only becomes available when you have multiple photos selected. It opens the files directly into Photoshop and places those photos into a single document as multiple layers, which is particularly useful if you've created different renderings in Lightroom that you want to merge in Photoshop.

If you're using Photoshop Elements, those additional direct integration options will be unavailable, but Matt Dawson's Elemental plug-in adds

similar functionality for Elements 10 or later, and is available from:
http://www.lrq.me/photogeek-elemental

ADOBE CAMERA RAW COMPATIBILITY FOR PHOTOSHOP

ACR, or Adobe Camera Raw, is the processing engine which allows Adobe programs to read raw file formats and convert them into image files. It's available as a plug-in for Adobe Bridge, Photoshop and Elements, and that same engine is built directly into Lightroom itself.

Updates are released every 3-4 months to add new camera support, with separate downloads for the plug-in and for Lightroom. Lightroom runs as a standalone program, without any need for Photoshop, but if you do want to use the two together, it's important to update both at the same time to make sure the ACR versions are fully compatible, or at least ensure that you understand the implications of a mismatch.

How do I check which Lightroom and ACR versions I have installed?

Every time a Lightroom update is released, there's a matching ACR plug-in update, and for full compatibility those versions need to match.

You can check both your Lightroom version number, and the matching ACR version, by going to About Adobe Photoshop Lightroom 4 under the Help menu (Windows) / Lightroom menu (Mac).

Also check...

"How do I update Lightroom with the latest version of ACR?" on page 665

To check your ACR version, open any raw photo into ACR using Bridge or Photoshop, and you'll see the number on the ACR dialog title bar.

Which ACR version do I need for the settings to be fully compatible?

At the time of Lightroom 4.0's release, the fully compatible ACR version is 7.0 for CS6. They're usually both released at the same time, so in the future, 4.2 is likely to match 7.2, 4.3 should match 7.3, and so forth.

ACR 7.x is only available for CS6 and Elements 10, but Adobe don't force you to upgrade Photoshop every time you upgrade Lightroom. If you're using Elements 9, CS5, or another earlier release, Lightroom will still work correctly, but you may miss out on some of the cross-application support when using the Edit in Photoshop tools.

ACR 6.7 for CS5 is also compatible with Lightroom 4.0, although not all of the controls are available in the ACR 6.7 dialog.

What happens if I'm still using an older version of ACR and Photoshop?

When you open a photo directly into Photoshop, without an interim TIFF/PSD file, Lightroom passes the original raw data and instructions over to the ACR plug-in hosted by Photoshop, and ACR performs the conversion.

If you're using a mismatched version of ACR, it may not understand all of Lightroom's settings, and therefore the rendering may be different—or in the case of Lightroom 4's new Basic panel settings, the rendering may be completely wrong! Also, if you try to open a proprietary raw file from a camera that wasn't supported by your ACR version, the file won't open.

In recent years, there have been changes to the demosaic (the initial translation of the raw data into an image), new sliders such as Grain, Lens Corrections, Post-Crop Vignette have been added, and new camera profiles have been introduced. Existing sliders such as Noise Reduction, Sharpening, Highlight Recovery and Fill Light have been redesigned. Chromatic Aberration also changed from sliders to a checkbox. Many of those changes were so significant that the concept of Process Versions was introduced. We discussed those in more detail in the Develop chapter.

Also check...

"Process Versions" section starting on page 356

In Lightroom 4, the changes have been taken to a new level, with Process Version 2012 bringing a new set of Basic sliders, changes to Clarity, RGB curves, new sliders in Local Adjustments, and so forth.

Here's a quick reference of the most recent ACR versions for each Photoshop release, and the differences (shown in brackets) that you're likely to see if you leave ACR to convert your photos. This chart is comparing against Lightroom 4.0, so any Develop changes made to future 4.x releases may create further mismatches, particularly with ACR 6.7.

	PV2003	PV2010	PV2012
CS3 / 4.6	Close (chromatic aberration)	Mismatch	Completely different!
CS4 / 5.7	Close (chromatic aberration)	Significant differences (chromatic aberration, no UI, no lens corrections, changes to some sliders like Recovery)	Completely different!
CS5 / 6.6	Close (chromatic aberration)	Close (chromatic aberration)	Completely different!
CS5 / 6.7	Match	Match	Match (no UI)
CS6 / 7.0	Match	Match	Match

If you use the sliders and Process Versions that were available at the time of your ACR version's release, then opening directly into Photoshop should give very similar, if not identical, results. Limiting yourself to those old sliders would, however, mean you miss out on all of the more recent improvements. Instead, you can use the latest sliders and ask Lightroom to render the file as a TIFF or PSD, which it can then pass correctly to Photoshop. There's an additional dialog which appears when the ACR version is mismatched, offering you the choice of Render Using Lightroom or Open Anyway.

What's the difference between Render Using Lightroom and Open Anyway in the ACR mismatch dialog?

If you're working with a mismatched ACR version (i.e. ACR 5.7 in CS4 with Lightroom 4.0), you should see the ACR Mismatch dialog, which allows you to choose how to handle the file. There's a diagram of the options and their results at the end of the chapter.

Render using Lightroom uses Lightroom's own processing engine to render the file, which is then automatically opened into Photoshop. This does mean that an additional TIFF or PSD file is created, depending on your preferences, however all of your Lightroom adjustments will be applied correctly.

Open Anyway ignores the mismatch and passes the image data and settings to Photoshop for ACR to process, which may produce something close to the correct rendering or may be completely different, depending on how great the mismatch is, and which sliders you've used. It doesn't save the TIFF/PSD until you choose to save the changes.

Also check...

"Raw Files" diagram on page 486 and "Rendered Files (JPEG/PSD/TIFF)" diagram on page 485

If you choose Open Anyway but support for your camera was added after that ACR version was released, Photoshop will open but the photo won't open, as ACR won't know what to do with it.

Can I open a raw file directly into the ACR dialog?

You can't open a photo into the ACR dialog directly, but all of the controls are available in Lightroom anyway.

If you do want to open into the ACR dialog, you have a couple of options. You can select the file and press Ctrl-S (Windows) / Cmd-S (Mac) to save the settings to XMP. Having done so, you can either browse to the file in Bridge or Photoshop and open in those programs, or right-click on the file in Lightroom and choose Show in Explorer (Windows) / Finder (Mac). That will take you directly to the file for you to double-click to open in Photoshop, saving you browsing to find it.

If you have CS3 or later, you can use Open in Photoshop as Smart Object and then double-click on the Smart Object to open that into ACR. Be aware that any Develop settings you change will not be reflected in Lightroom if you do that though, and unless you're running a matching ACR version, as we discussed in the previous question, the photo will render differently.

If I use ACR to convert, having saved the settings to XMP, will the result be identical to Lightroom?

If you're using a fully compatible version of ACR in Photoshop or Bridge, the results will be identical to Lightroom 4, as it uses exactly the same processing engine.

I'd prefer to let Bridge run the conversion to JPEG using Image Processor to run an action. Is it possible?

You can use Lightroom to work through your photos, and then save the settings to XMP, browse to them in Bridge, and convert the photos using

Also check...

"Post-Processing Actions & Droplets" section starting on page 515

Image Processor. It would allow you to run a Photoshop action on the photos at the same time as converting them, but you can do the same using droplets from Lightroom, which we'll cover in more detail in the Export chapter. Using Image Processor to convert does tie up Photoshop, whereas Lightroom would run its export in the background while you continue working on other photos. If you do use Bridge/Image Processor, don't forget that you'll need a fully compatible ACR version in order to get the same results.

Why is Bridge not seeing the raw adjustments I've made in Lightroom?

The adjustments you make to your photos in Lightroom are stored in Lightroom's own catalog, and other programs such as Bridge can't read that catalog. In order for Bridge to read the settings, you need to write to XMP by selecting the photos in Grid view and pressing Ctrl-S (Windows) / Cmd-S (Mac).

If you've written to XMP and the XMP files are correctly alongside the raw files, then you may find that Bridge hasn't yet updated its previews. You can force Bridge to update its previews by going to Tools menu > Cache > Build and Export Cache, or Purge Cache in that same menu if it still doesn't work.

Also check...

"XMP" section starting on page 320

Rendered Files (JPEG/PSD/TIFF)

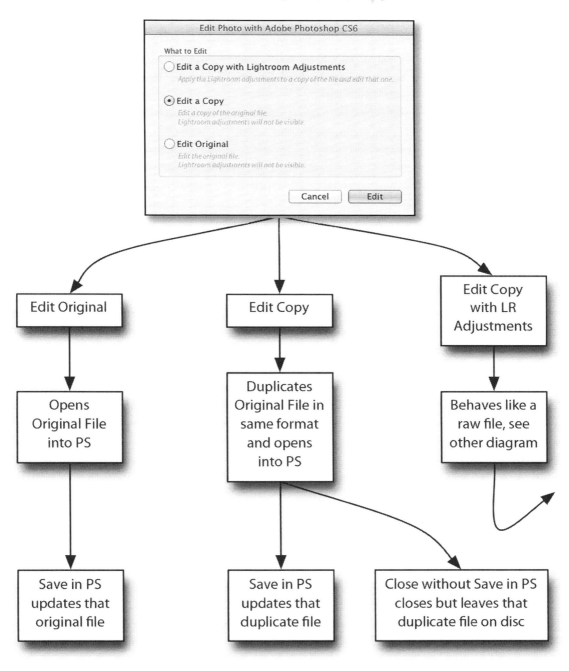

Raw Files

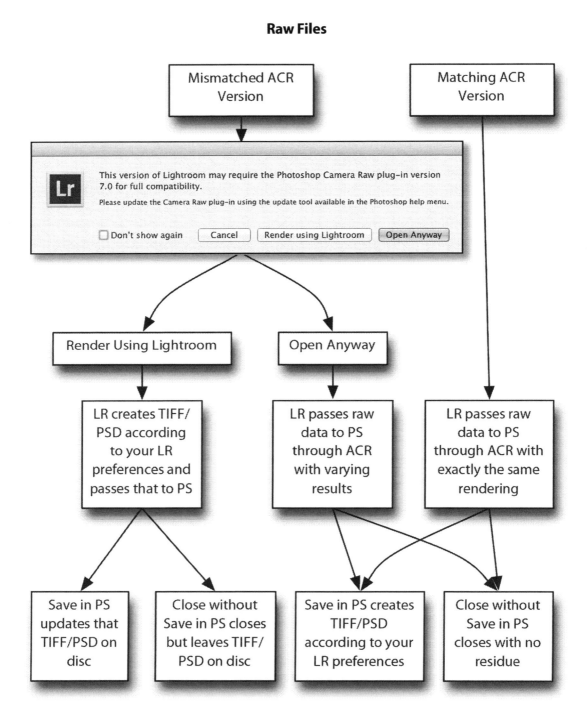

Export

As Lightroom works nondestructively, applying your Develop settings to your photos to view outside of Lightroom involves exporting them to new files, in the size and format suited to the purpose.

To export photos, select them and go to File menu > Export, use the shortcut Ctrl-Shift-E (Windows) / Cmd-Shift-E (Mac), press the Export button at the bottom of the left panel group in Library module, or select Export from the right-click menu. Right at the top of the Export dialog, there's a pop-up menu that's usually set to Hard Drive for normal exports, but also allows writing the exported files to CD/DVD, emailing photos, or exporting to specific plug-ins, such as Adobe Revel. Leave that on Hard Drive for the moment and we'll investigate some of the other options later.

EXPORT LOCATIONS & FILE NAMING

The first thing that you need to choose in the Export dialog is the location for your exported files, and also their filenames if you want to rename while exporting.

Can I set Lightroom to automatically export back to the same folder as the original?

In the Export dialog you can set Lightroom to export the photo to a specific folder or to the same folder as original photo, and placing them either directly within that folder or within a named subfolder of your choice. If the original photos are in different folders, 'Specific folder' will group all of the exported photos in one place, whereas 'Same folder as original photo' will result in the exported photos being placed with their original files, so they may be spread across variety of different locations.

If you need to replicate your folder structure during an export, for example, a wedding that's grouped into folders for each stage of the day, LR/TreeExporter plug-in can save you doing so manually. http://www.lrq.me/armes-lrtreeexporter

Can I set Lightroom to automatically re-import the exported files?

There's an option in the Export dialog which can automatically add the exported photos back into your catalog, bypassing the Import dialog. It's particularly useful if you're using Export instead of External Editors, in order to get access to additional file creation options.

Also check...

"Can I change other External Editor settings, such as a custom subfolder and a different filename for each editor, or a different file format?"
on page 472

If the exported files have been exported to the same folder as the original photos, you can also automatically stack them.

Why is the 'Add to Stack' checkbox unavailable?

Stacking is only available when photos are in the same folder, so the Add to Stack checkbox is only turned on when you have the export set to 'Same folder as original photo,' and not into a subfolder.

Can I set Lightroom to overwrite the original when exporting?

Lightroom won't allow you to overwrite the source file, as it goes against its philosophy of nondestructive editing. Overwriting the originals is like throwing away the negatives once you've made a print that you like! If you attempt to overwrite the source files that you're exporting, it should ask whether to skip them or use unique names. I say 'should' because that's been a recurring bug, which is currently fixed, but is best avoided just in case it returns!

Can I stop Lightroom asking me what to do when it finds an existing file with the same name?

In the Export dialog you can set a default action, so that when it finds existing files with the same name in the Export location, it doesn't stop and wait for your decision. You can choose to allow it to adjust the filename, automatically overwrite the existing file, skip exporting the conflicted file, or ask you what to do.

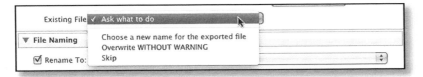

Also check...

"Stacking" section starting on page 187

How do I burn the exported files to CD or DVD?

Lightroom allows you to burn exported photos to CD or DVD directly from the Export dialog. At the top of the export dialog, change the pop-up menu which usually says Hard Drive to CD/DVD, and when you press the Export button, it will prompt for optical media. If there's too much data for a single disc, Lightroom will calculate how many discs will be needed and will span the data without splitting any individual files. Alternatively, you can export to your hard drive and use standalone software to burn instead.

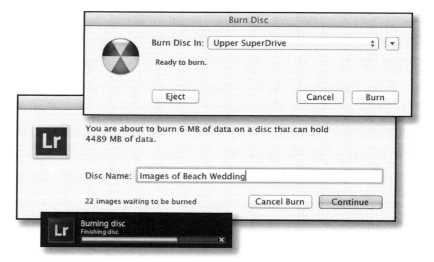

How do I change the filename while exporting?

Rather than having to rename and then export the files, or vice versa, you can use the File Naming section in the Export dialog. This won't affect the original photos in your catalog—it will only change the names of the exported photos.

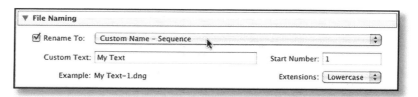

The dialog used for the File Naming Template is the same dialog that is used both for renaming while importing and later in the Library module.

VIDEO & FILE SETTINGS

The next sections in the Export dialog are Video and File Settings, where you select the file format, quality and color space. We'll come back to the color space in the next section.

The file format you select will depend on the purpose of the photo or video. JPEG is an excellent choice for emailing photos or posting them on the web, but it's a lossy format, whereas PSD and TIFF allow you to save Photoshop's layers and they're lossless. The Original options export in the original format, creating a duplicate of the original file but with updated metadata. Your edits are not applied to the image data when selecting Original format.

Also check...

"How do I rename the files while importing?" on page 94, "How do I rename one or more photos?" on page 196 and "Color Space" section starting on page 497

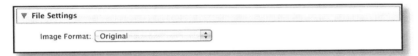

How do I export or save my edited videos?

If you've edited a video, you will likely want to apply the changes before sending it to someone else, just as you would for an image file. Using Export, you can create a duplicate of the original unedited video, or output to DPX or H.264 mp4 format.

DPX is a lossless format used for editing in some professional video editing programs, such as Adobe Premiere. H.264 is the best option for compressing your final videos.

If you're using H.264, Maximum quality uses a bit rate as close to the source file as possibly, to prevent any loss of quality. High quality retains the resolution but may reduce the file size slightly. Medium is useful for sharing on the web, as it's a lower resolution and bit rate. Low quality is intended for mobile devices such as mobile phones, with a much lower resolution and bit rate resulting in a much smaller file size.

As a guide, a 10 second clip from a Canon 600d gave the following results:

Original file: 155 MB for 27 seconds, so around 51 MB for 10 seconds

DPX—2.07 GB

H264 Max—29.7 MB, 1920x1080, 22 Mbps approx.

H264 High—29.7 MB, 1920x1080, 22 Mbps approx. (in this case it didn't make a difference)

H264 Medium—11.3 MB, 1280x720, 8 Mbps approx.

H264 Low—1.5 MB, 480x270, 1 Mbps approx.

What's the equivalent of JPEG quality...?

If you've used Photoshop, you'll notice that Lightroom uses a different scale (0-100 rather than 0-12) for JPEG quality. There isn't a direct equivalent, but as a rough guide:

Photoshop quality 8—approx. 65 in Lightroom Photoshop quality 10—approx. 80 in Lightroom Photoshop quality 12—100 in Lightroom

Visit http://www.lrq.me/friedl-jpegquality for a detailed explanation of the different quality ranges.

How do I set Lightroom to a JPEG level 0-12 so that Photoshop doesn't ask me every time I save?

As Lightroom doesn't save a 0-12 quality tag in the file, whenever you try to resave a JPEG in Photoshop, it will ask you for the quality. That's fine for individual files, but becomes irritating on a batch process. You can automatically set the quality rating for the whole batch by including a Save As, with the same name and location, in your action rather than a standard Save. Even if you override the save location when setting up the batch process, it will still use the quality tag that you used when setting up the action. As this is a Lightroom book, rather than a Photoshop book, we won't go into any more detail, but you'll get the general idea from the Post-Processing Actions & Droplets section later in the chapter.

Also check...

"Can I run a Photoshop action from Lightroom?" on page 515

Why won't Photoshop allow me to save my Lightroom file as a JPEG?

If you open a 16-bit file into Photoshop, either via Edit in Photoshop or after exporting, you can't save it as a JPEG. CS5 and later automatically convert to 8-bit when you try to save a JPEG, but earlier versions require you to make a decision. You can either convert the photo to 8-bit, in which case you can save as a JPEG, or you can save your 16-bit photo as another format such as TIFF or PSD. If you want to convert from 16-bit to 8-bit to save it as a JPEG, go to Photoshop's Image menu > Mode > 8 bits/Channel.

Should I choose 8-bit or 16-bit?

16-bit ProPhoto RGB is the officially recommended choice for best preserving color details from Lightroom, but what does that actually mean?

Every photo is made up of pixels. In an RGB photo, each pixel has a Red, a Green and a Blue channel, and in an 8-bit photo, each of those channels

Also check...

"Why can't CS2 save as JPEG when I've used Local Adjustments on the photo?" on page 532

has a value from 0-255. That means that a 3-channel 8-bit photo can mix those channels in a possible 16.7 million combinations, resulting in a potential 16.7 million different colors—256x256x256 = 16.7 million.

That sounds like a lot, but come back to those 256 levels per channel a moment. What happens if you need to make any significant tonal changes? You've only got a maximum of 256 levels per channel to play with. Perhaps you've significantly underexposed the photo, and all of the detail is in the first 128 levels. You can stretch the detail out to fill the full 0-255 range, but you can't create data, so you end up with gaps in the histogram like this:

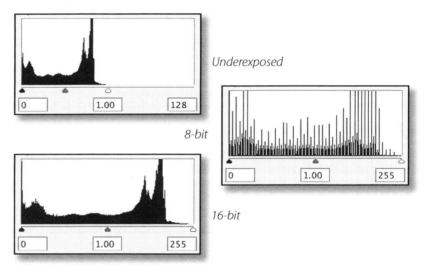

Underexposed

8-bit

16-bit

Those gaps may not notice on your average photo, but are more likely to notice as banding on photos with smooth gradients, such as a sky at sunset. A 16-bit photo, on the other hand, has 65,536 levels per channel, so you can manipulate it without worrying about losing too much data.

The downside to 16-bit is that all that extra data takes up more space on your hard drive, so in the real world, it's not always quite so clear cut. 16-bit files can only be saved as TIFF or PSD, not JPEG, and the file sizes are much bigger than an 8-bit quality 12 JPEG, often with very little, if any, visible difference to the untrained eye on a small print. A Canon 5D Mk2

file would be around 126MB for a 16-bit TIFF, 63mb for an 8-bit TIFF, but less than 15MB for a maximum quality 8-bit JPEG. That's a big difference on a large volume of files!

So the reality is you may want to weigh it up on a case-by-case basis. If you're producing a fine art print, 16-bit would be an excellent choice to preserve as much detail as possible. Or if you're going to take a file into Photoshop and make massive tonal changes, 16-bit would be an excellent choice, giving greater latitude for adjustments.

On the other hand, if you're processing a series of 1000 photos shot at a wedding, you're making your tonal changes within Lightroom using the full range of 12-bit or 14-bit raw data captured by the camera, before converting down to 8-bit, and they're only going to be small photos in an album with no major additional changes to be made, 8-bit JPEG could be a far more efficient choice. You can always re-export from Lightroom as a 16-bit file if you find a photo which would benefit, such as a photo exhibiting banding in the sky, or suchlike.

I am a high volume photographer (weddings, sports, etc.)— do I have to convert to PSD or TIFF for light retouching, or can I use JPEG?

As with the 8-bit vs. 16-bit debate, there's no fixed answer on whether to use JPEGs for your working files—it depends on your situation.

JPEG is a lossy format, which means that if you open, re-save, close and repeat that process enough times, you will eventually start to see the compression artifacts. TIFF and PSD, on the other hand, are lossless formats.

Some high volume photographers, such as wedding or sports photographers, are using 16-bit TIFFs for everything, simply because they've been told that's best. And technically, that is absolutely true. However we live in the real world, and, as with everything, there is a trade-off—TIFF and PSD formats are much larger than JPEGs. High

volumes of these files will rapidly fill your hard drive, and they will take longer to open and save due to the larger file sizes. If you're dealing with a small number of photos, that's not a problem, but for photographers working with thousands of photos every week, it becomes a question of ultimate quality vs. real-world efficiency.

So, some questions to consider…

- What are you doing to these files once they've left Lightroom? Major color/density shifts? Or a little light retouching before printing? If you're making major adjustments, a 16-bit TIFF or PSD will be the best choice, but ideally you would be making those adjustments within Lightroom using the raw data at an earlier stage in your workflow anyway.

- Do you want to keep layered files? If so, you could consider using TIFF or PSD for your working files, and then converting to high quality JPEG once you're ready to archive.

- How big are the photos going to be printed? A photo which is going to be printed as a poster-size fine art print will be best as a 16-bit TIFF or PSD, whereas you may choose to compromise and use JPEGs for photos that are only going to appear as smaller photos in an album or on the web.

- How often are you going to need to re-save this file? Are you going to keep coming back to it and doing a bit more retouching, or will it just be re-saved once or twice? If you're just opening it once, doing a little retouching, saving and closing, there's very little visible, real-world difference to the untrained eye—and the space savings are HUGE.

Test it for yourself—how many times can you open a file/save/close/ reopen and repeat before you can find any visible differences? At quality 12? Even at quality 10? Will your customers see it? Don't take someone else's word for it—check it for your own peace of mind. You can save as many times as you like while the file remains open in Photoshop, without any additional compression, as the original data remains in the

computers memory—it's only saving the file after closing and reopening that will re-compress it.

Only you can decide whether you're comfortable with that compromise in specific situations, having checked the facts for yourself.

COLOR SPACE

When it comes to the color space, there's lots of confusion. Should you choose sRGB because it's common? But you've heard ProPhoto RGB is better because it's bigger, so should you choose that one? Let's investigate the options…

Which color space should I use?

Color management is a huge subject in its own right, so we won't go into great detail here. If you'd like to learn more, Jeffrey Friedl wrote an excellent article on color spaces, which you will find at: http://www.lrq.me/friedl-colorspace

In short, we've already said that photos are made up of pixels, which each have number values for each of the color channels. For example, 0-0-0 is pure black. 255-255-255 is pure white. The numbers in between are open to interpretation—who decides exactly what color green 10-190-10 equates to? That's where color profiles come in—they define how those numbers should translate to colors.

Lightroom is internally color-managed, so as long as your monitor is properly calibrated, the only times you need to worry about color spaces are when you're outputting the photos to other programs. That may be passing the data to Photoshop for further editing, passing the data to a printer driver for printing, or exporting the photos for other purposes, such as email or web.

When considering the size of color spaces, imagine you're baking a cake, and you need to mix the ingredients. ProPhoto RGB is a big enough

mixing bowl that it won't overflow in the process, whereas sRGB is like the cake tin that just about fits the cake when you've finished, but will overflow and lose some of your cake mixture if you try to move it around too much. You use the right bowl for the job.

sRGB is a small color space, but fairly universal. It can't contain all of the colors that your camera can capture, which will result in some clipping. As it's a common color space, it's a good choice for photos that you're outputting for screen use (web, slideshow, digital photo frame), and many non-pro digital print labs will expect sRGB files too.

Adobe RGB is a slightly bigger color space, which contains more of the colors that your camera can capture, but still clips some colors. Many pro digital print labs will accept Adobe RGB files. It's also a good choice for setting on your camera if you choose to shoot JPEG rather than the raw file format, if your camera can't capture in ProPhoto RGB.

ProPhoto RGB is the largest color space that Lightroom offers, and it's designed for digital photographers. It can contain all of the colors that today's cameras can capture, with room to spare. The disadvantage is that putting an Adobe RGB or ProPhoto RGB file in a non-color-managed program, such as most web browsers, will give a flat desaturated result. That makes it an excellent choice for editing and archiving, but a poor choice when sending photos to anyone else.

So your chosen color space will depend on the situation. You don't need to worry while the photo stays in Lightroom, as all of the internal editing is done in a large color space which Lightroom manages. When the photo leaves Lightroom, then you need to make a choice. If you're sending a photo to Photoshop using the Edit In command, ProPhoto RGB will often be the best choice, retaining as wide a range as possible. ProPhoto RGB doesn't play well with 8-bit though, because you'd be trying to jam a large gamut into a small bit depth, which can lead to banding, so stick with 16-bit while using ProPhoto RGB. Once you've finished your editing, and you want to export the finished photo for a specific purpose, then you can choose a smaller color space.

Also check...

"Editing in Other Programs" chapter starting on page 469

Whichever color space you choose to use, always embed the profile on Export. A digital photo is just a collection of numbers, and the profile defines how those numbers should be displayed. If there's no profile, the program has to guess—and often guesses incorrectly. Lightroom always embeds the profile, but Photoshop offers a checkbox in the Save As dialog, which you need to leave checked.

Why do my photos look different in Photoshop?

A mismatch in colors between Lightroom and Photoshop is usually due to either a corrupted or incompatible monitor profile or incorrect color space settings. For example, a ProPhoto RGB photo mistakenly rendered as sRGB will display as desaturated and flat.

ProPhoto RGB photo correctly displayed as ProPhoto RGB:

ProPhoto RGB photo incorrectly displayed as if sRGB:

Also check...

"How do I change my monitor profile to check whether it's corrupted?" on page 339

The corrupted monitor profile is very easy to check, and we covered that in the earlier Previews & Speed chapter.

We'll also need to confirm that the color spaces match across the 2 programs. The same principles will also apply to opening photos in other software, not just in Photoshop.

First, check your color settings.

In Photoshop, go to Edit menu > Color Settings to view the Color Settings dialog.

The RGB Working Space is your choice, but whichever you choose to use, you're best to set the same in Lightroom's External Editor preferences and Export dialog. We'll come to that in a moment.

Also check...

"Which color space should I use?" on page 497

Selecting Preserve Embedded Profiles and/or checking the Ask When Opening for Profile Mismatches in that same dialog will help prevent any profile mismatches. Preserve Embedded Profiles tells Photoshop to use the profile embedded in the file regardless of whether it matches your usual working space. Ask When Opening for profile mismatches shows you a warning dialog when the embedded profile doesn't match your usual working space, and asks you what to do. If Preserve Embedded

Profile is selected, you can safely leave the two Profile Mismatch checkboxes unchecked.

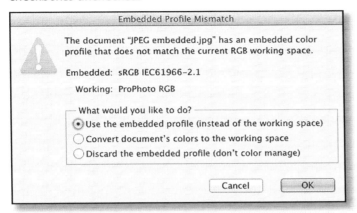

Then you need to set your External Editor settings in the Lightroom Preferences dialog > External Editing tab, and select the same color space that you've selected in Photoshop.

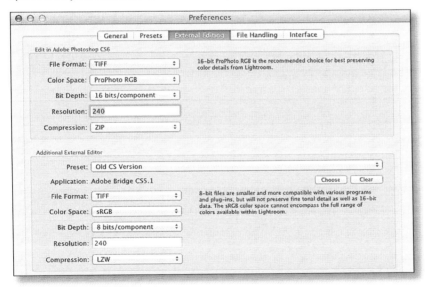

You'll also want to check the color space that you're using in the Export dialog, and again, if passing those photos to Photoshop, select the same color space for photos you're going to edit in Photoshop.

As long as your Photoshop and Lightroom color settings match, or you have Photoshop set to use the embedded profile, your photos should match between both programs.

Why do my photographs look different in Windows Explorer or on the Web?

Having checked your Photoshop color settings, you may still find that your photos look incorrect in other programs such as web browsers. This is because most web browsers, and many other programs such as Windows Photo Viewer, aren't color managed by default, if at all. If anything, they assume that your photos are sRGB, resulting in an incorrect appearance for photos tagged as Adobe RGB or with another profile embedded.

Photos destined for the web or other screen display should usually be exported as sRGB, unless you know that they're going to a fully color managed environment. sRGB isn't actually 'better'—the color space is actually smaller—but it will ensure that the rendering in non-color-managed programs will be at least as close as possible to the photo you're viewing in Lightroom.

Can I export with a custom ICC profile?

Selecting Other in the Export dialog Color Space pop-up menu will bring up a dialog box allowing you to choose which other custom ICC profiles will be available in the Color Space pop-up menu. These might include profiles for digital print labs or other printers. The only restriction is that the profiles have to be RGB, rather than CMYK or other color spaces.

Also check...

"Everything in Lightroom is a funny color, but the original photos look perfect in other programs, and the exported photos don't look like they do in Lightroom either. What could be wrong?" on page 338

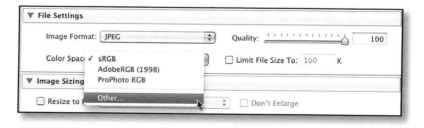

IMAGE SIZING & RESOLUTION

For Lightroom to resize the original photos would go completely against it's nondestructive design, after all, there's nothing more destructive than deleting pixels. Instead, you crop to a specific ratio in the Develop module and then set the actual size in the Export dialog.

What's the difference between Width & Height, Dimensions, Longest Edge, Shortest Edge & Megapixels?

Width & Height behaves like Fit Image and Image Processor in Photoshop. It fits the photos within a bounding box in their current orientation. This setting is width/height sensitive—settings of 400 wide by 600 high will give a 400×600 vertical photo, but only a 400×267 horizontal photo. To create photos of up to 400×600 of either orientation, you would have to enter a square bounding box of 600×600 and have 4x6 ratio crops.

Dimensions works slightly differently. It still fits your photo within a bounding box, but it's a little more intelligent. It takes into account the rotation of the photo, and it will make the photo as big as it can within your bounding box, even if it has to turn the bounding box round to do so. The Dimensions setting isn't width/height sensitive, so settings of 400 wide by 600 high will give a 400×600 or 600x400 photo. If your photo is a different ratio, it

will still make it as big as it can within those boundaries. To create photos of up to 400×600 of either orientation, you would simply enter 400x600.

Longest Edge sets the length of the longest edge, as the name suggests. A setting of 10 inches long would give photos of varying sizes such as 3"×10", 5"×10", 7"×10", 8"×10", 10"×10".

Shortest Edge sets the length of the shortest edge, again as the name suggests. A setting of 5 inches along the shortest edge would give varying sizes such as 5"×5", 5"×8", 5"×10", 5"×12".

Megapixels sets the dimensions automatically, based on your chosen pixel count. For example, selecting 24mp (24,000,000 pixels) would result in files of 4000x6000 and panoramas of 2400x10000, depending on their crop ratio.

Bear in mind that these measurements do still fall within the ACR limits of 65,000 pixels along the longest edge and 512MP, so if your photo will fall outside of this range according to the measurements you've set, Lightroom will simply make the photo as big as it can.

When I enter 4x6 as my output size, why do the vertical photos become 4x6 but the horizontal photos become 2.5x4?

If you're ending up with photos that are smaller than expected, you've got Export Resizing set to Width & Height, which fits the photo within a bounding box without rotating. Change it to Dimensions and it will work as you're expecting.

What does the 'Don't Enlarge' checkbox do?

The Don't Enlarge checkbox will prevent small photos from being upsized to meet the dimensions you've set, while still downsizing photos which are too large to fit your chosen dimensions.

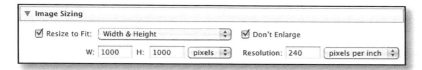

What PPI setting should I enter in the Export dialog?

The PPI (Pixels Per Inch) setting, or Resolution, is generally irrelevant as long as the overall pixel dimensions are correct. As a side point, DPI refers to Dots Per Inch, which doesn't apply to digital images until they're dots on a piece of paper.

We won't go into a lot of detail as a web search on 'PPI resolution' will produce a multitude of information, but you're simply defining how to divide up the photo. When you're talking in pixel dimensions, PPI doesn't mean anything. It's only useful when combined with units of measurements.

Imagine you've finished baking your cake—you can divide it into 4 fat slices, or 16 narrow slices, but the overall amount of cake doesn't change. Your photo behaves the same way. The PPI setting just tells other programs how many slices you think the photo should be divided into, but there's the same amount of data overall.

The PPI setting becomes more useful when resizing in inches or cm rather than in pixels, as it saves you calculating pixel dimensions. For example, creating a small image of 0.5" x 0.5" at 300ppi will give you 150px x 150px. That tiny image will look good when printed in that small size, but if you try to spread those same pixels over a larger area, for example, 2" x 2" at 75ppi which is also 150px x 150px, then the result will be lower quality and pixelated. To create a good quality print in the larger size, you'd need more data, so you'd need a larger number. If your image was 600px x 600px, or 2" x 2" at 300ppi, you'll see less pixelation.

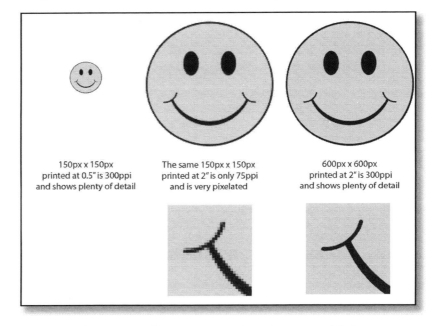

| 150px x 150px printed at 0.5" is 300ppi and shows plenty of detail | The same 150px x 150px printed at 2" is only 75ppi and is very pixelated | 600px x 600px printed at 2" is 300ppi and shows plenty of detail |

Moving on from smiley faces, when sending photos to a lab for printing, you may decide against sending them the full resolution file, and choose to downsize to a smaller file size for faster upload. As a rule of thumb, about 250-300ppi, with the correct print dimensions in inches or centimeters, is a good trade-off for printing. Selecting a photo size of 4"x6" at 300ppi, or the equivalent pixel dimensions of 1200x1800, is plenty for most labs to print a good quality 4"x6" print. On the other hand, using 4"x6" at 72ppi will give pixel dimensions of just 288x432, which will be pixelated and low quality.

If you're just starting out, here are some sample export settings for different uses:

Email—Longest Edge 800px, and you can ignore the resolution as we're specifying the size in pixels. Format JPEG, quality 60-80.

4" x 6" digital print—Dimensions 4" x 6" at 300ppi. Format JPEG, quality 80-100.

8" x 10" digital print—Dimensions 8" x 10" at 300ppi. Format JPEG, quality 80-100.

Full resolution master—uncheck the Resize to Fit checkbox. Format TIFF/PSD or JPEG quality 100.

When I crop to 8x10 in Lightroom and then open in Photoshop, why is it not 8"x10"?

When you're cropping in Lightroom, you're cropping to a ratio rather than a fixed size. Because you're not throwing away pixels in your nondestructive Lightroom workflow, that crop can be output to a number of different sizes—for example, your 8x10 crop could also be output as 16"x20", 8"x10", 4"x5" or 400x500 pixels for the web, amongst others, all without having to go back and re-crop the photo.

When you come to export, you then define the size that you wish to export, either as pixel dimensions or as inches/cm combined with a resolution setting.

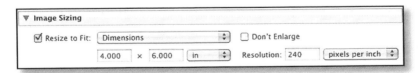

Is it better to upsize in Lightroom or in Photoshop?

When Lightroom resizes, you don't have a choice of interpolation method, unlike Photoshop which offers Nearest Neighbor, Bilinear, Bicubic, Bicubic Smoother and Bicubic Sharper. Instead, Lightroom uses

Also check...

"Cropping" section starting on page 450

an intelligent adaptive bicubic algorithm which will automatically adjust for the increase or decrease in size. Either program will resize your photo well, but Lightroom will automatically choose the best option, whereas Photoshop expects you to make the decision.

Can I export to a specific file size?

Because Lightroom's working on a lot of files, rather than Photoshop's one file, it doesn't give you a preview of the resulting file size when you adjust the quality. If you're uploading the photos to a website with a specific file size limit, it can be time-consuming to repeatedly export the photos, changing the quality setting to check that they fall inside of the limit of, for example, 70kb. If you check the Limit File Size To checkbox and enter a limit, Lightroom will do that work for you, however the export can take longer than a standard export. It also removes the embedded thumbnail to improve the reliability.

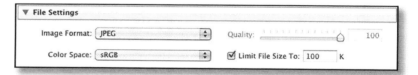

Lightroom only adjusts the quality setting automatically, and not the pixel dimensions, so attempting to export a full resolution photo under 50k would compress the photo beyond recognition and will show an error message warning you that it can't be done. Make sure you choose reasonable pixel dimensions for the file size.

OUTPUT SHARPENING

Once you've set the sizing, the sharpening is next in line. That output sharpening may only have 2 pop-up menus, but it's far more powerful than it looks.

Why does the Export Sharpening only have a few options? How can I control it?

Lightroom's sharpening controls are based on Bruce Fraser's multiple pass sharpening methods, as we mentioned earlier in the Develop chapter.

The output sharpening found in Export and the Book, Print and Web modules is based on the complex algorithms created by the team at Pixel Genius, who created the well-known Photoshop plug-in PhotoKit Sharpener.

Based on the size of the original file, the output size and resolution, the type of paper, and the strength of sharpening you prefer, it automatically adjusts the sharpening to create the optimal result.

To get the best out of the automated output sharpening, you do need a properly capture-sharpened photo, so the sharpening settings in the Develop module are still essential.

Also check...

"Detail—Sharpening & Noise Reduction" section starting on page 423

Which Export Sharpening setting applies more sharpening— screen, matte or glossy?

The difference between Matte and Glossy is barely noticeable on screen, but there is a difference between each of the settings. At a glance you'll see that the Screen setting sharpens the high-frequency details less than the Matte or Glossy settings, but there are a lot more technicalities behind that.

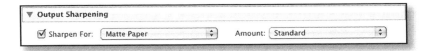

As a general rule, pick the right paper type, and you'll be about right. Sending matte sharpening to a glossy paper will look worse than sending glossy sharpening to matte paper, because the matte sharpening is compensating for the softer appearance of matte paper. Screen sharpening may look a little soft on CRT monitors as it's optimized for

Also check...

"Plug-ins" section
starting on page 526

LCD screens. Avoid over-sharpening in the Develop module, otherwise the Export Sharpening will make it look a lot worse.

PROTECTING YOUR COPYRIGHT WITH WATERMARKING

As soon as you release your photos, whether on the web or in printed form, they're at risk of being stolen. While you can't control that, ensuring that you have copyright metadata stored in the files, and possibly adding a watermark, can help to deter would-be thieves.

The Watermarking tool is designed as a very easy way to apply a simple watermark to your photos, rather than as a replacement for the popular, but complex, LR/Mogrify plug-in.

Can I strip the metadata from my files, like Save for Web in Photoshop?

In the Export dialog is a Metadata section, which allows you to decide how much of the photo's metadata is included in the exported file. The options are quite self-explanatory. From the most retained metadata to the least, they are All, All Except Camera & Camera Raw Info, Copyright & Contact Info Only or Copyright Only.

In the Metadata section there is also a Remove Location Metadata option. Any photos within a Private Saved Location will automatically have their location metadata removed regardless of this checkbox.

If you want to be more selective, Jeffrey Friedl's Metadata Wrangler Export Plug-in allows you to choose which metadata to remove and which to keep. You can download it from: http://www.lrq.me/friedl-metadatawrangler

Also check...

"Map Module" chapter
starting on page 245

While we're considering that section of the dialog, there's also a 'Write keywords as Lightroom hierarchy' checkbox. It uses the pipe character (|) to show parent/child relationships for your keywords, for example,

'Animals | Pets | William.' If you uncheck it, the keywords assigned to the photo will be recorded individually, resulting in 'Animals,' 'Pets,' and 'William.' It can be useful for software that doesn't understand a keyword hierarchy.

What is 'Simple Copyright Watermark' in the watermark menu?

The most basic form of watermark is a small text watermark in the corner of the photo. You'll find that listed as Simple Copyright Watermark in the Watermarking section of the Export dialog, and it takes its data from the Copyright metadata field. It's not the same as the watermarks set up in the Watermark dialog, but rather a small plain text watermark in the lower right corner of a photo. You can add that Copyright data in the Metadata panel in the Library module, or better, as part of an Import preset, so no photos are missing their Copyright information.

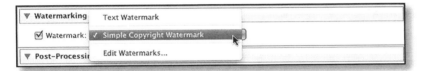

Also check...

"What Develop settings, metadata and keywords should I apply in the Import dialog?" on page 92 and "How do I add metadata to multiple photos at once?" on page 201

How do I create a decorative text or graphical watermark?

To create a more decorative watermark, select Edit Watermarks from the pop-up in the Watermarking section of the Export dialog. You can also access it from the Edit menu (Windows) / Lightroom menu (Mac). The Edit Watermark dialog, where you set up your watermarks, is shown on the following page.

If you want to add a text watermark, select the Text Style option at the top of the dialog, and then enter your text in the text field beneath the preview image. If you want to add a © copyright symbol, hold down Alt while typing 0169 on the number pad (Windows) or type Opt-G (Mac).

The options on the right allow you to choose the font and size of your watermark. The alignment buttons in the Text Options panel apply to

the text alignment within the bounding box and they only come into effect when you have multiple lines of copyright text.

If you would prefer a graphical watermark, press the Choose button in the Image Options panel and navigate to the JPEG or PNG file of your choice. Once you've found your watermark, you can adjust the size using the bounding box on the preview or you can change it in the Watermark Effects panel.

To move the watermark around on the image, you can't drag it, but you can use the Watermark Effects panel to lock it to the center, a corner, or an edge of the photo, and add additional spacing to distance it from the edge of the photo too.

Once you're happy with your watermark, use the pop-up menu at the top of the dialog to save it ready for use on your photos.

Also check...

"Saving Presets in Pop-Up Menus" on page 166

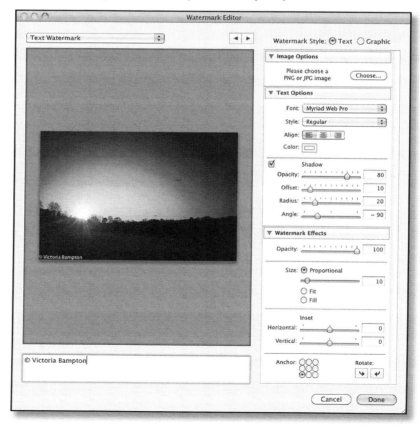

Are the watermarks intelligent for vertical and horizontal images?

The sizing of the watermark is proportional to the size and orientation of the exported photo, and you can decide whether to Fit the watermark within the short edge, Fill the long edge, or keep it Proportional to the current orientation.

Fit

Fill

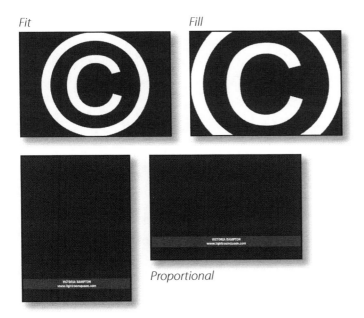

Proportional

Which file formats can I use for the graphical watermark?

You have a choice of JPEG or PNG formats for the watermarks. The PNG format has the advantage of allowing transparency, or semi-transparency—for example, you may want a large © symbol across your photo, but you don't want a large white square showing.

To create a transparent PNG, you'll need pixel editing software such as Photoshop. Create a new layer and drag the background layer to the trash, so that you can see the grey and white checkerboard underneath. Anywhere that you see that grey and white checkerboard is going to be transparent,

and you can also apply blend modes to the watermark to give it additional depth. In the Save or Save for Web dialog, select the PNG format.

You can download some of my favorite watermarks from:

http://www.lrq.me/lr4-bookdownloads

Can I overwrite an existing watermark?

As with many of the pop-up menus that we discussed in the Workspace chapter, if you've selected an existing watermark and then edited it, the name in the pop-up menu will add (Edited) to the end, and an Update Preset option will appear in the menu, allowing you to overwrite.

Also check...

"Renaming, Updating and Deleting Presets in Pop-Up Menus" on page 166

Where can I use my watermarks?

The watermarks are available at the bottom of the Export dialog for standard exports and emails, the Publish Services settings for managed exports, and also in the Slideshow, Print, and Web modules.

How do I change the watermark placement for each photo?

The Watermark tool's purpose is to apply a watermark to large numbers of photos in the same size and position, so there isn't an interface for moving the watermark on individual photos, unless you want to keep returning to the Edit Watermark dialog every time you export. You could save multiple versions of a watermark preset, with the watermark in different positions, however you'd still have to select the photos to use with each preset. Using the Identity Plate and Print to JPEG, which we'll cover in the Print module, may be an alternative workaround if you need to carefully position a watermark on each individual photo.

Can I create more complex watermarks, such as text and a graphic?

Using Lightroom's watermark feature, you can only add either a text or a graphical watermark—not both. If you want greater control over the watermarking, and you're willing to experiment to get your perfect result, the LR/Mogrify plug-in offers extensive options for adding multiple lines of text, multiple graphics, as well as borders. You can download it as donationware from: http://www.lrq.me/armes-lrmogrify2

Also check...

"How can I overlay a graphic such as a border onto my print?" on page 613

POST-PROCESSING ACTIONS & DROPLETS

Finally, Lightroom can pass your exported photos automatically to other programs when it's finished exporting, using the Post-Processing pop-up menu. Scroll down to the bottom of the dialog to find the Post-Processing options.

Can I run a Photoshop action from Lightroom?

Lightroom's not designed to be a file browser, so it doesn't work quite like Bridge, but it's still possible to run Photoshop actions on your exported photos without user intervention. The solution involves

creating a droplet in Photoshop from an existing action, and then telling Lightroom to run the droplet after exporting the photos.

Create the Action

In Photoshop, you need to have already created an action—if you're not familiar with creating Photoshop actions, there are plenty of web resources which will take you through step-by-step.

If you're going to run the action on JPEGs, it must include a Save As step to set the JPEG quality, otherwise it will ask for a quality setting for each and every photo, defeating the object of automating it! To do so, in the Save As dialog, just press OK without changing the filename or location, and make sure you choose your quality setting—you'll override the location in the Create Droplet dialog.

The resulting Action will look something like this simple 're-save as quality 12' action.

Create the Droplet

Go to File > Automate > Create Droplet to view the Create Droplet dialog.

Save your droplet somewhere safe with a logical name, and make sure you've set the save location to Save and Close to overwrite the exported file, and tick the 'Override save location' box. If you don't want to overwrite the exported file when running the droplet, set your destination folder instead. Click OK to create your droplet.

<u>Add the Droplet to Lightroom</u>

Open Lightroom, select a photo, and go to the Export dialog. At the bottom of the dialog, you'll see the Post-Processing pop-up menu. Click Go to Export Actions Folder Now at the end of the pop-up menu to show you that folder in Explorer (Windows) / Finder (Mac). Drop a shortcut/alias to your droplet in the folder which appears, or move the droplet itself, and then close the Export dialog box.

<u>Export Actions</u>

When you reopen the Export dialog box to export your photos from Lightroom, your droplet will appear in the Post-Processing pop-up menu. Export your photos from Lightroom, with your new droplet selected in that pop-up menu, and once the photos have finished exporting, they should automatically open Photoshop and run your action.

The droplet runs, but it doesn't save—what have I done wrong?

If you can see that Photoshop is opening the photos and running the action correctly, but simply isn't saving the changes, you've probably correctly checked the 'Override Action "Save As" Commands' checkbox in the Droplet dialog, but your action didn't include a Save As. Alternatively, you might find that you set your droplet or action up to save to another location. Either way, try creating your action and droplet again!

The droplet runs, but it keeps asking what JPEG compression to use—what have I done wrong?

If Photoshop keeps asking for the JPEG compression, you forgot to include a Save As in your action to set the JPEG quality, so just re-create the action and droplet again.

The droplet doesn't run at all—why not?

If the droplet doesn't run, the problem is likely with the droplet itself. You can check whether the droplet works by dropping files directly onto the droplet icon—that was their original purpose, and excludes Lightroom from the problem briefly. If it doesn't run, try re-creating your action and droplet, following the instructions carefully. If it still doesn't run when dropping files directly onto the droplet, it would suggest that you have a problem with your Photoshop installation, and reinstalling Photoshop should fix it.

The droplet only works on some of the photos and then stops—what's wrong?

When Lightroom tells Photoshop which files to run the action on, it passes it a string of file paths which looks something like: 'C:\Documents and Settings\username\Desktop\image1.jpg; C:\Documents and Settings\username\Desktop\image2.jpg;.' The maximum allowable length of that string is limited.

If the files you're sending are buried deep in the folder structure, you'll use up the available string length far quicker than a short file path such as: 'D:\image1.jpg, D:\image2.jpg' Don't be fooled into thinking that Desktop or My Pictures are short length paths—on both Windows and Mac operating systems, they're actually shortcuts to folders buried much deeper in the folder structure. Droplets aren't ideal for huge numbers of photos, but if you find it's cutting out too early, you could try exporting to a root level folder to keep that string as short as possible.

In my droplet I used a 'Save for Web' instead of a standard 'Save As'—why won't it overwrite the original file?

Save for Web isn't a standard Photoshop save—it's an Export Action, so any overrides such as Save Location in the Create Droplet dialog won't have any effect. If you want to use Save for Web, set your droplet to Save

for Web as part of the action, sending to a standard location (maybe a 'Droplet' folder on your desktop), don't put any other Save As in the action, and set the Droplet Destination to None. You'll have to delete the files created by the Lightroom export once the action has completed, as they won't have been overwritten by your Save for Web photos, but all of the Save for Web photos will appear in your 'Droplets' folder.

EMAILING PHOTOS

In previous versions, the ability to email photos directly from Lightroom depended on a number of plug-ins or post-processing actions. Lightroom 4 introduced simplified email, making it possible to email photos directly from Lightroom using an SMTP server or via your own desktop email software.

How do I email my photos from Lightroom via my desktop email software?

If you use a desktop mail client, Lightroom can pass the photos over, and the email will be sent using your usual client. On Windows, most email clients are supported, using standard Windows APIs to pass the images. That includes Windows Live Mail, Thunderbird, Eudora, Microsoft Outlook, etc. On Mac, only Apple Mail, Microsoft Outlook, Microsoft Entourage and Eudora are supported, as each has to be coded separately.

When you're ready to send your first email from Lightroom, select the photos and go to File menu > Email Photos. When you try to email through Lightroom, it will first check whether your default email client is supported. If it is, you'll be taken directly to the Email dialog and your email software will automatically be selected in the From pop-up.

When you select your email software, you don't need to fill in any of the other fields—just ensure that you've selected your chosen preset in the lower left corner so that Lightroom resizes the photos correctly,

and then you can enter the rest of the email details and message in your email client.

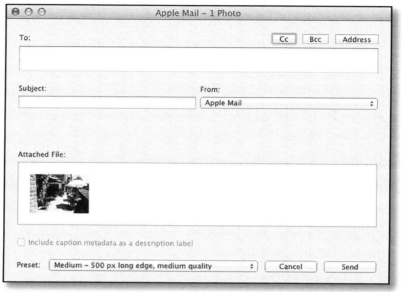

How do I set up my email account within Lightroom?

If your email client isn't supported, or you don't use an email client, you'll need to set up your email account within Lightroom. In the New Account dialog, select your email Service Provider—AOL, Gmail, Windows Live Hotmail or Yahoo Mail. Enter a name for the account to help you identify it, and enter your email address and password. Press OK and select your

new account in the From pop-up, and you'll be ready to send your first email.

If you use a different email host, other than the ones listed, it takes you through a slightly roundabout route! Select 'Go to Account Manager to set up other account' from the Service Provider pop-up, and then press the Add button in the Email Account Manager dialog and enter an account name

to identify the account. In the Service Provider pop-up, select Other. Pressing OK will return you to the Email Account Manager dialog, where you can enter the rest of your email SMTP server settings. If you're not sure which details to enter, skip on to the next question. Once you've finished entering the details, you can press Validate to confirm that you've set up the account correctly. It will then appear in the From pop-up in the main Email dialog, ready for use.

You're not limited to a single email account. The Email Account Manager is always accessible via the From pop-up, and you can use the Add button to add multiple email accounts, which will all be listed in that From pop-up.

What SMTP settings do I need for my email host?

Many popular email service providers are listed in the New Account pop-up, including AOL, Gmail (includes Google Apps), Windows Live Hotmail and Yahoo Mail, or you can select Other and set an account up manually.

I've added Me.com settings to the chart below, as it's a popular service and the SMTP details are not easy to track down. You'll note a pattern to the settings below, so if your email address ends in, for example, yahoo.

co.uk, try swapping the .com for .co.uk in the Yahoo Mail settings. If you use another email host, you may need to ask their tech support for your SMTP settings.

	SMTP Server	SMTP Port	Security	Authentication
AOL	smtp.aol.com	587	STARTTLS	Password
Gmail/Google Apps	smtp.googlemail.com	465	SSL/TLS	Password
Gmail/Google Apps (alternative)	smtp.googlemail.com	587	STARTTLS	Password
Me.com	smtp.me.com	587	STARTTLS	Password
Windows Live Hotmail	smtp.live.com	587	STARTTLS	Password
Yahoo Mail	smtp.mail.yahoo.com	465	SSL/TLS	Password
Note your settings here				

How do I email my photos from Lightroom directly?

Once your email setup is complete, you're ready to email your photos. If the Email dialog is not already showing, select the photos and go to File menu > Email Photos. You'll also find it in the right-click menu, or under the shortcut Ctrl-Shift-M (Windows) / Cmd-Shift-M (Mac).

In the From pop-up, select your email account, which you've already set up in the previous questions. Enter the address of the recipient, a subject for your email, and the message to include with your photos. Select the size of photos from the Preset pop-up in the lower left corner of the dialog, and finally press Send.

If you want to send an email to multiple email addresses, separate them with a ; and a space.

How do I select which email address to send from?

If you have multiple email accounts set up in Lightroom's Email Account Manager, they'll be listed in the From email address pop-up in the main Email dialog, and you can select the account you want to use.

How do I set the size of the photos I want to email?

In the bottom left corner of the Email dialog is the Preset pop-up. Lightroom comes with 4 email presets by default, with different sizes and JPEG quality settings. They are: 300px low quality, 500px medium quality, 800px high quality, and full resolution very high quality.

Bear in mind the overall email size, if you're sending lots of photos, or you're sending a few full resolution photos. Many email accounts have a 10mb-per-email limit, both for sending and receiving email, although Gmail has increased this to 25mb. A few full resolution photos can quickly reach that limit and cause the email to bounce. If you need to send many photos to the same person, consider creating a web gallery

or uploading them to a photo sharing site such as Flickr instead. If you're sending more than one or two full resolution photos, or original raw files, exporting them to a Dropbox folder (http://www.lrq.me/dropbox) and emailing a download link may be more efficient for both you and the email recipient, and avoid clogging their email inbox.

Can I save a custom Email preset including extra settings, such as a watermark or a different file format?

If you'd like to specify your own Export settings for the photos, perhaps including a watermark, or a different sharpening setting, you can do so from the Export dialog. If you're viewing the Email dialog, selecting Create New Preset from the Preset pop-up in the bottom left corner will take you directly to that dialog. If you're already viewing the Export dialog, at the top is an Export To pop-up which usually says Hard Drive, but changing it to Email allows you to create and edit Email presets instead. We'll come back to saving Export presets in more detail a little later in the chapter.

Can I access my main email address book?

Lightroom allows you to save email addresses in a Lightroom address book, which is saved with your other Lightroom presets, but the direct mail facility can't access your main email address book. If you use a supported desktop mail client, however, Lightroom will pass the photos over to that software, and you'll be able to send emails as normal, including using your email address book.

Also check...

"Can I save my Export settings as a preset?" on page 531

How do I use Lightroom's address book?

To use Lightroom's address book, press the Address button in the Email dialog.

To save a new address, press the New Address button and enter the details. The new address will then be listed in the main Address Book. If

you regularly send emails to the same group of people—perhaps family members—you may want to create a group of their email addresses for easy access. In the Address Book dialog, press New Group and click to put a checkmark against their email addresses in the left column. Press the >> button to send them to the group, shown in the right column. Give your group a name and press OK. Your group will then be listed in the Address Book dialog.

To use saved addresses in your email, press the Address button to return to the Address Book dialog and put a checkmark next to the individual or group, and their email addresses will automatically be added to the To field. For individuals, rather than returning to the Address Book dialog, you can simply start to type the name of the recipient or the beginning of the email address in the To, CC or BCC fields, and it will autofill. The autofill doesn't work for group names.

Why doesn't it have space for me to type an email message?

If you have Lightroom set to pass the photos to your default desktop mail client, you'll be able to write your email in that software. Lightroom only shows the message body field when using the direct email facilities.

Will a copy of my sent email appear in my normal email program?

If you send through Lightroom directly, saving the sent email will depend on the email host. Some, for example, Gmail/Google Apps, automatically keep all outgoing as well as incoming emails, whether they're sent via SMTP or directly through webmail. Most other hosts do not keep all email, but pressing the BCC button in the Email dialog and typing your own email address would send the email to your own inbox, as well as the primary recipient's inbox.

If you send through your default email client, the sent email storage will depend on the preferences for that software—if it usually saves your sent emails, it will continue to do so for emails initiated by Lightroom.

Why does it say my email information is incomplete?

If you try to send an email without completing and validating your SMTP details, it may show an error message. Select Email Account Manager in the From pop-up in the Email dialog and finish entering your server details.

PLUG-INS

Plug-ins allow third-party developers to add additional functionality to Lightroom. They're written in Lua, and the SDK (Software Development Kit) is freely available from: http://www.lrq.me/sdkdownload

What plug-ins are currently available?

There is a wide variety of plug-ins now available, and not all are confined to Export. Below are some of the most popular, and my personal favorites.

Links for these plug-ins can be found at http://www.lrq.me/links/plugins and I'll keep that page updated with new plug-ins as I hear about them.

Adobe have provided a number of plug-ins:

- Adobe Revel, previously known as Carousel, upload plug-in ships with Lightroom.

- Photoshop.com gallery upload plug-in is available from the Lightroom exchange.

- Flickr & Facebook basic plug-ins (more advanced versions are available from Jeffrey Friedl).

Jeffrey Friedl is the most prolific plug-writer, with plug-ins such as:

- Zenfolio, SmugMug, Flickr, Picasa Web, Facebook and Twitter uploads.

- Metadata Presets—allows you to arrange the Metadata panel in the order that suits you best.

- Metadata Wrangler—choose which metadata to strip or include.

- Focal-length Sort & Megapixel Sort—adds additional options to the Metadata Filter bar.

- Geocoding Support—expands on the geocoding tools offered by the Map module.

- PhotoSafe—prevents you from accidentally removing selected photos from your catalog.

- and much more besides.

Timothy Armes has written numerous Lightroom plug-ins:

- LR/Mogrify—borders & copyright watermarks, etc.

- LR/Enfuse—blending multiple exposures, creating HDR-type photos.

- LR/Transporter—imports, modifies and exports metadata from text files.

- LR/TreeExporter—exports files in your folder hierarchy.

- LR/Blog—export directly to your blog.

John Beardsworth has joined in too, with my favorites being:

- Open Directly—opens an original file directly into other software.
- Search Replace Transfer—designed for bulk changes to text in Metadata Panel fields, which can even be used for complex renaming.
- Syncomatic—allows you to sync metadata between files with matching names but different extensions, and also between VC's and their Masters.
- CaptureTimeToEXIF—adds an Exiftool interface, allowing you to assign capture dates to scanned photos.
- ListView—shows your catalog as a list of metadata instead of thumbnails.

Matt Dawson has been busy with plug-ins including:

- TPG Elemental—adds extra Edit in Photoshop Elements options, such as Merge to Panorama and Merge to HDR.
- TPG LR Backup—quickly backs up all of your presets.
- TPG Snapshotter—makes snapshots out of virtual copies, which can then be written to XMP.

Vladimir Vinogradsky has written the Lightroom Voyager plug-in, for transferring Publish Services between catalogs, as well as plug-ins for integrating many print labs and online galleries.

If you're searching for duplicate photos that you've imported into your catalog, try the Duplicate Finder plug-in by Jim Keir.

The Any File plug-in, by John Ellis, allows you to import unsupported file formats, such as support material for shoots. His Any Filter and Any Tag plug-ins are also worth a look.

For the geekier reader, Rob Cole has written many complex plug-ins which offer access to the deepest depths of Lightroom's catalog, although the documentation and testing is limited, so I don't recommend them for less experienced users.

The list of plug-ins is growing all the time—a simple Google search will bring up many new options. The official Lightroom Exchange is a great place to find all sorts of new plug-ins, presets and other goodies: http://www.lrq.me/lightroomexchange

How do I install Lightroom plug-ins?

Having downloaded the plug-in of your choice, you need to install it. If the plug-in has a .zip extension, double-click to unzip it, and store it somewhere safe. Then to install it, go to File menu > Plug-in Manager to show the Plug-in Manager dialog. Click on the Add button in the lower-left corner, and navigate to the '.lrplugin' or '.lrdevplugin' folder for the plug-in you would like to install. On Windows, you need to select the folder, rather than its contents, whereas .lrplugin files are a single package file on Mac.

Where should I store my plug-ins?

It's a good idea to keep all of your plug-ins in one place, to make them easy to find, update, transfer, back up or delete. Creating a Plug-ins folder alongside the other presets folders would be an ideal place, and

Also check...

*"The default location
of the Presets is…"
on page 656*

you can find that folder easily by going to Preferences dialog > Presets tab and clicking the Show Lightroom Presets Folder button.

Why can't I remove this Lightroom plug-in?

To remove any plug-ins that you've installed by means of the Add button, simply select the plug-in in the Plug-in Manager dialog and press the Remove button. That Remove button isn't available for plug-ins stored in Lightroom's own Modules folder, such as the Tether plug-ins, in case you want to reinstall them later.

How do I use Lightroom plug-ins?

Once you've installed the plug-in, it's ready to use. The way you access it depends on the individual plug-in, but each developer should provide instructions.

Some plug-ins that export directly to a different destination, such as the built-in Adobe Revel plug-in, show in the pop-up menu at the top of the Export dialog, which usually says Hard Drive. They may also create their own panels in the Export dialog.

Some, such as LR/Mogrify and Metadata Wrangler, appear in the Post-Process Actions section of the Export dialog, below the Export Presets. From there, you can choose which options you want to make available for your current export, for example, on LR/Mogrify, a single border. The plug-in panels that you choose then appear beneath the normal export panels.

Certain other Export Plug-ins, such as LR/Transporter have a menu listing under the

File menu or Library menu in the Plug-in Extras section instead (yes, there are 2 different menus with the same name!), and many of the plug-ins store additional information under those menus too.

Can I export directly to an FTP server?

If you download the plug-in SDK (Software Development Kit), there's a sample plug-in for uploading to a FTP server. It's not as complicated as it sounds—just go to http://www.lrq.me/sdkdownload and download the SDK zip, unzip it, and look in the Sample Plug-ins folder. There should be a folder called 'ftp_upload.lrdevplugin' which you can install using the instructions on the previous pages.

If that sounds too complicated, Tim Armes built a combined FTP export and Publish Service plug-in called FTP Publisher, which is available from http://www.lrq.me/armes-ftppublisher

OTHER EXPORT QUESTIONS & TROUBLESHOOTING

Having chosen all of your settings in the Export dialog, you can save them as a preset for easy access next time.

Can I save my Export settings as a preset?

A few Export presets are already included by default, but it's useful to save your own settings for easy access. Set up your Export options, and then press the Add button in the Presets panel of the Export dialog to save the settings for future use. As with other presets, you can organize them into folders for easy access, and update them when your settings change. You might choose to create presets

for regular exports, such as email, blog, printing at a lab, archiving full resolution, and so forth.

Do I have to use the Export dialog every time I export?

If you've set up Export presets, you can easily access these through File menu > Export with Preset, or through the right-click context-sensitive menu for any photo.

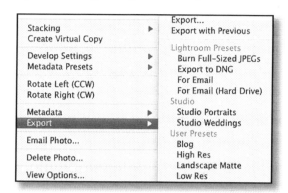

Why can't CS2 save as JPEG when I've used Local Adjustments on the photo?

If you edit a file in Lightroom using the Gradient tool or Adjustment Brush, open that file in Photoshop CS2, and then try to save it as a JPEG, Photoshop will show an error message which says 'Could not complete your request because of a program error.' Why?

Ok, it's a bug... but it's not a Lightroom bug. Photoshop CS2 trips up on some perfectly legitimate metadata that Lightroom saves into the files when you've used local adjustments. CS3 and later behave correctly with this metadata, but CS2 is no longer updated and so the bug will never be fixed. So what can you do about it? You have a few options:

Upgrade to the current Photoshop release version.

Select the 'All Except Camera & Camera Raw Info' option in the Metadata section of the Export dialog. It solves the problem, but removes additional camera information which you may want to keep.

Use Jeffrey's Metadata Wrangler to strip just the problem metadata from the file, which is by far the best option.

To use Jeffrey's Metadata Wrangler Export plug-in, you'll first need to download it and install the plug-in from:

http://www.lrq.me/friedl-metadatawrangler

Select the plug-in in the lower left of the Export dialog, and you'll see the additional section appear in the main Export options panel—scroll down if you can't see them.

The only part you need to remove is the 'crs' block marked in red—all of the rest of the metadata can stay. The 'crs' block is the Camera Raw Settings metadata, better known as the Develop settings, and photos exported with that block removed will quite happily save as a JPEG, even with Photoshop CS2.

It gives an error message—'Some export operations were not performed. The file could not be written.' or 'The file could not be found.' What went wrong?

If Lightroom says it couldn't export the files, press the Show in Library button to view an Error Photos temporary collection, so you can see the photos in question.

If the error says 'The file could not be found,' then some of the selected photos are missing because you've moved or renamed them with other software, or the drive is offline. Click on the question mark on the thumbnail and locate the original file, and run the export again.

Also check...

"Lightroom thinks my photos are missing—how do I fix it?" on page 240

If the error says 'The file could not be written,' check the permissions on the export folder or parents of that folder, because they're probably read-only, or you're running out of disc space on that drive.

The files appear in the export folder and then disappear again. Why is Lightroom deleting them?

If the files seem to appear in the Export folder and then immediately disappear again, it's because Lightroom isn't able to write to that folder.

The most likely reason is that you've run out of hard drive space, or are at least running very low. Try exporting to another hard drive or clearing some space, perhaps emptying the Recycle Bin (Windows) / Trash (Mac).

Why are my adjustments not being applied to my exported file?

If you choose Original as the File Format in the Export dialog, you'll create a duplicate of the original file, without your Develop settings applied. The file size may be slightly different as Lightroom will update the metadata, unlike an operating system duplication, but it won't re-compress the image data, so the quality won't be reduced.

How can I tell whether a photo has been exported?

When you export a photo, the date and time is added as a History state, so you can switch to the Develop module History panel to see a record of your exports.

Publish Services

Publish Services is another way of sharing your photos. You could consider it a 'managed export'—it keeps tracks of the photos exported to specific locations, and when you update those photos within Lightroom, it offers you the opportunity to update them at their exported location too. Depending on the service used, some updates, such as comments made on websites, can also be transferred back to your catalog.

GETTING STARTED WITH PUBLISH SERVICES

To get started with Publish Services, look at the Publish Services panel in the Library module. By default, you'll see 3 Publish Services—Hard Drive, Facebook and Flickr. There may also be others, depending on the plug-ins you've installed, but those 3 plug-ins ship with Lightroom.

Where's my favorite photo sharing website?

The built-in Flickr and Facebook plug-ins are just a starting point—a sample to show what can be done with Publish Services. Flickr was chosen because it's the most popular photo sharing website among Lightroom users, it has a good range of features and a stable API (Application Programming Interface) to build on. Facebook, on the other hand, change their API on a regular basis, making that plug-in a little less

Also check...

"What plug-ins are currently available?" on page 526

predictable. The SmugMug plug-in no longer ships with Lightroom 4, as it's easier for SmugMug to release updates from their own website.

Third-party developers, such as Jeffrey Friedl, have built much more robust versions of Publish Services plug-ins, with many additional features and more regular updates. If you find you are using the built-in Flickr and Facebook plug-ins, it would be worth considering upgrading to Jeffrey's versions which can be downloaded as donationware from http://www.lrq.me/friedl-plugins

Third-party developers have also created Publish Service plug-ins for many other popular photo sharing websites, including Zenfolio, SmugMug and Picasa. Each of the services will have slightly different limitations, dependent on the photo sharing website facilities and API, but the basic setup will be the same as the Flickr integration. As I find new Publish Service plug-ins, I'll continue to add their links to http://www.lrq.me/links/plugins

What can I use the Hard Drive option for?

The Hard Drive facility isn't the primary purpose for Publish Services, but it has its uses. You can set up a Hard Drive Publish collection and export some photos to a folder on your hard drive. Any further changes you make to those photos within your catalog will be tracked, allowing you to selectively export only the photos that have changed or are not yet published, without re-exporting the whole set.

For example, maybe you like to keep photos on your iPad, so you could have an iPad collection which updates the photos in a folder ready to be transferred by iTunes next time you sync your iPad.

Perhaps you like to have your screensaver showing your latest photos, so a smart collection sending your last month's photos to your screensaver folder would be useful.

If you're using album design software, it's also a convenient way of making changes to the individual photos in Lightroom, and then being able to keep the exported versions updated in the album design.

SETTING UP YOUR PUBLISH SERVICE ACCOUNTS

The basic principles of Publish Services setup are the same regardless of which service you're using—some just offer additional features. Most of the options will be familiar from the Export dialog, which we covered in the previous chapter, so in this section we'll just explore the options that are specific to Publish Services.

How do I set up my Flickr or Facebook Publish Services account?

Click on the Flickr or Facebook Set Up button to show the Lightroom Publishing Manager dialog.

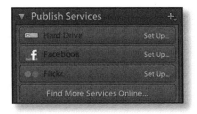

Give your account a name and then press the Log In or Authorize on Facebook button and it will ask you to authorize access to that account.

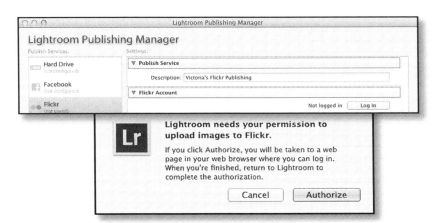

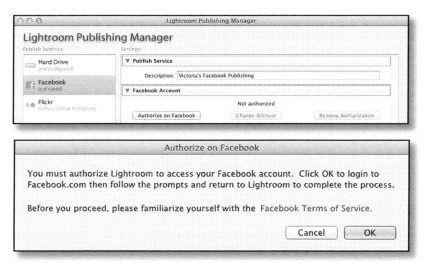

When you press Authorize, it will open Flickr or Facebook's website, and you'll need to log in using your normal account details. You'll then be asked to confirm that you want to allow Lightroom access to your Flickr or Facebook account. If you've previously authorized Lightroom access, it may skip the authorization page.

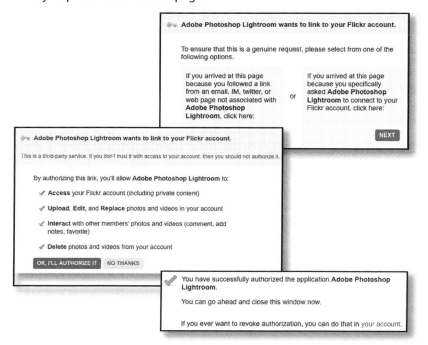

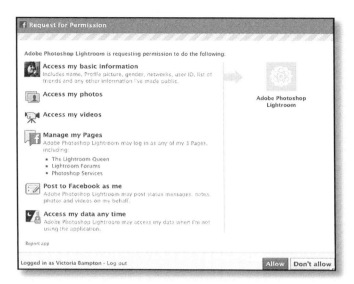

Switch back to Lightroom and press Done.

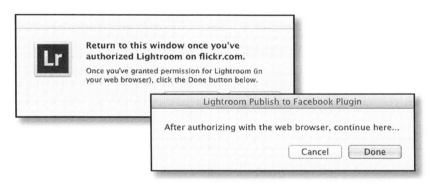

Once Lightroom has been granted permission, you can start setting up your normal export preferences.

On either service, you can determine the photo titles in addition to file naming. The title shown on the website can be the Filename or the IPTC Title metadata, or you can leave it blank and it will use the website's default setting.

Some of the other Export options differ, depending on the chosen website.

Also check...

"Export Locations & File Naming" section starting on page 487

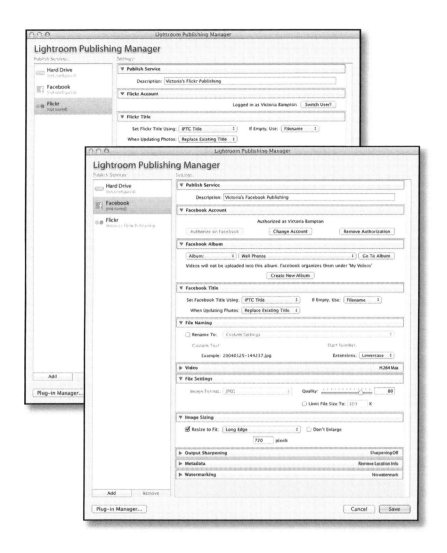

On Facebook, by default Lightroom uploads to the Wall Photos album, but you can select a different default album if you prefer, or create a new one from within Lightroom. To do so, go to the Facebook Album section, and press the

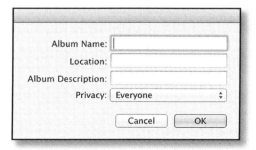

Create New Album button. You can then choose the name and privacy settings for your new album. The album pop-ups may disappear briefly, but when they reappear you'll be able to select your new album.

On Flickr, by default Lightroom uploads to Photostream. You can create photosets later, in the same way that you create normal collections. We'll come back to that in the next section.

Once you've finished with your preferences, press Save and you'll be ready to start setting up your Publish Collections. We'll set those up in the next section.

Can I choose the size of the photos to upload?

The Publishing Manager dialog gives you all of the controls that would usually be available in the Export dialog, including image sizing, sharpening and watermarking. If you need to upload different sizes, for example, in a Hard Drive Publish Service, you'll need to set up 2 separate Publish Services connections as the settings are per-connection. They can both link to the same online account, or the same hard drive folder.

How do I prevent it uploading a particular version of a photo?

Only add photos that you want to upload to your service, or if there's a particular version you would like to upload, use a virtual copy. You might have created a black & white version but only want to upload your color version, or perhaps there's a specific caption you'd like to use on the uploaded photo.

How do I control which keywords are visible on my published photos?

If you go to the Keyword List panel and right-click on the keyword, you can uncheck the Include on Export checkbox in the Edit Keyword dialog. Doing so will exclude that keyword from all exports. It's particularly useful when you've used keywords such as 'Place' or 'Subject' to group

Also check...

"Snapshots & Virtual Copies" section starting on page 417

Also check...

"Keywording" section
starting on page 204

similar keywords in a hierarchy, but they have no meaning in their own right.

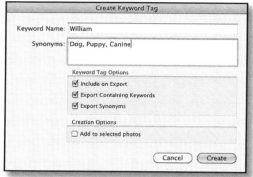

You may also want to exclude a specific keyword for a particular destination, for example, you'd prefer not to publish the name of a person on the web, but you wish to include it in your own exports. To do so, either use a virtual copy without that keyword applied, or select Copyright & Contact Information in the Metadata section of the Publishing Manager dialog to strip most of the metadata from all of the photos you're uploading.

If you want to be more selective about which metadata you strip, you could use Jeffrey's Metadata Wrangler plug-in to remove the keywords, while including other metadata of your choice.

http://www.lrq.me/friedl-metadatawrangler

Which settings should I use for Flickr's Privacy & Safety?

At the end of the Lightroom Publishing Manager dialog for Flickr is the Privacy & Safety section. Privacy controls who can view your photos, so they can be set to Public to be visible to everyone or limited to your friends and family. Safety controls Flickr's own content filters, rating the photos as safe for anyone to view through to restricted which are unsuitable for some age groups, just like movie parental guidance ratings.

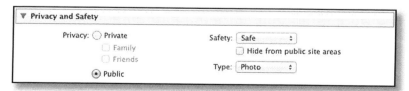

Can I have more than one account for each service connected to my catalog?

To connect multiple Flickr or Facebook accounts to the same catalog, right-click on its Publish Service, select Create Another * Connection, and go back and set it up as an additional account in the Publishing Manager dialog. You can also connect the same account to the same catalog multiple times, perhaps to use different upload settings for specific groups of photos.

Can I have the same account connected to multiple catalogs?

You can have the same Flickr or Facebook account connected to multiple catalogs, but there are limitations. You can't easily transfer your collections/photosets between catalogs, even using Export as Catalog, and Lightroom won't know about anything that's already on the website or in your other catalog.

How do I disconnect Lightroom from my account?

If you want to disconnect a Publish Service from your Flickr or Facebook account, right-click on it and choose Delete. Nothing will be deleted from Flickr or Facebook by doing this, but Lightroom will no longer have a record of which photos were uploaded, so if you decide to reconnect your account in the future, you would have to set up those collections again.

CREATING COLLECTIONS, PHOTOSETS & ALBUMS

You're not limited to putting photos directly into the Photostream for Flickr, Wall Photos album for Facebook, or a single folder for Hard Drive. You can organize your photos into collections, creating photosets for Flickr, albums for Facebook, or a hierarchy of folders and subfolders for the Hard Drive.

 Also check...

"Should I use one big catalog, or multiple smaller catalogs?" on page 279 and "Can I use Export as Catalog to transfer my Publish collections between catalogs?" on page 550

Can I divide my photos into different collections?

The Flickr Photostream will automatically appear in the Flickr section of the Publish Services panel when you create a Flickr connection. You can add photos to that collection as if it was a standard collection. You can also right-click to create another collection, only here they're called photosets to match with Flickr's name. You're not limited to standard collections—you can also use smart collections which will become additional photosets on Flickr.

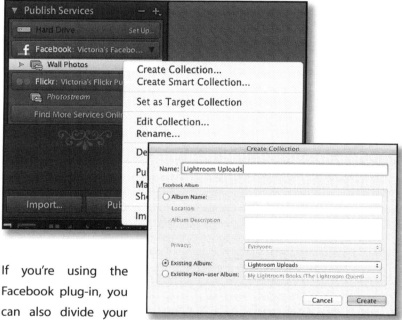

If you're using the Facebook plug-in, you can also divide your photos into collections by right-clicking on your existing Facebook collection and choosing Create Collection. Those collections become albums on Facebook.

Also check...

"Collections" section starting on page 183

How do I add photos into a photoset that already exists on Flickr?

If you create photosets within your Flickr Publish Service in Lightroom, and name them using precisely the same name as your photoset on

Flickr, photos in those collections in Lightroom will get added to the corresponding photoset on Flickr.

How do I add photos into an album that already exists on Facebook?

If you right-click on a collection within your Facebook Publish Service in Lightroom, you can choose Create Collection from the context-sensitive menu. That dialog gives you the option of creating a new album, or using an album which already exists at Facebook. If you're using an existing album, I would recommend giving it the same name within Lightroom, otherwise it can easily get confusing.

SYNCHRONIZING CHANGES

Once you've set up your Publish Service, chosen your photos, and grouped them, you're then ready to synchronize that with the other service, whether that's a website or a hard drive location.

How do I publish my photos?

Once you've created your collections, click on each and press Publish below. If you want to publish multiple collections in one go, Ctrl-click (Windows) / Cmd-click (Mac) or Shift-click on the collections to select them all before pressing Publish. The photos will start to upload which, depending on the dimensions chosen and your internet connection upload speed, could take a while!

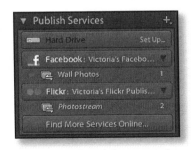

If you only want to limit your upload to specific photos temporarily, select them and then hold down the Alt (Windows) / Opt (Mac) key and the Publish button at the bottom of the left hand panel will change into a Publish Selected button.

Does it automatically publish changes I make to my photos?

Lightroom waits for you to click on the collection and choose Publish, rather than automatically uploading, otherwise it would be constantly uploading every time you made a change to a photo.

How do I update my service with the changes I've made to my photos?

When you come back to one of those collections later, having made changes to the photos, Lightroom will have divided it into different sections—New photos to publish, Deleted photos to remove, Modified photos to republish and Published photos. To update your service with your changes, right-click on the collection and choose Publish Now or press the Publish button below. To update multiple collections in one go, click on the first collection and hold down shift while clicking on the last collection to select them all, before pressing the Publish button below.

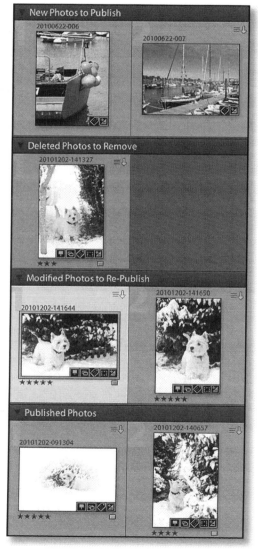

The Facebook Publish Service is unable to update existing photos due to Facebook's API. If you republish photos to Facebook, it will simply upload a new one and leave you to delete the old one in your web browser. Comments and likes can't be transferred to the updated photo either.

How do I mark photos as already published, so they don't upload again?

If you make a change to a photo, such as changing some metadata, it will be moved to the Modified Photos to Re-Publish section. If you don't want to republish them, perhaps because the change was minor or you're using a free account that would lose your comments, you can right-click on the photo and choose Mark as Up-To-Date to move it back into the Published Photos section.

How do I remove photos from the service?

Facebook doesn't allow you to remove photos using other programs. You could delete it on the website, and then delete it from Lightroom's published collection too. It's just a limitation of Facebook's API.

Flickr will allow you to remove photos by removing them from the collection within Lightroom and then pressing Publish.

How do I remove photos from my Lightroom catalog without removing them from the website?

If you remove a photo from your catalog or from your computer, but you want it left on Flickr or other websites (excluding Facebook), don't press Publish again, because it will also be removed from there. It doesn't work the other way round, so you can safely delete photos from your service without them being deleted from your catalog.

I didn't mean to remove a photo from a collection—how do I restore it?

If you accidentally remove a photo from a collection, just drag it back again. If you haven't run a Publish, nothing will change on the service (Flickr/Facebook, etc.) and it will move back into the Published photos section. If the photo has been deleted from the service, it will be uploaded again.

I deleted a photo on the web interface—how do I upload it again?

If you delete a photo on the Flickr or Facebook website, Lightroom won't know, and it will remain in Lightroom's Published Photos section. If you want to upload it again, right-click on the photo and choose Mark to Republish and when you next select Publish, that photo will be re-uploaded.

What happens if I rename a photo and then republish it?

If you rename a photo in Lightroom and then click Publish, the Flickr Free account will ignore the change of name, but the Flickr Pro account will update the existing Flickr photo to show its new name. Facebook can only upload it as a new photo.

FLICKR ACCOUNT QUESTIONS

Although the following questions refer specifically to Flickr accounts, many of the principles will also apply to other photo sharing websites.

What are the limitations of the Free vs. Pro Flickr accounts?

The limitations of a free Flickr account are listed on their website here: http://www.lrq.me/flickrlimits

As far as Lightroom's integration is concerned, the Free account can republish photos, but in doing so it removes the previous one and uploads a new one, so any links referring to the original photo are broken and changes made on the web interface are lost.

The Pro account is able to replace photos in place, without breaking the links to the Flickr page, although the links to the image files themselves do get broken as a result of limitations in the Flickr API.

I've switched to a Flickr Pro account—how do I tell Lightroom?

Lightroom only checks whether you have a Pro or Free account when you set up the Publish Service in Flickr. If you start out with a Free account, and then later decide to upgrade to a Pro account, you'll need to revoke the permissions and re-establish the connection again.

Open the Your Account page on the Flickr website, go to the Extending Flickr tab, and click on Edit. You'll see Lightroom in the list of Account Links. Click Edit at the end of that line, then Remove Permission on the following page, and finally confirm that you're revoking Lightroom's permissions. Switch back to Lightroom, right-click on the Flickr connection to go to the Publishing Manager dialog and click Log In to go through the Authorization steps again, as if you were setting the account up for the first time. Re-establishing the connection in this way should not affect any your photosets or uploads, whereas deleting and recreating the connection would break the links.

What does 'Flickr API returned an error message (function upload, message Not a Pro Account)' mean?

The Free account is more limited than a Pro account, and any error messages that say 'Not a Pro Account' are a result of trying to use a facility that isn't available with the Free account. For example, trying to upload a video which is longer than the 90 second Free account limit can cause such error messages. To avoid those limitations, you can upgrade to a Pro account.

PUBLISH SERVICES TROUBLESHOOTING

And of course, no chapter would be complete without a few hiccups that can occur along the way!

I accidentally revoked the authorization on the Flickr or Facebook website—how do I fix it?

If you accidentally revoke the authorization on the Flickr or Facebook website, right-clicking and choosing Edit Settings will take you to the Publishing Manager dialog, where you can log in and re-authorize Lightroom's access.

Can I use Export as Catalog to transfer my Publish collections between catalogs?

Publish collections are tied to one specific catalog, and aren't carried over when using Export as Catalog, unlike normal collections, so be careful to set it up in your master catalog rather than a temporary catalog.

There is a plug-in which can transfer Publish Services information between catalogs, although it does have limitations and some parts need to be done manually. You can find more information about the Lightroom Voyager plug-in at http://www.lrq.me/alloy-lrvoyager

Why is the Comments panel unavailable?

The Comments panel is designed to work with the Publish Services, synchronizing comments with supported photo sharing services, so it's only available when you have a Publish collection selected. If someone comments on one of your photos on the Facebook or Flickr website, those comments will be retrieved when you next publish that collection. There isn't currently an easy way of finding out which photos have comments.

 Also check...

"How does Export as Catalog work?" on page 305

Book Module

The Book module, as its name suggests, assists you in creating photo books without the need for external software. Using a template-based system and drag-and-drop interface, you can create a beautiful book complete with text, and then easily upload it to Blurb for printing. Blurb are a well known photobook company who print and ship high quality books to photographers worldwide.

The first time you switch to the Book module, Lightroom takes the photos from your current view and creates a book using Auto Layout. That gives you opportunity to explore—try moving photos, adding text, changing page templates and generally become acquainted with the Book module before starting on your first book project.

One quick hint, before you start—select a small folder or collection before switching to the Book module for the first time, otherwise it will try to create a book using all of the photos in the current view.

THE BOOK WORKSPACE

Before we go any further, let's familiarize ourselves with the workspace, especially the different sections of each page, as clicking in different parts of the page results in different behavior.

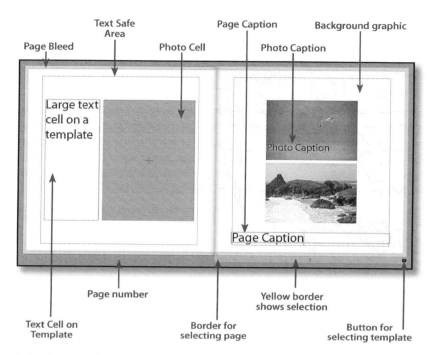

Text Safe Area | Page Caption | Background graphic

Page Bleed | Photo Cell | Photo Caption

Large text cell on a template

Photo Caption

Page Caption

Page number | Yellow border shows selection

Text Cell on Template | Border for selecting page | Button for selecting template

Selections in the Book module are marked in bright orange, so when you select a page, it shows an orange border. Clicking on the border area below the page, or on the page number itself, are the easiest ways of selecting a page without accidentally changing the page contents. We'll come back to the meaning of the other sections in the following pages.

How I do zoom in on book pages?

When Lightroom first switches to the Book module, it's in Multi-Page view. This is like the Library module Grid view, complete with the thumbnail size slider on the toolbar. If you slide the thumbnail slider to its maximum, the spreads fill the preview area, giving a very fluid workspace with a scroll bar on the right. You can return to Multi-Page view at any time by using the shortcut Ctrl-E (Windows) / Cmd-E (Mac) or pressing the button at the left end of the toolbar. If you can't see the toolbar, press T.

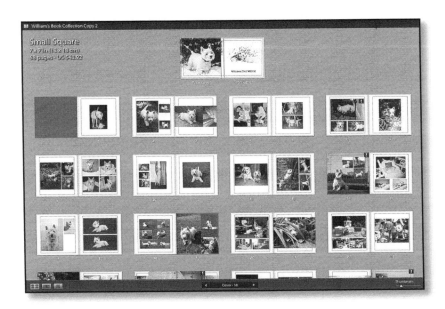

On the toolbar are two additional view modes. Spread view shows the spread filling the preview area, just like the maximum size thumbnails, but rather than a scrollbar, it uses the buttons on the toolbar to move from one page to the next. Ctrl-R (Windows) / Cmd-R (Mac) will switch back to the Spread view from another book view.

Single Page view is particularly useful when working with text, as the zoom options allow you to zoom in closer. You'll find the zoom options on the top of the Preview panel, just as they'd be on the Navigator panel in Library module. Ctrl-T (Windows) / Cmd-T (Mac) switches to the Single Page view and Ctrl-U / Cmd-U zooms in, since the standard Z or spacebar shortcuts would interfere with text entry.

You can also use the keyboard shortcuts Ctrl-left arrow and Ctrl-right arrow (Windows) / Cmd-left arrow and Cmd-right arrow (Mac) to move through the spreads/pages when viewing Spread or Single Page view.

What is Page Bleed?

Page bleed is marked as transparent grey on the preview when it's turned on in the Guides panel. It shows the area that is expected to be trimmed off when the book is printed, but allows a little flexibility when printing, in case something isn't lined up perfectly. If your photo is intended to stretch to the edge of the page, make sure it also covers the bleed area, but remember not to include any important elements in that

area as they will be trimmed off. You'll only see the page bleed when you're set to Blurb—not the PDF option.

What is Text Safe Area?

The Text Safe Area is marked with a thin grey line when it's turned on in the Guides panel. It's possible to put text outside of those lines, by going to Book menu > Book Preferences and unchecking 'Constrain captions to Text Safe Area,' however your text may get cut off when printing and trimming the book, so it's sensible to keep it within the Text Safe Area.

Why are there numbers on the photos in the Filmstrip?

When you've used a photo in your book, a marker appears on the photo in the Filmstrip to identify which photos have already been used and also how many times they've been used in the selected book.

Working with Pages & Templates

Having explored the workspace it's time to begin designing your book. The Book module uses a template based system, into which you drag and drop photos. We'll consider how to use the pages and templates first, before going on to add photos, text and decoration.

Also check...

"Collections" section
starting on page 183

How do I start a clean book?

Once you're ready to start designing your own book, you may want to clear Lightroom's first attempt. You can either select the Clear Book button at the top of the preview area, or the Clear Layout button in the Auto Layout panel.

You'll then need to select some photos to use in your book. You can find the photos as you go along, but it's usually quicker to group the photos in a collection before you start to design the book, so switch back to the Library module and create a collection of photos before continuing.

Having chosen your photos, you're then ready to start designing your book.

How do I select a book size and type?

One of the first decisions you need to make is the size of book that you're going to design. You can change this later, but Lightroom would have to reflow the photos and layout to fit, which may result in the design of your book changing.

At the top of the right panel group in the Book module is the Book Settings panel. This is where you choose to create a Blurb book, or a standard PDF for other uses. The most important thing to select is the size. By default those options are small square, standard portrait, standard landscape, large square, or large landscape. The other options can more easily be adjusted later.

How do I add a new page?

Having cleared your book, you can add a new page using the Page panel on the right. Click the small arrow and the Page Template Picker will

appear. It shows all of the templates available for your chosen book size. They're grouped into different sets, so you don't have to scroll through all of the available templates each time. Select a template set and scroll through its templates in the lower half of the Page Template Picker. Once you've found a page template that you like, click on it to add the page to your book.

To add more pages, repeat the process, but ensure that you don't have an existing page selected when you go to the Page panel, as clicking on a template would change the existing page rather than add a new one.

What's the difference between Add Page and Add Blank Page?

Also in the Page panel are two buttons–Add Page and Add Blank Page.

Add Page adds a new page using the template shown above the button, whereas Add Blank Page obviously adds a blank one. If you add blank pages, you can go back and apply your choice of template later.

How many pages can I have in my book?

Blurb books can have a maximum of 240 pages, with as many photos are you like on those pages. PDF books don't have a limit, although the larger the book, the longer it will take to render.

How do I put multiple photos on a page, or create a double-page spread?

When you're scrolling through the available templates in the Page Template Picker, you'll notice that you're not limited to a single photo per page. There are templates available with 1, 2, 3, 4, or even more cells per page. You'll also see some two-page spreads, allowing you to stretch a photo—perhaps a panoramic photo—across two facing pages.

What's the difference between the grey cells and the white ones with grey lines?

The grey cells in the Page Template Picker are for photos, whereas the white ones with grey lines are text cells. Once the template has been applied to a page, the grey lines in the text cells disappear and are replaced with Filler Text.

What's the difference between the Clean, Creative, Portfolio, Travel & Wedding sets?

The Clean, Creative, Portfolio, Travel and Wedding sets of templates are simply slightly different themes, but they can be mixed and matched. For example, the Clean templates have straight edges around the photos and no text, whereas the Creative templates offer textured borders around the photos. The same templates are also available within the numbered page template sets.

Clean

Creative

How do I select a page without moving its contents?

If you add a page, and later decide to change the template or move the page, you'll need to select it. If you click the wrong spot on the page, you can accidentally move a photo or text. The easiest way of accurately selecting the page is to select the border or number just below the page. Once the page is selected, it's surrounded by an orange border.

How do I change the template for an existing page?

Having selected the page, you'll see a small black arrow in the bottom right corner of the orange page border. This brings up the same Page Template Picker you used earlier. From there, or from the Page panel, you can select a new template and any photos on the page will try to auto flow into the new design. If you need to change multiple pages, you can select them and the template you choose will be applied to all of the selected pages. Shift-clicking selects consecutive pages, or Ctrl-clicking (Windows) / Cmd-clicking (Mac) selects non-consecutive pages.

How do I rearrange the page order?

To rearrange the page order, simply drag and drop in the Multi-Page view, just as you would rearrange thumbnails in the Library module Grid view. Select the page by clicking in the border and drag it to its new position. The pages will separate slightly showing where you can drop the page and a vertical line appears showing where it will land.

How do I insert a page between existing pages?

If you want to insert a page between existing pages, the easiest option is to add a new page anywhere and drag it into position. Alternatively, you can select an existing page and then press the New Page button to insert it to the right of the existing selected page.

How do I delete pages?

Deleting pages isn't quite so obvious, as the Delete key removes the photo from the page, not the page itself. If you right-click on the page or page border, however, there is a Remove Page option in the context-sensitive menu. If multiple pages are selected, they'll all be deleted.

Why can't I delete the last page?

At the beginning and end of the book you'll see darker grey pages, which are the inside of the front and back covers. You can't print on the insides of the cover, and you definitely can't delete them.

Can I duplicate a page? Or can I copy the layout from a previous page?

Having arranged a layout that you particularly like, perhaps including additional padding, which we'll come to later in the chapter, you may want to duplicate the page layout for use on another page, rather than

setting it up manually again. If you select the page, you will find Copy Layout and Paste Layout under the Edit menu, and also in the right-click context-sensitive menu. Copy Layout followed by Paste Layout will create a duplicate of the page without the photos or text, ready to reuse.

Can I change the size of the photo or text cells?

The Book module uses a template based system, so you can't enlarge or move the existing cells. You can, however, use cell padding to shrink the cells. Select a template with a larger cell than you need, and then increase the padding in the Cell panel to reduce the size of the photo within the cell. The disclosure triangle hides additional sliders, which allow you to set the left, right, top and bottom to different values.

Can I link opposite cell padding sliders, to move multiple sliders in one go?

The individual padding sliders have white squares next to them by default. When a square is white, it means the sliders are linked, and will move at the same time. You can click on the squares to link or unlink sliders, so you may link the left and right sliders to move them in tandem, without moving the top and bottom sliders, or vice versa.

Can I create custom templates?

Adobe are expected to release a Book Template SDK for developers, although it's not available at 4.0's release. Once that's released, it will be possible for developers to create custom page sizes and templates for use in Lightroom 4.

FAVORITE TEMPLATES

Having explored the Page Template Picker, you may already have some favorite templates which you would usually use. Rather than having to scroll through all of the templates to find them again, you can mark them as favorites.

How do I create a favorite template?

In the Page Template Picker, right-click on the template and select Add to Favorites. If you've already used a template in your book, click on the arrow in the page border and you'll see that your page template is already selected in the Page Template Picker, so you don't have to search

through all of the templates to find it. Two-page spreads (or double-page spreads) can't be added to favorites, but they're already separated into a small group of their own, so they're easy to find.

How do I remove a template from my favorites?

To remove a template from your favorites, find it in the Page Template Picker and right click on it to select Remove from Favorites.

How do I reuse my favorite templates?

Once you've selected some favorite templates, you'll find them grouped together in the Favorites set in the Page Template Picker. They're also used in the Auto Layout, which we'll investigate next.

AUTO LAYOUT

Auto Layout is a quick way of turning your photos into a book, and it's often a great starting point for your design, rather than adding one page

at a time. You can create a preset defining which page templates Auto Layout is allowed to use, and Lightroom takes all of the photos from the Filmstrip and automatically builds a book using those templates.

How do I use Auto Layout?

Using Auto Layout is simple—select a built-in preset in the Auto Layout panel, or select Edit to create your own. Once you're happy with your chosen preset, press the Auto Layout button. Lightroom will use the templates included in the preset to add pages and fill them with the photos in the Filmstrip. If you've already added empty pages with templates, Lightroom will fill those empty cells with photos from the Filmstrip instead.

How do I create my own Auto Layout preset?

Lightroom ships with a few Auto Layout presets, however you can also create your own to suit your personal tastes. Go to the Auto Layout panel and select the Preset pop-up. At the bottom is an Edit option which shows the Auto Layout Preset Editor dialog. This is where you select your Auto Layout preferences.

The options are replicated for both sides, so you can apply one template to the left pages and a different template to the right pages. For example, you may choose to have a single large photo filling the right page, and a mix of different sized photos on the left pages.

Also check...

"Saving Presets in Pop-Up Menus" on page 166

Either side can be left blank, use a fixed template selected within the Auto Layout Preset Editor, or use random templates from your favorite templates.

There are further options for selecting default fit/fill zoom settings and adding text captions, which we'll explain further on the following pages.

Having chosen your Auto Layout options, you can save it as a preset using the pop-up at the top of the dialog, ready to run.

What does 'Match Long Edges' do?

If you've selected Zoom Photos to Fit in the Auto Layout Preset Editor, the photos will be placed in the cell without cropping, rather than filling the cell. That means you could end up with different aspect ratios on the same page, and that mixture of sizes can look untidy, so Match Long Edges sets the photo zoom to line up mixed ratio photos.

Match Long Edge unchecked

Match Long Edge checked

How do I control which metadata is used for Photo Captions when using Auto Layout?

When you enable Add Photo Captions in the Auto Layout Preset Editor

Also check...

"Why doesn't selecting the 'Title-Sans Serif' preset fill in the photo Title metadata?"
on page 581

dialog, the content of the text captions is controlled by the Book menu > Book Preferences > Fill text boxes with setting. If that's set to Filler Text, instead of Title or Caption, the text cells will be added but left blank. If you want the metadata to be selected automatically, select Title or Caption in that preferences dialog.

Why does Auto Layout say I don't have any favorites?

If you've selected Random from Favorites at the top of the Auto Layout Preset Editor, you need to have selected some favorite templates using the instructions in the previous section.

If, when you press the Auto Layout button, it shows an error saying it doesn't have any favorites, it's likely

because the favorites you selected were not for the same size and shape book. Alternatively, you may have checked 1, 2, 3 and 4 photos in the Auto Layout Preset Editor dialog, but only have favorite templates with 1 and 4 photos, for example.

Why isn't Auto Layout doing anything?

If all of the photos in the Filmstrip already appear in your book, there's nothing for Auto Layout to do.

If you've manually filled your book, Auto Layout will add any leftover photos, filling any leftover cells with unused photos and adding additional pages at the end if needed.

WORKING WITH PHOTOS

Having learned the basics of pages and templates, it's time to start manually adding and editing photos in your photo book.

How do I add a photo to a page?

Adding photos to your pages is a simple drag and drop operation. You must have a template on the page, ready to receive the photo. You can either drag the photo from the Filmstrip at the bottom of the screen or use the secondary window set to Grid view and drag from there, dropping it into a photo cell on a page.

Also check...

"Auto Layout" section starting on page 563

How do I add all of the visible photos to my book in one go?

If you want to add all of the photos to your book in one go, the quickest way is to use Auto Layout, which we discussed in the previous section. Even if you've already added pages and templates, Auto Layout will fill them for you.

How do I rearrange or swap the photos?

Once you've added your photos to a page, you can replace them by dragging other photos up from the Filmstrip, or you can drag the photos between cells in the book and the photos will swap between the target and source cell.

How do I zoom into a photo?

When you click on a photo in a cell, a zoom slider will appear, allowing you to zoom in and hide parts of the photo. The zoom goes from small enough to fit the photo entirely within the cell without cropping, to 2x the length of the longest cell edge, which is enough for most situations. If you want to zoom in further, or you want a specific ratio for your photo, switch back to Develop module to crop accurately and then adjust the photo on the page.

If the photo doesn't fill the cell, how do I adjust the position?

If you've zoomed in on a photo or it's set to fill the cell automatically,

Also check...

"Can I link opposite cell padding sliders, to move multiple sliders in one go?" on page 562

you can click on the photo and drag it around within the cell to get the positioning just right.

You can also adjust the size and shape of the cell using the Padding sliders in the Cell panel, as we mentioned in an earlier question.

If I've changed the zoom, how do I change it back to Fill automatically?

If you've been experimenting with the zoom slider, but want to automatically fill the cell, right-click on the photo and select Zoom Photo To Fit Cell from the context-sensitive menu.

Can I set it to automatically fit the photos to the cells, rather than filling the cell?

If you find that you always adjust the photos to fit within the cell without cropping, rather than filling the cell, you can change the default setting.

If you look under the Book menu > Book Preferences, you will find a few book specific options, including the Default Photo Zoom options. When you use Auto Layout, there's a matching preference in the Auto Layout Preset Editor dialog.

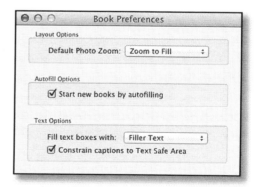

How do I remove a photos?

To remove a photo from a page, you can either drag it to another page, select it and press the Delete key on your keyboard, or right-click on the

photo and select Remove Photo from the context-sensitive menu. You can select multiple cells by Ctrl-clicking (Windows) / Cmd-clicking on them, to delete the photos from multiple cells in one go.

If you want to remove all of the photos from the pages, go to Edit menu > Select All Photo Cells or press Ctrl-Alt-Shift-A (Windows) / Cmd-Opt-Shift-A (Mac). You can then press the Delete key on your keyboard to remove the contexts.

Also check...

"How do I add a photo as a page background?" on page 571

How can I tell which photos I've used so far?

In the Filmstrip, you will note that each of the photos that you've used has a black marker with a number. The number shows the number of times you've used the photo within the book. The front and back cover photos are marked with 2 by default, as they're used both on the cover and within the body of the book when the book autofills. If you've used photos as backgrounds, that will also increase the use count.

Can I filter to see which photos are currently used in my book?

In the Filmstrip Filter bar, you'll find presets for Used and Unused filters, which will hide the applicable photos. Showing only the unused photos can help to see which photos you've missed from your book design.

Do I have to fill all of the cells on the page?

Although the Book module is template-based, which is slightly more limited than a free-form design, you don't have to fill all of the available cells. This allows you additional flexibility when designing your book.

What does the exclamation mark on the photo mean?

If you see a black exclamation mark on the photo, it's warning you that the photo will be low resolution at that size and therefore may not print well. If you click on the exclamation mark, it shows the resolution so you can adjust accordingly. Zooming out, increasing the cell padding to make photo smaller, or moving that photo to a smaller cell may help if you don't have a higher resolution version of the photo.

A red exclamation mark shows that the photo is offline, and if you try to export the book to PDF or Blurb, that photo will be missing.

When I've finished designing the book, can I go back and apply further Develop changes?

Having finished designing the book, you may find that some photos need further adjustment to make them look their best on the page together. That's not a problem—just switch back to the Develop module and adjust the photos as normal, and the changes will be reflected in your book.

PAGE STYLES & SETTINGS

Once you've added photos to your book, it may be time to start thinking about other page decoration. At the bottom of the right panel group is the Background panel, which allows you to change the background color or graphic, either on a single page or globally.

How do I change the background color of my pages?

To change the page color, check the Background Color checkbox in the Background panel and click in the box to its right to show the color picker. By default it's set to shades of grey, however if you want a colored

background, click on the bar on the right of the color picker and the full range of colors will become available. As in the Develop module, if you click on the color picker and drag the eyedropper onto the photo, it will select colors from beneath the eyedropper automatically.

How do I add a photo as a page background?

You're not limited to only using colors as your page backgrounds. You can also use photos, textures or other graphics as the page backgrounds. There are some graphics built into Lightroom, such as map images for travel photography and some gentle swirls intended for weddings. As with the background color, you can also select the color of the background graphic by clicking the box to the right of the Graphic checkbox.

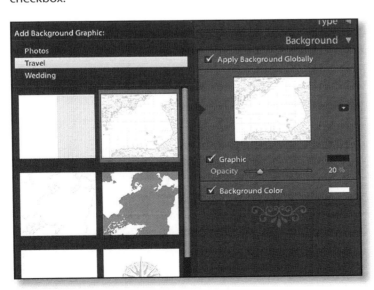

You can also use your own photos by dragging and dropping them onto the background graphic selector in the Background panel and reducing the opacity. You can also download textures from the web, for example, paper textures, and use those as backgrounds. If you click on the arrow to the right of the background graphics selector, you can see all of the built-in graphics and the photos you've added as backgrounds.

ADDING TEXT TO YOUR BOOK

You're not limited to solely having photos in your photobook. Many photographers like to add text captions, describing the photos. You can go even further, adding lengths of text, telling a whole story. Lightroom offers 3 different options for adding text—template text cells, photo captions and page captions.

What's the difference between Page Caption, Photo Caption and text cells on page templates?

The text cells built into the templates are in a fixed position, although you can use padding to position the text within the text cell. They're ideal for longer paragraphs of text, and there's a template which is purely for text.

Photo Captions are aligned to the photo or photo cell. They can be above, below, or overlaid on top of the photo, and you can move them up and down using the offset slider. If the photo

doesn't fill the cell, the 'Align With Photo' checkbox offsets the text from the edge of the photo instead of the edge of the cell.

Page Captions span the full width of the page and move up and down using the offset slider. Combining a page caption with cell padding allows you to put text anywhere on the page.

How do I add text to a page?

If you're using a page template with existing text cells, you can simply click in the cell and start typing.

If you'd prefer to use a Photo Caption or Page Caption, there are checkboxes in the Caption panel. You can select the alignment and offset from the photo, and then click in the cell to start typing your caption.

Once you've added your text, you can format the text using your choice of style. We'll come back to those options in the next section.

How do I automatically enter text based on metadata?

If you right-click on text cell, you can select Auto Text from the context-sensitive menu. You can choose either Title or Caption. These take existing metadata from the photo itself, which you entered in the Metadata panel in the Library module.

If you're adding custom text to your photos in the Book module, it's worth considering adding it to the metadata of the photo if it's not already there, and using the Auto Text options. Custom text entered directly in the Book module may get wiped if you change the page format or move the photo, whereas metadata is stored with the photo itself.

Also check...

"Viewing & Editing Metadata" section starting on page 201

Can I add use other metadata apart from Title or Caption?

Lightroom 4.0 only offers Title or Caption as the metadata based captions. If you want to use other metadata, such as the filename, you can copy it to the Title or Caption field. If you need to do that on a large number of photos, the Search Replace Transfer (http://www.lrq.me/beardsworth-searchreplace) or LR/Transporter (http://www.lrq.me/armes-lrtransporter) plug-ins will automate the process.

Why is the text field not updating when I change the related photo?

If you've used Auto Text, and then you click in the cell, it automatically becomes a custom text cell, but leaves the previous text there ready for you to edit. If you then change the related photo, the custom text remains there instead of automatically updating. You can right-click on the text cell to reselect an Auto Text option.

I've changed the metadata—how do I update the text in the book to match?

If you edit the metadata in the Metadata panel, Lightroom won't immediately update the book text captions to match, otherwise you could unintentionally change the content of your book. To update the book with the new metadata, go to Book menu > Update Metadata Based Captions.

How do I change the default text?

If you select Book menu > Book Preferences, you can choose to automatically fill new text cells with Title,

Caption, or Filler Text for Custom text fields, depending on which you use most.

How do I remove text captions?

To remove text, select the cell by clicking on it and press the Delete key on your keyboard. You can select multiple cells by Ctrl-clicking (Windows) / Cmd-clicking on them, to delete the text from multiple cells in one go.

If you want to remove all of the text from the book, go to Edit menu > Select All Text Cells or press Ctrl-Alt-A (Windows) / Cmd-Opt-A (Mac) to select all of the text cells and then press the Delete key on your keyboard.

Can Lightroom check my spelling?

On the Mac version, there is a spellcheck available under the Edit menu, which utilizes the OS X built-in dictionary, however at the time of writing, it doesn't work in the Book module. This feature is not available on Windows. If you're typing a long section of text, it may be worth typing in a text editor and then pasting into Lightroom, to ensure that you make any needed spelling corrections before printing.

Can I zoom in closer to read the text?

Trying to read a block of text can be difficult if it's too small, however on the Preview panel there are zoom ratios up to 4:1, which make it much easier to read. The keyboard shortcut Ctrl-U (Windows) / Cmd-U (Mac) is the quickest way of switching to the Zoomed Page view. To move around the page when zoomed in, either drag

the rectangle in the Preview panel or hold down the Spacebar to access the hand tool to drag the page itself.

How do I remove the placeholder text?

By default, Lightroom shows 'Photo Title' or lorem ipsum placeholder text for longer text cells. When you click in a text cell, that placeholder text will disappear. If you want to hide it on all pages in one go, uncheck the Filler Text checkbox in the Guides panel.

How do I see where the text cells are?

If you've hidden the Filler Text, it can be difficult to spot the text cells. If you float the mouse over the page, the grey cell borders will appear.

How do I position the text on the page?

Like the photo cells, you can adjust the text position within the cell using the Padding sliders in the Cell panel. The white squares to the left of the sliders show that the sliders are linked and will all move by the same amount, but unchecking Link All below the sliders will separate them.

What's the red square marker with a cross in the middle?

If there's a red marker on the bottom right corner of a text cell, it's an overset text warning showing that there's too much text for the cell to contain. To fix it, you could reduce the font size, reduce the padding to make the cell larger, or you can simply remove some of the text.

Also check...

"Can I link opposite cell padding sliders, to move multiple sliders in one go?"
on page 562

TEXT FORMATTING

Your text captions are not limited to a standard sans-serif font. In the Type panel, there are extensive text formatting tools taken from industry

standard software, such as Photoshop, Illustrator and InDesign.

How do I change the font and size?

Having selected the text, or placed the cursor in an empty text cell, go to the Type panel. From there, you can choose from the fonts installed on your system, and adjust the font size, opacity, color and alignment of the text, as well as more advanced text formatting tools.

How do I change the text color?

Next to the Character label is a color picker which allows you to select the color of the font. It defaults to shades of grey, however you can access the full range of colors by clicking on the bar on the right of the color picker.

I'm adjusting Type sliders—why is nothing changing?

If there's existing text in a cell, you need to select the text before adjusting the sliders and other settings.

How do I adjust the line height?

Hiding behind the disclosure triangle in the Type panel are some advanced text options, and one of those options—Leading—is the equivalent of line height in programs such as Microsoft Word. If the text is bunched up because the leading value is too low, you can also use the Auto Leading button instead of adjusting it manually.

Leading too low *Leading better*

What are Tracking, Baseline, Leading and Kerning?

Tracking is the space between multiple characters (l i k e _ t h i s).

Baseline shift moves characters off their normal baseline. The baseline is the line most letters sit on, although some letters such as 'y' hang below the baseline. You may use it for situations such as the 'TH' in 6TH MARCH 2012.

Leading, which is pronounced like heading, is the space between lines, also known as the line height.

Kerning is the space between pairs of characters, for example, V and A are moved closed together as a standard gap would look unnaturally large. Most fonts handle kerning automatically, so you don't usually need to worry about it, however important text on a cover may benefit from a manual kerning adjustment. To adjust the kerning, you place the cursor between 2 characters and adjust the slider.

How do I use the Text Targeted Adjustment Tool?

Like the Develop module, the Book module has a Targeted Adjustment Tool, this time for adjusting text. It's an easy way of visually adjusting the text without having to understand or remember each of the slider names. The adjustments are relative to the existing settings, so if the selected text is two different sizes, it will change both by a relative amount.

To use it, select the text you want to adjust. Select the TAT from the Type panel—it's the small circle with a dot in it—and then click on the text or cursor and drag in the applicable direction.

- Dragging horizontally over a selection adjusts text size.
- Dragging vertically over a selection adjusts leading or line height.

- Holding down Ctrl (Windows) / Cmd (Mac) while dragging horizontally over a selection adjusts tracking.

- Holding down Ctrl (Windows) / Cmd (Mac) while dragging vertically over a selection adjusts baseline shift.

- Dragging horizontally over the insertion cursor adjusts kerning.

- Holding down Alt (Windows) / Opt (Mac) temporarily deactivates the TAT tool so you can change your text selection. This only applies if you're trying to change a selection in an area that's already selected.

When you're finished, hitting the Escape key exits the TAT tool.

How do I adjust the horizontal and vertical alignment?

At the bottom of the Type panel are the text alignment buttons, for left, center, and right alignment, as well as various text justification options and vertical alignment too. They're a little easier to miss, as they're not as bright as most of Lightroom's other buttons.

What is the gutter?

You can split your text into columns using the Columns slider in the Type panel. The gutter slider only comes into effect when you have more than one column of text, as the gutter is the space between the columns.

Lorem ipsum dolor sit amet, consectetur adipisicing elit, sed do eiusmod tempor incididunt ut labore et dolore magna aliqua. Ut enim ad minim veniam, quis nostrud exercitation ullamco laboris nisi ut aliquip ex ea commodo consequat. Duis aute irure dolor in reprehenderit in voluptate velit esse cillum dolore eu fugiat nulla pariatur. Excepteur sint occaecat cupidatat non proident, sunt in culpa qui officia deserunt mollit anim id est laborum. Lorem ipsum dolor sit amet, consectetur adipisicing elit,

sed do eiusmod tempor incididunt ut labore et dolore magna aliqua. Ut enim ad minim veniam, quis nostrud exercitation ullamco laboris nisi ut aliquip ex ea commodo consequat. Duis aute irure dolor in reprehenderit in voluptate velit esse cillum dolore eu fugiat nulla pariatur. Excepteur sint occaecat cupidatat non proident, sunt in culpa qui officia deserunt mollit anim id est laborum.

How do I change the text style on multiple text cells?

To change the text style on multiple cells at the same time, go to Edit menu > Select All Text Cells, or if you only want to change specific cells,

hold down Ctrl (Windows) / Cmd (Mac) while clicking to select them. You can then apply a Text Style preset or adjust the settings in the Type panel, and all of the selected cells will be updated.

The settings are sticky, so any new cells you create will inherit the settings of the previously selected cell.

Can I save my text style to apply to other cells?

At the top of the Type panel is a Text Style Preset pop-up. This allows you to save your text settings as a preset for use on other cells or even other

books. Set your text style settings and then select Save Current Settings as New Preset from the pop-up menu. When you select text in another cell, you can then select the preset to apply all of your style settings.

Why doesn't selecting the 'Title-Sans Serif' preset fill in the photo Title metadata?

In the Type panel, you'll find Text Style Presets with names like 'title-sans serif' and 'caption-wedding.' Those names are slightly misleading, as they're only the names of the presets, and nothing to do with the Title and Caption metadata fields and Auto Text.

DESIGNING THE COVER

We all tend to judge a book by its cover, so it's important to get the cover just right. As with page templates, there are also cover templates offering a number of different styles. You change them in exactly the same way as you change a page template.

Also check...

"Saving Presets in Pop-Up Menus" on page 166

Also check...

"How do I control which metadata is used for Photo Captions when using Auto Layout?" on page 565

Also check...

*"How do I change
the background
color of my pages?"
on page 570*

How do I add spine text?

The cover templates automatically have a spine text cell ready for you to add text to the spine of the book, so you can click in the cell and type as normal. If you leave it empty the spine will be blank, which can be useful for thin books which would have a very narrow spine.

How do I change the spine or cover color?

The cover background color is controlled from the Background panel, in the same way as the page backgrounds. If the cover is set to the default template, which has photos covering the front and back covers, adjusting the background color will only affect the spine color.

How do I wrap a photo around the cover, including across the spine?

One of the available templates wraps a panoramic photo right around the cover, and it also has full sized text fields which would allow you to place text anywhere on the front or back cover.

SAVING BOOKS

Having spent time and effort on designing your book, you'll no doubt want to save it! Considering the amount of time involved, I'd recommend saving your work at an early stage, perhaps even before starting on your design.

How do I save my book?

To save your work for the first time, either click the Create Saved Book button at the top of the preview area, or press the + button on the Collections panel to select it from the panel menu. In the Create Book dialog, you can choose to save the book within an existing collection or set, or at the top level of the Collections panel, or place it within an existing collection or set. Grouping your books within collections or sets keeps them organized so you can easily find them later.

If you haven't used all of the photos shown in the Filmstrip, it will also give you the option to 'include only used photos.' If you're concerned that you may later edit one of the photos, making it look out of place in the book, you can also 'make new virtual copies' which will be saved with the book. Marking those virtual copies with a color label would help to remind you not to change them.

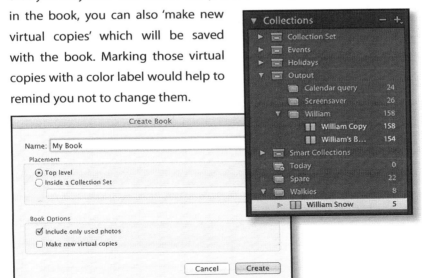

Also check...

"Collections" section starting on page 183

If you've already given your work a name, it will appear at the top of the preview area. Any changes you make to that book will automatically be saved in the background from that time on, so you don't need to worry about saving your work again.

What's the difference between a saved book and an unsaved book?

When you enter the Book module, unless you've first selected an existing book from the Collections panel, you'll be viewing an unsaved book. You'll see the header bar above the preview area has Unsaved Book listed as the book name. That's like a scratchpad, where you can play around with things without saving them. The Filmstrip in Unsaved Book shows all photos used in the book so far, plus the photos from the currently selected folder or collection.

When you want to keep something you've created, you save it as a book. It will then show up as a separate item in the Collections panel, with a book icon to identify the module. Once the book is saved, the photos in the Filmstrip are only those stored with the book, although you can add additional photos by dragging them into that book collection.

When you start designing a proper book, rather just playing around, I would recommend saving the book before you start the design.

Also check...

"How are Books, Slideshows, Prints and Web Galleries different to standard collections?" on page 184

How do I edit my saved book?

Once you've given your book a name, you'll find it listed in the Collections panel. You can return to it at any time by double-clicking on the name if you're in the Library, Develop or Map modules, or by single-clicking on the name if you're in one of the other output modules.

How do I create a snapshot of my book, in case I make changes and want to go back to a previous version?

Anything you do to a book will be automatically saved within a few seconds. If you make a change and then decide you don't like it, Ctrl-Z (Windows) / Cmd-Z (Mac) will undo the changes, however if you've closed Lightroom, that edit history will be gone. If you want to try something different, right-click on the book in the Collections panel and select Duplicate Book. This new copy will appear in the Collections panel as a separate book, so you can experiment with different variations. Once you've created a book version that you're happy with, you can delete the other copies of the book.

How do I save my book layout as a template for use on other photos?

Unlike the Slideshow, Print and Web Modules, the Book module doesn't have a concept of Templates. In most cases, you'll add page templates from your favorites, selecting the best one for the photos. If, however, you do want to reuse a particular book design, it is possible. Go to the Collections panel and right-click on the book that you wish to use as a template. Select Duplicate Book from the context-sensitive menu and then, with your new book selected, switch back to Grid mode and delete the photos from that collection. All of the photos will be removed from the new book, leaving you with just the page layout, ready for you to insert other photos.

EXPORTING & PRINTING BOOKS

Having finished designing your perfect book, it's time for everyone else to see it. Your book can be exported as a PDF file or uploaded directly to Blurb for printing as a high quality photo book.

Also check...

"Can I create custom templates?" on page 562

Who are Blurb?

Blurb are a well-known book printing company, who ship to countries all over the world. You can explore their website at http://www.blurb.com

Why are other vendors not available for printing books?

The Blurb integration is just a starting point, with potential to add other vendors in the future. Focusing on one initial supplier meant that Adobe could create a fully integrated system, complete with the ability to select papers and covers directly from Lightroom, and get the sizing and sharpening just right. Blurb is based in San Francisco, not far from Adobe's headquarters in San Jose, which meant that they could easily do extensive testing to make sure the quality was going to be acceptable. Blurb already have an excellent reputation for creating high quality photo books for photographers worldwide.

Just because Blurb are currently the only integrated service, however, doesn't mean that they're the only company who can print your book. The PDF output allows you to send your photo book to any other companies who accept PDF files, although that option will be a little more limited until you can create custom sized pages.

Can I view a soft proof of my Blurb book?

Blurb do provide a profile for soft-proofing, however it's a CMYK profile and Lightroom is RGB only. Blurb use a number of different printers/presses and different papers, and for accuracy you'd need different profiles for each printer/paper combination. Lightroom sends sRGB data to Blurb, so if you want to soft-proof the photos for your book, use the sRGB profile in the Develop module soft-proofing.

Also check...

"Soft-Proofing" section starting on page 397

How do I save my book as a PDF?

Whether you've designed the book as a Blurb book or as a PDF, you can export your book to PDF format. This allows you to check the Blurb proof

more carefully, send a copy to someone else to view, show people on your computer or tablet PC, and even send the book to an alternative photo book printer.

To save your blurb book as a PDF proof, use the Export to PDF button at the bottom of the left panel group. If your book was originally designed for PDF, the Export Book to PDF button is at the bottom of the right panel group.

What's the difference between a PDF and a Blurb PDF?

The main purpose of the Blurb PDF is to give you a proof copy of your book before you send it off, so it is exactly the same file that will be sent to Blurb. The Blurb PDF includes the logo page if you have that turned on, and it uses the output settings, such as output sharpening, that will be used when sending to Blurb. A standard PDF gives you additional control, such as the resolution and sharpening.

What quality, color profile, resolution and sharpening settings should I select for my PDF book?

In the Book Settings panel, where you select the PDF option, there are extra preferences to set. If you're exporting a standard PDF, your chosen settings will depend on whether the PDF is for screen or print use. If you're planning to e-mail the PDF or view it solely on a computer screen, you may use a much lower quality setting, sRGB color profile and 72 PPI resolution. If the book is going to be printed by another printer, you may need to check the settings for that specific company. As a guide, a

high-quality setting, 200 to 300 PPI resolution and sRGB profile are often used for print.

How do I select quality, color profile, resolution and sharpening for a Blurb book?

If you're exporting a Blurb book, you don't need to worry about the quality, color profile, resolution or sharpening settings, as Adobe have done extensive testing and selected the best output settings for Blurb's presses. Sharpening is set to standard glossy behind-the-scenes.

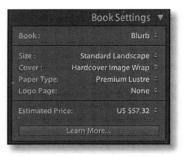

Which cover style and paper should I select?

You can see the different cover styles and paper options by visiting http://www.lrq.me/blurboptions and clicking on the different options.

The cover is available in Hardcover (Dust Jacket) or Hardcover (ImageWrap), and in some sizes, it's also available with a Softcover.

- Softcover has a laminated glossy finish, like many paperback books, and is only available for the Small or Standard sized books.
- Hardcover, Dust Jacket has a plain black linen cover with a laminated glossy dust jacket and front and back flaps
- Hardcover, ImageWrap has a durable matte printed hard cover sealed directly onto the book

There are 3 different grades of paper available from Blurb through Lightroom—Premium Lustre, ProLine Uncoated and ProLine Pearl Photo.

- Premium Lustre is 148gsm coated paper with a lustre finish, which is a slightly glossier coating than a standard Matte finish.

- ProLine Uncoated is 148gsm uncoated paper with an eggshell-textured finish.

- ProLine Pearl Photo is 190gsm paper, which is slightly heavier and glossier than the Premium Lustre.

How much will my Blurb book cost?

In the Book Settings panel, the cost is calculated according to the size of book, number of pages, and other settings selected. In that pop-up, you can select your chosen currency. The price shown doesn't include local sales taxes or shipping costs—those will be confirmed before you check out. You can also check Blurb's pricing by visiting their website pricing page at http://www.lrq.com/blurbprice

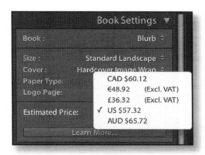

What is the Logo Page?

In a Blurb book, with the logo page turned on, look at the last page. It has the Blurb logo on it and the price is discounted if you leave it there. It is possible to remove the logo page by changing it in the Book Settings panel, however the price will increase accordingly.

How do I send my book to Blurb?

Once you've finished designing your book and you're ready to order, the first thing to do is export the book to PDF as a proof. You may spot a mistake! To do so, press the Export Book to PDF button at the bottom of the left panel group. Having confirmed that there aren't any mistakes, you can start the order process by pressing the Send Book to Blurb button at the bottom of the right panel group.

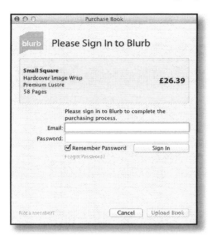

The Purchase Book dialog will ask for your Blurb.com login details. If you don't already have an account, click the Not a Member link in the bottom left corner to sign up. Otherwise, go ahead and sign in to your account.

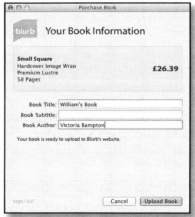

The next dialog will ask you to assign a Title and Author to the book, to help identify it. It will then start rendering the book before uploading. That process may take some time, depending on your computer speed and internet connection. You can watch the progress in the Activity Viewer.

It then switches to your default web browser, where you can preview the book, edit paper and end sheet settings, and finalize your order.

Slideshow Module

The Slideshow module isn't designed to replace specialized slideshow software, so it does have some limitations, but it's a great way of showing your photos to friends, family and clients. If they're sat next to you, the slideshow can run directly within Lightroom with background music to set the atmosphere, or you can export your slideshow to PDF or movie format to share with others. If you prefer to use other slideshow software, to set different transitions and timings for each slide, you can still use Lightroom's slide design tools to create beautiful slides and then export them to JPEG format.

STYLES & SETTINGS

Lightroom's slideshows aren't limited to just showing the photo full screen. You can design the slides with background images and tints, add borders and drop shadows to lift the photos off the screen, and include metadata describing the photos.

How do I create my first slideshow?

Lightroom comes with a few templates to get you started. As you hover the mouse over the templates in the Template Browser panel, the Preview panel above will show you a small preview of that template, so find one you like and click on it.

The 'Default' template is a good starting point, but you might like to customize it further, so start exploring the panels on the right. With the default black background, a white stroke around the edge of the photo can help to lift it, so go to the Options panel and click to show the Color Picker for the Stroke Border setting. If you find the margin guides distracting, you can turn them off by unchecking Show Guides in the Layout panel.

At the bottom of the right hand panel are the Preview and Play buttons, which allow you to check your slideshow. Preview shows you the slideshow within the normal content preview area, whereas Play will show it full screen. To go back to the slide editing mode at any time, just press Escape on your keyboard.

If you're going to show your slideshow to other people, it's wise to do a full dry run first, to make sure that your previews are fully rendered and everything behaves as you expect.

How do I add my Identity Plate to my slideshow?

Your Identity Plate is tucked away in the corner of that Default template, but if you click on it, you can resize or move it, or switch to a different one using the Overlays panel. It's a great way of personalizing your slideshow, adding your name or logo, but it doesn't have to stay in that corner. You might like to place it below the photo in the center, in which case you'll probably need to adjust the bottom margin by dragging that guideline or changing the Bottom slider in the Layout panel. If all of the guidelines

move at the same time, uncheck the Link All checkbox in the Overlays panel.

Also check...

"Module Picker, Identity Plate and Activity Viewer" on page 144

How do I adjust the anchor point?

As you move the Identity Plate around on the slide, you'll see a small fly-out anchor point which snaps to the corners and edges of the photo or screen. That locks the relative position of the Identity Plate, and it also works on the text overlays that we'll consider next. If you want the Identity Plate below the photo in the center, pick up the anchor point and drag it to the bottom center of the screen, rather than the photo, so that it doesn't jump around as you go through each slide. If you'd prefer to use it as a signature, lock it to the bottom right corner of the photo instead. You can check how it will look on other photos by clicking on them in the Filmstrip or using the left/right arrow keys. It's worth testing both horizontal and vertical photos to see whether your layout will work well with both orientations.

How do I add captions to the slides?

If you press the ABC button on the toolbar, you can add text captions to the slides. The Custom Text option, which is selected by default, only

Also check...

"Using Tokens in Dialogs" on page 167

creates a static line of text which is the same on each slide. If you'd like to add a different caption to each slide, perhaps telling the story behind each photo, you first need to add the caption for each photo in the Metadata panel in the Library module. To show that caption in the slideshow, press the ABC button on the toolbar to create a new field or click on an existing text field to edit it, but this time choose Caption from the pop-up menu. That will only show text on photos which have a caption in the metadata, and others will be blank.

You're not limited to only adding captions. You might like to add the camera EXIF data if you're presenting your photos to the local camera club, or show the filename and your star rating if you're presenting to a client. If you select Edit in that pop-up menu, you can use tokens to create your own combination of data in the Text Template Editor dialog.

Each time you press the ABC button, a new text field is created. To remove a spare text field, click on it and press Delete on your keyboard.

How do I change the font on my text overlays?

If you click on a text overlay to make it active, indicated by the bounding box around the text, then you can change the font and text color for that specific overlay using the Text Overlays controls in the Overlays panel. If you have more than one text overlay, you have to change each in turn. To change the font size, click and drag the edges of the bounding box. It's the vertical height that you need to get right, as the width will automatically adjust according to the text.

How do I remove the quotation marks when a caption is blank?

If you create a slideshow using the 'Caption & Rating' slideshow template which comes installed with Lightroom, the caption is shown in quotation marks, such as "Mount Rushmore," but when the caption field is empty, those quotation marks still show as "" which can look quite odd. You could check all of your photos to ensure they all have entries in the Caption field, or you could just remove the quotation marks. To do so, click on the bounding box which says "" on the preview and then find the pop-up menu on the toolbar that says 'Custom Settings' and select Edit from that menu. In the Text Template Editor dialog, remove the quotation marks and press Done. You might want to save your settings as a new 'Caption & Rating' template for use again in the future, so we'll come back to saving templates later in the chapter.

How do I change the background?

Personally I like the clean black background, as it doesn't distract from the photos themselves, but if you scroll down to the Backdrop panel, you can choose a different background color, add a gentle gradient, or even a background photo or texture. If you add a background photo, I'd suggest setting the background color to white, and dropping the opacity of the background photo so that it doesn't compete for your attention.

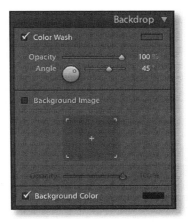

What does Zoom to Fill Frame do?

The Zoom to Fill Frame checkbox in the Options panel fills the entire cell with the photo, making them all an identical orientation and ratio. If you

have any panoramic or vertical photos, they can look odd cropped tight, so you may want to leave it unchecked.

Can I add Intro and Ending slides?

If you want to build the anticipation and prevent your guests from viewing the first slide until you're ready, you can check the Intro and Ending Screen checkboxes in the Titles panel, and they can include an Identity Plate to personalize your slideshow.

If you'd like more complicated title pages, you can design them in Photoshop and save them as an image format (i.e., JPEG). You'll then be able to import them into Lightroom and place them at the beginning and end of your slideshow. You can use the same idea for title slides in the middle of your slideshow, perhaps introducing each city you visited on vacation.

When you're setting up your slideshow, press Play, but then immediately press the Spacebar to pause the slideshow on that Intro slide. When you're ready to play, just press the Spacebar again.

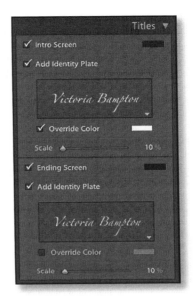

Can I advance the slides manually, but still have them fade from one to the next?

If you advance to the next slide manually by pressing the left and right arrows on the keyboard, Lightroom assumes that you don't want to wait for the set slide duration, and therefore you also don't want to wait for the fade either. At this point in time it's not possible to manually advance with the fade.

Can I rate photos while a slideshow is running?

You can use the 0-5, 6-9 and P, U, X shortcut keys to mark the photos with star ratings, color labels or flags while the slideshow is running. Even if you don't have those markers showing as captions on your slideshow, the new rating will appear briefly in the lower left corner of the screen so you can see the rating you've just applied.

How do I make the slideshow display on my second screen?

If you have more than one screen attached to your computer, they both appear in the Playback panel, and you can click on whichever screen you want to use to display the slideshow. Your chosen screen will be marked with a triangle—a Play icon.

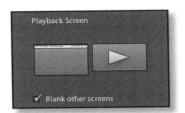

Also check...

"Ratings & Labeling"
section starting
on page 190

MUSIC

Lightroom allows you to add a music track to your slideshow, which adds to the atmosphere. You'll find the controls in the Playback panel.

How do I select or change the music track?

To select your music track, check the Soundtrack checkbox and press the Select Music button to navigate to the track of your choice. The name of the track will appear above, along with the track length.

Which music formats can Lightroom play?

Lightroom can play MP3 or AAC files, as long as they're DRM free.

How do I adjust the slide timings to fit the length of the music track?

Once you've chosen the photos and music track, you can select the fade timing of your choice in the Playback panel, and then press the Fit to Music button. You'll see the slide timings automatically adjust to fit, and you can then press Preview to test your settings. If the slide duration and fade duration aren't well balanced, you can adjust the fade timing and press Fit to Music again. You don't have to fit the slideshow to your chosen music track, but if the slideshow finishes before the music, the music will also stop mid-song.

How do I work around the lack of individual slide durations?

Lightroom doesn't currently offer slide-specific timings, however there is a partial workaround. If you want a slide to stay onscreen longer than the others, you can create a virtual copy—the slideshow will play the original then the virtual copy, resulting in a slide duration twice as long

as the other slides. For longer durations, you can create additional virtual copies. It's undoubtedly a workaround and creates an excessive number of virtual copies, but in some situations it may solve the problem.

Why can't Lightroom find my iTunes playlists?

Lightroom no longer looks for the iTunes library on the Mac version, bringing the behavior of the Mac version in line with the Windows version. Instead, you select a specific track to play as your slideshow soundtrack.

How do I play multiple different music tracks during my slideshow?

You can't select multiple tracks to play during your slideshow using Lightroom. If the track ends while the slideshow is still running, the music track will loop back to the beginning and play again. You can, however, join multiple tracks into a single long music file using free audio editing software, such as Audacity (http://www.lrq.me/audacity), and then set Lightroom to play that long combined track.

SAVING SLIDESHOWS

Having set up your slideshow just the way you want it, you'll need to save those settings for later, both as a collection for those specific photos, and perhaps as a template to apply to other photos.

How do I save my slideshow?

To save your work for the first time, either the click Create Saved Slideshow button at the top of the preview area, or press the + button on the Collections panel to do the same. In the Create Slideshow dialog, you can choose to save the slideshow within an existing collection or set, or at the top level.

Create Saved Slideshow

Also check...

"Collections" section starting on page 183

If you're concerned that you may later edit one of the photos you've used in your slideshow, making it look out of place, you can also 'make new virtual copies' which will be saved in the slideshow. Marking those virtual copies with a color label would help to remind you not to change them.

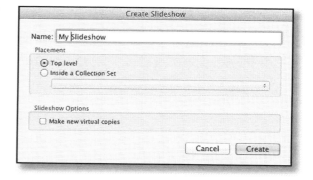

If you've already given your work a name, it will appear at the top of the preview area. Any changes you make to your slideshow will automatically be saved in the background from that time on, so you don't need to worry about saving your work.

How do I edit my saved slideshow?

Once you've given your slideshow a name, you'll find it listed in the Collections panel. You can return to it at any time by double-clicking on the name if you're in the Library, Develop or Map modules, or by single-clicking on the name if you're in one of the other output modules.

Anything you change with that saved slideshow selected will be automatically saved, overwriting your previous version. If you've created a slideshow which you're happy with, but want to try a variation, right-click on it in the Collections panel and select Duplicate Slideshow. That creates a copy which you can edit without changing your original slideshow.

How do I save my slideshow settings as a template for use on other photos?

To reuse those slideshow settings on another set of photos, you can save them as a template by clicking on the + button on the Template Browser panel, just as you would with Develop presets. Name your template, and place it in the User Templates folder or another folder of your choice. As with all presets, you can update your templates at any time by changing your settings and then right-clicking on the template in the Template Browser and choosing Update with Current Settings from the menu.

How do I select which template will be used for an Impromptu Slideshow?

The Impromptu Slideshow can be run from any module by hitting Ctrl-Enter (Windows) / Cmd-Return (Mac), and it will play a slideshow of the photos in the current view. In previous releases, it was slightly pot-luck to see which template would be used for the Impromptu Slideshow, depending on whether you'd previously created a slideshow for that source. In Lightroom 4, selecting the template has become much simpler—right-click on the template in the Template Browser panel and select Use for Impromptu Slideshow from the context-sensitive menu. The chosen template will be marked with a + symbol as a reminder.

EXPORTING SLIDESHOWS

Being able to play your slideshow in Lightroom is great if the people are sat next to you, but Lightroom can also export the slideshow to other formats to send to your viewers. You have a choice of export options, including JPEG slides for use in other software, PDF format without music, or MP4 Video format with the music and transitions.

Can I export my slideshow to run in a DVD player?

If you need to create a DVD slideshow specifically, the Export to JPEG option does give you the possibility of designing the bordered slides in Lightroom, exporting them to JPEG format, and then using those slides in other software which is specifically designed to create DVD slideshows—your CD/DVD burning software may have that capability. Some newer DVD players will also play the MP4 video format created by Export to Video.

Can I export my slideshow for viewing on the web?

If you export using the Export as Video option, you can host that MP4 file on your own website or blog, YouTube, Facebook, and other video hosting websites. If you would prefer a Flash slideshow for your website, they can be created in the Web module using the standard Flash gallery, or using some of the third-party web gallery plug-ins, such as SlideShowPro (http://www.lrq.me/slideshowpro) or TTG Monoslideshow 2 (http://www.lrq.me/ttg-monoslideshow2).

Can I export the slideshow with the music?

Export to PDF doesn't include music, but Export to Video does. Alternatively, if you own Adobe Acrobat Pro™, it would be possible to embed the soundtrack into the PDF file once it's been created by Lightroom, along with other security features limiting access to the PDF.

Also check...

"Web Module" chapter starting on page 623

Where has the Export to JPEG option gone?

The Export to JPEG option is still available in the Slideshow menu, but its button has been taken over by the more popular Export to Video option. The button's still there, but it's now hiding under the Export to PDF button—hold down the Alt (Windows) / Opt (Mac) key and it will temporarily change back into an Export to JPEG button.

I exported to PDF, but it doesn't automatically start the slideshow when I open the PDF. Why not?

If you check the 'Automatically show full screen' checkbox in the Export Slideshow to PDF dialog, it will automatically run as a full screen slideshow when opening the PDF—but only in certain PDF software, for example, a current version of Adobe Reader.

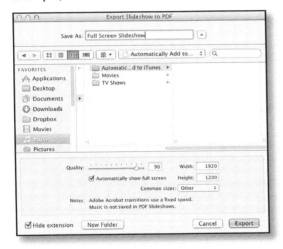

Which movie size option should I choose?

Adobe's recommendations are:

320 x 240—smallest file size, suited to email, compatible with Quicktime, iTunes, Adobe Media Player, Windows Media Player 12, etc.

480 x 320—ideal for mobile devices such as iPhone, iPod Touch, Android, etc.

720 x 480—small handheld devices, email, web

960 x 540—home media display i.e. AppleTV

720p—medium size HD for online sharing, YouTube, Facebook, blip.tv, and for home media/entertainment such as iPad, AppleTV or Windows Media Center

1080p—high quality HD video

ERRORS

Of course, problems can occur, but there are a few things you can do to fix them.

Why does it stall part way through the slideshow or go much slower than the times I'd chosen?

If the previews aren't rendered in advance, or are too low in quality, Lightroom will be working hard to render the previews to show in the slideshow. This can create delays, so there's a Prepare Previews in Advance checkbox in the Playback panel which makes sure the previews of the whole slides, including their backgrounds and borders, are rendered before starting the slideshow. If you choose to uncheck this box, or press Escape when the preview rendering dialog shows, the slideshow will start playing but it may stall or show lower quality previews, particularly on slower hardware.

Everything appears to be running correctly, then the screen just goes plain grey or black when I try to run the slideshow. Why?

Problems with running a slideshow are usually due to issues with the graphics card driver, so check with the card's manufacturer for an updated driver. Selecting a lower screen resolution can help when the graphics card is struggling.

Also check...

"Previews & Speed" chapter starting on page 333

Print Module

Although most photos today start out as digital files, at some stage you may to want to print them. Exporting the photos and sending them to a digital lab, perhaps online, is an easy option. Lightroom also offers a Print module which allows you, not only to print single prints, but also to build contact sheets and lay out multiple photos on a page for printing to a local printer.

LAYING OUT YOUR PHOTOS

Lightroom offers 3 different options for printing, which you select in the Layout Style panel.

- Single Image/Contact Sheet = a single photo or different photos all the same size, laid out as a grid
- Picture Package = the same photo in different sizes, laid out fixed to grid lines
- Custom Package = different photos in different sizes, laid out freeform

How do I set up a single borderless print, for example, a 4x6 snapshot?

To create a borderless print, you first need to set the Layout Style panel to Single Image/Contact Sheet. Click on the Page Setup button at the bottom of the left panel and set your printer paper size to borderless because Lightroom won't allow you to reduce the borders past the printer setting. Those options are limited to paper sizes that your own printer driver offers. If your printer can't print without a border, plan to print on a larger sheet of paper and cut it down.

If you have Page Bleed checked in the Guides panel, Lightroom will show the printable area for the selected printer. The minimum margins will be shaded in grey. Once you've set your paper size to borderless, those grey borders will disappear and you can adjust the margins to 0 in the Layout panel and check the Zoom to Fill checkbox.

If the Print Job panel is set to Print to: JPEG file rather than Printer, you can skip the printer page sizing and set Custom File Dimensions instead. Again, adjust the margins to 0 in the Layout panel and check the Zoom to Fill checkbox.

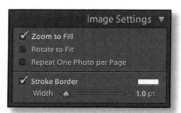

How do I change the page size and paper orientation?

If your Print to: setting in the Print Job panel is set to Printer, then the printer

driver is setting the paper size and orientation, and you must go Page Setup to change that paper size.

If you're printing to JPEG format, you can set custom file dimensions in the Print Job panel, and reverse those dimensions to change the orientation.

How do I create a contact sheet?

If you're just getting started, there are a number of default contact sheet templates in the Template Browser panel to get you started. You can either pick one of those and adjust it to your taste, or start from scratch.

If you're starting from a clean page, first set the page size and orientation in the Page Setup dialog. In the Layout Style panel, select Single Image/ Contact Sheet, and then moving down to the Layout panel, choose the numbers of rows and columns that you want on your contact sheet and adjust the spacing between the cells. You may need to go back to the Image Settings panel to turn off Rotate to Fit if you have a mixture of horizontal and vertical photos.

We'll come back to other design customization such as background colors and text information later in the chapter.

How do I select which photos to include in my contact sheet?

You may wish to exclude certain photos when creating your contact sheet, for example, virtual copies. You could filter the current Filmstrip view to hide specific photos. Alternatively, there's a pop-up on the toolbar which allows you to use Selected Photos, Flagged Photos or All Filmstrip Photos.

How can I change the order of contact sheet photos?

The contact sheet photos will display in the current sort order, so if you rearrange the sort order in Grid view or Filmstrip, the contact sheet will automatically update to show your new sort order.

Also check...

"Why can't I drag and drop into a custom sort order or User Order?" on page 224 and "How do I save my print?" on page 614

If you're going to need to reprint the contact sheet again later, you may decide to save the photos in a Print collection, as the collection will retain the sort order, in addition to your Print module settings.

How do I use Picture Package?

The Picture Package enables you to print multiple versions of the same photo in varying sizes, for example, printing 2 small copies for your wallet, and a larger copy for a frame.

There are some default Picture Package templates, for example, '(1) 5x7, (4) 2.5x3.5,' or you can create your own package using the Cells panel.

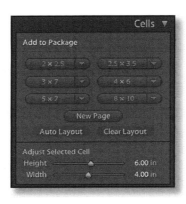

Clicking any of the size buttons in the Cells panel will create a cell of that size, and those buttons have a pop-up menu allowing you to create buttons for custom sized cells. Holding down Alt (Windows) / Opt (Mac) while dragging an existing cell on the page will duplicate that cell.

If you want to resize an existing selected cell, you can use the sliders in the Cells panel, or drag the edges of the bounding box. Holding down the Shift key while resizing the bounding box will constrain the ratio of the cell, and holding down Alt (Windows) / Opt (Mac) resizes from the center point instead of the corner, just like in the Crop tool.

Clicking the Auto Layout button will arrange the cells on the page to waste as little paper as possible, or you can drag and drop them into a layout that you like.

What does the exclamation mark in the top right corner mean?

If the photos are overlapping in the Picture Package, an exclamation mark will show in the top right corner of the preview to warn you. If you ignore that warning, they'll print in the overlapping layout you've designed, which can be used to produce a montage.

How do I create a Custom Package?

The Custom Package enables you to print any photos in a mixture of sizes to avoid wasting paper, so you have 2 choices—either you place the cells first and then drop the photos into those cells, or you drop the photos directly onto the page and their cells will be automatically created, ready for you to resize.

As in the Picture Package, holding down Alt (Windows) / Opt (Mac) while dragging an existing cell will duplicate that cell, and you can resize it using the sliders in the Cells panel or by dragging the edge of the bounding box. Again, holding down the Shift key while resizing the bounding box will constrain the ratio of the cell, and holding down Alt (Windows) / Opt (Mac) resizes from the center point instead of the corner, just like in the Crop tool.

What's a pinned or anchored cell?

If you right-click on a cell in the Custom Package and choose Anchor Cell, that cell and its contents will be placed on each page in exactly the same place, and moving or deleting it on one page will do the same on the other pages. It's particularly useful for adding a logo onto each page.

How do I replace a photo in an existing cell?

To change a photo, just drag another photo from the Filmstrip onto the existing cell, and it will automatically be replaced.

How do I see the cell size?

If you click on a cell, the cell dimensions are available in the Cells panel, but if you turn on the Dimensions checkbox in the Rulers, Grid & Guides panel, they'll also appear in the top left corner of any cell containing a photo. They update live as you resize each cell, and in the Rulers, Grids & Guides panel, you can choose whether to show the sizes in inches, centimeters, or a variety of other units.

How can I stop the photos being cropped by the cells?

If you want to do a one-off resize to fit the cell to the photo's aspect ratio, right-click on the photo and choose Match Aspect Ratio. The cell will then be adjusted to fit, but it's not locked to that ratio, so any further resizing could alter the ratio again, whereas the Lock to Photo Aspect Ratio checkbox in the Cells panel will force all of the cells on the page to match the aspect ratio of the photos they contain.

How do I rotate a photo within a cell?

You can't manually rotate a photo within a cell—just the cell itself—but if Rotate to Fit is checked in the Image Settings panel, the photo will automatically rotate within the cell to best fit your chosen crop.

How do I move a photo within a cell?

If the cell doesn't match the aspect ratio of the photo, for example, you have a standard ratio photo in a long thin cell, you can hold down the Ctrl (Windows) / Cmd (Mac) key while dragging the photo to move it

around within the cell. The movement is limited to moving up and down the short edge of the cell, so if you need a specific crop, it's better do the cropping first in the Develop module.

Also check...

"Cropping" section starting on page 450

How do I scroll through custom package pages?

There's a button in the Cells panel to create a new page, or dropping another photo on a page that's already full will automatically create another page.

The first 6 pages you create are all shown on screen at the same time, and then as you start adding additional pages, the arrow buttons on the toolbar

become available to scroll through each following set of 6 pages.

The page previews do get a bit small once you have 6 pages, and there isn't currently a way to zoom in on just one page, so custom packages needing detailed alignment may be best created one or two pages at a time unless you have a very large monitor.

STYLES & SETTINGS

Having laid your photos out on the page, you may want to add additional details to the page, such as filenames in the case of a contact sheet, or your logo or other personalization.

How do I add the filename and watermark to my contact sheet?

At the bottom of the Page panel there's a Photo Info checkbox—if you check it and choose Filename, that information will show beneath each

Also check...

"Using Tokens in Dialogs" on page 167

photo. You're not just limited to the filename. If you select Edit from the pop-up menu, you can combine tokens to create your own combination of metadata, using a dialog which is similar to the Filename Template Editor dialog used when renaming photos.

To protect your photos, particularly for contact sheets, you might also want to add the watermark that we created earlier in the Export chapter. You'll find the Watermarking checkbox and pop-up menu in that same Page panel.

Is it possible to personalize my print by changing the background color?

You can change the page background color at the top of the Page panel, but by default it's limited to neutral shades to avoid clashing with your photos. If you want another color, click the bar on the right and the full color picker will show. A black page background combined with a narrow white stroke, which you'll find further up in the Image Settings panel, can look striking and makes a change from a traditional white background.

While you're personalizing your contact sheet or print, you can also add your logo using the Identity Plate, also found in the Page panel. You may need to change the page margins to leave space for your Identity Plate, which you can do by dragging the margin guide if you have the guide lines set to show, or by using the sliders in the Layout panel.

How can I overlay a graphic such as a border onto my print?

Lightroom isn't currently designed to overlay graphical borders, however there's a popular workaround using Identity Plates or the Watermarking feature.

Make a series of PNG border files using Photoshop—in the Lightroom community they're known as TPI's or Transparent PNG Images—and then save these as Identity Plates or Watermarks. You can download examples from: http://www.lrq.me/lr4-bookdownloads

Although the Identity Plate dialog says it requires a maximum height of 57 pixels, this doesn't apply to Identity Plates that you'll use for overlaying on photos. These need to be the correct ratio for the prints you'll use them on, and if you're going to use them for printing, they'll need to be high resolution. You can have several Identity Plates or Watermarks saved, and then just choose the one you want to overlay.

Here's an example of one of the possibilities for framing photos using a soft edge. On the PNG file the black areas are transparent, however I've made the transparent areas black so you can see them.

 Also check...

"Module Picker, Identity Plate and Activity Viewer" on page 144 and "Protecting your Copyright with Watermarking" section starting on page 510

With 1 photo on a sheet, I can place the Identity Plate anywhere on the photo. Is that possible for multiple photos?

If you print one photo per page, you can reposition the single Identity Plate, or rotate it as needed, and adjust the opacity too. It can be a useful workaround when you need to put a watermark in a different place on each image, as you can then Print to JPEG, but that can be a time-consuming job.

If you're printing multiple photos on the same page and you have Render on Every Image checked, you can't reposition the Identity Plate, but you can still adjust the size and opacity. In that case, it's better to use the Watermarks feature. You have to set the position and size in the Watermark Template Editor, rather than directly in the Print module, but the watermark can be saved in any position on the photo, rather than just being placed centrally, and will appear in that relative position on each of the photos.

SAVING PRINTS

Having set up your print just the way you want it, you may want to save it for reprinting later, and perhaps save the layout and settings as a template to apply to other photos.

How do I save my print?

To save your work for the first time, either click Create Saved Print at the top of the preview area, or press the + button on the Collections panel to do the same. In the Create Print dialog, you can choose to save the print as a separate print at the top level of the Collections panel, or place it within an existing collection or set.

Grouping your prints within collections or sets keeps them organized so you can easily find them later.

If you haven't used all of the photos shown in the Filmstrip, it will also give you the option to 'Include only used photos.' If you're concerned that

you may later edit one of the photos you've used in your print, making it look out of place, you can also 'Make new virtual copies' which will be saved with the print. Marking those virtual copies with a color label would help to remind you not to change them.

If you've already given your print a name, it will appear at the top of the preview area. Any changes you make to your print will automatically be saved in the background from that time on, so you don't need to worry about saving your work.

How do I edit my saved print?

Once you've given your print, or set of prints, a name, you'll find it listed in the Collections panel. You can return to it at any time by double-clicking on the name if you're in the Library, Develop or Map modules, or by single-clicking on the name if you're in one of the other output modules.

Anything you change with that saved print selected will be automatically saved, overwriting your previous version. If you've created a print which you're happy with, but want to try a variation, right-click on it in the Collections panel and select Duplicate Print. That creates a copy which you can edit without changing your original print.

Also check...

"Collections" section starting on page 183

How do I save my print settings as a template for use on other photos?

If you want to save your settings for use on a variety of different photos, for example, your personalized contact sheet, save them as a template. The printer settings from the Page Setup and Print Settings dialogs are also saved as part of the template. Having arranged the Print settings to suit, use the + button on the Template Browser panel, just as you would with Develop presets, and name your template and place it in a folder so you can easily find it again later. That template will then appear in the Template Browser panel for use on any photos in the future.

As with all presets, you can update your User Templates at any time, by changing the settings and then right-clicking on the template and clicking Update with Current Settings.

PRINTING

Lightroom's Print module allows you to print to a local printer, or output those files to JPEG format to send to an offsite lab.

Why do Page Setup, Print Settings and Print buttons show the same dialog?

Some driver/operating system combinations show the same dialog when you press the Page Setup, Print Settings, and/or Print buttons, while other combinations show different dialogs. This means that none of the buttons can be removed, even though they may not be needed for your setup.

Where different dialogs are shown for the different buttons, generally the Page Setup dialog allows you to set paper size, orientation and margins, whereas

Print Settings sets up paper type, quality, color management and other printer-specific settings.

The Page Setup and Print Settings buttons on the left panel group allow you to set up and save your settings as part of a template without using the Print button on the right panel group to actually queue up a print job.

Which Print Sharpening option do I choose?

As in the Export dialog, select the correct paper type (Glossy or Matte) and the strength of sharpening you prefer. Standard strength is a good default if you're not sure which to choose. Lightroom will then work out the sharpening automatically, based on the size of the original file, the output size and resolution, and the type of paper.

When should I turn on 16-bit printing?

The 16 Bit Output checkbox in the Print Job panel sends 16-bit data to the printer driver, which can help with banding in gentle gradients. It does require 16-bit printer drivers provided by your printer manufacturer, which are currently limited to high end printers, and it's also currently limited to the Mac OS. If you send 16-bit data to a printer that doesn't support it, printing will be slower than normal.

What is 'Draft Mode Printing'?

The Draft Mode Printing checkbox in the Print Job panel allows you to print a photo using Lightroom's JPEG preview, rather than reading and processing the original image data from the file. As the data is cached, it's quicker to print in draft mode, however the quality is dependent on the size of the cached preview. Output sharpening and color management are disabled when printing in Draft Mode. It can be useful for quick contact sheets or for checking positioning on the printed page.

Also check...

"Why does the Export Sharpening only have a few options? How can I control it?" on page 509 and "Which Export Sharpening setting applies more sharpening—screen, matte or glossy?" on page 509

Also check...

"Where else can I go to find solutions to my problems that aren't covered here?"
on page 669

How do I set up my printer to match the preview I see on screen?

Setup for each printer is different, so we'll just run through the basic guidelines. If you need help with your specific printer, it's best to drop by one of the Lightroom forums for one-to-one assistance. Option 1's usually the best option to choose. Make sure the profile is only being applied in one location.

Option 1—Lightroom manages color

In the Print Job panel in Lightroom, find the Color Management section and select the correct ICC profile from the pop-up menu for your printer/ink/ paper combination.

In the Printer dialog, select the correct paper type and quality settings, and set the Color Management section to No Color Adjustment. The Printer dialog will vary depending on the operating system and printer model, so these screenshots are just a guide.

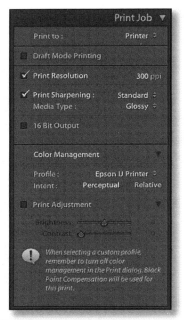

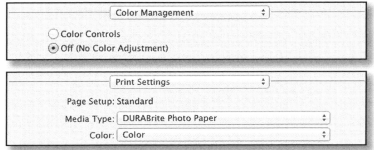

Option 2—Printer manages color

In the Print Job panel in Lightroom, find the Color Management section and select Managed by Printer from the pop-up menu.

In the Printer dialog, select the correct paper type and quality settings and select the correct ICC profile in the Color Management section. As in option 1, the Printer dialog will vary depending on the operating system and printer model, so these screenshots are just a guide.

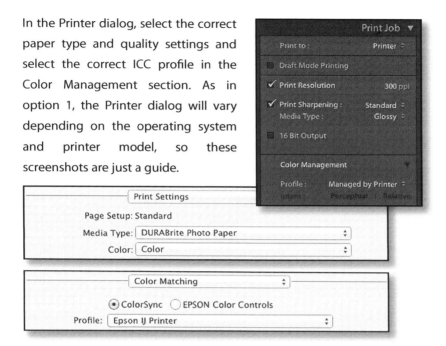

Why do Lightroom's prints not match the preview on screen?

Printing correctly should be a science, but there are so many variables, between the operating system, the drivers, the printer manufacturers, the inks, the papers, and the profiles, that it's not always quite so simple. The same settings that print correctly in one program, can react differently in another program, simply as a result of using a newer print path which links the software to the operating system. There are a few things to double check if you're having problems.

- Calibrate your monitor using a hardware calibration device, otherwise you have no way of telling whether you're seeing an accurate preview on screen. Most monitors are too bright straight out of the box. They're set up to be bright and punchy, which is great for movies, but that doesn't match printed output. Ideally you want to calibrate your monitor using a hardware calibration device and adjust the luminance to about 110-120 cd/m2, depending on your viewing conditions. This may be under the

Also check...

"Everything in Lightroom is a funny color, but the original photos look perfect in other programs, and the exported photos don't look like they do in Lightroom either. What could be wrong?" on page 338

Advanced section of your calibration software. If your software doesn't offer that option, try reducing the brightness to approximately match a print, before calibrating.

- Use the correct ICC profile for your printer/ink/paper combination, because printer profiles aren't one-size-fits-all. If you're not using the manufacturer's own ink and paper, or other properly profiled combinations, you will need some trial and error to create prints vaguely matching your screen.

- Make sure you have the latest printer drivers.

- Check your print settings in Lightroom. You either want Lightroom to manage the colors, or your printer to do so, but not both.

Adobe have also introduced a "quick and dirty" method for print matching, namely the Brightness and Contrast sliders in the Print Adjustment section of the Print Job panel.

How do I compensate for prints that are too light, too dark or too flat?

The Print Adjustment section at the bottom of the Print Job panel isn't intended to be a replacement for proper color management. That said, even with the best color management in the world, printing isn't always 100% accurate, and not everyone needs and wants to go into that much detail anyway. You may find that your inkjet prints are always a little light, a bit dark, or a bit flat compared to your screen, even though your screen is properly calibrated. Lightroom doesn't cause the problem, but it is the easiest place to solve it.

The "quick and dirty" solution is to adjust the Brightness and Contrast sliders to compensate. The adjustments are not previewed on screen because it's compensating for something that only happens when printing, just like the output sharpening, and it's not an adjustment that you'd change for each photo. With a few initial test prints, you can work out the ideal settings for your printer/paper/ink combination and they'll be saved in templates and saved prints.

How do I print to a file such as a JPEG to send to my lab?

Lightroom offers full Print to JPEG facilities, so you can save JPEGs of contact sheets, bordered photos and a whole host of other ideas. You can then send them to a photographic lab rather than printing them on a desktop printer.

To print to a JPEG file from the Print module, select JPEG File from the Print Job panel. In that panel, you can set a custom file size (using the ruler units selected in the Layout panel), the file resolution (PPI), JPEG quality, sharpening settings and the ICC profile.

When you press the Print to File button, it will ask you for a filename. If you're just printing a single page, it will just use that filename, but if you're printing multiple pages, it will create a folder with that name, and put the pages inside that folder with a sequence number on the end of the filename. For example, if you give it the name Test, it will create a Test folder and create files called 'Test-1.jpg,' 'Test-2.jpg' and so forth. It doesn't currently have the option to use the name of the photo that you're printing, as you may be printing more than one photo per page.

If you're simply creating JPEGs of single photos to send to your lab, rather than contact sheets or multiple-image prints, it's far quicker to use the standard Export dialog instead of the Print module.

How do I get Lightroom to see my custom printer profile?

If your paper manufacturer or digital lab provides custom printer profiles, you'll need to install them on your computer so that Lightroom can access them, and then restart Lightroom.

Windows: Right-click on the profile in Explorer and select Install Profile from the context-sensitive menu. If that doesn't work, you can install them manually by placing the profile in C:\Windows\system32\spool\drivers\color, which may be a hidden folder.

Mac: Place the profile in Macintosh HD/Users/[your username]/Library/ColorSync/Profiles, or the global ColorSync folder if multiple users will need access to it. On 10.7 Lion, the user folder is a hidden folder by default.

Once the profiles are installed and you've restarted Lightroom, you can select the Profile pop-up menu and choose Other to view a list of all available profiles. Putting a checkmark next to a profile adds it to the main Profile pop-up menu, allowing you to select it as your output profile.

To remove an ICC profile, you simply retrace your steps and uncheck the profile.

Why does my custom ICC printer profile not show in Lightroom's list of profiles?

If your profile doesn't show in the Choose Profiles dialog which is shown when you choose Other, it may be a CMYK profile. Lightroom isn't designed to output CMYK. If you have access to a Mac, you can open the profile in ColorSync Utility to check—the color space is recorded in the profile info. Some other ICC profiles, intended for software RIPs, may also be non-standard and therefore not work properly with Lightroom.

Also check...

"How do I show hidden files to find my preferences and presets?" on page 655

Web Module

The Web Module allows you to create beautiful galleries of your photos for displaying on the web, and you don't need any web design experience to create them.

STYLES & SETTINGS

Lightroom comes with 5 different web gallery styles, including basic HTML and Flash galleries, and additional third-party web galleries can be downloaded too. You can then customize them further, adjusting the colors, styles and layouts to suit your taste.

How do I create my first web gallery?

Adobe have provided a whole selection of pre-built web templates in different colors and styles to get you started, and as you float over those templates in the Template Browser panel, the preview appears in the Preview area above.

Click on a template that you like, and then start exploring the options in the panels on the right. You can add gallery titles and contact information in the Site Info panel. The Color Palette and Appearance panels allow you to change the colors of various elements and change

the layout of the pages, and as you change those options, the preview of the gallery updates in the main preview pane.

In the Image Info and Output Settings panels, you can choose to add metadata such as the filename or caption, set the quality and sharpening for the large photos, and most importantly if you're putting photos on the web, add watermarking too.

Having adjusted those settings, you're ready to upload your web gallery, which we'll come back to in a moment.

The default Flash gallery appears to be capped at 500 photos—how do I increase the number of photos it can hold?

The default Flash gallery is capped at 500 photos. If you need to include more photos, consider splitting them across multiple galleries, or using one of the third party galleries which can be added to Lightroom. If you still want to use the default Flash gallery, it's possible to change that limit, but it involves digging in the program files to duplicate the gallery, so take care! Duplicating the gallery means that you won't need to repeat the process every time you install a dot release update (i.e., 4.1).

Windows:

1. Find the following folder: C:\Program Files\Adobe\Adobe Photoshop Lightroom 4.x\shared\webengines\default_flash. lrwebengine\

2. Copy that default_flash.lrwebengine folder to your user Web Galleries folder. You may have to create the Web Galleries folder at: C:\Users\[your username]\AppData\Roaming\Adobe\ Lightroom\Presets\Web Galleries\

3. Ensure that you have read/write access to the folder and files.

4. Inside that folder is a file called galleryInfo.lrweb, which you need to open in a basic text editor such as Notepad.

5. Find the line that says "maximumGallerySize=500," and increase the value.

6. Save and close the file.

7. Restart Lightroom and check that your gallery will now allow larger numbers of photos.

Mac:

1. Go to the Applications folder

2. Right-click on Adobe Lightroom 4.app and select 'Show Package Contents'

3. Navigate to Contents > Plug-ins > Web.lrmodule

4. Right-click on Web.lrmodule and select 'Show Package Contents'

5. Navigate to Contents > Resources > Galleries

6. Copy that default_flash.lrwebengine folder to your user web galleries folder. You may have to create the Web Galleries folder at: Macintosh HD/Users/[your username]/Library/Application Support/Adobe/Lightroom/Presets/Web Galleries/

7. Ensure that you have read/write access to the folder and files.

8. Inside that folder is a file called galleryInfo.lrweb, which you need to open in a basic text editor such as TextEdit.

9. Find the line that says "maximumGallerySize=500," and increase the value.

10. Save and close the file

11. Restart Lightroom and check that your gallery will now allow larger numbers of photos.

Is it possible to add music to the galleries?

Some third party galleries, such as SlideShowPro or TTG Monoslideshow-2, allow you to add a music track to a Flash web gallery.
http://www.lrq.me/slideshowpro
http://www.lrq.me/ttg-monoslideshow2

ADDITIONAL GALLERIES

Although Lightroom comes with 5 galleries by default, many web designers have created additional web galleries for use in Lightroom. They offer a huge range of different styles and functions, making it possible to create whole websites. They also enable you to add music to web slideshows and include PayPal links for customers to purchase photos, amongst other features.

Where can I download additional web galleries?

There's a current index of web galleries on my website at http://www.lrq.me/links/web-galleries which I'll keep updated as I find new galleries.

The Lightroom Exchange is a great place to find all sorts of new galleries, plug-ins, presets and other goodies:
http://www.lrq.me/lightroomexchange

Are there any web galleries with download links or an integrated shopping cart such as PayPal?

The TTG Client Response gallery allows your clients to select photos and email you a list automatically, but it doesn't include payment facilities.
http://www.lrq.me/ttg-clientresponse

Some of the other TTG galleries also include payment facilities:
http://www.lrq.me/ttg-ecommerce

Those galleries also offer optional full resolution downloads, for occasions when you may want to make photos freely available for download.

How do I install new web galleries?

Most web galleries are zipped, so double-click to unzip it, and then copy the resulting folder to the Web Galleries folder. If the Web Galleries folder doesn't already exist, you may need to create it. The file locations are:

Windows—C:\Users\[your username]\AppData\Roaming\ Adobe\Lightroom\Presets\Web Galleries\

Mac—Macintosh HD/Users/[your username]/Library/Application Support/Adobe/Lightroom/Presets/Web Galleries/

Don't put it in the Web Templates folder instead of the Web Galleries folder, as there is a difference. Web Templates are the settings you store

Also check...

*"The default location of the Presets is..."
on page 656*

in the Template Browser panel, whereas Web Galleries are the engines that appear in the Layout Style panel.

Restart Lightroom and your new galleries should appear in the Layout Style panel.

SAVING WEB GALLERIES

Having set up your web gallery just the way you want it, you may want to save it, both as a collection for those specific photos, and perhaps as a template to apply to other photos. That will allow you to go back and edit it later.

How do I save my web gallery?

To save your work for the first time, either click the Create Saved Web Gallery button at the top of the preview area, or press the + button on the Collections panel to do the same. In the Create Web Gallery dialog, you can choose to save the web gallery within an existing collection or set, or at the top level.

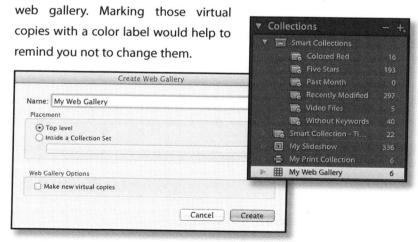

If you're concerned that you may later edit one of the photos you've used in your web gallery, making it look out of place, you can also choose to 'Make new virtual copies' in that dialog, saving them with the web gallery. Marking those virtual copies with a color label would help to remind you not to change them.

Also check...

"Collections" section starting on page 183

If you've already given your work a name, it will appear at the top of the preview area. Any changes you make to your web gallery will automatically be saved in the background from that time on, so you don't need to worry about saving your work.

How do I edit my saved web gallery?

Once you've given your web gallery a name, you'll find it listed in the Collections panel. You can return to it at any time by double-clicking on the name if you're in the Library, Develop or Map modules, or by single-clicking on the name if you're in one of the other output modules.

Anything you change with that saved web gallery selected will be automatically saved, overwriting your previous version. If you've created a web gallery which you're happy with, but want to try a variation, right-click on it in the Collections panel and select Duplicate Web Gallery. That creates a copy which you can edit without changing your original web gallery.

How do I save my settings as a template for use on other photos?

To reuse those web gallery settings on another set of photos, you can save them as a template by clicking on the + button on the Template Browser panel, just as you would with Develop presets. Name your template, and place it in the User Templates folder or another folder of your choice. As with all presets, you can update your templates at any time by changing your settings and then right-clicking on the template in the Template Browser and choosing Update with Current Settings.

EXPORTING & UPLOADING

Once you've finished creating your web gallery, it's time to upload it to your web space. You can either let Lightroom upload the files using its built-in FTP client or export the gallery to your hard drive and use your own dedicated FTP software.

How do I upload my gallery?

Once you've set up your gallery, go to the Upload Settings panel and select your FTP Server from the pop-up menu if you've already set it up, or select 'Edit' to show the Configure FTP File Transfer dialog. Enter the details for your website, including the FTP server address, username, password and server path. You may need to check with your web host for the details. Save the details as a preset for next time, and press OK to return to the Lightroom interface.

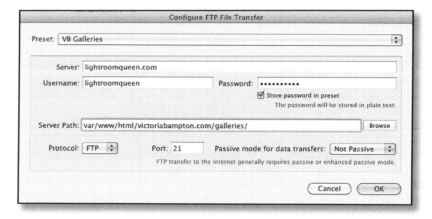

Back in the Upload Settings panel, enter a subfolder name, otherwise any further galleries that you upload could overwrite your existing galleries. Be careful—if you don't select a subfolder in the Put in Subfolder field, you could

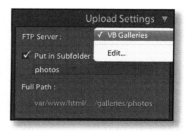

overwrite your home page. Then you can press Upload and leave it to work. You can carry on working in Lightroom while the upload runs in the background, and you can check the progress in the Activity Monitor in the top left hand corner of the screen. The upload speed, once it's created the gallery, depends on your internet connection.

Alternatively, you could use the Export button to export your gallery to your hard drive, and

then upload to your server using your normal FTP software. That's my preferred option, because if the upload fails, you don't then have to start again.

Why doesn't the FTP upload work—it says 'Remote Disc Error'?

Lightroom's FTP facility is there for convenience, but it's not as robust as dedicated FTP software. Check your FTP settings, because they may be incorrect, and you could also try with and without the Passive setting checked in the Configure FTP File Transfer dialog. Large uploads may time out, depending on your web server.

If it still doesn't work smoothly, export directly to your hard drive using the Export button rather than the 'Upload' button, and then use standard FTP software to upload instead. If you don't already have FTP software, you can download free FTP clients, such as the FileZilla Client (http://www.lrq.me/filezilla).

Why are my FTP settings not saved in the templates?

Lightroom saves your upload settings with your web gallery as it assumes that you'll want to upload those same photos to the same place. Templates are used when selecting a new set of photos, so you're likely to change the upload location each time you use the template otherwise you would overwrite the previous gallery, therefore FTP settings aren't saved with templates.

Can I have multiple galleries on my website?

If you want to put multiple galleries on your website, just put each gallery in its own subfolder on your web server, and add an index page. TTG AutoIndex can create index pages for many galleries and it's not limited to the TTG galleries. You can purchase it from:

http://www.lrq.me/ttg-autoindex

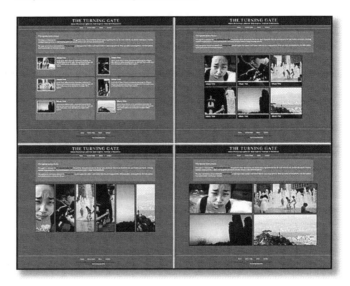

Some of the other third party web galleries can create whole websites, linking multiple galleries together.

Is it possible to embed a web gallery into an existing website or web page?

Also check...

"Where can I download additional web galleries?" on page 627

If you want to embed a web gallery into an existing website, the easiest option is to place the gallery in a subfolder and link to it. If you want to embed a gallery into an existing page, it is possible, but requires some web design skills. An HTML iframe is the easiest way of integrating into an existing page.

Designing Your Workflow

Workflow is one of the most popular topics among photographers, but why? What does it actually mean?

The term workflow simply describes a series of steps undertaken in the same order each time. For photographers, that workflow runs from the time of shooting (or even before), through transferring the photos to your computer, sorting and selecting your favorites, editing and retouching them, and then outputting to various formats, whether on screen or in print.

Why is workflow important?

The initial aim for your workflow is consistency. If you do the same thing, in the same order, every time, you reduce the risk of mistakes. Files won't get lost or accidentally deleted, metadata won't get missed, and you won't end up redoing work that you've already completed once.

How should I design my workflow?

Like the rest of this book, I'm not going to tell you how you 'must' work. There is no perfect workflow for everyone, as everyone's needs are different. Instead, we'll consider some sample workflows and the thoughts behind them, so you can start to build your own ideal workflow. Let's start with my personal workflow.

My Personal Workflow

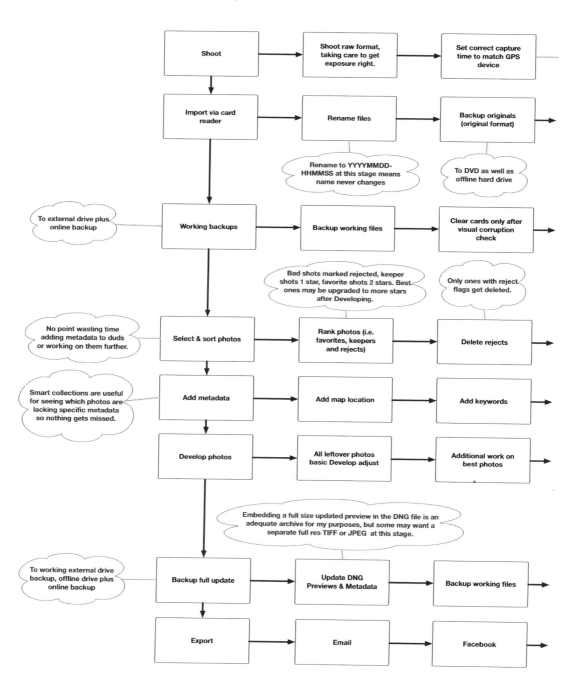

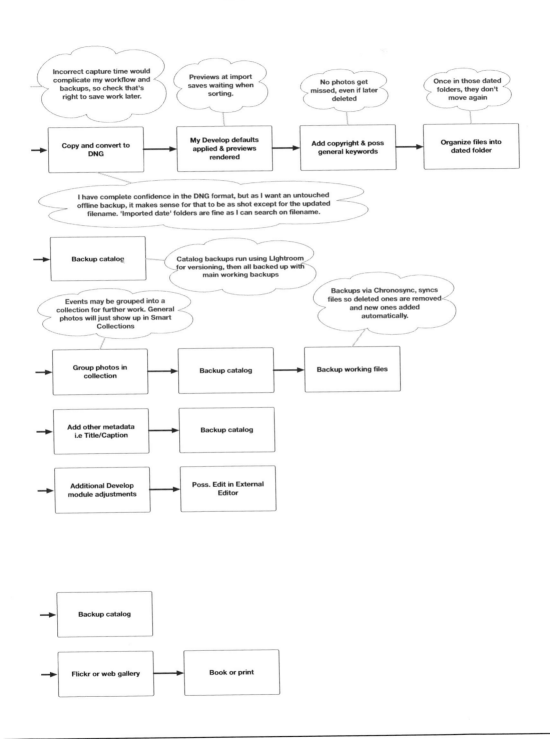

Incorrect capture time would complicate my workflow and backups, so check that's right to save work later.

Previews at import saves waiting when sorting.

No photos get missed, even if later deleted

Once in those dated folders, they don't move again

Copy and convert to DNG

My Develop defaults applied & previews rendered

Add copyright & poss general keywords

Organize files into dated folder

I have complete confidence in the DNG format, but as I want an untouched offline backup, it makes sense for that to be as shot except for the updated filename. 'Imported date' folders are fine as I can search on filename.

Backup catalog

Catalog backups run using Lightroom for versioning, then all backed up with main working backups

Events may be grouped into a collection for further work. General photos will just show up in Smart Collections

Backups via Chronosync, syncs files so deleted ones are removed and new ones added automatically.

Group photos in collection

Backup catalog

Backup working files

Add other metadata i.e Title/Caption

Backup catalog

Additional Develop module adjustments

Poss. Edit in External Editor

Backup catalog

Flickr or web gallery

Book or print

STAGES OF THE AVERAGE WORKFLOW

As you can see from my personal workflow, workflows are made up of individual building blocks which can be rearranged to suit you. We've already covered all of those topics earlier in the book, so rather than repeating everything, here are the links to the applicable sections and questions:

Shooting your Photos

"Shooting Raw, sRAW OR JPEG" section starting on page 77

Importing your Photos

"Import" chapter starting on page 77

Renaming your Photos

"How do I rename the files while importing?" on page 94

"How do I rename one or more photos?" on page 196

Backing up your Catalog and Photos

"Making and Restoring Backups" section starting on page 290

Converting to DNG

"Proprietary Raw vs. DNG" section starting on page 108

Organizing your Photos on the Hard Drive

"How should I organize my photos on my hard drive?" on page 101

"Renaming, Moving & Deleting" section starting on page 196

Rendering Previews

"Previews" section starting on page 333

Adding Metadata to your Photos

Selecting and Sorting your Photos

Editing your Photos

Displaying your Finished Photos

Example Workflow - Selecting Your Best Photos

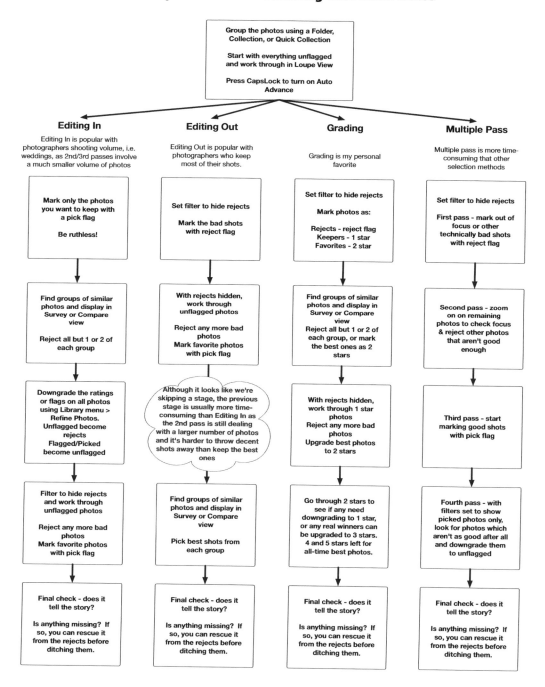

Group the photos using a Folder, Collection, or Quick Collection

Start with everything unflagged and work through in Loupe View

Press CapsLock to turn on Auto Advance

Editing In

Editing In is popular with photographers shooting volume, i.e. weddings, as 2nd/3rd passes involve a much smaller volume of photos

Mark only the photos you want to keep with a pick flag

Be ruthless!

Find groups of similar photos and display in Survey or Compare view

Reject all but 1 or 2 of each group

Downgrade the ratings or flags on all photos using Library menu > Refine Photos. Unflagged become rejects Flagged/Picked become unflagged

Filter to hide rejects and work through unflagged photos

Reject any more bad photos Mark favorite photos with pick flag

Final check - does it tell the story?

Is anything missing? If so, you can rescue it from the rejects before ditching them.

Editing Out

Editing Out is popular with photographers who keep most of their shots.

Set filter to hide rejects

Mark the bad shots with reject flag

With rejects hidden, work through unflagged photos

Reject any more bad photos Mark favorite photos with pick flag

Although it looks like we're skipping a stage, the previous stage is usually more time-consuming than Editing In as the 2nd pass is still dealing with a larger number of photos and it's harder to throw decent shots away than keep the best ones

Find groups of similar photos and display in Survey or Compare view

Pick best shots from each group

Final check - does it tell the story?

Is anything missing? If so, you can rescue it from the rejects before ditching them.

Grading

Grading is my personal favorite

Set filter to hide rejects

Mark photos as:

Rejects - reject flag Keepers - 1 star Favorites - 2 star

Find groups of similar photos and display in Survey or Compare view Reject all but 1 or 2 of each group, or mark the best ones as 2 stars

With rejects hidden, work through 1 star photos Reject any more bad photos Upgrade best photos to 2 stars

Go through 2 stars to see if any need downgrading to 1 star, or any real winners can be upgraded to 3 stars. 4 and 5 stars left for all-time best photos.

Final check - does it tell the story?

Is anything missing? If so, you can rescue it from the rejects before ditching them.

Multiple Pass

Multiple pass is more time-consuming that other selection methods

Set filter to hide rejects

First pass - mark out of focus or other technically bad shots with reject flag

Second pass - zoom on on remaining photos to check focus & reject other photos that aren't good enough

Third pass - start marking good shots with pick flag

Fourth pass - with filters set to show picked photos only, look for photos which aren't as good after all and downgrade them to unflagged

Final check - does it tell the story?

Is anything missing? If so, you can rescue it from the rejects before ditching them.

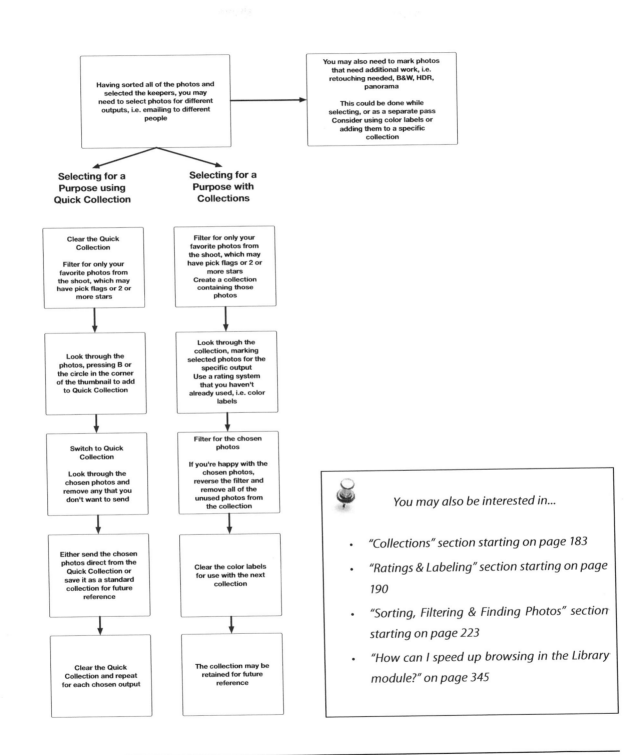

Having sorted all of the photos and selected the keepers, you may need to select photos for different outputs, i.e. emailing to different people

You may also need to mark photos that need additional work, i.e. retouching needed, B&W, HDR, panorama

This could be done while selecting, or as a separate pass Consider using color labels or adding them to a specific collection

Selecting for a Purpose using Quick Collection

Selecting for a Purpose with Collections

Clear the Quick Collection

Filter for only your favorite photos from the shoot, which may have pick flags or 2 or more stars

Filter for only your favorite photos from the shoot, which may have pick flags or 2 or more stars
Create a collection containing those photos

Look through the photos, pressing B or the circle in the corner of the thumbnail to add to Quick Collection

Look through the collection, marking selected photos for the specific output
Use a rating system that you haven't already used, i.e. color labels

Switch to Quick Collection

Look through the chosen photos and remove any that you don't want to send

Filter for the chosen photos

If you're happy with the chosen photos, reverse the filter and remove all of the unused photos from the collection

Either send the chosen photos direct from the Quick Collection or save it as a standard collection for future reference

Clear the color labels for use with the next collection

Clear the Quick Collection and repeat for each chosen output

The collection may be retained for future reference

You may also be interested in...

- *"Collections" section starting on page 183*
- *"Ratings & Labeling" section starting on page 190*
- *"Sorting, Filtering & Finding Photos" section starting on page 223*
- *"How can I speed up browsing in the Library module?" on page 345*

Example Workflow - Developing Your Photos

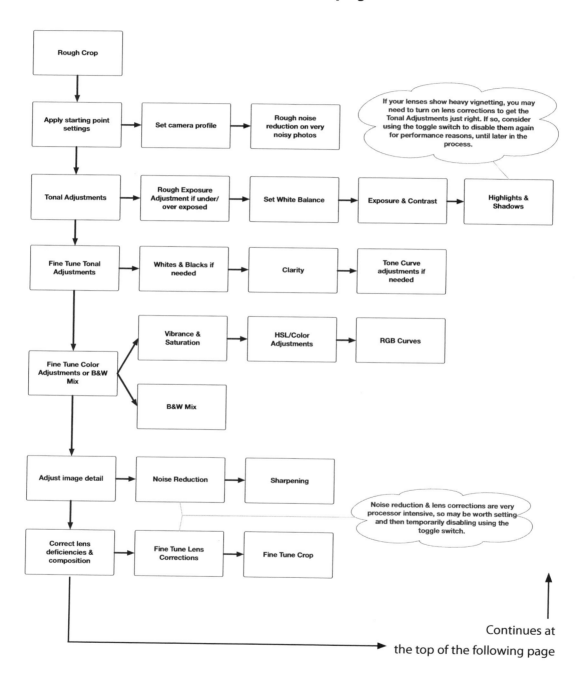

Continues at
the top of the following page

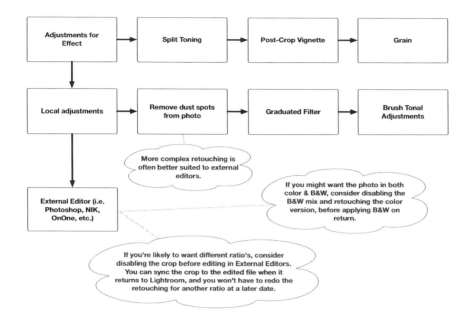

You may also be interested in...

- *"Basic Adjustments" section starting on page 362*

- *"Adjusting Multiple Photos" section starting on page 387*

- *"HSL, Color, B&W & Split Toning" section starting on page 384*

- *"Detail—Sharpening & Noise Reduction" section starting on page 423*

- *"Lens Corrections" section starting on page 427*

- *"Cropping" section starting on page 450*

- *"Local Adjustments—Graduated Filter & Adjustment Brush" section starting on page 458*

- *"How can I speed up browsing in the Develop module? And what are these Cache*.dat files?"
 on page 346*

Example Workflow - Travel

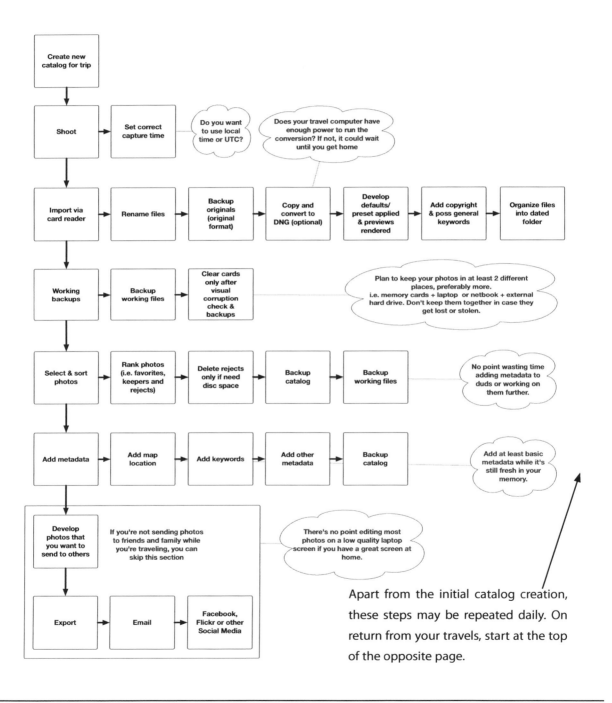

Apart from the initial catalog creation, these steps may be repeated daily. On return from your travels, start at the top of the opposite page.

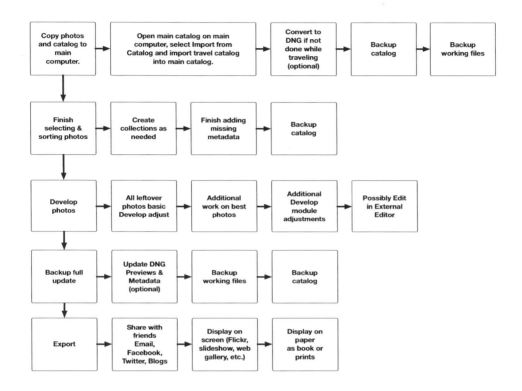

You may also be interested in...

- *"Working with Multiple Machines" section starting on page 305*

- *"How does Import from Catalog work?" section starting on page 306*

- *"Making and Restoring Backups" section starting on page 290*

- *"Are there any limitations when importing and exporting catalogs?" on page 308*

Example Workflow - Taking Files Offsite

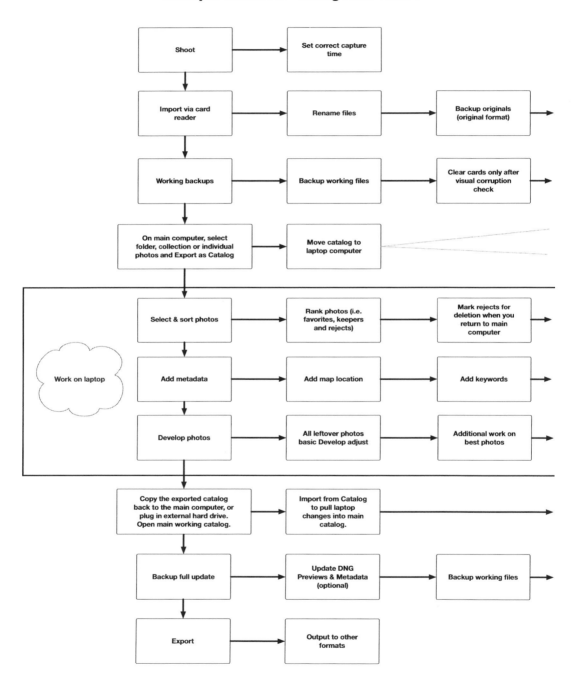

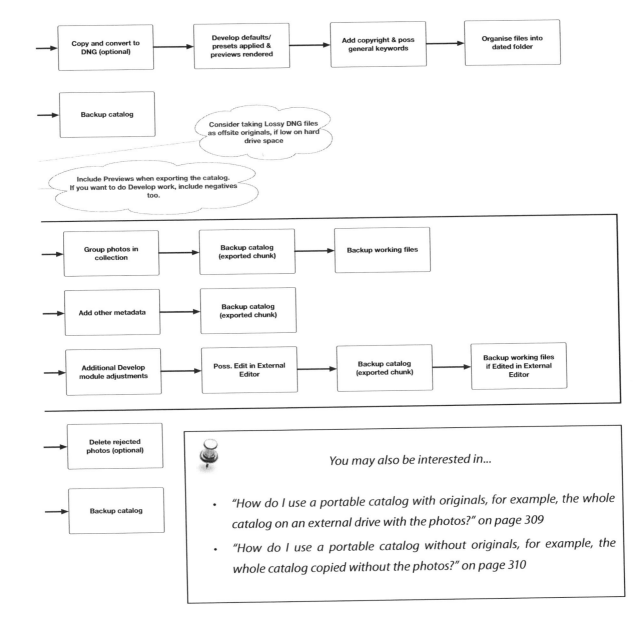

Example Workflow - Wedding Photography

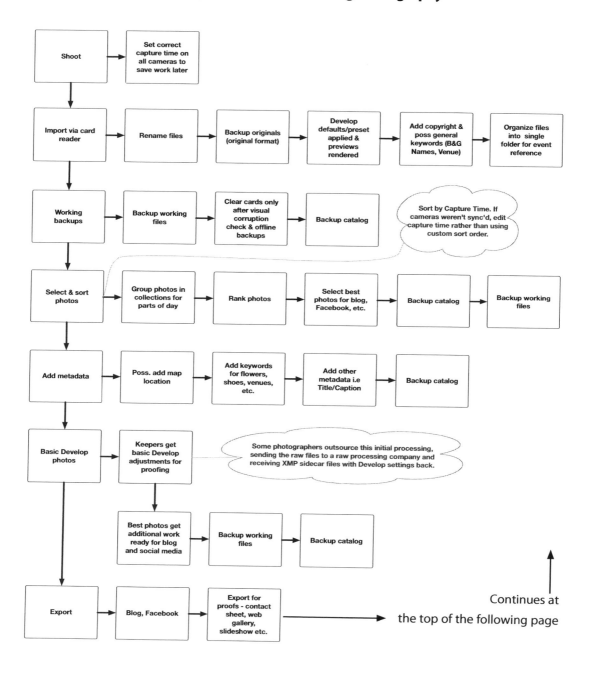

Continues from the opposite page

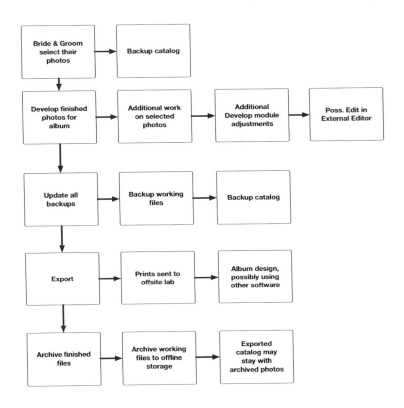

You may also be interested in...

- *"Making and Restoring Backups" section starting on page 290*
- *"Editing the Capture Time" section starting on page 214*
- *"Ratings & Labeling" section starting on page 190*
- *"Viewing & Editing Metadata" section starting on page 201*
- *"How can I speed up browsing in the Library module?" on page 345*
- *"How can I speed up browsing in the Develop module? And what are these Cache*.dat files?" on page 346*

Also check...

"Register your book for additional benefits"
on page 670

Now it's time to start building your own workflow...

... and once you've settled on a good workflow, that isn't the end of the story. You'll likely find that you continue to tweak it, finding slightly more efficient ways of doing things. It will continue to build with time and experience, as well as with the introduction of new technology. The principles, however, remain the same.

This topic will continue to be expanded in the private Members Area, where I'll gradually be adding more examples of workflows, so don't forget to register your copy of this book.

If you have any ideas of workflow examples you'd like to see, you'd like to share your own workflow with others, or just want to check that your planned workflow doesn't have any serious holes, please get in touch. You can contact me at http://www.lrq.me/newticket

We also have an area of the forum dedicated to discussing workflow, if you'd like to bounce some ideas around. Visit the workflow forum at http://www.lrq.me/workflowforum

Troubleshooting & Useful Information

It's a computer—they don't always work the way you expect! Hiccups do occur, so we'll cover some of the most useful troubleshooting steps, as well as more general information on installing and upgrading Lightroom in various languages and formats.

TROUBLESHOOTING STEPS

As with all computer software, problems can occur with Lightroom, so it's useful to have some simple troubleshooting steps to try before you need to ask for additional help.

I have a problem with Lightroom—are there any troubleshooting steps I can try?

On the following pages are some standard troubleshooting steps for the most frequent issues, but as always, make sure you have backups before you try any troubleshooting steps.

1. Restart Lightroom.

2. Restart the Computer.

3. Make sure you're running the latest updates, both for Lightroom (by going to Help menu > Check for Updates) and also for your operating system.

4. Optimize the Catalog. Go to File menu > Optimize Catalog and wait for it to tell you it's completed before moving on.

5. Delete the Preferences file. Close Lightroom and find the Preferences file. The Preferences may be in a hidden folder on some systems, which you may need to show. You could move or rename that Preferences file, rather than deleting, and if it doesn't solve the problem, you can put it back. More instructions on that in the next question.

6. If your catalog won't open, check for a *.lock file alongside your catalog file, and delete it, and then try to restart. The lock file can get left behind if Lightroom crashes, preventing you from opening the catalog. If you find a *.lrcat-journal file, do not delete that, as it contains important information.

7. Create a new catalog to rule out catalog corruption. Restart Lightroom while holding down Ctrl (Windows) / Opt (Mac). Select Create New Catalog. Import some photos into that new catalog to check everything is working as expected. If this works, the problem is with the catalog, possibly corruption. (Don't panic, that can usually be fixed!)

8. Move all user presets to another location in case a corrupted preset is causing the problem. Corrupted fonts have also been known to cause problems.

9. Update drivers on your machine, particularly the graphics card drivers.

10. Damaged RAM can also cause some odd problems—Lightroom will find dodgy memory quicker than almost any other program. Run software such as Memtest to check your memory.

If none of those troubleshooting steps solve the problem, post a description at http://www.lightroomforums.net and we'll help you figure it out!

Also check...

"How do I check which Lightroom and ACR versions I have installed?" on page 479, "What general maintenance will keep my catalogs in good shape?" on page 275, "Lightroom says that my catalog is corrupted—can I fix it?" on page 277, "How do I create a new catalog and switch between catalogs?" on page 270 and "The default location of the Presets is…" on page 656

How do I delete the Preferences file?

Removing Lightroom's Preferences file can solve all sorts of 'weirdness,' so it's a good early step in troubleshooting.

On Windows, the easiest way to find it is to go to Edit menu > Preferences > Presets tab and press the Show Lightroom Presets Folder button. You can also navigate directly to C:\Users\[your username]\AppData\ Roaming\Adobe\Lightroom\Preferences\ Whichever way you choose to find that folder, close Lightroom before going any further. In the Lightroom\Preferences folder will be a Lightroom 4 Preferences.agprefs file—move it to another folder or delete it, and then restart Lightroom.

On Mac, you'll find com.adobe.Lightroom4.plist with the other Preferences files rather than Lightroom's Presets, so you'll need to navigate directly to Macintosh HD/Users/[your username]/Library/ Preferences/. This is a hidden folder by default on Mac OS X 10.7, so check the sidebar link for information on how to show hidden folders. As with Windows, close Lightroom and move that file to another folder or delete it, and then restart Lightroom.

Moving or renaming that preferences file, rather than deleting it, does mean that you can put it back if it doesn't solve the problem, to save you recreating your preferences again.

Don't panic if Lightroom opens with a blank catalog or asks you to create one after trashing the preferences. If it finds a catalog at the default location, that's the catalog it will initially open, but you can go to File menu > Open Catalog to navigate to your normal catalog.

What is deleted when I delete my Preferences file?

When you delete your Preferences file, the obvious settings that you lose are those in the Preferences dialog, but it also includes other details such as your View Options settings, last used catalogs, last used settings, FTP server details, some plug-in settings, etc.

Also check...

"The default location of the Preferences is…" on page 655 and "How do I show hidden files to find my preferences and presets?" on page 655

Your original photos, Develop settings, Develop defaults, collections, presets and suchlike aren't affected by deleting the Preferences file. The Store Presets with Catalog setting also goes missing if you delete the preferences file, but the presets themselves are perfectly safe, and switching the setting back on will cause the presets to reappear.

I installed Lightroom, but it says 'An error occurred while attempting to change modules'. How do I fix it?

If Lightroom says 'An error occurred while attempting to change modules,' a few things could be going wrong. The standard troubleshooting steps apply—corrupted catalogs, preferences, presets and fonts have been known to cause similar problems. If that doesn't work, reinstall the latest Lightroom release—there have been some cases of the installation not copying across all of the necessary program files, or certain software removing those files.

If you're seeing that error message having just installed Lightroom, try installing into a clean user account. There's a mysterious problem that shows up intermittently with the installer, but it can't be reproduced on demand, which makes it difficult to fix. It appears to be a file permissions issue. If the clean user account works, you can then transfer the AppData (Windows Vista/7) / Application Support files (Mac) back to your normal user account—they're listed on the following pages under Preset locations. If it still doesn't work, try copying the catalog and preferences over from the clean account too.

Also check...

"The default location of the Presets is…" on page 656

It says 'There was an error working with the photo' or there's an exclamation mark in the corner of the thumbnail and a small fuzzy preview. What's wrong?

Unfortunately files can become corrupted. It usually happens while importing, as a result of a damaged card reader or cable, but there are various possible causes, and as we discussed in the Import chapter, severely corrupted photos often don't even pass the import stage.

If you can see a preview but it has a black line around it, that's the camera's embedded preview. If there's a little more data available, Lightroom may try to read the full file, in which case you'll see a colorful pattern instead. Try opening the photo in the Develop module, and if the file's corrupted, it should warn you that it can't be opened. You can double check by converting it using another raw processor—simply viewing it in a program that shows the embedded JPEG won't be enough, as the embedded JPEGs often escape the corruption.

> The file appears to be unsupported or damaged.

Unfortunately, either way the data is not readable, so you'll need to re-download the file from the memory card or replace it with a backup. If you don't have an uncorrupted version, Instant JPEG from RAW may be able to extract a readable embedded JPEG preview. You can download it freely from http://www.lrq.me/instantjpegfromraw

PREFERENCES & SETTINGS

A few of the menu commands are in different locations on Windows and Mac, depending on the operating system standard. Rather than

Also check...

"Lightroom appears to be corrupting my photos—how do I stop it?" on page 134

repeating them every time I refer to Preferences or Catalog Settings, here's a quick reference:

Lightroom Preferences & Catalog Settings are...

Windows—under the Edit menu

Mac—under the Lightroom menu

Photoshop Preferences are...

Windows—under the Edit menu

Mac—under the Photoshop menu

DEFAULT FILE LOCATIONS

If you need to find Lightroom's files at any time, you'll need to know where to look, so here are the most popular Lightroom file locations.

By default, the boot drive is C:\ on Windows and Macintosh HD on Mac. If your operating system is installed on a different drive, you may need to replace the drive letter/name on the file paths that are listed below.

[your username] refers to the name of your user account, for example, mine is called Vic.

The default location of the Lightroom catalog is...

Windows Vista or 7—C: \ Users \ [your username] \ My Pictures \ Lightroom \ Lightroom 4 Catalog.lrcat

Mac—Macintosh HD / Users / [your username] / Pictures / Lightroom / Lightroom 4 Catalog.lrcat

The catalogs are fully cross platform, and the catalog file extensions are:

*.lrcat is version 1.1 onwards.

*.lrdb was version 1.0.

*.aglib was the early beta.

The default location of the Preferences is...

Windows Vista or 7—C: \ Users \ [your username] \ AppData \ Roaming \ Adobe \ Lightroom \ Preferences \ Lightroom 4 Preferences.agprefs

Mac—Macintosh HD / Users / [your username] / Library / Preferences / com.adobe.Lightroom4.plist

Preference files aren't cross-platform. By default, Preferences are a hidden file on Windows and Mac OS X.

How do I show hidden files to find my preferences and presets?

On Windows, you can open the Start menu and type %appdata%\ Adobe\Lightroom in the Start menu search box and you'll be taken directly to the Lightroom user folder.

If you want to always show the hidden files and system folders, open an Explorer window and go to Organize menu > Folder and Search Options. Under the View tab, you may select 'Show hidden files, folders, and drives,' and I also like to uncheck 'Hide Extensions for Known File Types' as the extensions can be useful. Then click Apply to implement your changes. Bear in mind that those folders and files are hidden for good reason, so be careful if you decide to change these options.

On OS X Snow Leopard (10.6), you can navigate straight to the user Library folder using Finder. On OS X Lion (10.7), the user Library folder is hidden by default. If you go to Finder, select the Go menu, and hold down the Opt key, you'll see Library appear in the menu, and then you can navigate to the Preferences or Application Support folder. Personally, I drag that Library folder to the sidebar so that it's always easily accessible.

The default location of the Presets is...

Windows Vista or 7—C: \ Users \ [your username] \ AppData \ Roaming \ Adobe \ Lightroom \

Mac—Macintosh HD / Users / [your username] / Library / Application Support / Adobe / Lightroom /

Each type of preset has its own folder, for example Develop Presets, Filename Templates and Metadata Presets. Presets are cross-platform and are saved in a Lightroom-only format (.lrtemplate).

If you've checked the Store presets with catalog checkbox in Preferences, they'll be stored next to your catalog file instead.

To find them easily on either platform, go to Preferences > Presets tab and press the Show Lightroom Presets Folder button.

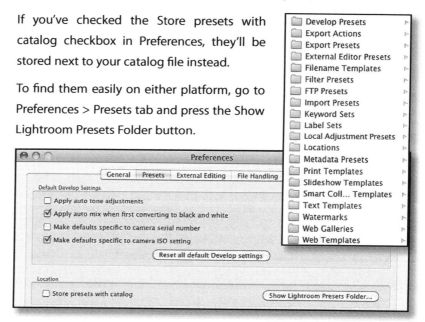

Your Develop Defaults, Lens Defaults and Custom Point Curves are stored at...

Windows Vista or 7—C: \ Users \ [your username] \ AppData \ Roaming \ Adobe \ CameraRaw \

Mac—Macintosh HD / Users / [your username] / Library / Application Support / Adobe / CameraRaw /

Your Develop default settings, lens defaults and custom point curves are

shared with ACR, so they're stored in the shared location, regardless of your 'Store presets with catalog' setting.

The default location of the Camera Raw Cache is...

Windows Vista or 7—C: \ Users \ [your username] \ AppData \ Local \ Adobe \ CameraRaw \ Cache \

Mac—Macintosh HD / Users / [your username] / Library / Caches / Adobe Camera Raw /

Your custom Camera Raw & Lens Profiles should be installed to the User folders...

Lightroom 4 no longer uses the shared ProgramData (Windows) / Application Support (Mac) folders for Camera or Lens Profiles. Instead, it stores the built-in profiles with its program files.

When you create camera or lens profiles, they must be stored in the user locations listed below. If you previously stored custom profiles in other locations, you'll need to move them to these user folders, otherwise Lightroom won't be able to find them.

Windows Vista or 7—C: \ Users \ [your username] \ AppData \ Roaming \ Adobe \ CameraRaw \ CameraProfiles \

Mac—Macintosh HD / Users / [your username] / Library / Application Support / Adobe / CameraRaw / CameraProfiles /

For the lens profiles, substitute the LensProfiles folder for the CameraProfiles folder.

The camera and lens profile file extensions are:

.dcpr—camera profile recipe file used for creating/editing a profile in the DNG Profile Editor

.dcp—camera profile

.lcp—lens profile

Also check...

"How can I speed up browsing in the Develop module? And what are these Cache.dat files?" on page 346*

Also check...

"How do I create a Lens Profile using the Lens Profile Creator?" on page 438 and "DNG Profile Editor" section starting on page 445

INITIAL INSTALLATION

If you're reading this book, you've probably already purchased and installed Lightroom 4, but just in case you're running the trial version, or you need to install on another computer, we'll cover a few basics.

Should I buy the download or the boxed version?

The download is exactly the same as the boxed version—it just doesn't come in a box. Choose whichever is most convenient, and whichever you select, don't forget to store your serial number safely. If you register your software with Adobe, or you buy the download, then Adobe will also keep a record of your serial number, and you can retrieve it at any time by logging into your Adobe account.

Do I have to install the 4.0 version from my CD before installing updates?

Lightroom's trial and update downloads are all the full version of the software, rather than a small update package. If you need to install some months after Lightroom 4.0's release, check Adobe's website to see if a newer 4.x release is available or visit http://www.lrq.me/adobedownloads for easy access to the download links. If there is an updated version, you can just download the latest version and enter your serial number, without first installing from the CD.

Why won't Lightroom 4 install on my computer?

Lightroom 4 has updated minimum system specifications, which are as follows:

Windows

- Intel® Pentium® 4 or AMD Athlon® 64 processor
- Microsoft® Windows Vista® with Service Pack 2 or Windows 7 with Service Pack 1

Mac

- Multicore Intel® processor with 64-bit support
- Mac OS X 10.6.8 (Snow Leopard) or 10.7 (Lion)

For either OS

- 2GB of RAM
- 1GB of available hard-disk space
- 1024x768 display
- DVD-ROM drive
- Internet connection required for Internet-based services

The main changes are to the operating systems—XP is no longer supported on Windows, and 10.6.8 is the minimum for Mac OS X. Lightroom 4 uses many system API's which are not available in older operating systems. On Mac, PowerPC and 32-bit Intel processors aren't supported either, for the same reasons.

64-BIT

The terms 32-bit and 64-bit refer to the way a computer handles information. In practical terms, it means that 64-bit software running in a 64-bit operating system can take advantage of more of your computer's RAM than a 32-bit system, which brings performance improvements.

If you're running the 64-bit version of Lightroom with more than 4GB of RAM, you should see an improvement in Develop module response speeds, moving back and forth between photos, or other tasks where Lightroom is loading large amounts of data into memory. It won't make a significant difference in building previews or running large imports or exports as these are mainly tied to disc I/O speeds.

Also check...

"Speed Tips" section starting on page 344

How do I install the 64-bit version?

For Windows, the installation package will automatically default to the correct version for your operating system—64-bit for a 64-bit OS and 32-bit for a 32-bit OS.

On Mac OS X, Lightroom 4 is 64-bit only. That means that it won't run on 32-bit processors. Only the original Core Solo and Core Duo (different to more recent Core 2 Duo) Intel Machines are unable to run Lightroom 4. You can check that your Mac's processor is compatible by visiting http://www.lrq.me/64bitmac

How can I check whether I'm running the 32-bit or 64-bit version?

To check which version you're running, go to Help menu> System Info, and you'll find a line titled Application Architecture. x64 shows that you're running 64-bit. If you're running the 64-bit version, it will also show in the splash screen when you start Lightroom.

UPGRADING FROM LIGHTROOM 1, 2, 3 OR VERSION 4 BETA

If you're upgrading from a previous version, such as Lightroom 3, you'll need to upgrade your catalogs in addition to upgrading the program.

How do I upgrade Lightroom?

Full releases (1.0, 2.0, 3.0, 4.0, etc.) are always paid upgrades, whereas dot releases (1.3, 2.5, 3.2, 4.3 etc.) are free updates.

If you haven't already purchased Lightroom 4, you can buy a boxed copy from many computer retailers, and Adobe also offer a download version from their own online store. If you already own Lightroom 1, 2, or 3, there's discounted upgrade pricing available.

Do I have to install Lightroom 1, 2 or 3 if I purchased an upgrade version?

If you're installing Lightroom on a new machine, you don't need to install the earlier versions of Lightroom before installing an upgrade version, but you will need to enter the serial number from a previous release.

If I install Lightroom 4, will it overwrite my current Lightroom 3 or earlier version?

Installing Lightroom 4 doesn't affect your existing installations, and you can choose to uninstall those when you're ready. Lightroom 4 will share presets and plug-ins with earlier versions of Lightroom, and will ask to upgrade your older catalogs to the Lightroom 4 format.

Which catalog versions will upgrade to Lightroom 4?

Catalogs from versions 1.x, 2.x, 3.x and from the public beta of 4.0, will upgrade to the final 4.0 release.

Much older beta catalogs, such as those from the Lightroom 2 or 3 beta, may not upgrade without first going through the applicable release version, but you can still download those earlier release versions and run them as a trial in order to convert the catalogs.

How do I upgrade my catalog from version 3 to version 4?

If you're ready to upgrade, first make sure you have a current catalog backup, just in case something goes wrong. Proper measures have been put in place to avoid disasters, but you can never be too careful.

When you open Lightroom 4 for the first time, it should follow any existing Lightroom 3 preferences, and either prompt you for a catalog to open, or try to open your default catalog. If you've never run Lightroom on this machine, it will ask you where to create a default catalog.

When you try to open any earlier catalogs, Lightroom 4 will show the following dialog, asking to upgrade your catalog.

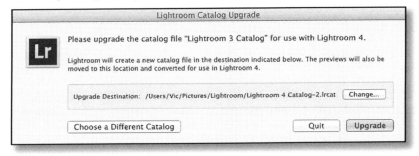

You can select a different folder name or location for the upgraded catalog if you wish. The new version 4 catalog will be an upgraded copy—your original catalog won't be edited.

Once the upgrade has completed, Lightroom will open the newly upgraded catalog as a normal catalog, and will ask you to make a decision on reverse geocoding. You can read more about that choice in the Map module chapter.

Also check...

"Reverse Geocoding"
section starting
on page 262

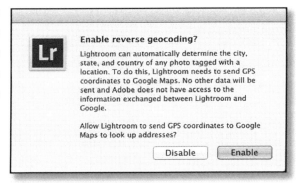

If I upgrade, can I go back to Lightroom 3?

Once you've upgraded your catalog, you won't be able to open the upgraded catalog in an earlier release. You'll still have your earlier catalog untouched, however if you work on the upgraded copy in version 4, for example, using a trial version of Lightroom 4, and then decide to go back to version 3 or earlier, the changes you've made to your photos in version 4 will not show up in your earlier catalog. Even if you write the settings to XMP, Lightroom 3 will not understand PV2012 Develop Settings. You won't want to go back anyway!

Do I have to upgrade a catalog before I can import it into version 4 using Import from Catalog?

If you select an older catalog in the Import from Catalog dialog, it will warn you that it needs to upgrade the catalog before importing. You'll be given a choice of saving that upgraded catalog, as if you had opened the catalog normally and run the upgrade, or discarding the upgraded catalog if it's not needed. Either way, the original catalog is left untouched.

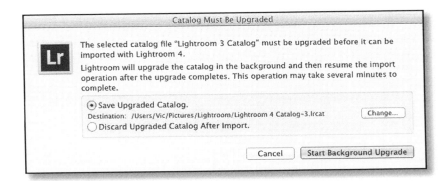

Also check...

"How does Import from Catalog work?" on page 306

What happens if I try to upgrade a catalog that I've already upgraded?

Lightroom keeps track of which catalogs you've already upgraded, so if you try to upgrade the same catalog again, it will warn you and give you the choice of either re-upgrading the catalog or opening the previously upgraded catalog.

Can I uninstall or delete my previous installations?

If you have older Lightroom installations on your computer, for example, Lightroom 3 or the recent beta, you can uninstall them without affecting your current installation. Your catalog, preferences and presets shouldn't be affected by the uninstall, but it's always sensible to keep solid backups regardless. If you do have a problem with running the current version after uninstalling an old version, simply reinstall the current version.

INSTALLING, UPDATING & DOWNGRADING

Lightroom's updated on a 3-4 monthly basis and, as well as new camera releases, there are often bug fixes, particularly in the early dot releases such as 4.1, so it's worth staying current with those updates.

How do I check which update I'm currently running?

Go to the Help menu > System Info and the first line will confirm the version and build number, or the splash screen will also tell you your current version number when you start Lightroom.

How do I find out whether my new camera is supported yet?

Each time a new camera is released, Adobe has to update Lightroom and ACR to be able to read and convert the raw files. These updates are usually released at 3-4 monthly intervals and there's a list of currently supported cameras at: http://www.lrq.me/camerasupport

How do I update Lightroom with the latest version of ACR?

Although ACR updates are usually released at the same time as Lightroom updates, they're only for use in Photoshop Elements or the Creative Suite. Lightroom has the ACR engine built in to its main program files, so if you install a Lightroom update, you're done. If you use Photoshop, you will also need to install the ACR updates for Edit in Photoshop compatibility, but Lightroom itself will work correctly without it. Turn back to the Adobe Camera Raw Compatibility section for additional information.

How do I update to a newer Lightroom dot release?

Lightroom will automatically check for updates on a regular basis, or you can go to Help menu > Check for Updates at any time, to see if a new version has been released. Either notification will direct you to a page on Adobe's website, where you can download the latest update and install it like any other program.

How do I downgrade to an earlier Lightroom dot release in the case of problems?

On a Mac, you should be able to download and reinstall without any problems, and on Windows, a full uninstall using Add/Remove Programs should allow you to download and reinstall again.

Also check...

"It says: 'Some import operations were not performed. The file is from a camera which isn't recognized by the raw format support in Lightroom.'" on page 132 and "Adobe Camera Raw Compatibility for Photoshop" section starting on page 479

LANGUAGES

Lightroom's not just limited to English—it's also available in Chinese Simplified, Chinese Traditional, Dutch, French, German, Italian, Japanese, Korean, Portuguese, Spanish, or Swedish.

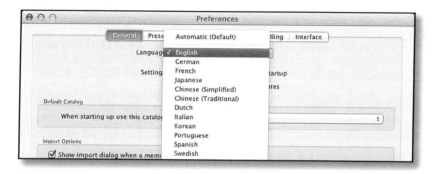

How do I switch language?

On Windows, and also now on Mac, it's easy to switch to one of the other supported languages. Just go to Edit menu > Preferences > General tab, select the language you want to use and then restart Lightroom.

Some of the shortcuts don't work with my language version or non-English keyboard—can I fix it?

If you're using the English version of Lightroom with another language's keyboard, some of the keyboard shortcuts might not work. You can change those shortcuts using the same TranslatedStrings.txt file that we used in the Import chapter to create custom dated folder templates.

The TranslatedStrings.txt file contains all of the translations for its language—and also includes the shortcuts. This isn't officially supported by Adobe, but you can edit the file to reassign the shortcuts, and many users have done so without issue.

If you're using another language, the TranslatedStrings.txt file will already be in your language's project folder, for example 'fr.lproj' for

French, and you'll need to edit that file. If you're editing an existing file, obviously back it up first! The locations of the language project files are:

Windows—C: \ Program Files \ Adobe \ Adobe Photoshop Lightroom 4 \ Resources \

Mac—Macintosh HD / Applications / Adobe Lightroom 4.app / Contents / Resources /

To access the Mac folder, right-click on the app and select Show Package Contents.

If you're using the English version of Lightroom, the file and folder may not exist, but you can just create a plain text file called TranslatedStrings.txt inside a 'en' (Windows) or 'en.lproj' (Mac) folder. If you're using another language, the file will already be in your language's project folder, for example 'fr' or 'fr.lproj' for French, and you'll need to edit that file. Use a plain text editor such as Notepad on Windows or TextEdit on Mac, rather than a word processor like Word. If you're editing an existing file, obviously back it up first!

The file is long, so you'll probably need to use your text editor's search function to find the shortcut that you need to change. For example, to change the Decrease Rating shortcut from [to ; you'd find the line that says "$$$/LibraryMenus/MenuShortcut/DecreaseRating=[" and change it to "$$$/LibraryMenus/MenuShortcut/DecreaseRating=;". It comes into effect next time you start Lightroom.

Once you're happy with the result, don't forget to back up your new TranslatedStrings.txt file, as it will be replaced each time you update Lightroom. If you have any problems, delete the file if you're using the English version, or restore the backup of the other language version.

There is a plug-in called Keyboard Tamer, which not only allows you change existing keyboard shortcuts, but also create some keyboard shortcuts. http://www.lrq.me/armes-kbtamer

LICENSING INFORMATION

You can download the full license agreement from:

http://www.lrq.me/licenseagreement

Lightroom is listed under its full name of Adobe Photoshop Lightroom.

I'm switching from PC to Mac—how do I switch my Lightroom license?

If you're switching from Windows to Mac, or vice versa, you'll be pleased to know that, unlike Photoshop, the Lightroom license is cross-platform and the same license key and program CD work on both Windows and Mac. There are separate downloads for the Windows and Mac versions.

How many machines can I install Lightroom on?

You can install Lightroom on up to 2 machines for your own personal use, for example, your desktop and your laptop, as long as you're not using Lightroom on both machines simultaneously. Unlike Photoshop, they don't have to both be the same operating system, so you can have 1 Mac and 1 Windows if you wish.

The applicable part of the license agreement says:

"2.1.3 Portable or Home Computer Use. Subject to the restrictions set forth in Section 2.1.4, the primary user of the Computer on which the Software is installed under Section 2.1 ("Primary User") may install a second copy of the Software for his or her exclusive use on either a portable Computer or a Computer located at his or her home, provided that the Software on the portable or home Computer is not used at the same time as the Software on the primary Computer."

How do I deactivate Lightroom to move it to another machine?

There is currently no activation on Lightroom, so moving to a new computer is just a case of uninstalling and reinstalling. They trust you!

FINAL WORDS...

Ok, not quite the final words, as we still have keyboard shortcuts, an appendix and an index to cover, but you might appreciate contact details for Adobe, while we're talking about useful information.

Where else can I go to find solutions to my problems that aren't covered here?

Adobe Support Pages for Lightroom: http://www.lrq.me/officialsupport

Adobe User to User forums are the official Adobe-sponsored forums: http://www.lrq.me/officialforums

Lightroom Forums is a friendlier independent forum: http://www.lrq.me/forum

And of course you're always welcome to talk to me! Visit my website at http://www.lightroomqueen.com and if you've registered your book (or bought it direct from my website), you'll be able to log into the Members Area (http://www.lrq.me/members) to get priority access! :)

I've got a great idea, or I've found a repeatable bug—how do I tell Adobe?

The Lightroom team have welcomed customer feedback since the early betas, and they're still listening now. You can submit feature requests and bug reports using the Official Feature Request / Bug Report Forum at: http://www.lrq.me/featuresbugs

The engineers can't reply to all of the posts, due to the volume of the requests and reports they receive, however they are all read by the Lightroom team themselves. It's a great way of supporting future development.

Finally, enjoy it!

REGISTER YOUR BOOK FOR ADDITIONAL BENEFITS

By registering your copy of this book, you gain access to additional benefits absolutely free—and who doesn't like free?!

- Access to all available eBook formats.
- Any updates to the Lightroom 4 book.
- Discounts on future book purchases.
- Priority access to me! I'll still be on the forums and answering emails, but anyone who is registered as a book owner gets my attention first.
- Access to a private Members Area which is currently under construction... let's just say I have plans!

To register your book, all you need to do is send me a copy of your purchase receipt or shipping confirmation, and include the following code: CAZ032512

The best way of sending me those details is to go to http://www.lrq.me/newticket and open a support ticket. I'll still reply personally, but the help desk software avoids your emails getting caught in spam. Alternatively, you can email the details directly to members@lightroomqueen.com

If you purchased the book direct from http://www.lightroomqueen.com, you'll already be registered, and you should have received your Members Area login details by email within 48 hours of ordering. If you haven't received your login details, just ask.

Keyboard Shortcuts

On the following pages are all of the known keyboard shortcuts for Adobe Lightroom, both Windows and Mac versions. They're also available in printable format from my Lightroom Queen website: http://www.lrq.me/shortcuts

		Windows Shortcuts	Mac Shortcuts
Working with Catalogs			
Open Catalog...		Ctrl O	Cmd Shift O
Open Specific Catalog when opening Lightroom		Hold down Ctrl while opening Lightroom	Hold down Opt while opening Lightroom
Import			
Import Photos and Video...		Ctrl Shift I	Cmd Shift I
Tethered Capture	Hide Tethered Capture Window	Ctrl T	Cmd T
	Shrink Tethered Capture Window	Alt-click on close button	Opt-click on close button
	New Shot	Ctrl Shift T	Cmd Shift T
Layout Overlay	Show Layout Overlay	Ctrl Alt O	Cmd Opt O
	Choose Layout Overlay Image...	Ctrl Alt Shift O	Cmd Opt Shift O
	Options	Hold Ctrl key	Hold Cmd key
Workspace			
Grid View	Go to Grid view	G	G
	Increase Grid Size	= (or +)	= (or +)

		Windows Shortcuts	**Mac Shortcuts**
	Decrease Grid Size	-	-
	Show/Hide Extras	Ctrl Shift H	Cmd Shift H
	Show/Hide Badges	Ctrl Alt Shift H	Cmd Opt Shift H
	Cycle Grid View Style	J	J
Loupe View	Go to Loupe view	E	E
	Show Info Overlay	Ctrl I	Cmd I
	Cycle Info Display	I	I
Compare View	Go to Compare view	C	C
	Switch Select and Candidate	Down arrow	Down arrow
	Make next photos Select and Candidate	Up arrow	Up arrow
	Swap most-selected/active photo	\	\
Survey View	Go to Survey view	N	N
Zoom	Toggle Zoom View	Z	Z
	Zoom In	Ctrl = (or +)	Cmd = (or +)
	(Zoom In Some)	Ctrl Alt = (or +)	Cmd Opt = (or +)
	Zoom Out	Ctrl -	Cmd -
	(Zoom Out Some)	Ctrl Alt -	Cmd Opt -
	Open in Loupe	Enter	Return
View Options...		Ctrl J	Cmd J
	Show / Hide Toolbar	T	T
Moving between Modules	Library Module	G/E/C/S or Ctrl Alt 1	G/E/C/S or Cmd Opt 1
	Develop Module	D or Ctrl Alt 2	D or Cmd Opt 2
	Map Module	Ctrl Alt 3	Cmd Opt 3
	Book Module	Ctrl Alt 4	Cmd Opt 4
	Slideshow Module	Ctrl Alt 5	Cmd Opt 5
	Print Module	Ctrl Alt 6	Cmd Opt 6
	Web Module	Ctrl Alt 7	Cmd Opt 7
	Go Back to Previous Module	Ctrl Alt up arrow	Cmd Opt up arrow
	Go Back	Ctrl Alt left arrow	Cmd Opt left arrow
	Go Forward	Ctrl Alt right arrow	Cmd Opt right arrow
Panels	Expand / Collapse Left Panels	Ctrl Shift 0-9 (panel number)	Cmd Ctrl 0-9 (panel number)
	Expand / Collapse Right Panels	Ctrl 0-9 (panel number)	Cmd 0-9 (panel number)
	Open/Close All Panels	Ctrl-click on panel header	Cmd-click on panel header

		Windows Shortcuts	**Mac Shortcuts**
	Toggle Solo Mode	Alt-click on panel header	Opt-click on panel header
	Open Additional Panel in Solo Mode	Shift-click on panel header	Shift-click on panel header
	Show / Hide Side Panels	Tab	Tab
	Show / Hide All Panels	Shift Tab	Shift Tab
	Show / Hide Module Picker	F5	F5
	Show / Hide Filmstrip	F6	F6
	Show Left Panels	F7	F7
	Show Right Panels	F8	F8
Selections	Select All	Ctrl A	Cmd A
	Select None	Ctrl D or Ctrl Shift A	Cmd D or Cmd Shift A
	Select Only Active Photo	Ctrl Shift D	Cmd Shift D
	Deselect Active Photo	/	/
	Select Multiple Contiguous Photos	Shift-click on photos	Shift-click on photos
	Select Multiple Non-Contiguous Photos	Ctrl-click on photos	Cmd-click on photos
	Add previous/next photo to selection	Shift left/right arrow	Shift left/right arrow
	Select Flagged Photos	Ctrl Alt A	Cmd Opt A
	Deselect Unflagged Photos	Ctrl Alt Shift D	Cmd Opt Shift D
	Select Rated/Labeled Photo	Ctrl-click on symbol in Filter bar	Cmd-click on symbol in Filter bar
Moving between photos	Previous Selected Photo	Ctrl left arrow	Cmd left arrow
	Next Selected Photo	Ctrl right arrow	Cmd right arrow
Screen Mode	Normal	Ctrl Alt F	Cmd Opt F
	Full Screen and Hide Panels	Ctrl Shift F	Cmd Shift F
	Next Screen Mode	F	F
	Previous Screen Mode	Shift F	Shift F
Lights Out	Lights Dim	Ctrl Shift L	Cmd Shift L
	Next Light Mode	L	L
	Previous Light Mode	Shift L	Shift L
Secondary Display	Show Secondary Display	F11	F11
	Full Screen	Shift F11	Cmd Shift F11
	Show Second Monitor Preview	Ctrl Shift F11	Cmd Shift Opt F11
	Grid	Shift G	Shift G
	Loupe—Normal	Shift E	Shift E
	Loupe—Locked	Ctrl Shift Enter	Cmd Shift Return

		Windows Shortcuts	Mac Shortcuts
	Compare	Shift C	Shift C
	Survey	Shift N	Shift N
	Slideshow	Ctrl Alt Shift Enter	Cmd Opt Shift Return
	Show Filter View	Shift \	Shift \
	Zoom In	Ctrl Shift = (or +)	Cmd Shift = (or +)
	(Zoom In Some)	Ctrl Shift Alt = (or +)	Cmd Shift Opt = (or +)
	Zoom Out	Ctrl Shift -	Cmd Shift -
	Zoom Out Some	Ctrl Shift Alt -	Cmd Shift Opt -
	Increase Thumbnail Size	Shift = (or +)	Shift = (or +)
	Decrease Thumbnail Size	Shift -	Shift -
Hide Lightroom			Cmd H
Hide Others			Cmd Opt H
	Close Window		Cmd W
	(Close All)		Cmd Opt W
	Minimize		Cmd M
	(Minimize All)		Cmd Opt M
Lightroom Help...		F1	F1
Current Module Help...		Ctrl Alt /	Cmd Opt /
Current Module Shortcuts...		Ctrl /	Cmd /
Plug in Manager		Ctrl Alt Shift ,	Cmd Opt Shift ,
Preferences...		Ctrl ,	Cmd ,
Catalog Settings...		Ctrl Alt ,	Cmd Opt ,
Quit Lightroom		Ctrl Q	Cmd Q
Library Module			
Undo/Redo	Undo	Ctrl Z	Cmd Z
	Redo	Ctrl Y	Cmd Shift Z
Quick Collection	Add to Quick Collection	B	B
	(Add to Quick Collection and Next)	Shift B	Shift B
	Show Quick Collection	Ctrl B	Cmd B
	Save Quick Collection...	Ctrl Alt B	Cmd Opt B
	Clear Quick Collection	Ctrl Shift B	Cmd Shift B
	Set Quick Collection as Target	Ctrl Alt Shift B	Cmd Opt Shift B
Folders / Collections	New Collection...	Ctrl N	Cmd N
	New Folder...	Ctrl Shift N	Cmd Shift N

		Windows Shortcuts	Mac Shortcuts
	Expand all subfolders	Alt-click on folder disclosure triangle	Opt-click on folder disclosure triangle
	Show in Explorer/Finder	Ctrl R	Cmd R
Stacking	Group into Stack	Ctrl G	Cmd G
	Unstack	Ctrl Shift G	Cmd Shift G
	Collapse/Expand Stack	S	S
	Move to Top of Stack	Shift S	Shift S
	Move Up in Stack	Shift [Shift [
	Move Down in Stack	Shift]	Shift]
Toggle Flag	Flagged	P	P
	Unflagged	U	U
	Rejected	X	X
	Toggle Flag	`	`
	Increase Flag Status	Ctrl up arrow	Cmd up arrow
	Decrease Flag Status	Ctrl down arrow	Cmd down arrow
	Auto Advance	Hold shift while using P, U, X or turn on Caps Lock	Hold shift while using P, U, X or turn on Caps Lock
Toggle Rating	0-5 stars	0, 1, 2, 3, 4, 5	0, 1, 2, 3, 4, 5
	Decrease Rating	[[
	Increase Rating]]
	Auto Advance	Hold shift while using 0-5 or turn on Caps Lock	Hold shift while using 0-5 or turn on Caps Lock
Toggle Color Label	Red, Yellow, Green, Blue Label	6-9	6-9
	Auto Advance	Hold shift while using 6-9 or turn on Caps Lock	Hold shift while using 6-9 or turn on Caps Lock
Painter Tool	Enable Painting	Ctrl Alt K	Cmd Opt K
Rename	Rename Photo...	F2	F2
Rotation	Rotate Left (CCW)	Ctrl [Cmd [
	Rotate Right (CW)	Ctrl]	Cmd]
Delete	Delete Photo...	Delete	Delete
	Remove Photo from Catalog...	Alt Delete	Opt Delete
	(Remove and Trash Photo...)	Ctrl Alt Shift Delete	Cmd Opt Shift Delete
Metadata	Copy Metadata...	Ctrl Alt Shift C	Cmd Opt Shift C
	Paste Metadata	Ctrl Alt Shift V	Cmd Opt Shift V
	Enable Metadata Auto Sync	Ctrl Alt Shift A	Cmd Opt Shift A

		Windows Shortcuts	**Mac Shortcuts**
	Save Metadata to File	Ctrl S	Cmd S
	Show Spelling and Grammar	Mac only	Cmd :
	Check Spelling	Mac only	Cmd ;
OS Copy/Paste (within text fields)	Cut	Ctrl X	Cmd X
	Copy	Ctrl C	Cmd C
	Paste	Ctrl V	Cmd V
Keywording	Go to Add Keywords field	Ctrl K	Cmd K
	(Change Keywords...)	Ctrl Shift K	Cmd Shift K
	Set Keyword Shortcut...	Ctrl Alt Shift K	Cmd Opt Shift K
	Toggle Keyword Shortcut	Shift K	Shift K
	Next Keyword Set	Alt 0	Opt 0
	Previous Keyword Set	Alt Shift 0	Opt Shift 0
	Apply Keyword	(Alt numberpad for 1 9)	(Opt numberpad for 1 9)
Filtering	Enable/Disable Filters	Ctrl L	Cmd L
	Show Filter Bar	\	\
	Refine Photos...	Ctrl Alt R	Cmd Opt R
Text Filters	Select Text Filter	Ctrl F	Cmd F
	Starts with...	+ at beginning of word	+ at beginning of word
	Ends with...	+ at end of word	+ at end of word
	Doesn't Contain...	! at beginning of word	! at beginning of word

Video Editing			
Trimming	Set In Point	Shift I	Shift I
	Set Out Point	Shift O	Shift O
Toggle Play/Pause		Space	Space

Develop Module			
	Go to Develop	D	D
Copying, Pasting & Syncing	Copy Settings...	Ctrl Shift C	Cmd Shift C
	Paste Settings	Ctrl Shift V	Cmd Shift V
	Paste Settings from Previous	Ctrl Alt V	Cmd Opt V
	Sync Settings...	Ctrl Shift S	Cmd Shift S
	Sync Settings—no dialog	Ctrl Alt S	Cmd Opt S
	Enable Develop Auto Sync	Ctrl Alt Shift A	Cmd Opt Shift A
	Match Total Exposures	Ctrl Alt Shift M	Cmd Opt Shift M

		Windows Shortcuts	Mac Shortcuts
Sliders	Select next Basic panel slider	.	.
	Select previous Basic panel slider	,	,
	Increase slider value	= (or +)	= (or +)
	Decrease slider value	-	-
	Move slider value by larger increment	Shift while using = (or +) or -	Shift while using = (or +) or -
	Move slider value by smaller increment		Opt while using = (or +) or -
Auto	Go to White Balance Tool	W	W
	Auto White Balance	Ctrl Shift U	Cmd Shift U
	Auto Tone	Ctrl U	Cmd U
Black & White	Toggle Black & White	V	V
Snapshots & Virtual Copies	Create Snapshot	Ctrl N	Cmd N
	Create Virtual Copy	Ctrl '	Cmd '
Presets	New Preset...	Ctrl Shift N	Cmd Shift N
	New Preset Folder...	Ctrl Alt N	Cmd Opt N
Before / After Previews	Toggle Before/After	\	\
	Left / Right	Y	Y
	Top / Bottom	Alt Y	Opt Y
	Split Screen	Shift Y	Shift Y
	Copy After's Settings to Before	Ctrl Alt Shift left arrow	Cmd Opt Shift left arrow
	Copy Before's Settings to After	Ctrl Alt Shift right arrow	Cmd Opt Shift right arrow
	Swap Before and After Settings	Ctrl Alt Shift up arrow	Cmd Opt Shift up arrow
Targeted Adjustment Tool	Deselect TAT	Ctrl Alt Shift N	Cmd Opt Shift N
	Tone Curve	Ctrl Alt Shift T	Cmd Opt Shift T
	Hue	Ctrl Alt Shift H	Cmd Opt Shift H
	Saturation	Ctrl Alt Shift S	Cmd Opt Shift S
	Luminance	Ctrl Alt Shift L	Cmd Opt Shift L
	Black & White Mix	Ctrl Alt Shift G	Cmd Opt Shift G
Clipping Indicators	Show Clipping	J	J
	Temporarily Show Clipping	Hold Alt while moving slider	Hold Opt while moving slider
Reset	Reset Slider	Double-click on slider label	Double-click on slider label
	Reset Group of Sliders	Double-click on group name	Double-click on group name

		Windows Shortcuts	**Mac Shortcuts**
	Reset All Settings	Ctrl Shift R	Cmd Shift R
Cropping	Go to Crop Tool	R	R
	Reset Crop	Ctrl Alt R	Cmd Opt R
	Constrain Aspect Ratio	A	A
	Crop to Same Aspect Ratio	Shift A	Shift A
	Rotate Crop Aspect	X	X
	Crop from Center of Photo	Alt while dragging	Opt while dragging
	Rotation Angle Ruler	Ctrl-click on start and end points	Cmd-click on start and end points
	Cycle Grid Overlay	O	O
	Cycle Grid Overlay Orientation	Shift O	Shift O
Spot Removal	Go to Spot Removal	Q	Q
	Increase spot size]]
	Decrease spot size	[[
	Hide Pins or Spots	H	H
	Delete Pin or Spot	Select Spot then Delete	Select Spot then Delete
Local Adjustments	Go to Adjustment Brush	K	K
	Go to Graduated Filter	M	M
	Show Overlay	O	O
	Cycle Overlay Color	Shift O	Shift O
	Switch brush A / B	/	/
	Temporary Eraser	Hold Alt	Hold Opt
	Increase brush size]]
	Decrease brush size	[[
	Increase brush feathering	Shift]	Shift]
	Decrease brush feathering	Shift {	Shift {
	Set Flow value	0-9	0-9
	Constrain Brush to Straight Line	Shift while dragging	Shift while dragging
	Constrain Gradient to 90 degrees	Shift while dragging	Shift while dragging
	Invert Gradient	' (apostrophe)	' (apostrophe)
	Hide Pins or Spots	H	H
	Confirm brush stroke	Enter	Return
	Delete Pin or Spot	Select pin then Delete	Select pin then Delete
	Increase or decrease Amount slider	Click and drag horizontally on pin	Click and drag horizontally on pin

		Windows Shortcuts	Mac Shortcuts
Soft Proofing	Show/Hide Soft Proof	S	S
	Destination Gamut Warning	Shift S	Shift S
Edit in Photoshop & Other Programs			
Edit in...	Edit in Photoshop...	Ctrl E	Cmd E
	Edit in Other Application...	Ctrl Alt E	Cmd Opt E
Export			
Export...		Ctrl Shift E	Cmd Shift E
Export with Previous		Ctrl Alt Shift E	Cmd Opt Shift E
Email Photo...		Ctrl Shift M	Cmd Shift M
Map Module			
Previous Photo		Ctrl left arrow	Cmd left arrow
Next Photo		Ctrl right arrow	Cmd right arrow
Search...		Ctrl F	Cmd F
Tracklog	Previous Track	Ctrl Alt Shift T	Cmd Opt Shift T
	Next Track	Ctrl Alt T	Cmd Opt T
Delete GPS Coordinates		Backspace	Delete
Delete All Location Metadata		Ctrl Backspace	Cmd Delete
Show Filter Bar		\	\
Show Map Info		I	I
Show Saved Location Overlay		O	O
Lock Markers		Ctrl K	Cmd K
Map Style	Hybrid	Ctrl 1	Cmd 1
	Road Map	Ctrl 2	Cmd 2
	Satellite	Ctrl 3	Cmd 3
	Terrain	Ctrl 4	Cmd 4
	Light	Ctrl 5	Cmd 5
	Dark	Ctrl 6	Cmd 6
Zoom Map	Zoom In	= (or +)	= (or +)
	Zoom Out	-	-
	Zoom to Selection	Alt-drag rectangle on map	Opt-drag rectangle on map

		Windows Shortcuts	Mac Shortcuts
Book Module			
Selections	Select All Text Cells	Ctrl Alt A	Cmd Opt A
	Select All Photo Cells	Ctrl Alt Shift A	Cmd Opt Shift A
Select Multiple Cells		Shift-click	Shift-click
Copy/Paste	Copy Layout	Ctrl Shift C	Cmd Shift C
	Paste Layout	Ctrl Shift V	Cmd Shift V
Delete	Remove Photo from Page	Backspace	Delete
	Remove Page	Ctrl Shift Backspace	Cmd Shift Delete
Create Saved Book		Ctrl S	Cmd S
Go to	Beginning	Ctrl Shift left arrow	Cmd Shift left arrow
	Previous Page	Ctrl left arrow	Cmd left arrow
	Next Page	Ctrl right arrow	Cmd right arrow
	End	Ctrl Shift right arrow	Cmd Shift right arrow
Show Header Bar		\	\
Show Guides		Ctrl Shift G	Cmd Shift G
Guides	Page Bleed	Ctrl Shift J	Cmd Shift J
	Text Safe Area	Ctrl Shift U	Cmd Shift U
	Photo Cells	Ctrl Shift K	Cmd Shift K
	Filler Text	Ctrl Shift H	Cmd Shift H
Show Info Overlay		I	I
View Options	Multi-Page View	Ctrl E	Cmd E
	Spread View	Ctrl R	Cmd R
	Single Page View	Ctrl T	Cmd T
	Zoomed Page View	Ctrl U	Cmd U
	Next View Mode	Ctrl = (or +)	Cmd = (or +)
	Previous View Mode	Ctrl -	Cmd -
	Increase Grid Size	= (or +)	= (or +)
	Decrease Grid Size	-	-
Text Targeted Adjustment Tool	Text Size	Drag horizontally	Drag horizontally
	Leading/Line Height	Drag vertically	Drag vertically
	Tracking	Ctrl-drag horizontally	Cmd-drag horizontally
	Baseline Shift	Ctrl-drag vertically	Cmd-drag vertically
	Kerning	Drag horizontally over cursor / insertion point	Drag horizontally over cursor / insertion point

		Windows Shortcuts	Mac Shortcuts
	Temporarily deactivate TAT tool	Hold down Alt	Hold down Opt
	Exit the TAT tool	Escape	Escape
Slideshow Module			
Impromptu Slideshow		Ctrl Enter	Cmd Return
New Template		Ctrl N	Cmd N
New Template Folder		Ctrl Shift N	Cmd Shift N
Create Saved Slideshow		Ctrl S	Cmd S
Go to	Next Slide	Right arrow	Right arrow
	Previous Slide	Left arrow	Left arrow
Show Header Bar		\	\
Show / Hide Guides		Ctrl Shift H	Cmd Shift H
Run Slideshow		Enter	Return
Pause Slideshow		Space	Space
End Slideshow		Escape	Escape
Export	PDF Slideshow...	Ctrl J	Cmd J
	JPEG Slideshow...	Ctrl Shift J	Cmd Shift J
	Video Slideshow...	Ctrl Alt J	Cmd Opt J
Print Module			
New Template		Ctrl N	Cmd N
New Template Folder		Ctrl Shift N	Cmd Shift N
Create Saved Print		Ctrl S	Cmd S
Go to	First Page	Ctrl Shift left arrow	Cmd Shift left arrow
	Previous Page	Ctrl left arrow	Cmd left arrow
	Next Page	Ctrl right arrow	Cmd right arrow
	Last Page	Ctrl Shift right arrow	Cmd Shift right arrow
Show Header Bar		\	\
Show / Hide Guides		Ctrl Shift H	Cmd Shift H
Guides	Page Bleed	Ctrl Shift J	Cmd Shift J
	Margins and Gutters	Ctrl Shift M	Cmd Shift M
	Image Cells	Ctrl Shift K	Cmd Shift K
	Dimensions	Ctrl Shift U	Cmd Shift U
Show/Hide Rulers		Ctrl R	Cmd R
Page Setup...		Ctrl Shift P	Cmd Shift P
Print Settings...		Ctrl Alt Shift P	Cmd Opt Shift P

		Windows Shortcuts	Mac Shortcuts
Print...		Ctrl P	Cmd P
Print One		Ctrl Alt P	Cmd Opt P
Web Module			
New Template		Ctrl N	Cmd N
New Template Folder		Ctrl Shift N	Cmd Shift N
Create Saved Web Gallery		Ctrl S	Cmd S
Reload		Ctrl R	Cmd R
Use Advanced Settings		Ctrl Alt Shift /	Cmd Opt Shift /
Preview in Browser...		Ctrl Alt P	Cmd Opt P
Export Web Photo Gallery...		Ctrl J	Cmd J

Standard Modifier Keys

On both platforms, in addition to keyboard shortcuts, the standard modifier keys are used in combination with mouse clicks to perform various tasks.

Ctrl (Windows) / Cmd (Mac) selects or deselects multiple items that are not necessarily consecutive. For example, hold down Ctrl (Windows) / Cmd (Mac) to select multiple photos, select multiple folders, select multiple keywords, etc.

Shift selects or deselects multiple consecutive items. For example, hold down Shift while clicking to select multiple photos, select multiple folders, select multiple keywords etc.

Alt (Windows) / Opt (Mac)—Changes the use of some controls. For example, in Quick Develop, it swaps the 'Clarity' and 'Vibrance' buttons for 'Sharpening' and 'Saturation.' In Develop panels, it changes the panel label to a panel 'Reset' button, and holding it down while moving some sliders shows masks or clipping warnings.

To switch catalogs when opening, hold down Ctrl (Windows) / Opt (Mac).

Index

Made in the USA
Lexington, KY
24 October 2012